THE ART OF THE PORTRAIT

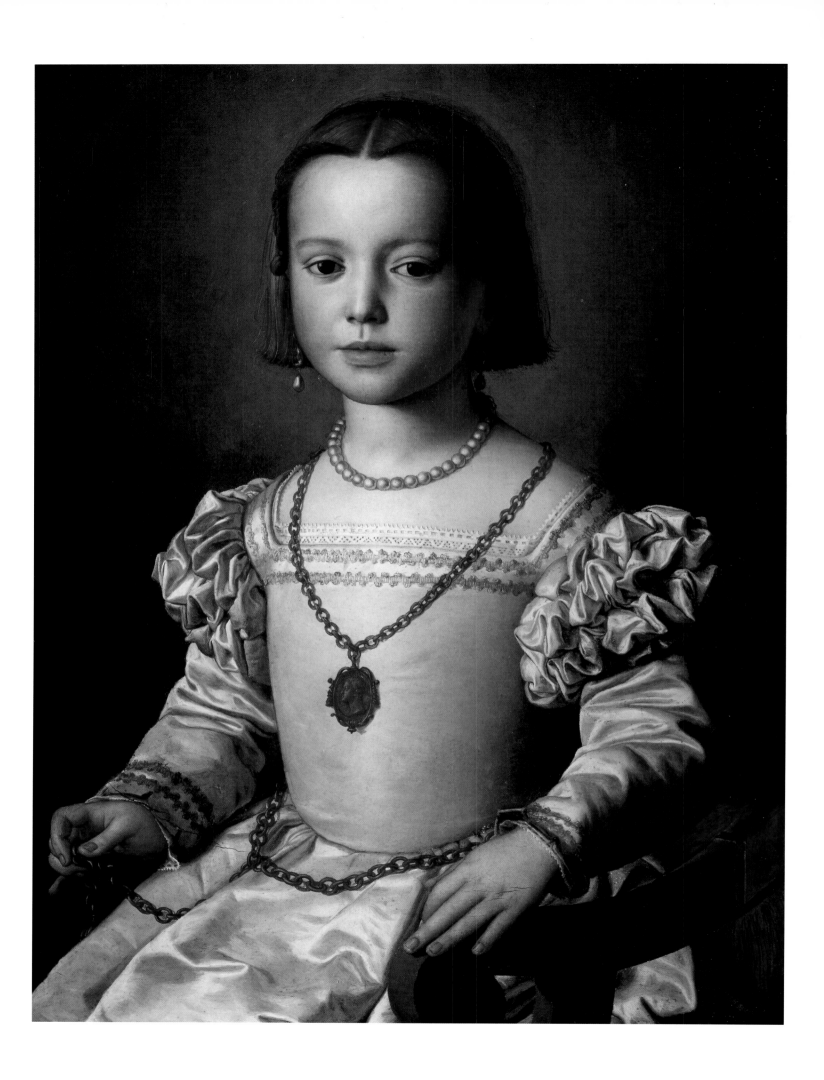

Norbert Schneider

THE ART OF THE PORTRAIT

Masterpieces of European Portrait Painting

1420–1670

TASCHEN

KÖLN LONDON MADRID NEW YORK PARIS TOKYO

ILLUSTRATION PAGE 2:
Agnolo Bronzino
Bia de' Medici, undated
Tempera on panel, 59 x 45 cm
Florence, Galleria degli Uffizi

© 1999 Benedikt Taschen Verlag GmbH
Hohenzollernring 53, D–50672 Köln
English translation: Iain Galbraith, Wiesbaden
Cover design: Angelika Taschen, Cologne

Printed in Germany
ISBN 3–8228–6522–2

Contents

The Great Age of the Portrait

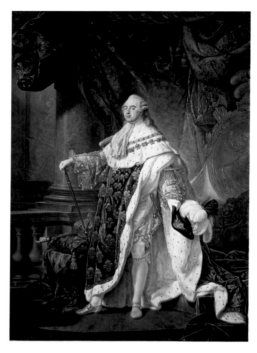

Antoine-François Callet
Louis XVI, 1783
Oil on canvas, 273 x 193 cm
Madrid, Museo Nacional del Prado

Full-length portraits were usually reserved for rulers and the nobility. Titian's portrait of Charles V in a silver brocade coat, based on an earlier model by the Austrain painter Jacob Seisenegger, is an excellent example.

Titian
Emperor Charles V, 1532/33
Oil on canvas, 192 x 111 cm
Madrid, Museo Nacional del Prado

The portraits presented in this book are selected exclusively from works executed between the late Middle Ages and the seventeenth century. There are good reasons for limiting study to this period, for it was then that portraiture came into its own. It was this era that witnessed the revival and genuine renewal of the individualised, "au vif" depiction of privileged or highly esteemed persons, a genre largely neglected since Classical antiquity. From the fifteenth century onwards, not only princes, the high clergy and noblemen, but members of other social groups – merchants, craftsmen, bankers, humanist scholars and artists – sat for their portraits, keeping themselves, quite literally, in the public eye.

The period also saw the development of various portrait types, subgenres which determined the forms taken by portraits in the following centuries. Examples of these are the "full-length portrait", usually reserved for ruling princes or members of the nobility (ill. p.7), the "three-quarter-length portrait" (ill. p.19) and the many different kinds of "head-and-shoulder portrait", the most frequently occurring portrait type, with its various angles at which the sitter posed in relation to the spectator. Typical poses included the "profile view" (ill. p.53) with its dignified, hieratic air reminiscent of Classical antiquity, the "three-quarters view", the "half-length" and the frontal, or "full-face view", with its often highly suggestive form of "direct address".

Besides the "individual portrait", whose function was the depiction of public figures who wished to demonstrate their social standing as autonomous individuals (see Hans Holbein's *Georg Gisze,* ill. p.8), the "group portrait" continued during this period to be cultivated as an artistic institution.[1] Such portraits served as status symbols for corporate bodies such as guilds or other professional societies and trade associations, while at the same time defining the various roles and hierarchies within the groups themselves. Similarly, portraits of married couples and family portraits allowed the basic social units of the early modern state to project an image of themselves that was, in the main, consistent with the mores and conventions of their age.

It remains a source of continual astonishment that so infinitely complex a genre should develop in so brief a space of time, indeed within only a few decades of the fifteenth century, especially in view of the constraints imposed upon it by the individual requirements of its patrons. Its complexity is revealed in its rhetorical gesture, in its vast vocabulary of physical postures and facial expressions and in the range of emblems and other attributes characterising the sitters and symbolising their spheres of influence.

While the earliest works of this period, by early Netherlandish portraitists (see, for example, Jan van Eyck, ill. p.31), appear to have concentrated exclusively, and with almost microscopic attention to detail, on the rendering of external reality, rejecting psychology altogether, the portraits painted towards the end of the fifteenth century focused increasingly on inward

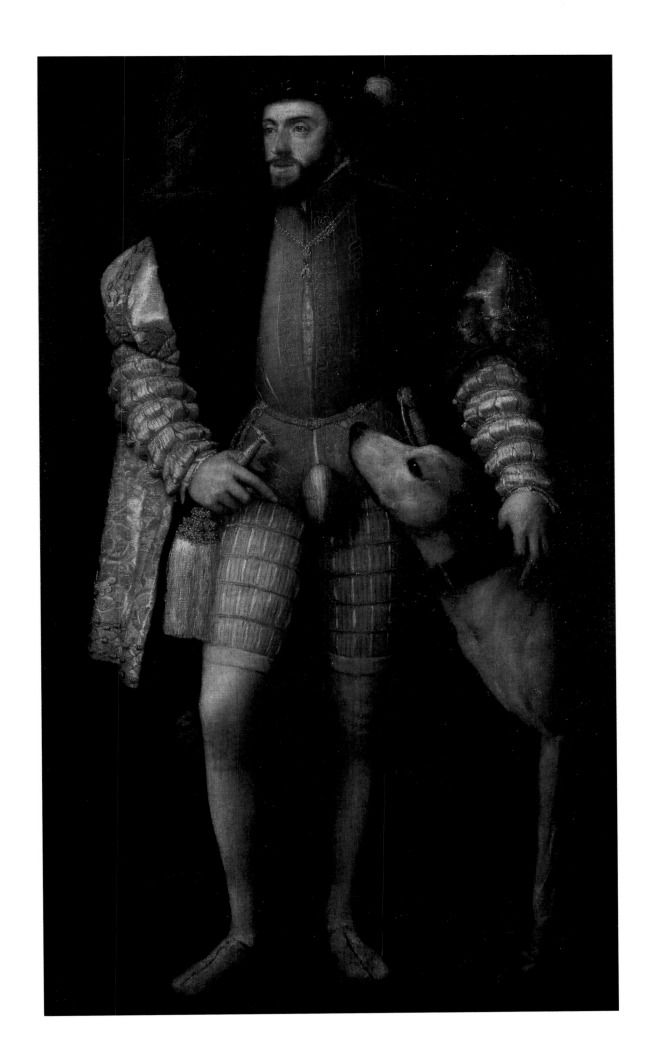

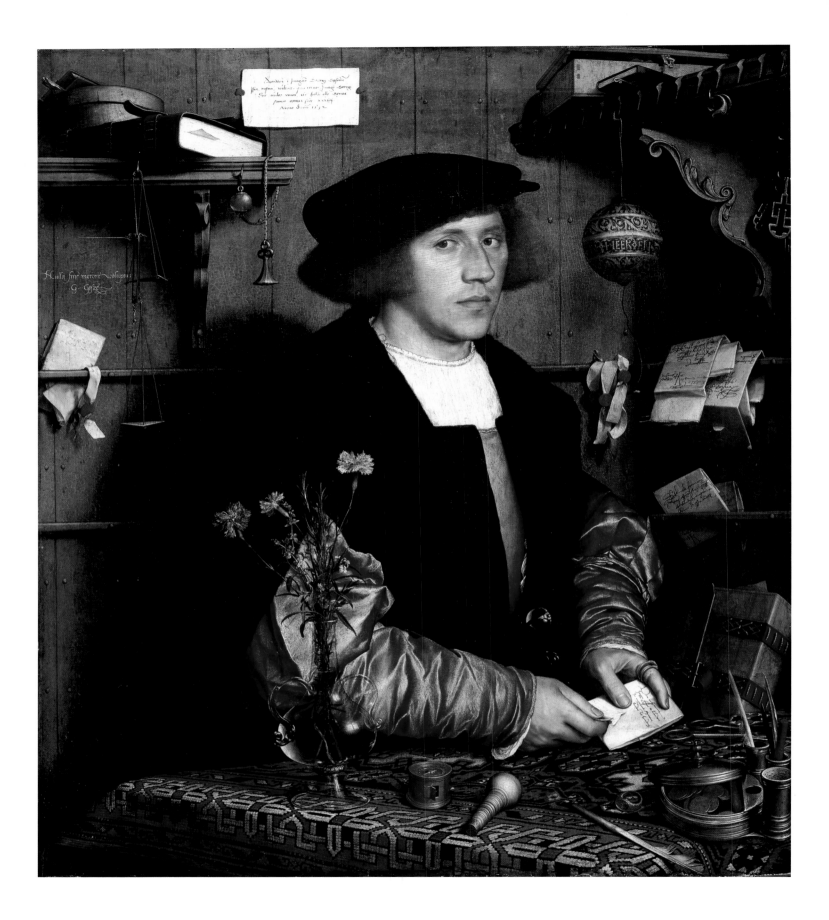

PAGE 8:
Hans Holbein the Younger
Georg Gisze, 1532
Oil on oak panel, 96.3 x 85.7 cm
Berlin, Staatliche Museen zu Berlin –
Preußischer Kulturbesitz, Gemäldegalerie

This merchant from Danzig was visiting London when his portrait was painted. The Latin inscription on the paper on his office wall certifies the portrait's accuracy: "Distich on the likeness of Georg Gisze. What you see is Georg's countenance and counterfeit; so bold is his eye, and thus his cheeks are formed. In his thirty-fourth year of Our Lord 1532."

states, on the evocation of atmosphere and the portrayal of mental and moral attitudes. The tendency to psychologise went so far that it eventually provoked a retreat from the open expression of thoughts or feelings. The sitter no longer revealed himself as an open book but turned to a mysterious, inward world from which the spectator was more or less excluded.

There are cultural and historical correlations between the portraits executed in the late Middle Ages and early modern era and the idea of human dignity so emphatically championed by Renaissance philosophy. In his tract "De dignitate hominis", for example, Pico della Mirandola's creator-god, described as a "demiurge" (a skilled worker), has this to say of human destiny: "O Adam, we have not given you a certain abode, nor decided on any one particular face for you, nor have we provided you with any particular single ability, for you shall choose whatever dwelling-place pleases you, whatever features you consider becoming, whatever abilities you desire. All other beings are limited by natural laws that we have established. But no boundary shall impede your progress. You shall decide, even over Nature herself, according to your own free will, for in your hand have I laid your fate."[2]

Solemn diction cannot conceal a belief expressed in this passage in the autonomy of the individual. This notion lent metaphysical significance to the self-regard of a bourgeoisie whose confidence was already heightened by technical and economic progress, as well as by new opportunities accompanying geographical expansion and social mobility. But in providing an appropriately symbolic form for this view of the world, the portrait fulfilled a function that was appreciated by other ruling strata in society as well, especially by those with absolute power.

Even when the bourgeoisie had become more solidly established, images of individuality evolved during the "heroic era" of portraiture continued to dominate the genre and to guide its exponents. Against the background of changed historical circumstances, however, the use of the portrait to

The most respected non-aristocratic groups in society were the clergy, scholars and merchants. They paid considerable attention to their public image. Here is an example of the bust portrait usually commissioned by these groups.

Anthonis Mor
Two Canons, 1544
Oil on oak panel, 74 x 96 cm
Berlin, Staatliche Museen zu Berlin – Preußischer Kulturbesitz, Gemäldegalerie

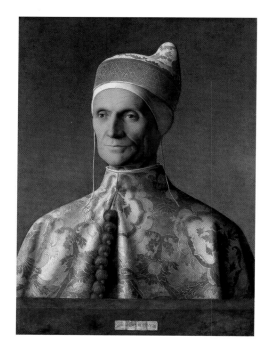

TOP AND DETAIL PAGE 11:
Giovanni Bellini
Leonardo Loredan, Doge of Venice, 1501/05
Oil on panel, 61.5 x 45cm
London, The National Gallery

Bellini's portrait of the Venetian Doge, Leonardo Loredan (1438–1521) is reminiscent of bust portraits by 15th-century Florentine sculptors whose style had developed from the medieval bust reliquary. Loredan was doge from 1501–1521. As military commander-in-chief he led Venice through a period of crisis when the town was besieged by the "League of Cambrai".

symbolise rank and power inevitably led to derivative or anachronistic forms and to a dubious kind of pathos (as in the portraits of Franz von Lenbach during the second half of the nineteenth century). Still officially cultivated in the nineteenth century, portrait-painting was "certainly not on its death-bed, but (…) far more rarely practised than it used to be", as Jakob Burckhardt put it in 1885.[3] The growth of photography, a medium capable of faster, easier and more faithful reproduction, seemed to confirm the obsolete nature of the painted portrait with its time-consuming sittings and laborious sketches. Furthermore, the new technique was considerably cheaper.

Only art movements which opposed the academies of the late nineteenth century – the various Realist, Impressionist and Naturalist secessions – achieved innovations that broke with the self-aggrandizing manner, as it now appeared, of an increasingly "nouveau riche" clientele. The few expressive portraits of the twentieth century have come from artists associated with openly figurative movements, or from those who have viewed the critique of society as an integral part of their work. For obvious reasons, the non-figurative avant-garde radically rejected portraiture. It is therefore hardly surprising that an artist as well-disposed to abstraction as Don Judd, one of the most prominent Minimal artists, should declare: "Unfortunately, art tends to become a likeness, but that's not really what it is."[4]

Portrait – Counterfeit – Likeness

Disregarding Judd's implied value judgement, it may be noted that his use of language, possibly unintentionally, echoes seventeenth-century usage, in which the terms "portrait" and "likeness" were understood to mean "pictorial imitation" of any kind, thus equating them with the concept of representation in general.[5] The same is true of the older synonym "counterfeit" (Lat. "contrafacere" = to imitate). In a book of patterns and sketches, appropriately enough called his "Livre de portraiture", Villard de Honnecourt (13th century) used the term "counterfeit" not only to denote representations of human beings, but also for drawings of animals.[6] Only much later did the use of these terms become more restricted, indeed long after the portrait had established itself as a genre and collections of portraits of "famous men", or "viri illustres" (like that by Paolo Giovio, 1521) had become highly sought-after collector's items.

While the French engraver Abraham Bosse (1602–1676) still defined "portraiture" as "a general word for painting and engraving"[7], equating "portrait" in meaning with "tableau" (a picture or painting), it was Nicolas Poussin's friend André Félibien who first suggested that the term "portrait" be reserved exclusively for likenesses of (certain) human beings. Félibien further suggested the use of the term "figure" for the pictorial rendering of animals, while the term "représentation" was to be used for the depiction of vegetable or inorganic forms, for plants, or, at the very bottom of the pyramid of being, stones.[8]

The tendency, inherent in this "modern", anthropocentric terminology, to draw clear distinctions between humans and other living beings possibly marks the end of a typically feudal "symbiosis" between animals and humans. It is perhaps of historical interest here to note that animals were considered as legal entities or "persons" in the Middle Ages, and that they could, for example, be brought to trial.[9]

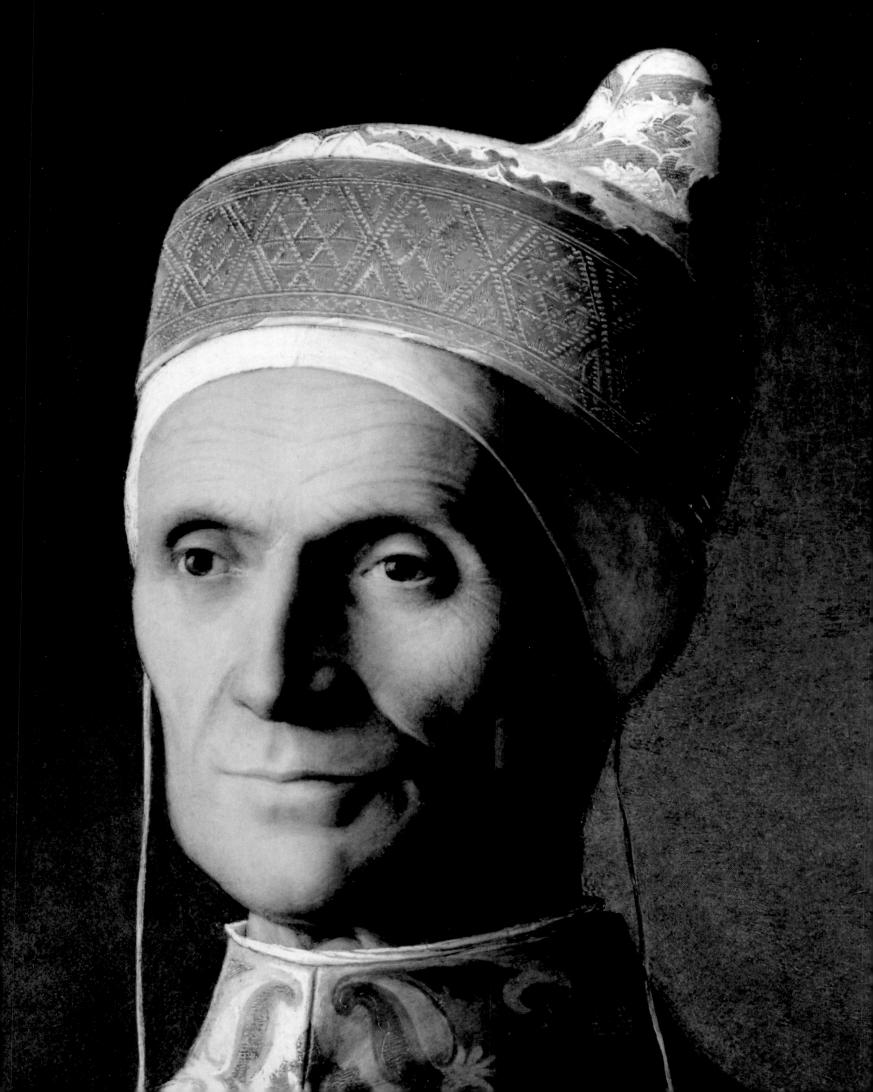

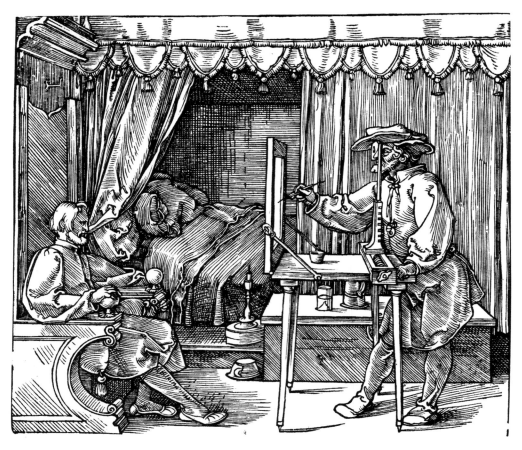

Albrecht Dürer
An Artist Drawing a Seated Man, 1525
Woodcut, 12.9 x 14.8 cm
London, Department of Prints and Drawings,
British Museum

Félibien's hierarchical construction implies that individualisation is a term that can only be used in connection with human beings. Arthur Schopenhauer, too, in his major philosphical work "The World as Will and Idea" (1819), contends that animals, because of their species, cannot be portrayed (Book 3, § 45). Portraits, he wrote, could only be made of the human countenance and form, whose appearance induced a "purely aesthetic contemplation" in the spectator, "filling us with an inexpressible sense of well-being that transcends us and all that tortures our souls."[10]

An important mechanical device designed to help the portraitist was a square pane of glass upon which the artist traced the outlines of the sitter. From here the outlines were copied onto the panel. The artist would view his sitter through a peep-hole located at the top of a rod whose height could sometimes – as seen above – be adjusted. This machine enabled artists to apply the principles of centralized perspective described in Leon Battista Alberti's treatise on painting (c. 1435).

Similarity and Idealisation

However exaggerated we may consider Schopenhauer's Romantic enthusiasm to be, and however distant his ideas may seem to us now, it can hardly be denied that portraits continue to fascinate us, especially those of the period we are considering here. Almost no other genre of painting is capable of transmitting such an intimate sense of lived presence over so great a distance in time. This undoubtedly is linked to our subconscious attribution to the portrait of authenticity: we expect a faithful rendering that shows us what the sitter was really like.

Leaving aside for a moment the question of whether it is actually possible to empathise with portraits executed in earlier periods, or whether psychological explanations based on our own, emotionally-coloured perceptions are ultimately tenable, it must be pointed out that genuine likenesses were – in any case – not necessarily always the order of the day.

Indeed, instead of the likeness of a ruler, coins during the early Middle Ages would often carry the "imago" or "effigies" of a Roman emperor in whose dynastic or official succession the ruler of the day – by "translatio imperii" – saw himself as standing.[11] The actual appearance of a living prince was therefore less important than the political and social institution within whose tradition he wished, or demanded, to be seen.

This did not change until the late Middle Ages, when it became unacceptable to substitute one likeness for another. One may be quite right to doubt whether an early French profile portrait of *King John the Good*, painted c. 1360 (see ill. p. 13) at the same time as the portrait of *Rudolf IV of Habsburg*, really shows the person named in the inscription. However, scepticism of this kind is perhaps less appropriate with regard to Jan van Eyck's *Tymotheos* portrait (see ill. p. 31), especially since the artist has attempted to dispel such doubts from the outset. The inscription LEAL SOUVENIR – loyal remembrance – certifies the authenticity of the portrait; its purpose, not unlike that of a notary's attestation, is to verify the identity of the likeness and the sitter.[12]

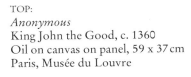

TOP:
Anonymous
King John the Good, c. 1360
Oil on canvas on panel, 59 x 37 cm
Paris, Musée du Louvre

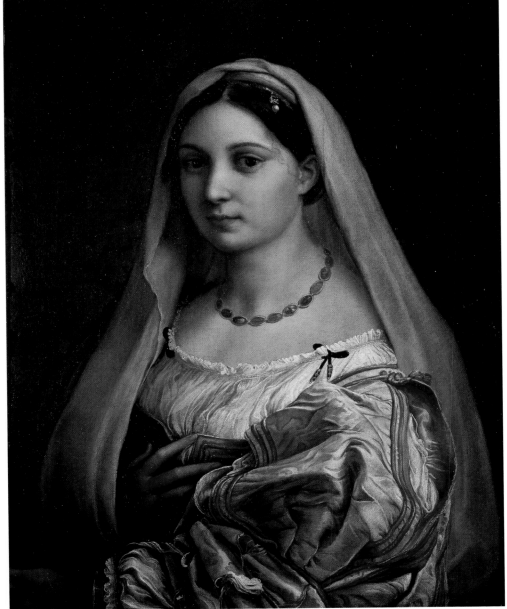

BOTTOM:
Raphael
Donna Velata, c. 1513
Oil on canvas, 85 x 64 cm
Florence, Galleria Pitti

Attributes of this unidentified woman's dress, her veil and the pearls in her hair, suggest the painting was executed to mark the occasion of her marriage.

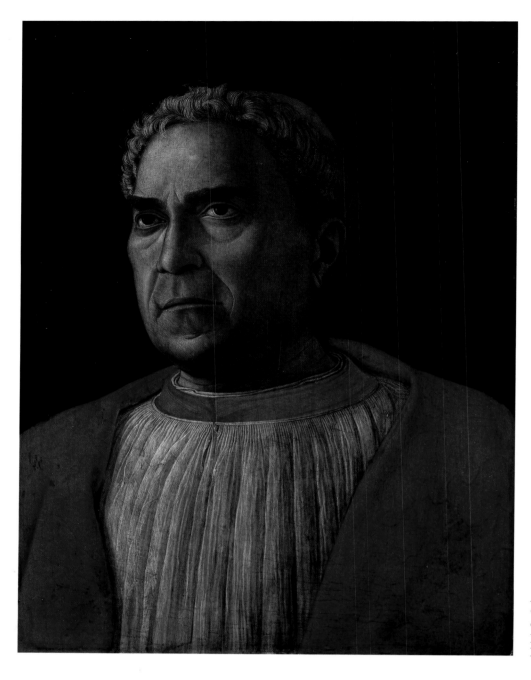

Andrea Mantegna
Cardinal Lodovico Trevisano
Oil on panel, 44 x 33cm
Berlin, Staatliche Museen zu Berlin –
Preußischer Kulturbesitz, Gemäldegalerie

"Identity" here evidently has little to do with that consistent sense of self which links several periods in a person's life[13] – a notion that does not appear to have gained currency prior to the emergence of seventeenth-century Neo-Stoicist ideals of constancy – but is rather used to describe the relationship between the external appearance of a person and its apprehension by others: the mimetic equation. "All similarity… is an image or sign of equality" (Similitudo autem omnis est aequalitatis species seu signum), wrote Nikolaus von Kues, a contemporary of Jan van Eyck.[14] Natalie Zemon Davis has shown that we can only understand the sixteenth-century story of Martin Guerre, whose wife was deceived by the appearance of her husband's double,[15] if we remember that recognition, or identification, even of intimate acquaintances, had not yet become existentially significant in everyday life. The notion of individuality implied by such recognition does not seem to have replaced more traditional patterns of thought until the adoption of Roman Law by the social élite. Portraits now assumed an important role in helping to identify individuals. Inevitibly,

The sitter, viewed slightly from below, was formerly identified as Cardinal Mezzarota. However, more recent research suggests he is Cardinal Lodovico Trevisano (1401–1465). Trevisano was personal physician to Cardinal Gabriele Condulmaro. On later becoming Pope Eugene IV, Condulmaro appointed Trevisano to high ecclesiastical office.

LEFT:
Jan van Eyck
Cardinal Nicola Albergati, c. 1432
Oil on panel, 34 x 26 cm
Vienna, Kunsthistorisches Museum

RIGHT:
Jan van Eyck
Cardinal Nicola Albergati, undated
Silverpoint on whitish prepared paper,
21.4 x 18 cm
Dresden, Staatliche Kunstsammlungen
Dresden, Kupferstichkabinett

this altered the dominant aesthetic, intensifying naturalistic demands for a faithful pictorial imitation of reality.

Verifiable resemblance therefore became an essential criterion of portrait-painting during the late Middle Ages and Renaissance. This greatly contrasted with the later, almost normative views expounded in Georg Wilhelm Friedrich Hegel's "Aesthetics", which raged at "almost repulsively lifelike portraits"[16] and demanded that the portrait-painter flatter his subject, paying less attention to outward appearance and "presenting us with a view which emphasises the subject's general character and lasting spiritual qualities." According to this view, it was spiritual nature that should determine our picture of the human being.

The concept of identity expressed here derives from the principle of inwardness in German idealist philosophy. Although it might therefore support an analysis of the nineteenth-century portrait, it would be out of place in an account of the genre's earlier history. The unusual degree of accuracy found in early likenesses must be seen in conjunction with the

Jan van Eyck probably made silverpoint preliminary drawings for most of his portraits. This study was made for his portrait of Cardinal Albergati, whose visit to Bruges lasted only from 8th to 11th December 1431. Written on the drawing are precise colour notes for the painting itself.

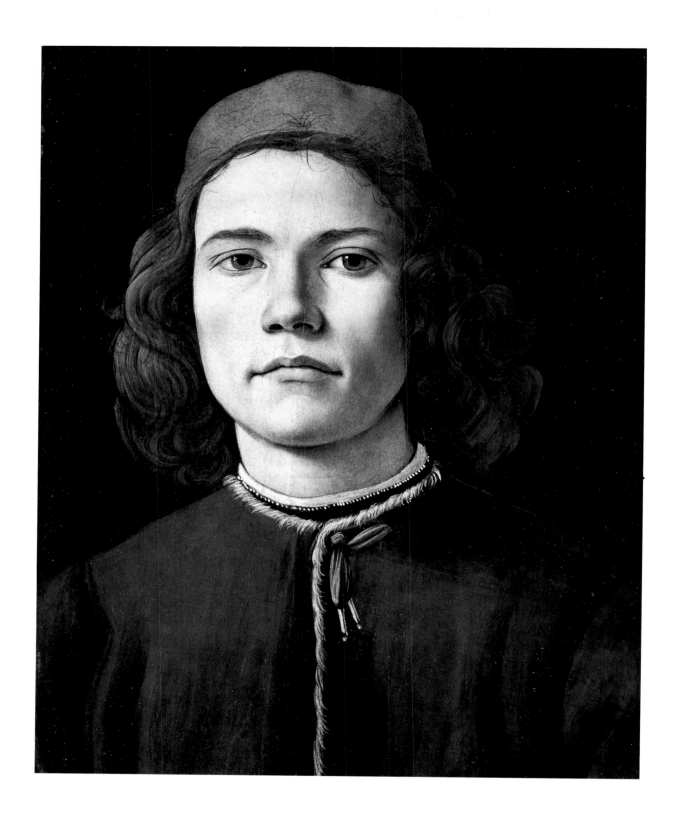

TOP:
Sandro Botticelli
Young Man, c. 1480
Oil on panel, 37.5 x 28.2 cm
London, The National Gallery

PAGE 17:
Albrecht Dürer
Hieronymus Holzschuher, 1526
Oil on panel, 48 x 36 cm
Berlin, Staatliche Museen zu Berlin –
Preußischer Kulturbesitz, Gemäldegalerie

This portrait of a Nuremberg patrician, a friend of Dürer, was orginally kept in a locked case. This suggests that it was not intended for offical use, a hypothesis reinforced by the fact that Holzschuher is bareheaded. The sitter's piercing gaze may indicate that Dürer wished – as in his similiarly staring "Apostle" Paul – to characterise Holzschuher's melancholic temperament.

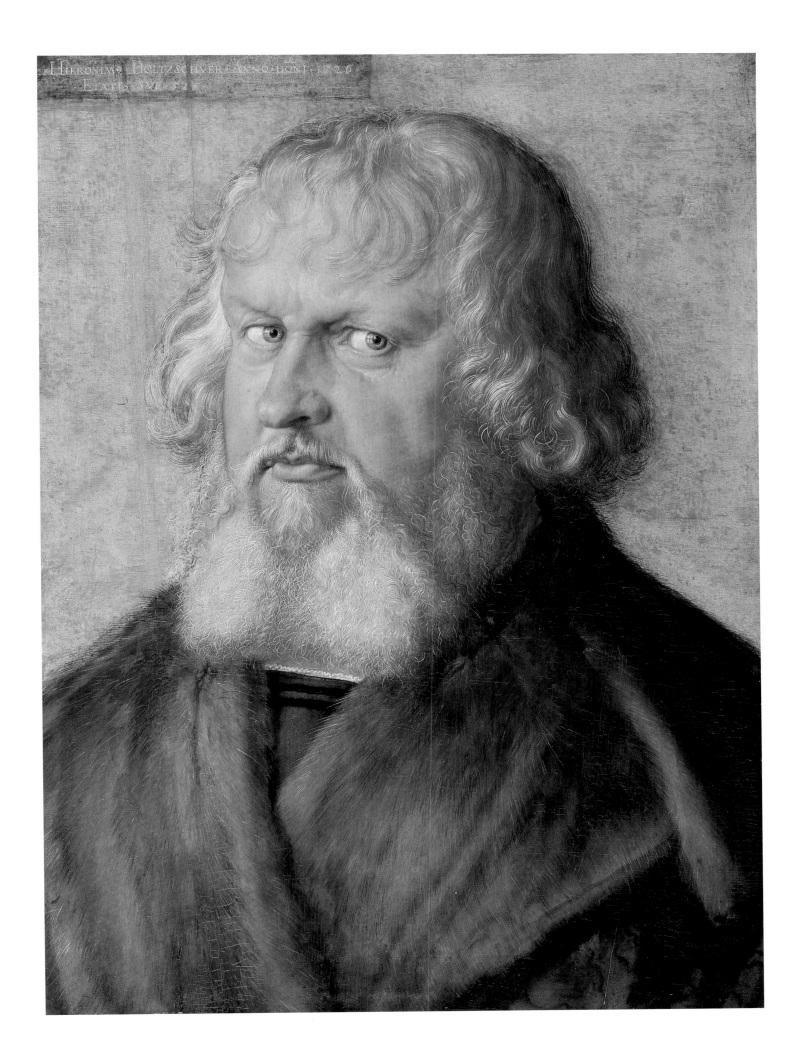

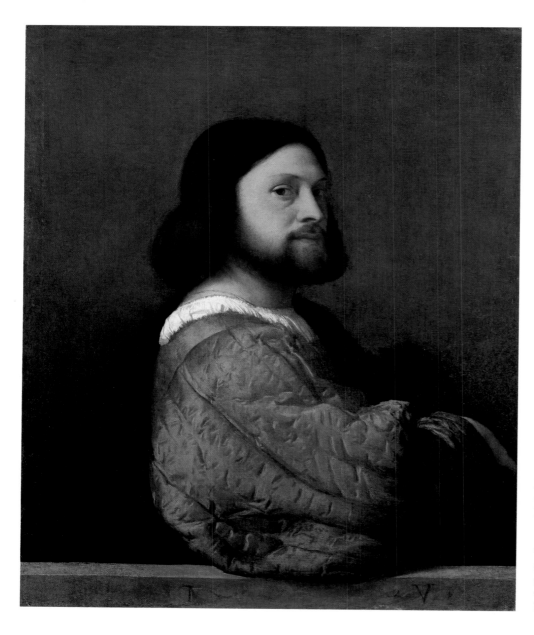

Titian
Man (alias "Ariosto"), c. 1512
Oil on canvas, 81.2 x 66.3 cm
London, The National Gallery

Titian's portrait of "Ariosto", showing the sitter from the side with his bent arm resting on a parapet, established a new type of portrait which found many admirers, including Rembrandt (see ill. p. 112).

absence of categories of beauty or ugliness. Earlier portraits, for example by van Eyck, seem entirely indifferent to judgement from this quarter. It was only in the late fifteenth century that studies of ideal proportions, especially by Italian artists, led to the establishment of aesthetic norms. In his treatise on painting Giovanni Paolo Lomazzo (1538–1600) expresses the essential purpose of these new standards by demanding of the portrait-painter, that he "emphasise the dignity and grandeur of the human being, suppressing Nature's irregularities."[17]

Problems of Portrait Interpretation

Most art historians continued to see the portrait in the light of Hegel's views until well into the twentieth century. The Expressionist aesthetic continued in this vein, giving metaphysical presence to the "essential being" of the subject portrayed. It was thought that this quality could be ascertained directly from physiognomic expression.

Philosophical and scientific interest in psychological questions increased, especially in Italy, during the second half of the quattrocento.[18] It had become a matter of compelling urgency to gain a clearer picture of the "pathological" significance of certain mimic or gestural manners of expression, since emergent capitalist trade relations demanded the ability to "read" the intentions of business partners and to seek protection against fraud. A similar situation had arisen in the political sphere, where exposure to the new economic conditions made it essential to establish some means of orientation in a world of increasingly unstable and opaque interrelations. It was therefore not surprising that many of the early physiognomic handbooks were composed specifically for merchants and statesmen.[19]

Writers such as Michele Savonarola, the grandfather of the famous Dominican preacher, or the scholar Pomponio Gaurico committed themselves to the interpretation of bodily expressions. They analysed the expressive force of different parts of the face, the eyes for example, which even today's characterological studies regard as the "mirror of the soul".[20] In so doing, they would frequently allow themselves to be guided by the

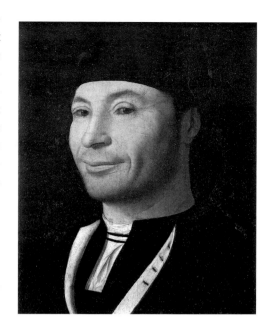

TOP:
Antonello da Messina
Smiling Man, c. 1470
Oil on panel, 30 x 25 cm
Cefalù, Museo Mandralisca

BOTTOM:
Giovanni Battista Moroni
Don Gabriel de la Cueva, Duke of Albuquerque, 1560
Oil on canvas, 114.5 x 90.8 cm
Berlin, Staatliche Museen zu Berlin –
Preußischer Kulturbesitz, Gemäldegalerie

TOP AND DETAIL PAGE 21:
Titian
Ranuccio Farnese, c. 1542
Oil on canvas, 89.7 x 73.6 cm
Washington (DC), National Gallery of Art,
Samuel H. Kress Collection

Ranuccio (1530–1565) was the son of Pierluigi
Farnese (1503–1547), whose own father, Pope
Paul III (his real name was Alessandro Far-
nese; see ill. p. 98), had made him Duke of Pia-
cenza and Parma. Ranuccio was in Venice in
1542, and it is thought that Titian painted the
young nobleman's portrait during that year.
The cross decorating his robe identifies him as
a Knight of Malta.

notion of the humours found in earlier, medical theories of the temperaments. Studies undertaken by Leonardo da Vinci, too, attached separate meanings to different parts of the body. The various grotesque figures which resulted from his work on the classification of anatomical and physiognomic aspects of the human face have rightly been seen as precursors of the modern caricature (ill. p. 75).

However, most physiognomic tracts were highly schematic in approach. Often, as with Giovanni Battista della Porta,[21] they drew psychological parallels from what appeared to be physical resemblances between animals and human beings, much in the tradition of the medieval "bestiarium humanum". Such sources are unlikely to help us understand the Renaissance or Baroque portrait, unless, of course, we assume the artists also sought advice from them, or translated them into their own visual medium. From a cultural and historical point of view it may be quite correct to see portraiture and physiognomy as deriving from related needs and interests. However, the mechanistic application to contemporary portrait-painting of classifications found in such compendia can easily lead to misinterpretation. Indeed, it is doubtful whether today's spectator can interpret the sitter's gestures correctly at all. Would it be correct, for example, to attribute a "fixed" gaze to Antonello da Messina's so-called *Condottiere* (ill. p. 47)? According to Pomponio Gaurico, this was a sign of insanity – a reading which the portrait as a whole hardly serves to corroborate. His gaze and protruding lower lip have led various critics to attribute to the sitter a firm strength of will, indeed almost ruthless defiance. Thus he has come to be seen as cold-blooded and inhuman, a power-hungry usurper and commander of mercenaries. The most well-known object of psycho-diagnostic projection, however, is Leonardo da Vinci's *Mona Lisa* (ill. p. 57), whose smile has attracted almost every interpretation imaginable. It is prudent to be wary of the diagnostic interpretion of expression. Georg Christoph Lichtenberg penned a well-known warning against the dangers of pseudo-scientific attempts to discern the personality on the basis of arbitrary physiognomic characteristics.[22]

It remains open to debate whether the psychological aspect of portrait-painting – though undeniably intended by artists and patrons – really was quite as important as art critics, influenced by a later aesthetics of empathy, continued to propagate. Instead of attempting – in an entirely unhistorical manner – to determine the personality of the sitter through diagnoses that can be affirmed or rejected according to each spectator's perception of the painting, a process amounting to little more than a Rorschach test, it would surely be more productive to examine the relationship between psychological aspects and the social function of portraits (or their genres).

Sitter and Setting

It is important to remember that portraits are always the products of composition. They are the result of an agreement between the artist and the sitter, between an aesthetic conditioned by the relatively autonomous precepts or traditions of the genre and the patron's individual requirements. Although relations between the artist and his patron might have been strained to the breaking point, they generally provided a framework in the form of a contractually underpinned consensus within which the patron –

Giovanni Battista della Porta
Physiognomic comparison between a human
and an animal. From: De humana physiogno-
mia. Vico Equense 1586

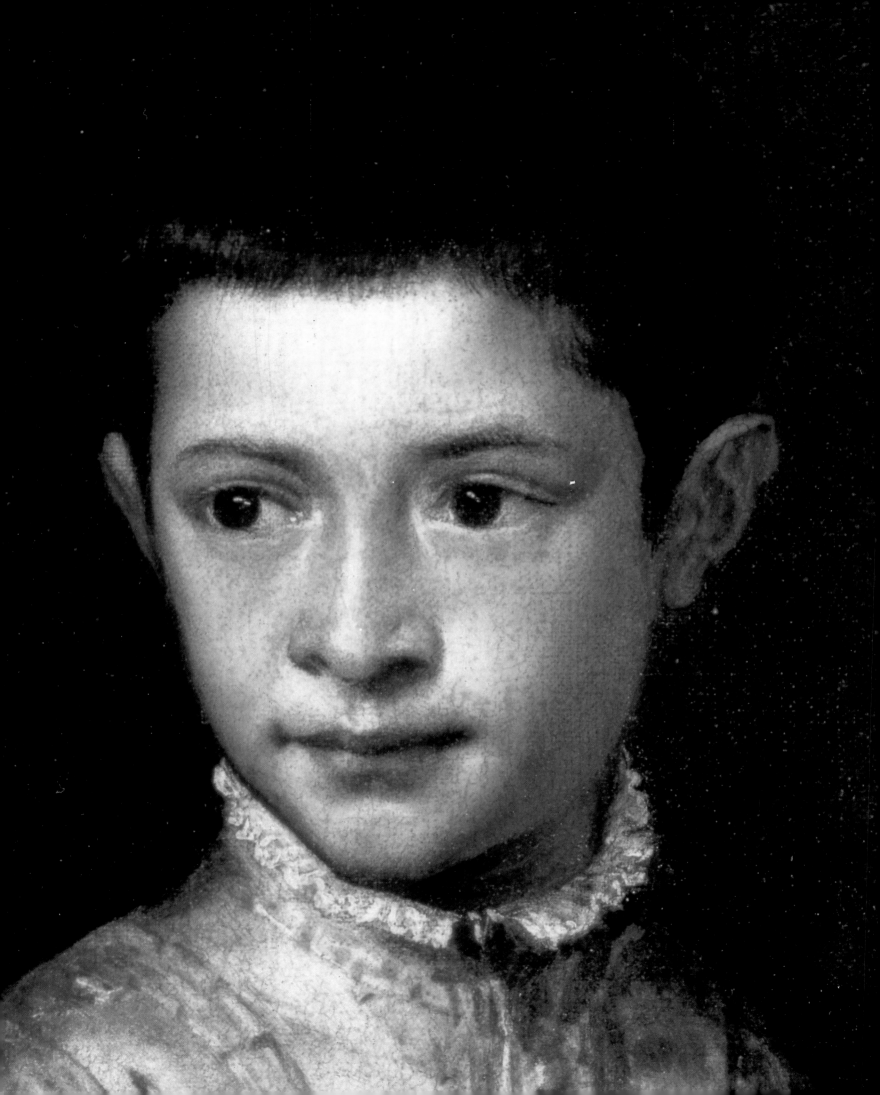

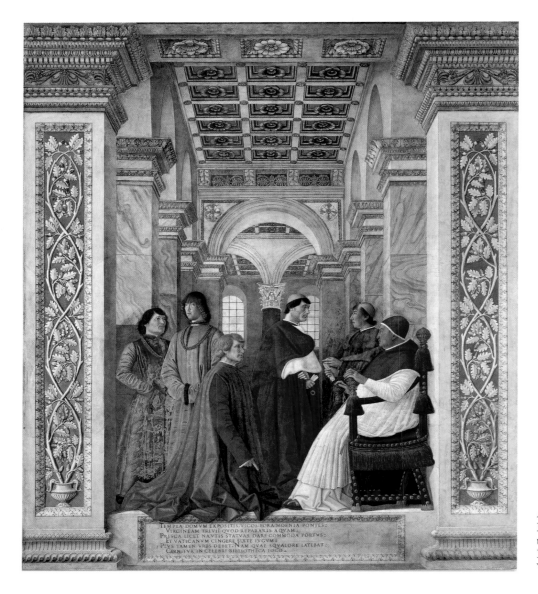

Melozzo da Forli
Pope Sixtus IV appoints Platina as Prefect of
the Vatican Library, 1475
Fresco transferred to canvas, 370 x 315 cm
Vatican, Pinacoteca

at least during the period we are considering here – was able to formulate
his own wishes and thus go some way towards determining how his
"imago" would be perceived. However conscious the use of psychology
in a portrait might therefore be, to view its subject solely in characterologi-
cal terms would be to expect the naive spontaneity of a fleeting, everyday
scene from what is essentially an aesthetic construct.

The intended effect of a portrait was often revealed in its setting, which
generally consisted of a spatial environment by means of which the sitter
sought to define his role in society and to tell the spectator something
about his interests, intentions and values. Backgrounds, whether land-
scapes or interiors, were compositional devices consisting of several differ-
ent elements which would sometimes combine to form an integrated, at-
mospheric whole. These elements converted ideas into objects, into sym-
bols representing types of social practice.

Settings, however, were not merely symbolic ensembles, but referred the
spectator to two main fields of worldly activity which were increasingly
thought to be diametrically opposed. Landscape backgrounds thus often
referred to the public sphere, much as the very notion of different land-
scapes (Ital. paesaggio, Fr. paysage) was for a long time associated with the

Melozzo shows Pope Sixtus IV (1414–1484)
in a quadratura hall of pillars, painted accord-
ing to the rules of centralized perspective. The
pope is shown in the company of his nepotes
Giovannino and Giuliano della Rovere (who
later became Pope Julius II), and two other
courtiers (Girolamo and Rafaele Riario). Be-
fore him kneels Bartolommeo Sacchi, known
as Platina, whom the pope is shown appoint-
ing to the position of Prefect of the Vatican
Library.

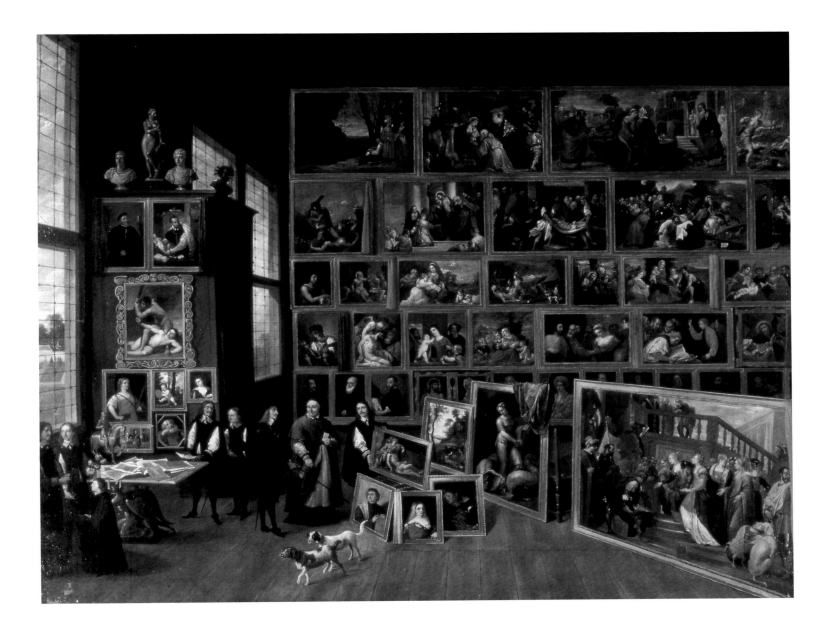

division of land into jurisdictional and administrative territories, each representing a socio-political, cultural unity.[23] This is well illustrated by the landscape backgrounds in Piero della Francesca's *Montefeltro*-diptych (ill. pp. 48–49), which show us the territory ruled over by the sitters, the Duke of Urbino and his wife.

The background of Luca Signorelli's so-called *Lawyer* (ill. p. 77) – showing a detail of an urban landscape, presumably intended as ancient Rome – consists of various ancient monuments and ruins, perhaps suggesting that the sitter was interested in archaeology. Beyond documenting what may possibly have been a contribution to the preservation of monuments – for he lived during, or shortly after, the era in which ancient Rome was restored under Pope Sixtus IV – the background may be a reference to the man's interests and humanist erudition, expressed by two scenes, probably taken from ancient history or mythology, painted at either side of his head.

Background scenes often assumed the character of a so-called "impresa". This was a motto expressing a resolution or lifelong pledge.[24] It might also be described as a personal emblem or badge (see Giovanni Battista Moroni, ill. p. 19). The "impresa" first emerged as a medieval heraldic

David Teniers the Younger
Archduke Leopold Wilhelm's Gallery at Brussels, 1651
Oil on canvas, 127 x 162.5 cm
Petworth House, Sussex, National Trust Photographic Library

The Great Age of the Portrait 23

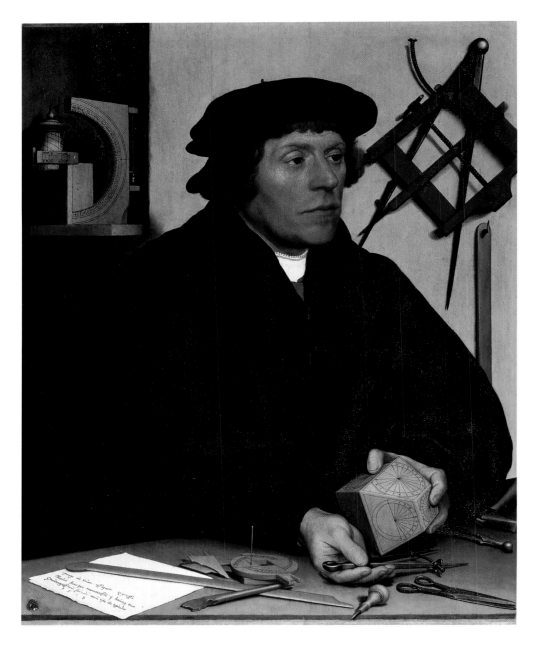

Hans Holbein the Younger
The astronomer Nikolaus Kratzer, 1528
Oil on panel, 83 x 67 cm
Paris, Musée du Louvre

device at the Burgundian court, but its underlying principle was soon taken up by the ascendant bourgeoisie. It was not unusual for a sitter to use the device for purposes of identification with some figure in ancient history or mythology.

By the late fifteeenth century, the "impresa" had often become obscure and mysterious, sometimes presenting an insoluble riddle. Ideas inspired by the cabbala or by alchemy joined "hieroglyphic" symbols and pictorial cryptograms said to be based on the Alexandrian scholar Horapollo's (4th century A.D. ?) reading of ancient Egyptian hieroglyphs. The "hieroglyphica" were sometimes invented by the artists themselves, however.[25]

Besides the landscape, the interior (bare or furnished) was a second type of background by means of which the sitter might give symbolic expression to his norms and values. This may be seen in portraits by Hans Holbein the Younger (ill. p. 8, p. 89). The portraits of the merchant Gisze or humanist scholar Erasmus demonstrated a desire for privacy, a wish to withdraw from the public sphere. The sitters are nevertheless shown en-

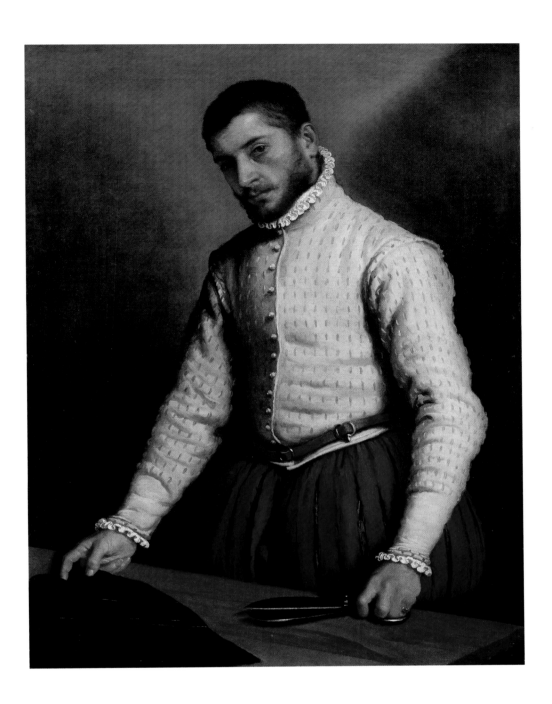

Giovanni Battista Moroni
The Tailor, c. 1563/66
Oil on canvas, 97 x 74 cm
London, The National Gallery

gaging in types of activity whose effect carried well beyond the private realm. Their desire to perfect their knowledge of the world is illustrated by the objects which surround them, instruments of technological progress and symbols of "modern" civilisation such as the telescope, the planisphere or the globe. Books symbolised the spread of knowledge and assumed a central position in portraits of Erasmus.[26] Many symbols have nothing to do with knowledge, however, referring instead to the sitter's moral or ethical beliefs, or adhesion to certain notions of virtue. The latter played a particularly important role in early modern portraits of women. These portraits almost always showed married women, brides or fiancées, and occasionally courtesans. The objects surrounding them were allusions to certain qualities attributed to women, or expected of them by society. The settings of these portraits were therefore almost exclusively concerned with the social and artistic definition of the female gender role.

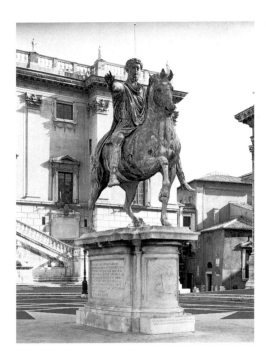

Equestrian Statue of Marc Aurel,
161–180 A.D.
Bronze, larger than life
Rome, Piazza del Campidoglio

This elegant lady, sitting with dignified, up-right posture before a conche-like recess and absent-mindedly gazing towards the specta-tor, wears a vermilion dress whose large, bright, evenly-lit surface contrasts with the olive-green sheen of her sleeves. Her lap-dog symbolises conjugal fidelity. Her rosary sig-nifies piousness.

Jacopo Pontormo
Lady in a Red Dress, 1532/33
Oil on panel, 89.7 x 70.5 cm
Frankfurt/M., Städelsches Kunstinstitut

The Functions of Portraits

Portraits painted between the fifteenth century and the end of the seven-teenth century must be seen in connection with the advent and develop-ment of empiricism, a tendency which had been making itself felt in the arts since the late Middle Ages. Their execution therefore seems guided by an underlying rationalistic impulse, an impression reinforced by demands that they should be true to life and their subjects verifiable – criteria, in other words, derived from the practicalities of "rational" Roman Law. Paradoxically, however, portraits from this era still exhibit many magical or fetishistic characteristics. These were expressed in the "substitutive" or "vicarious" properties of the portrait, qualities which had been attributed to the likeness since the dawn of civilisation.

It had long been customary – and indeed remained so until well into the Age of Enlightenment – for likenesses of criminals who continued to elude the authorities' grasp to be "executed" in place of their real persons ("ex-ecutio in effigie"). The law stipulated in such cases that the painting should be an accurate representation of the delinquent, and that the chastisement be applied symbolically to the picture as if to the parts of a real body.[27] A similar phenomenon, based on ideas of sympathetic magic such as those sometimes witnessed in shamanism, was the scratching out of a portrait's eyes. The practice is found to this day, as evidenced by hoardings, often of a political nature, with figures whose eyes have been erased. At the time, however, the vicarious disfigurement of an enemy's or opponent's features was still widespread. Atavistic behaviour of this kind included the public display of likenesses of outlawed persons in order to proclaim their dis-grace. These portraits usually caricatured their subjects and were designed to provoke the spectator's scorn and derision.

The examples cited above are almost all related to matters of jurisdiction or politics. Their attitude towards the person portrayed is dismissive, or negative, driven by the desire to punish or enact revenge. However, the talismanic or fetishistic quality of a portrait could equally express a posi-tive attitude towards its subject.

An early eighteenth-century description of diplomatic protocol in-forms us that "the likeness of the Sovereign… is usually displayed in the form of a raised half-length portrait between the baldachin and chair of state in the audience chambers of his envoys. The painting represents the person as if he were actually there, for which reason those seated may not turn their backs towards him, nor may any person, ambassadors ex-cepted, leave his head covered when entering a room in which the like-ness of a ruling potentate hangs" (1733).[28]

This passage shows that one of the "vicarious" properties of the portrait was its "representative" function (which it has to this day). The purpose of most likenesses was the more or less frank demonstration of power, hegemony or prestige. This was of course equally true of the "executio in effigie", only here the purpose was to destroy the power held by the ad-versary.

Portraits of ruling princes were particularly candid demonstrations of the will to power. Among these, however, the equestrian portrait has a special place. Following the example of the equestrian sculpture of Marc Aurel (161–180 A.D.), the equestrian portrait was generally intended to awe the spectator into submission. Its use during the Renaissance and Baroque was not confined to demonstrations of pathos by feudal princes who wished to

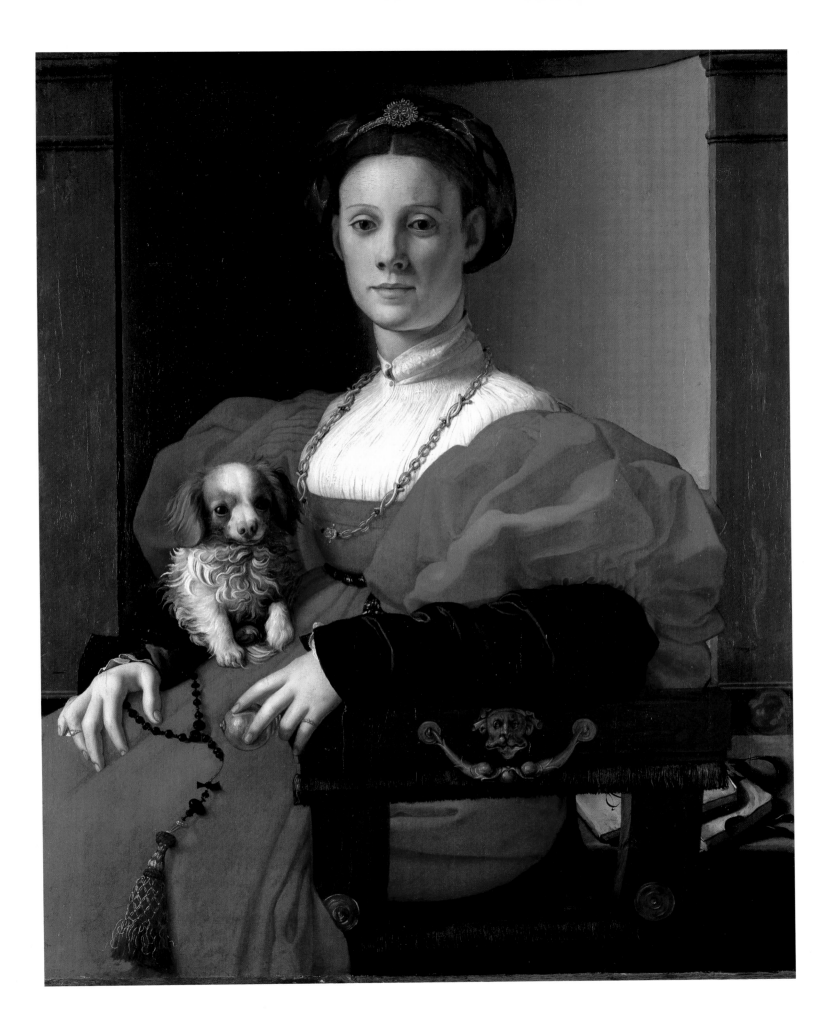

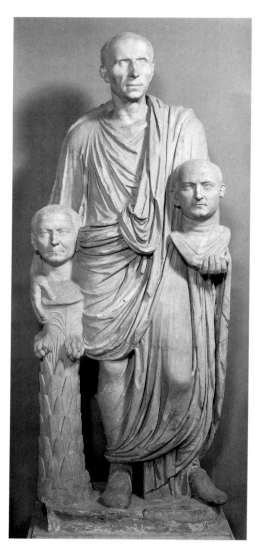

Roman patrician carrying busts of his
ancestors, c. 30 B.C.
Marble, life-sized statue
Rome, Musei Capitolini

reinforce their claim to power. It is indicative of the resourcefulness of the
ascendant bourgeoisie that parvenu-usurpers such as the mercenary com-
manders of the day – the condottieri – were capable of appropriating this
means of displaying their power. However, since the power of their pockets
was not always sufficient to afford a sculpture in stone or marble, some
condottieri had to make do posthumously with the illusionistic – but none-
theless imposing – impression created by a commemorative fresco (ill.
p.46).

Counterfeits of humanist scholars, however subtle or discrete, were also
displays of power and social prestige. Competing for status with the rich
merchant class and nobility, they demonstrated with proud restraint the
superiority of their erudition, spiritual values and ethical independence.

In general, therefore, it may be said that all portraits were intended to
impress. They sought to command respect for the authority of the sitter,
however extended or limited the scope of his influence might be.

"Commemoration" was a particularly important function of portrait-
ure. Dürer's well-known dictum on the ability of paintings to preserve the
likeness of men after their deaths was an expression of faith in the magical
victory of art over time, as if painting could overcome death. It is significant
in this respect that the portrait itself is descended from the tomb effigy, or
at least was originally associated with this art form. Examples of likenesses
of deceased persons – usually members of the high clergy – in the form of
reliefs or sculptures on altar tombs date from as early as the high or late
Middle Ages: the tombstone of Archbishop Friedrich of Wettin (c. 1152)
at Magdeburg cathedral, for example, or that of Siegfried III of Eppenstein
(Mainz cathedral), shown crowning two reduced-scale kings.

Links between the portrait and the cult of the dead may be traced back
to antique art. In Roman times wax masks were taken of the dead and kept
in a shrine in the atrium of patrician villas. "These likenesses were taken for
commemorative purposes and were not considered works of art. Owing to
the ephemerality of wax, they probably did not keep longer than a few
decades. The wish to recreate them in marble is therefore understandable,
unfulfilled as it remained until early in the first century B.C. During this
period the patricians saw their hegemony threatened. It is therefore
possible that their desire to exhibit their ancestors publicly was combined
with a need to reassert their claim to power."[29]

These bust portraits, the "imagines maiorum", held here by the Roman
patrician and usually carried at the head of public processions, evidently
served as models for the sculptors of the quattrocento, as perhaps can be
seen in Donatello's painted clay busts of Niccolò da Uzzano. Contempor-
ary paintings attempted to imitate the plasticity of the bust portrait, the
artist employing illusionistic devices, such as the application of realistic
colouring, to make up for a lack of real plasticity.

The functions of the portrait mentioned above, together with their con-
comitant archetypical ideas, norms and expectations, may be seen as ex-
amples of mental structures whose emergence can be traced back to the
early stages of civilisation. They had endured (in the sense of Fernand
Braudel's "longue durée"[30], or extended duration) the vicissitudes of time
and the passing of several different types of societies.

Their universal character and usefulness as a frame of reference make it
necessary to see the modern portrait in relation to these structures. Our
purpose shall be to elucidate the specific historical significance, the pur-
pose, allusiveness and relation to the history of ideas, of the symbolic

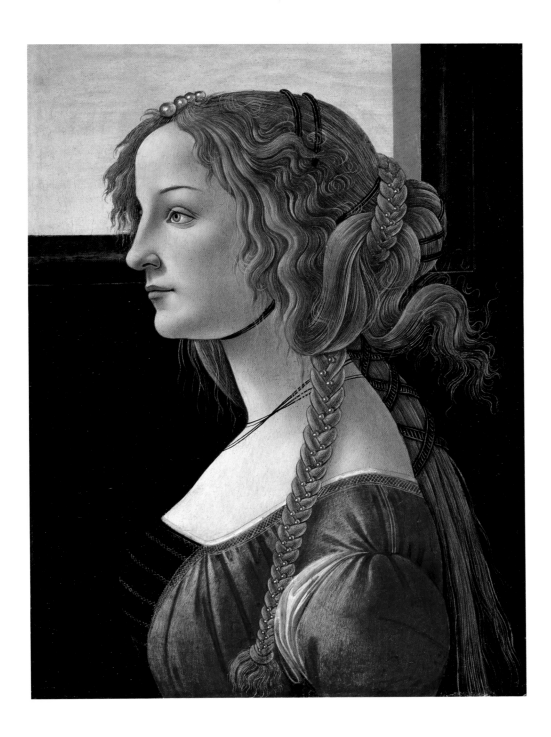

Sandro Botticelli
Profile of a Young Woman, after 1480
Oil on panel, 47.5 x 35 cm
Berlin, Staatliche Museen zu Berlin –
Preußischer Kulturbesitz, Gemäldegalerie

forms manifested in various styles and subjects. Since all forms of aesthetic expression occur within specific cultural and social contexts, it is necessary to expose them to iconological analysis.

This book sets out to analyse some of the major works of early modern portraiture. The portraits themselves have been selected on the basis of their subjects' rank and profession (e.g. portraits of popes, princes or humanist scholars), or gender (portraits of women). The value of this method of selection is its proximity to both the painters' intentions and their patrons' requirements. While neither can be said to have considered the formal aspects of portraiture insignificant, they nonetheless saw them as the compositional means of reaching a pre-defined, figurative goal, although this, in turn, was conditioned by certain aesthetic expectations with specific historical roots.

Jan van Eyck: Tymotheos (Leal Souvenir)

It is perhaps no accident that Jan van Eyck's earliest surviving portrait[31] carries a date (10th October 1432), for temporality constitutes an important aspect of this work in other ways too. Traces of the passage of time – in the form of cracks, chipped-off or broken pieces of stone and "sgraffito"-like scratchmarks – are visible on a relatively broad, trompe-l'œil parapet which serves as a repoussoir and suggests a frame, pushing the sitter back – though not very far – from the picture-plane. Even hard, apparently permanent materials do not last – what hope then for the human counterfeited here! An inscription, not unlike an epitaph, and yet evidently referring to a living person, is chiselled on the parapet: LEAL SOUVENIR, "loyal remembrance". The words anticipate that rapid process of change which the sitter, portrayed here on a certain day, will soon experience in his own life. The portrait resembles a record[32] of something which is subject to continual change, and which the painter, or sitter, wishes to commit to memory, or preserve. It is as though images had magical powers, as if appearances could replace reality, or, indeed, be a substitute for life altogether. Yet all that remains is the apparently authentic reproduction of a physical sensation on the retina, in other words, the transmission of optical signs, of perceptions of light, via colour and paint.

The portrait is a three-quarters view of a man of about – according to Erwin Panofsky – thirty years, turned slightly to the left before an homogenously dark background. He sports a fashionable green head-dress from which a scarf hangs down onto his right shoulder. He is also wearing a red coat with a thin fur collar. His left arm is folded behind the parapet, his left hand obscured by his right, which is holding a scroll of paper.

The identity of the sitter has been the subject of considerable speculation. It would seem logical to expect the strange name which someone appears to have lettered onto the stone in Greek – TYMΩ-ΘΕΟC (Tymotheos) – to provide a clue. In fact, the name did not occur in the Netherlands before the Reformation, a discovery which led Panofsky to see it as a scholarly humanist metonym whose purpose was to link the sitter with an eminent figure in Classical antiquity. As far as Panofsky was concerned, there was only one outstanding person of that name it could have been: Tymotheos of Milet, who revolutionized Greek music during the age of Euripides and Plato. It followed that van Eyck's sitter could only have been a musician, one equally renowned for his innovative contribution to the art. What was more, there had indeed been a radical upheaval in early fifteenth-century music, centred in Burgundy and known as "ars nova". Its leading exponents were the courtly composers Guillaume Dufay and Gilles Binchois. Since Dufay was known to have been abroad when the portrait was painted, the sitter – according to Panofsky – can only have been Binchois.

Wendy Wood's more recent, alternative explanation is based on a similar argument. Rather than the musician mentioned above, Wood traces the antique Tymotheos to a sculptor celebrated for his bas-reliefs.[33] Seeking an analogous sculptor at the Burgundian court, she identifies "Tymotheos" as Gilles de Blachère.

It is not clear what kind of document the man is holding in his hand. If the sitter was a musician, the scroll may be a piece of music. One theory suggests the paper is the plan for a sculpture.

PAGE 31 AND DETAIL LEFT:
Jan van Eyck
"Leal Souvenir" ("Tymotheos"), 1432
Oil on panel, 34.5 x 19 cm
London, The National Gallery

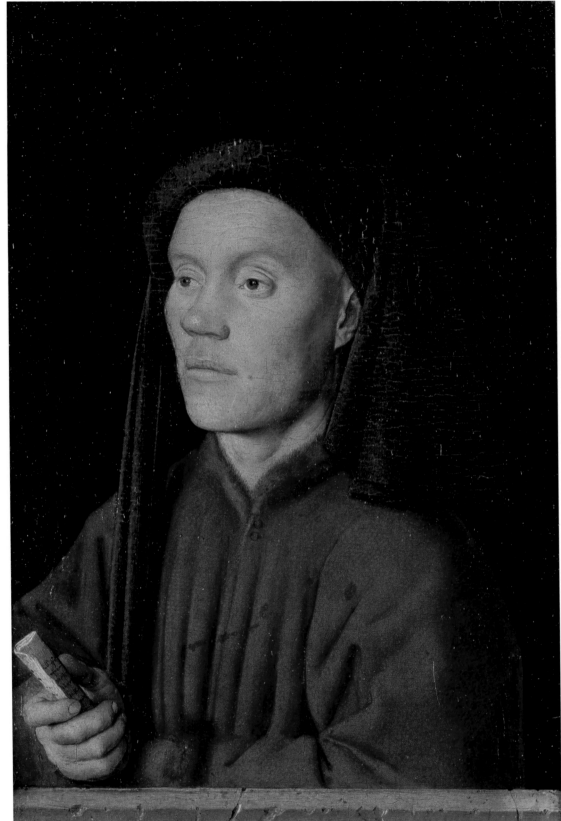

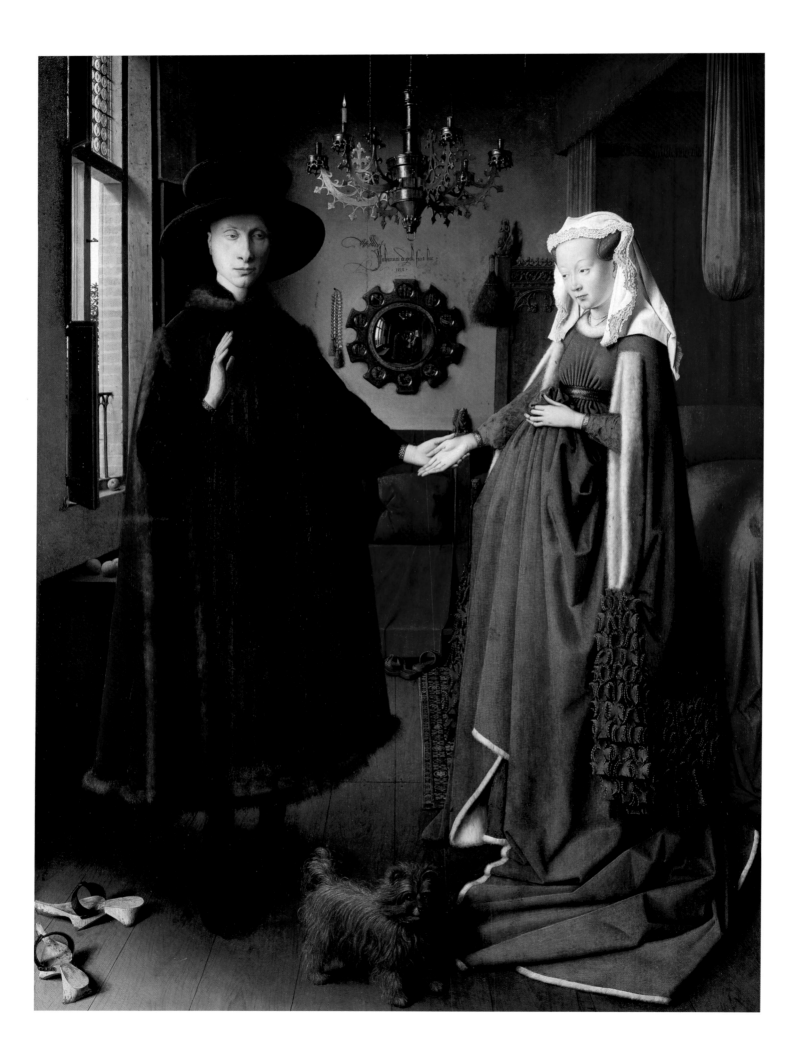

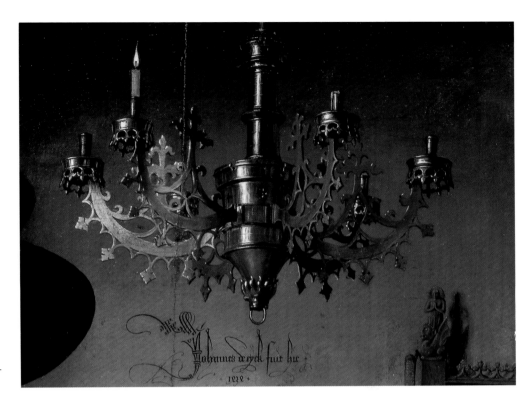

The burning candle in the chandelier is a traditional motif in Annunciation iconography.

Jan van Eyck: The Marriage of Giovanni Arnolfini

This double portrait, dated 1434, is described in the inventories of Margaret of Austria as a painting of "Hernoulle Fin", or "Arnoult Fin", probably French corruptions of the Italian name Arnolfini.[34] Since this early explanation of his identity has never been called into question, it is probably permissable to assume that the man wearing the scapular-like,[35] mink-trimmed coat and tall, broad-brimmed hat is indeed the Italian merchant Arnolfini, who managed the Lucchese company of Marco Guidecon at Bruges, where Jan van Eyck lived and worked. Records show his wife was Jeanne (Giovanna) Cenami, born in Paris and also of Italian extraction. She is consequently the woman in the picture, wearing a heavy, green dress and extending her hand to Arnolfini. Arnolfini has his hand raised in what appears to be a gesture of blessing. He may be about to lay his hand upon the open, outstretched palm of his young wife. Arnolfini faces the spectator, although his gaze itself is averted; Giovanna Cenami's eyes are meekly lowered. She is carrying the fur-lined train of her dress bunched up in front of her. This has caused some critics to see the swelling contours of her belly as a sign that the lady is pregnant. However, this was no more than a ritual gesture, consistent with contemporary conventional attitudes towards the family and marriage and intended to symbolise fertility, for the double portrait was painted on the occasion of the couple's marriage. The painting is a visual record of the event; indeed it even acts as a wedding certificate, since it documents the artist's attendance and consequent witness of the ceremony in the inscription on the far wall ("Johannes de Eyck fuit hic").[36] Along with a second witness, van Eyck is reflected in a convex mirror on the same wall. The mirror enlarges the room and is framed by ten painted scenes from the Passion. It was still customary in the fifteenth century for bride and bridegroom to promise marriage without the presence of a priest. The "dextrarum junctio" – joining of right hands – and the bridegroom's pledge were considered legally binding.[37]

The use of the inscription illustrates a growing tendency to document legal transactions in writing, a development which accompanied the adoption of Roman Law. The inscription should therefore not be understood as functioning here simply as a signature. It had a real testimonial force, as in the signing of a official register.

It was customary in the fifteenth century for bride and bridegroom to promise marriage without the presence of a priest. The joining of hands and the bridegroom's oath were legally binding.

PAGE 32 AND DETAIL TOP:
Jan van Eyck
The Marriage of Giovanni Arnolfini, 1434
Oil on panel, 81.8 x 59.7 cm
London, The National Gallery

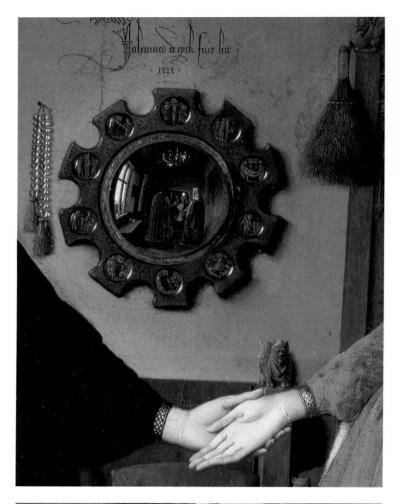

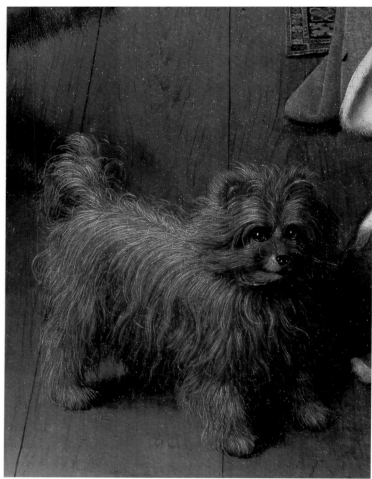

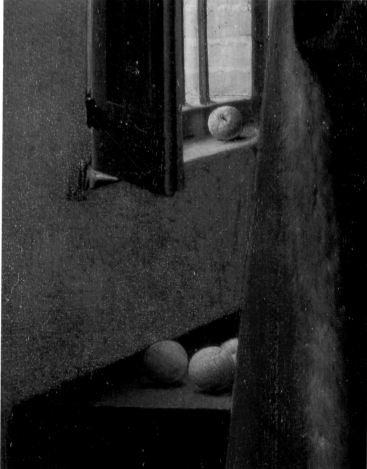

Details from illustration page 32
Together with a second witness, van Eyck is
reflected in a convex mirror on the wall. The
reflection creates the illusion that the room ex-
tends to a point behind the spectator.

The dog, a symbol of devotion since time im-
memorial, stands for conjugal fidelity, while
the apples on the window-sill are an allusion
to the Fall and a warning against sin.

Van Eyck depicts this early bourgeois
interior with its wooden floor as a tha-
lamus, or inner, nuptial chamber, adding,
by his faithful rendering of objects in the
room, a number of hidden meanings, a
theological and moral commentary on the
event taking place. Thus the everyday
convex mirror is a "speculum sine ma-
cula" (an immaculate mirror), signifying
the purity of the Virgin and the virgin
purity of the bride, who, according to
contemporary tracts on marriage, would
be expected to remain "chaste" as a mar-
ried woman. In the foreground, the dog –

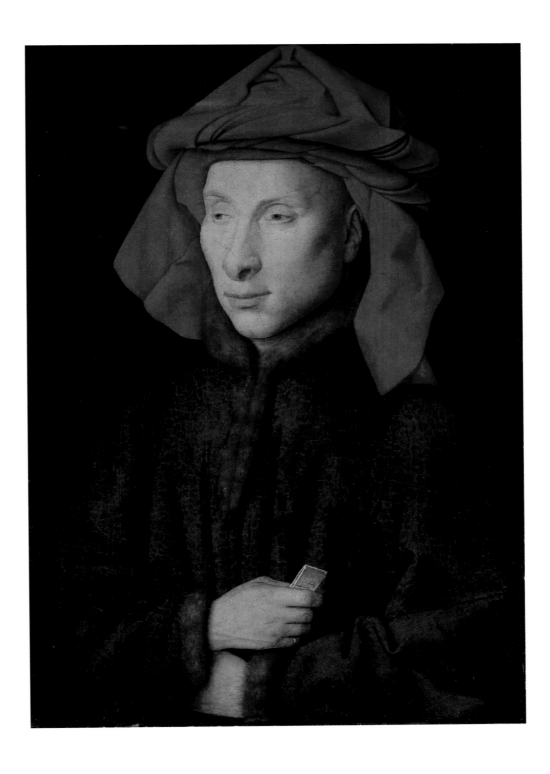

always a symbol of devotion – stands for conjugal fidelity. The red alcove to the right, an allusion to the Song of Solomon, symbolises the bridal chamber. The cork clogs on the left, evidently removed by the bridegroom and casually left lying on the floor, are a reference to the Book of Exodus ("Put off thy shoes from off thy feet, for the place whereon thou standest is holy ground", Exodus 3, 5). The burning candle in the chandelier, a wedding candle, cites traditional Annunciation iconography. It underlines the Mariological character of the painting. Addressed

specifically to women, Mariolatry was a constitutive factor in fifteenth-century conjugal mores. The apples lying on the window-sill are an allusion to the Fall and a warning against sinful behaviour. The switch hung from the wooden paneling is an etymological pun on the Latin words "virga/virgo", and serves to emphasise the motif of virgin purity. Its counterpart in folklore was the "rod of life",[38] a symbol of fertility, strength and health, with which the bridegroom was ritually beaten in order to ensure the couple was blessed with a large number of children.

Jan van Eyck
Giovanni Arnolfini, c. 1438
Oil on panel, 29 x 20 cm
Berlin, Staatliche Museen zu Berlin –
Preußischer Kulturbesitz, Gemäldegalerie

Jan van Eyck: The Virgin of Chancellor Rolin

The painting shows Chancellor Nicolas Rolin (1376?–1462), born at Autun into bourgeois circumstances, who, entrusted with setting up an early absolutist system of state administration under Philip the Good, had attained the high rank of a Notable.[39] Van Eyck – who had entered the Duke's service as "varlet de chambre" (valet) in 1425, which in fact meant he was court painter – has portrayed him attired in an opulent, brownish, mink-trimmed brocade coat with a raised pomegranate pattern in gold thread. Rolin is viewed from the side, though not in full profile, kneeling at a cushioned table spread with a turquoise cover. His eyes are directed towards the Virgin sitting opposite him with the naked Child on her lap, while the Child is in the act of blessing Rolin. This arrangement is unusual.

In his *Virgin with Canon van der Paele*,[40] van Eyck painted a majestic Virgin, enthroned in full-face view, presenting her as the virtual object of his adoration. Here, however, the side view objectifies the Virgin so that the spectator acts as the witness of her meeting with the Chancellor. Van Eyck has minutely recorded the signs of aging in Rolin's face. The folds and wrinkles are no less precisely rendered than the arteries at Rolin's shaved temples, however. Van Eyck, although he was not – despite Vasari's later claim – the actual inventor of oil-painting, brought a previously unparallelled mastery to this new art, revealing, by means of repeated glazing, the throbbing life beneath Rolin's skin. Van Eyck does not present the face as a vehicle for the expression of feelings, but records the quiddity of each object: a visual nominalism,[41] with precise syllabic counterparts for every "thing" that met his gaze. However, his radical empiricism did not preclude use of the kind of allegory found in late scholastic biblical exegesis.

On the contrary, almost every detail of the painting contains a spiritual allusion. This is borne out by the triple-arched loggia through which the interior gives onto a crenellated courtyard-garden. Reliefs decorating architectural features on the right of the loggia show scenes from the Old Testament: the expulsion from Paradise, Cain and Abel and Noah's drunkenness. The scene on the capital at the right depicts the justice of Trajan. These motifs, in other words, refer to the Fall, and to a paragon of virtue. The enclosed garden with its blos-

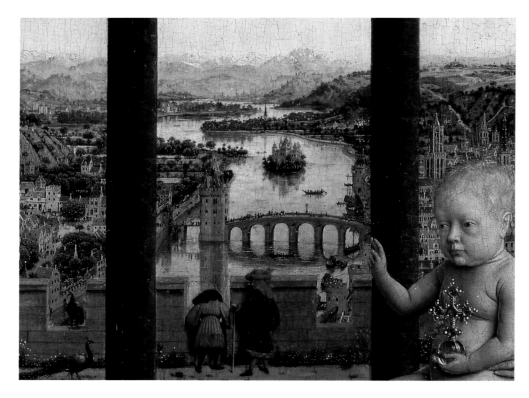

Detail from illustration page 37
A bridge can be seen in the middle distance of a landscape extending to an Alpine skyline. Van Eyck probably wished to refer to some historical event. John the Fearless was murdered on the bridge at Montereau in 1419.

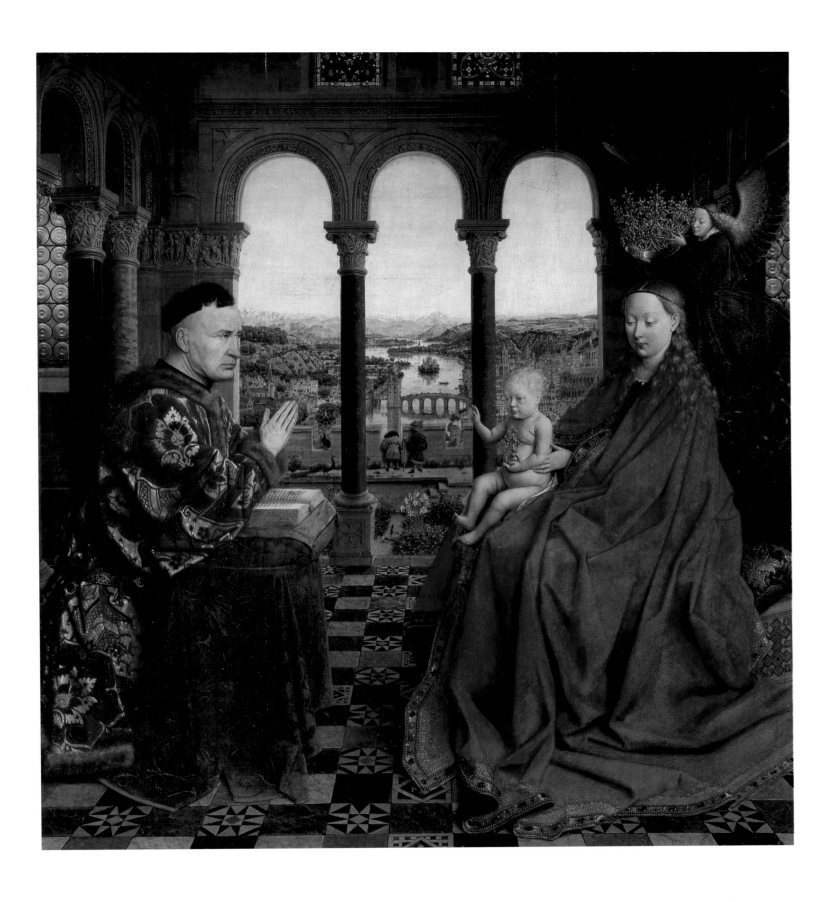

Jan van Eyck
The Virgin of Chancellor Rolin, 1436
Oil on panel, 66 x 62 cm
Paris, Musée du Louvre

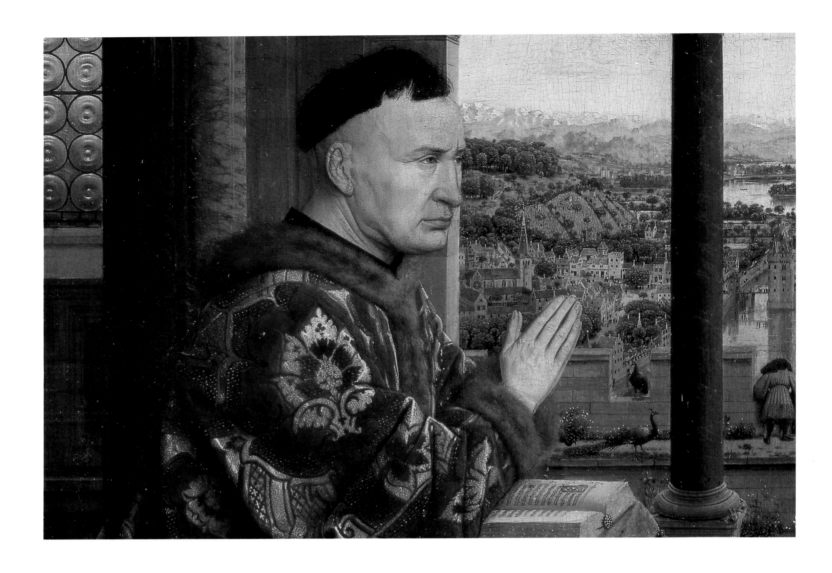

TOP AND PAGE 39:
Details from illustration page 37
On becoming Chancellor, Nicolas Rolin (1376?–1462), a lawyer from Autun, had risen to the highest public office at the Burgundian court. Rolin was elevated to the nobility by the Duke. The "noblesse de robe" to which Rolin belonged distinguished itself from military knighthood in that its members were lawyers, scholars and civil servants.

soms – roses, irises and lilies traditionally symbolised the Virgin – alludes to the "garden enclosed" (hortus conclusus)[42] in Song of Solomon (4, 12), equated metaphorically in medieval exegesis with the Virgin Mary. The peacocks suggest Paradise. Two men, one of whom seems to be gazing into the receding landscape, are shown looking over the parapet. The one on the right is wearing a red, scarfed headdress, presumably similar to that worn by van Eyck himself – a hypothesis prompted by van Eyck's *Man in a Red Turban* (London), thought to be a self-portrait, and by the metallic reflection on St. George's armour in his Paele-panel. Although the landscape is realistic in the *Chancellor Rolin* painting, it is not, in fact, an authentic scene. Instead, van Eyck has used various sketches to construct an ideal "panoramic landscape" with an alpine massif disappearing into the distant, atmospheric blue.

Emil Kieser has shown convincingly that the bridge over the river, on which a tiny cross may be made out, should be seen in connection with the murder of Philip the Good's father, John the Fearless, on the bridge at Montereau on 10 Sept. 1419. The Treaty of Arras, concluded by Rolin on 21 Sept. 1435, contained a decree to the effect that a cross in memory of the assassination be erected on the bridge. The years between the murder and the recently concluded Treaty can be read in the number of floor-tiles between the arcade and the picture-plane.[43]

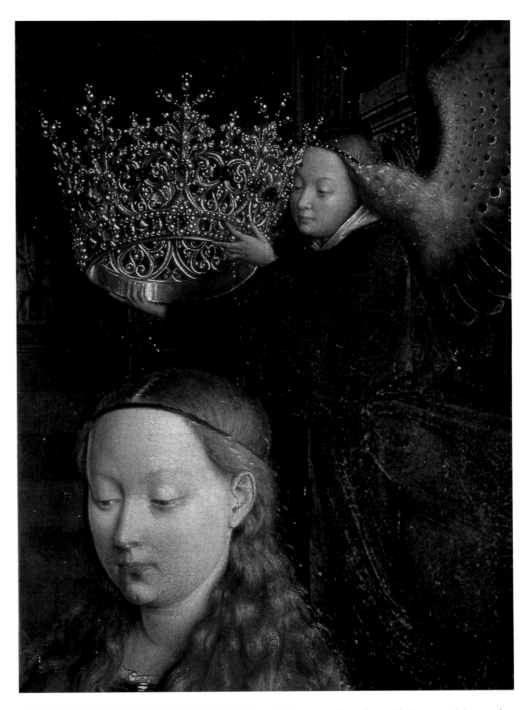

The terraced garden with its roses, irises and lilies, symbols of the Virgin, is an allusion to a passage in Song of Solomon: "A garden enclosed is my sister, my spouse; a spring shut up, a fountain sealed" (4, 12).

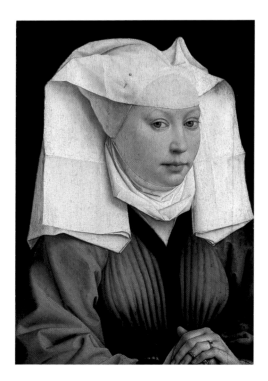

Rogier van der Weyden: Portrait of a Lady

TOP AND DETAIL PAGE 41:
Rogier van der Weyden
Portrait of a Lady, c. 1460
Oil on oak panel, 34 x 25.5 cm
Washington (DC), National Gallery of Art,
Andrew W. Mellon Collection

With the work of Rogier van der Weyden, early Netherlandish portraiture entered a new stage in its development. It is thought that Rogier became apprenticed at the workshop of Robert Campin at Tournai, graduating in 1432 as Maistre of the Painters' Guild. He was appointed official painter to the city of Brussels in 1436. His work for the city included paintings on the theme of justice for the court room of the town hall. Besides his official work, he was commissioned to do a large number of portraits, usually by distinguished patrons at the Burgundian court (Duke Philip the Good, his son Duke Charles the Bold, Philippe de Croy, "Le Grand Bâtard de Bourgogne", Francesco d'Este, Nicolas Rolin etc.).

While Jan van Eyck reproduces the texture of his sitters' skin in microscopic detail, seeking in a manner analogous to that of the nominalistic philosophy of his time to embrace the unique, contingent physicality of each individual portrayed, however crude or ugly this might make them seem, Rogier emphasises the social status of his sitters, especially through his portrayal of hands and face. Rank is primarily displayed – as it is with van Eyck – by means of opulent robes and heraldic or emblematic attributes. But Rogier's stylised portraits – his attention, for example, to the sharply contrasting outlines of lips and nose, or his emphasis on the slenderness of limbs – idealise his sitters, lending them a greater sophistication. While van Eyck shows nature "in the raw", as it were, Rogier improves on physical reality, civilising and refining Nature and the human form with the help of his brush.

His half-length, three-quarters view *Portrait of a Lady* (Washington) serves to illustrate this. Her narrow face and elaborately pinned-up, transparent veil covering ears and brow stand out against a neutral, dark, two-dimensional background. Her hair, brushed tightly back from her high forehead and held in place by the black rim of her ornamental bonnet, pulls the corners of her eyes into light, upward slants. The veil was usually worn to hide the sensuality of the flesh; here, its fashionable transparency achieves quite the opposite effect. Unlike Rogier's male sitters, the female subjects of his portraits lower their gaze as a sign of chastity and humility. One exception to this is his early portrait of a woman, painted in 1435 – today in Berlin (ill. p. 40) – and thought to represent the artist's wife.

As in most of Rogier's head-and-shoulder portraits, particular attention is paid to the refined delicacy of the sitter's hands. The fashionably extended sleeves of her elegant dress cover the backs of her hands, leaving only the slender frailty of her fingers in view, whose finely chiselled, interlocking layers bear a similarity to the exquisitely wrought golden buckle of the vermilion belt behind them.

BOTTOM:
Rogier van der Weyden
Portrait of a Lady, 1435/40
Oil on oak panel, 47 x 32 cm
Berlin, Staatliche Museen zu Berlin –
Preußischer Kulturbesitz, Gemäldegalerie

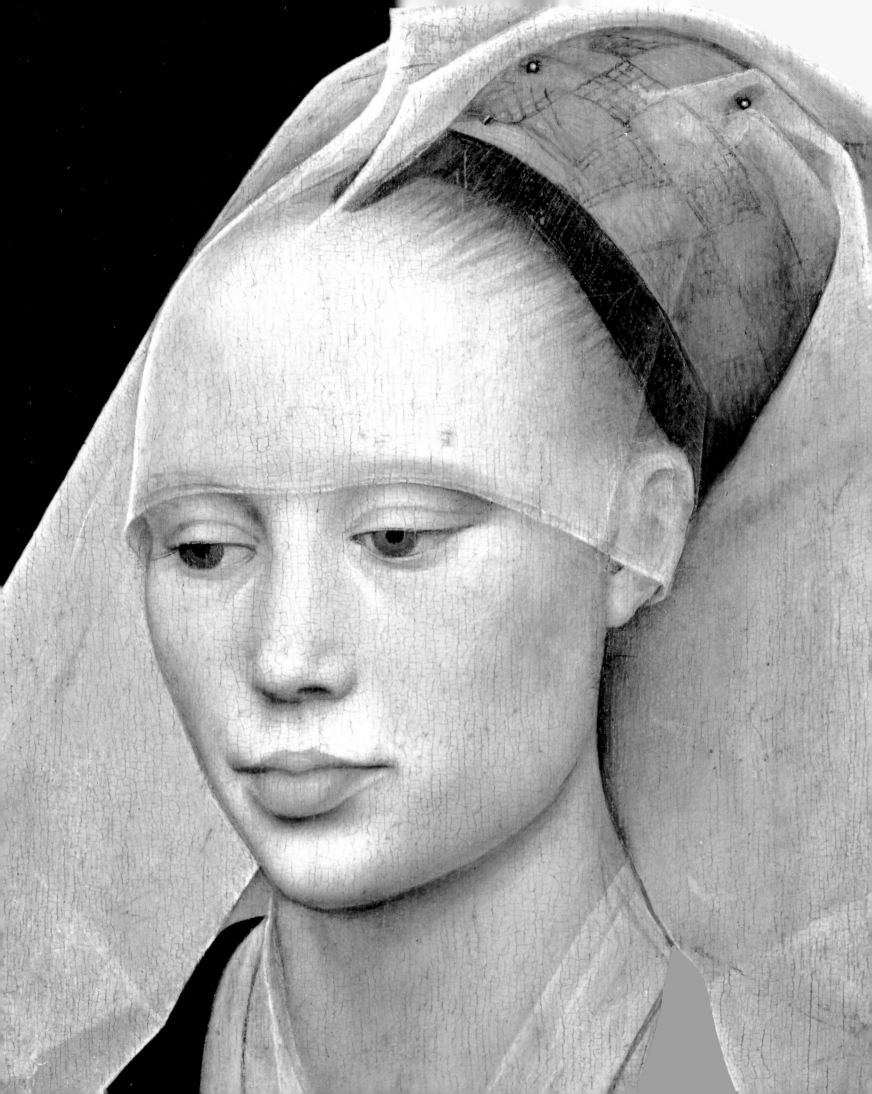

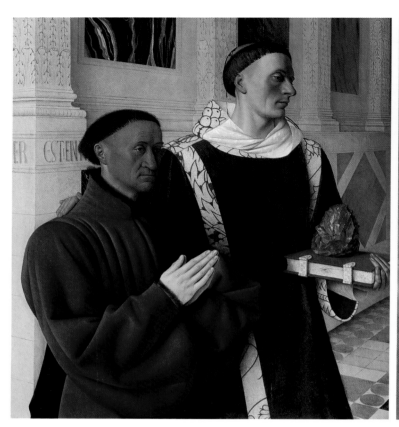

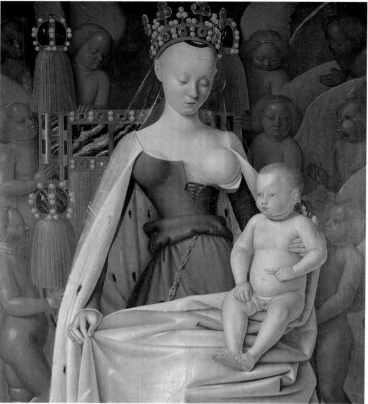

Jean Fouquet: Etienne Chevalier Presented by St. Stephen

LEFT:
Jean Fouquet
Etienne Chevalier Presented by St. Stephen,
c. 1450
Oil on panel, 93 x 85 cm
Berlin, Gemäldegalerie, Staatliche Museen zu
Berlin – Preußischer Kulturbesitz

RIGHT:
Jean Fouquet
Virgin and Child (Agnès Sorel?), c. 1450
Oil on panel, 94.5 x 85.5 cm
Antwerp, Koninklijk Museum voor Schone
Kunsten

According to tradition, Fouquet painted the
Virgin with the features of Agnès Sorel, the fa-
vourite of Charles VII. Agnès Sorel made
Etienne Chevalier her executor, undoubtedly
the sign of a close relationship between them.

Van Eyck's realism soon enjoyed interna-
tional renown. In Italy, Bartolomeo Fazio
extolled the Flemish artist in 1455/56 as the
"prince of our century's painters". In
France, too, where Burgundian art was al-
ready well known, the new style quickly
won favour, becoming known as "la nou-
velle pratique". Traces of its influence can
be felt in the work of Enguerrand Charon-
ton, and in the celebrated *Pietà of Ville-
neuve-lès-Avignon* (see ill. p. 43), painted c.
1470 by an anonymous master of southern
France.[44] The donor, whose face is real-
istically represented, is shown kneeling in
an attitude of prayer at the bottom left of
the Pietà. His white robe, as well as the at-
tribute of oriental architecture (the Church
of the Holy Sepulchre in Jerusalem)
against a gold background, suggest he has
travelled as a pilgrim to Jerusalem. The ar-
tist has given powerful dramatic ex-
pression to the grief of the mourners, and
the intention to introduce the donor into
their company seems obvious enough.
Nevertheless, the gaze and gestures of the
donor have not (yet) made any impression
on the holy figures themselves, so that he
remains outside their gestural narrative.
Although part of the painting, the donor

thus seems somewhat isolated within it.
His gaze is intended to be directed towards
the events taking place, but in order meet
his patron's demands, the artist has painted
him looking less into the centre of the
painting than diagonally out of it.

Etienne Chevalier's gaze is similarly
posed by Jean Fouquet in a work, commis-
sioned by Chevalier, that was probably ex-
ecuted in 1451 following the artist's return
from Italy to Tours (where he spent much
of his life working at one of the French
royal residences).[45] Chevalier is portrayed
on the left wing of a diptych, now at Berlin,
usually known as the "Melun Diptych"
after the donor's place of birth.

Chevalier, a high-ranking official at the
courts of Charles VII and Louis XI, is
shown in a simple, but elegant, red robe.
His long, slender hands, whose pale,
slightly flaccid skin contrasts so strongly
with the brownish complexion of his face,
are held together in the act of prayer. His
portrait is the pair to the Virgin on the right
wing of the diptych. Unlike the donor, she
is shown in full-face view, idealised as an
archaic object of worship. Etienne Cheva-
lier poses in three-quarters view; thus his
gaze, although turned to the Virgin, sees

past her. Here, too, the purpose of the portrait – to show the donor – conflicts with the donor's desire to be part of the holy scene in the painting.

According to tradition, the Virgin is here represented with the features of Agnès Sorel, the favourite of Charles VII. Richly dressed in an ermine robe and a crown of pearls, her forehead shaved according to the courtly fashion of the day, the Virgin meekly lowers her eyes and offers the Child her breast. Behind her throne stands a crowd of alternately red and blue, angelic putti.

The portrait of Etienne Chevalier is similar, in some respects, to van Eyck's portrait of Chancellor Rolin (see ill. p.37). Fouquet too was commissioned to paint an official who had risen from a non-aristocratic background to a high-ranking position in the feudal absolutist state, and whose desire to create a memorial to himself betrayed his need to compete for social status with the nobility. At the same time, the diptych may have been an ex-voto gift, a token of his gratitude on being appointed Chancellor ("Trésorier") of France in 1451. Possibly, it was intended to commemorate the king's respected mistress, who had died on 9 Feb. 1450. Whereas van Eyck had found a "pro-gressive" solution to the problem of integrating into a spatial and narrative unity a donor worshipping the Virgin, Fouquet, who had been leading court artist for many years, although not officially made "peintre du roi" until 1475, shows Chevalier and St. Stephen, the donor's patron saint, in silhouette. The purity of the outlines and trenchant, extensive areas of colour are emphasised by the light background of the marble wall and pilasters, on which the name of the donor is repeated in a frieze-like pattern. Fouquet's novel departure from Netherlandish donor portraiture is the reduction of his subject's complexity to a minimum of clear, expressive components. Van Eyck's compression of numerous allusive details in his compositions contrasts with Fouquet's simple, lapidary symbols: the stone, for example, evidently a sign of the artist's interest in geology, resting on a leather-bound, gilt-edged prayer-book. Like the wound on the saint's tonsure, from which blood drips down into the hood of his dalmatic, the stone signifies the patron saint's martyrdom. In a Book of Hours produced for Chevalier (1452–60), and now at the Musée Condé at Chantilly,[46] Fouquet painted the lapidation of St. Stephen in miniature.

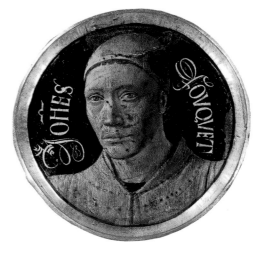

Jean Fouquet
Self-portrait, c. 1451
Gold and enamel on copper, 7 cm
Paris, Musée du Louvre

Southern French Master
Pietà of Villeneuve-lès-Avignon, c. 1470
Oil on panel, 163 x 218 cm
Paris, Musée du Louvre

Hans Memling: Man with a Roman Coin (Giovanni de Candida?)

More than any other painter in the second half of the fifteenth century, Hans Memling can be said to have added a new dimension to the type of portrait founded by Jan van Eyck in the Netherlands, and developed further by Petrus Christus and Rogier van der Weyden. Unlike his predecessors, Memling characterises his sitters in a highly personalised manner, a technique learned partly from his Italian contemporaries. He achieves this – in this small-format portrait now at Antwerp[47] – by using landscape to evoke a mood which corresponds to his subject's sensibility. In contrast to van Eyck's dark and neutral backgrounds, or Petrus Christus' use of paneling to suggest interior space – as can be seen in his portrait of a young lady, now at Berlin – Memling follows the example of quattrocento Italian portraiture in making the landscape background an essential part of the portrait itself. The role of landscape in Memling's "œuvre" is to reflect the mental and emotional state of the sitter, al-

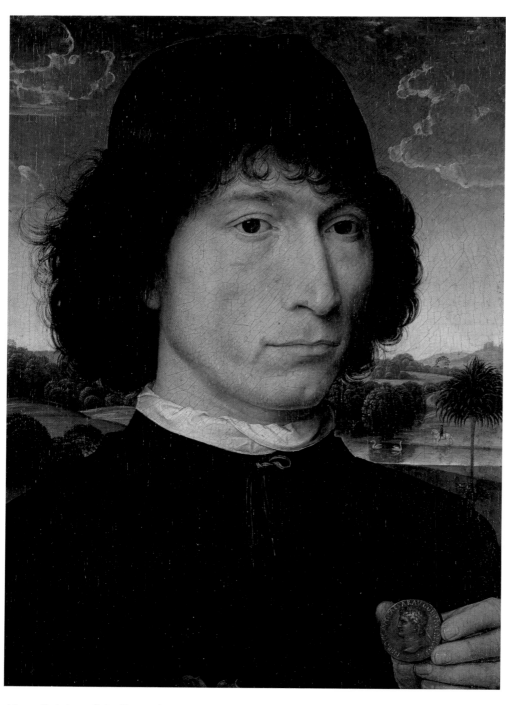

LEFT AND DETAIL PAGE 45 TOP:
Hans Memling
Man with a Roman Coin (Giovanni de Candida?), c. 1480
Oil on parchment on panel, 29 x 22 cm
Antwerp, Koninklijk Museum voor Schone Kunsten

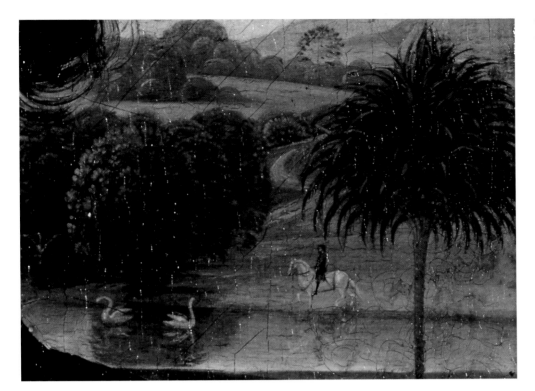

The use of landscape background to reflect the mental and emotional state of the sitter shows an awareness of modern attitudes to the natural world. The motifs employed here are nevertheless largely indebted to conventional Christian symbolism.

though conventional symbols and emblems, suggesting the ethical and religious coordinates of his sitters' lives, still figure in his background scenes. Here, the young man is painted wearing a black gown and cap whose colour merges with, and therefore emphasises, the darkness of his hair. He is posed before a riverscape with trees, over which dusk is beginning to fall. A man riding a white horse along the riverbank is possibly an allusion to the rider[48] in the Revalation of St. John (6, 2), whom medieval exegetes saw as the victorious figure of Christ. The motif is consistent with the swans, which, owing to their legendary dying songs, have often been related to Christ's Passion. The palm-tree, too, highly unusual in a northern European landscape, and therefore particularly significant, would fit the context of the Passion. Perhaps the artist has been put in mind of New Testament martyrdom by the antique coin bearing the head of Nero (54–68). The young man, evidently the owner of the coin, is deliberately showing it to the spectator. According to the "Annals" (XV, 44) of Tacitus, Nero persecuted the Christians in Rome. Before they were executed, he had them subjected to the most bestial tortures.

Memling's painting is based on a portrait of a young man – of which he had probably seen a copy, or which he may have been acquainted with as a type – whose hands encompass a medallion bearing the head of Cosimo de' Medici. This portrait (ill. p. 45), now in the Uffizi, is ascribed to Botticelli.[49] The medallion must have been cast after 1465, since it carries the inscription MAGNVS COSMVS/MEDICES PPP. The abbreviation PPP stands for "Primus Pater Patriae", a title conferred posthumously upon Cosimo. A miniature by Francesco d'Antonio del Cherico, contained in an Aristotelian manuscript now at the Laurenziana, shows that the medallion was cast for Cosimo's son Piero il Gottoso, who died in 1469. It must therefore have been made between 1465 and 1469, and Botticelli must have painted his portrait not long afterwards. The identity of the sitter has been the subject of much fruitless speculation. Sometimes seen as Piero il Gottoso himself, he has been equated with – among others – Pico della Mirandola, Niccolò Fiorentino and Cristoforo di Geremia. Since the young man with the red cap is holding the medallion close to his heart, thereby revealing the extent of his feelings for it, the portrait may be viewed as a demonstrative sign of the sitter's support for the Medici during the period of the Pazzi consiracy (1478).

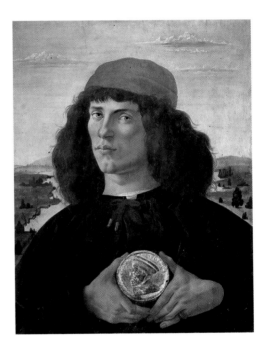

Sandro Botticelli
Young Man with a Medallion of Cosimo de' Medici, c. 1474
Oil on panel, 57 x 44 cm
Florence, Galleria degli Uffizi

Antonello da Messina: Portrait of a Man, known as "Il Condottiere"

TOP:

Andrea del Castagno
Monument of Niccolò da Tolentino, 1456
Fresco, transferred to canvas, 833 x 512 cm
Florence, Cathedral

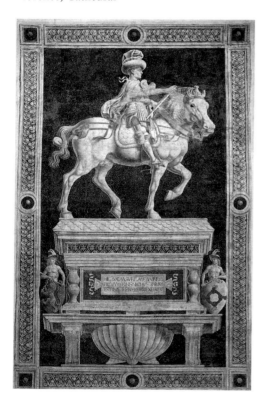

RIGHT:

Nino da Fiesole
Bust of Niccolo Strozzi, 1454
Marble, height 49 cm
Berlin, Staatliche Museen zu Berlin –
Preußischer Kulturbesitz, Skulpturengalerie

PAGE 47:

Antonello da Messina
"Il Condottiere"
Oil on panel, 35 x 28 cm
Paris, Musée du Louvre

The portrait was given the title *Il Condottiere* (the mercenary commander) during the late nineteenth century because of the wilful determination in its sitter's face. It entered Napoleon III's collection in 1865, fetching 113,500 francs at a sale at the Pourtalès-Gorgier Gallery. The large sum paid for it is proof of the high esteem in which the Italian painter was held by the mid-nineteenth century. Its new title betrays the reason for renewed interest in the portrait: it provided an aesthetic medium through which to identify with the power-hungry usurpers, the heroes and new, strong men of the Renaissance, with their ebullient, nouveau-riche style and dramatic rise to power. In an era of highly competitive capitalist and colonialist expansionism, upstarts of this kind were suitable models for those pursuing a successful career in politics or finance, and thus for the Emperor himself.

It is unlikely we shall ever know whether the mercenary activity ascribed to the sitter was of the type we might associate with Gattamelata or Bartolommeo Colleoni, with Sir John Hawkwood or Niccolò da Tolentino (ill. p.46). In fact, none of these is very likely, since he was probably a noble. This is suggested by the sobriety of his clothes against the dark background, a fashion in Burgundian aristocratic circles at the time. The probable Venetian origin of the sitter is documented by the unfolded "cartellino" on a painted panel at the bottom of the painting, signed and dated "1475. Antonellus Messaneus me pinxit". It was during this year that the Sicilian painter – who may, though the likelihood is not great, have learned oil-painting techniques in Bruges under Petrus Christus (according to Germain Bazin)[50] – was in Venice, where he helped to familiarize Venetian artists with methods of making and using oil paints, which, by contrast with tempera, were more lucid and flexible.

The portrait-type used by Antonello was of Netherlandish origin, too: the widely painted three-quarters view, exemplified (above) by Jan van Eyck's *"Leal Souvenir"* (ill. p.31), with its neutral background and foreshortening parapet calculated to persuade the spectator that what he is seeing is real. Antonello does not provide his subject with attributes defining social standing or profession, unless we see the sitter's plain hair and garments in this light. Instead, he emphasises the alertness and clarity with which the sitter holds the spectator in his gaze. By restricting our view to the head and upper shoulders – a method borrowed from the bust portrait developed after Roman models in sculptures by Nino da Fiesole, Desiderio da Settignano or Antonio Rosselino (ill. p.46 bottom) – Antonello calls attention to the sitter's face, which, standing out against a uniformly dark background, is revealed as the centre of the man's vitality and strength of will – characteristics felt through the subject's gaze. In his "De visione Dei", Nikolaus von Kues refers to the way the eyes of a portrait, without themselves moving, follow the spectator to whatever point in the room he is standing, so that he always has the feeling of being watched. Von Kues compared this to the mystical "eye of God".[51]

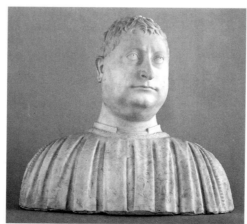

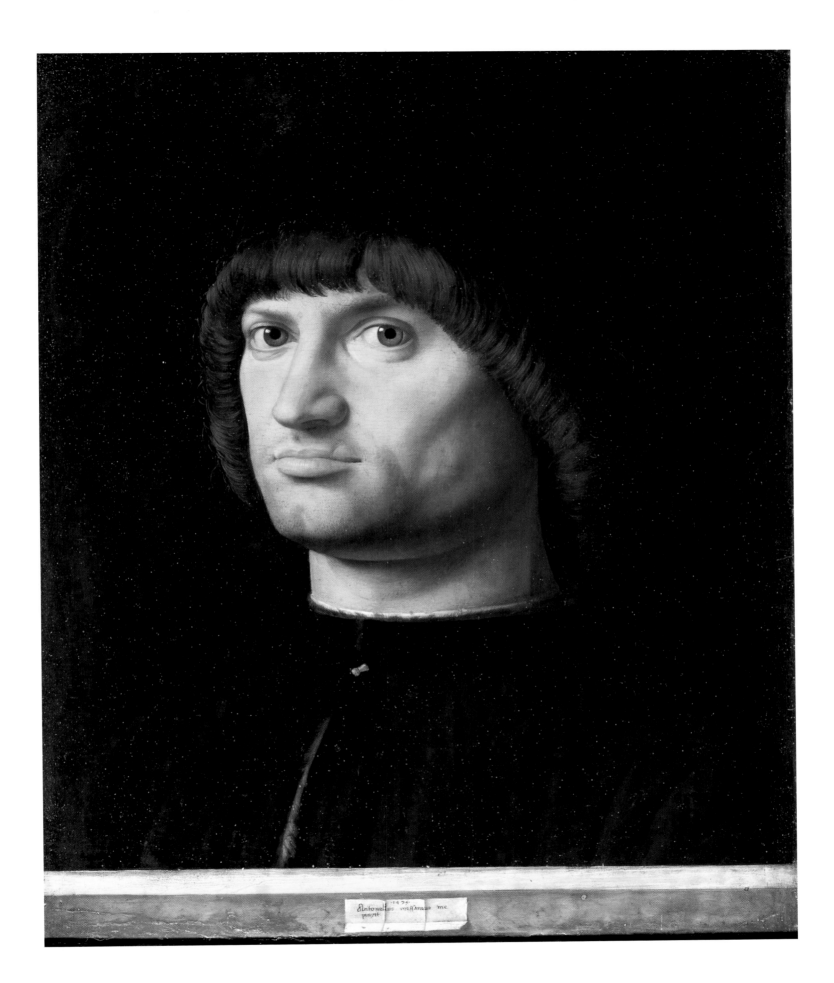

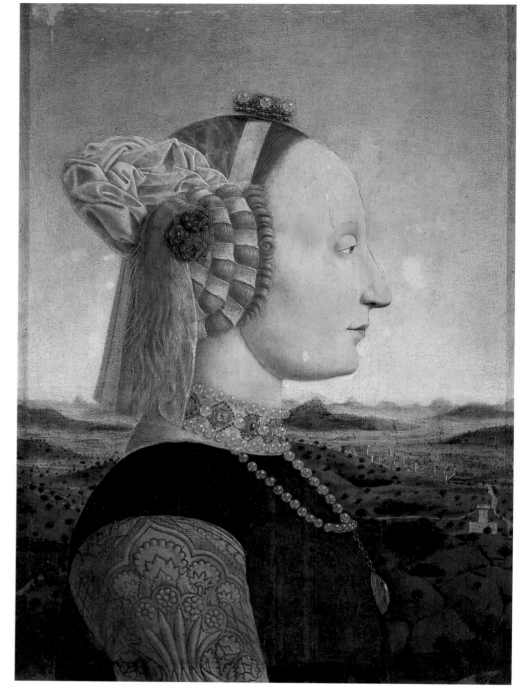

Piero della Francesca: Federigo da Montefeltro and his Wife Battista Sforza

In choosing the diptych as a suitable form for the portrait, the artist adapts a conventional means of eliciting sympathy that can be traced back to Classical antiquity. Roman consuls would often present double portraits, painted on hinged leaves of wood, metal or ivory, to emperors, senators or influential friends.[52] This painting may have been a present, too, but nothing is actually known of its early history. The painting was first recorded in 1631, when the Duchy of Urbino, along with the property of the ruling Rovere family, was annexed by the Papacy. At the time, the painting was taken to Florence, thus finding its way into the Uffizi.[53]

Formally speaking, the work is a portrait of a man and his wife. However, its subject, unlike that of van Eyck's Arnolfini-portrait of 1434 (ill. p. 32), is not contained on a single panel. Nor does the painting record an event of importance to

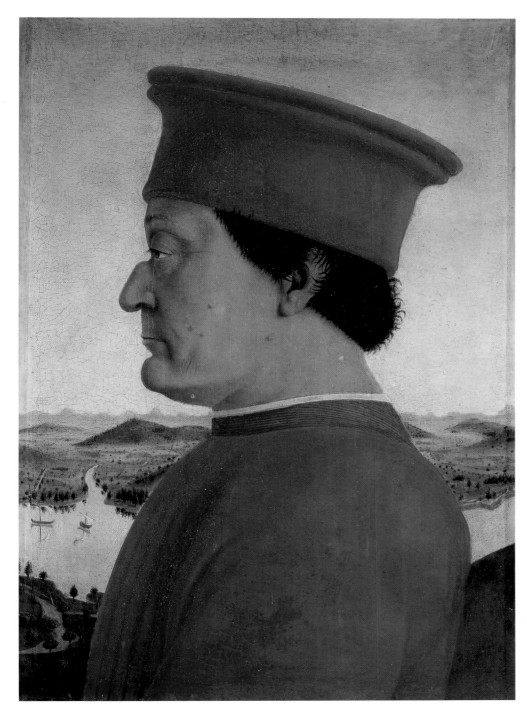

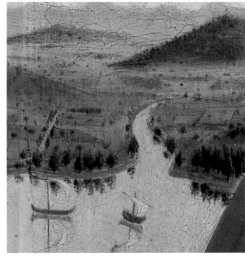

the couple – like an act of betrothal, or a wedding ceremony.

The partners are posed separately, facing each other in a deliberately archaic manner: the Duke on the right, mirrored, as it were, by his wife. Both are shown in sharply defined, bust profile, a type of portrait reminiscent of Pisanello's medals.

The portrait avoids contact between the gaze of the sitters and the spectator. Despite their proximity, Federigo da Montefeltro and his wife Battista Sforza seem distant from one another, their relationship abstract. Their robes display dignity and wealth. The Duke's red cylindrical biretta

with its slightly wider crown and matching plain topcoat emphasise his powerful presence, his might and majesty. His stern simplicity anticipates an ideal formulated a quarter of a century later by Baldassare Castiglione (ill. p. 80), also from Urbino, in his book on the "gentiluomo", or courtly gentleman.

Federigo da Montefeltro's wife, of pale complexion, is wearing a white veil elaborately plaited into her snail-shaped, chequered braids. Her rich pearls and finely cut jewels demonstrate her considerable wealth. However, her pearls are allusions to Marian virtues, too. At the time, the

Piero della Francesca
Federigo da Montefeltro and his Wife
Battista Sforza
Tempera on two panels, each 47 x 33 cm
Florence, Galleria degli Uffizi

Virgin was often portrayed wearing rich pearl jewellery to illustrate her status as "regina coeli" (Queen of Heaven) – by van Eyck, for example, on the altarpiece at Ghent.

The Duke and Duchess are placed so far forward against the picture-plane that they act as a repoussoir, directing the eye into an infinitely receding, undulating landscape with scattered pine-trees. The panoramic view is reminiscent of Antonio Pollaiuolo's landscapes of the Arno valley; it shows the countryside around the court of Urbino, twenty miles inland from the Adriatic coastline between Loreto and Rimini. The Apennine foothills are just visible in the blurred, "sfumato" background. The fortifications and ships at the coast are intended to demonstrate the military prowess of this mercenary commander, whose army had fought under the flags of Naples, Milan and the Papacy. Fortifications – a chain of fortresses gleaming in the sunshine – are also visible in the landscape behind Battista Sforza.

The landscape motif is repeated on the reverse of the panels, only here it is translated into mythological allegory. A pair of white horses and a pair of tawny unicorns are shown pulling triumphal chariots, carrying the Virtues and the Duke and Duchess, across a flat rock – the symbol of conjugal fidelity. Federigo is depicted wearing knightly armour, crowned by Glory and surrounded by the cardinal virtues of Justice, Wisdom, Valour and Moderation.

Battista, reading a prayer-book, is assisted by the three theological virtues of Faith, Hope and Charity, as well as by Pudicitia: matronly chastity. Holding onto the reins, cupids (symbols of conjugal love) stand on cornucopia-style pedestals above the shaft of each chariot. The stilted Latin inscriptions on the architrave-like "parapets" below the landscapes pompously celebrate the fame of this "illustrious sovereign", who, as prince and bearer of the sceptre, apparently was a match for the greatest of kings. His lady's qualities, meanwhile, are praised as a credit to her husband.

Iconographically, the motifs are related to Petrarch's "Trionfi", which were written in about 1352 and appeared in Venice in 1470,[54] only a few years after Piero della Francesco painted the portraits. Petrarch's didactic allegories, of which Federigo, a collector of rare books and manuscripts, probably possessed a copy – his famous collection was later acquired by the Vatican Library –, describe the triumph of six allegorical figures. Among them is the "Triumphus pudicitiae", here associated with Battista Sforza, and the "Triumphus famae", shown on the reverse of Federigo's portrait.

Despite their small format, the panels are an impressive testimony to the thirst for glory of a Duke who had himself confidently portrayed as "fortis sapiensque",

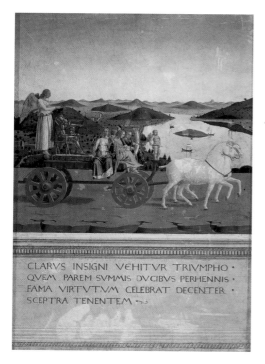

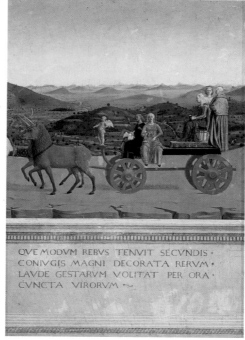

The reverse of the panels shows the Duke and Duchess surrounded by the Virtues attributed to them. Federigo is depicted with the cardinal virtues: Justice, Wisdom, Valour and Moderation. Battista is assisted by the three theological virtues: Faith, Hope and Charity.

LEFT AND DETAILS PAGE 51:
Piero della Francesca
Reverse of the Montefeltro-Diptych: Triumphal Chariots of Federigo da Montefeltro and his Wife Battista Sforza
Tempera on two panels, each 47 x 33 cm
Florence, Galleria degli Uffizi

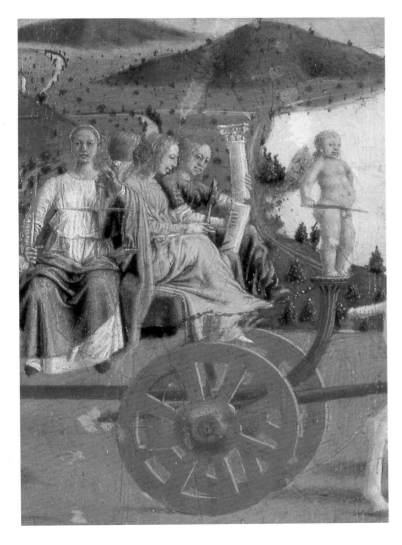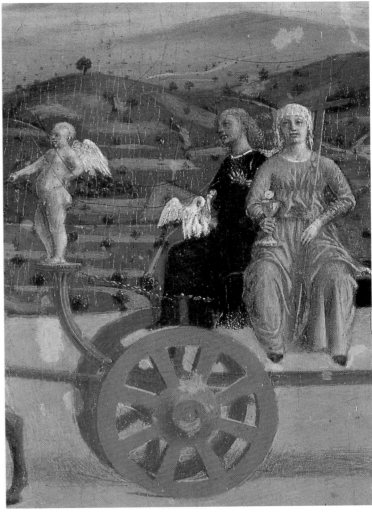

courageous and wise, an expert both in war and in science – qualities demanded of the ideal ruler by medieval and Renaissance "princely codes".[55]

It is possible that the portraits were not painted until after 1474, when Federigo, still only Signore da Urbino, was crowned Duke. The emphasis on the sceptre as a sign of newly acquired rank would seem to support this. At the same time, this would mean that the portrait of Battista was executed posthumously, since she is known to have died in 1472. The perfect tense ("te-nuit") in the inscription under Battista's allegory is thus probably used in a commemorative sense. In this case, her face would not have been seen as an authentic life study, but as the copy of an earlier portrait. Federigo, on the other hand, appears to be roughly the same age here as in his likeness by Pedro Berruguete, painted in 1477, which shows him reading a valuable codex.

Pisanello: Young Lady of the Este Family

Pisanello
Lionello d'Este
Tempera on panel, 28 x 19 cm
Bergamo, Accademia Carrara di Belle Arti

Lionello d'Este (died 1 Oct. 1450) was born into one of the oldest families of noble lineage in Tuscany. The area controlled by the Este family had grown from century to century. They were Lords of Ferrara and its hinterland (Modena, Parma and Reggio). In the quattrocento they earned a reputation as important patrons of the arts and sciences.

This likeness of a young lady belongs to the early period of modern portraiture.[56] It was executed in the decade during which Jan van Eyck and Robert Campin painted their most important portraits. However, it differs from these in its use of the profile view, a pose reminiscent of antique art and frequently chosen by Pisanello (1395–1455) for his medals and plaquettes. It is to the influence of coin and medal portraiture, too, that we may attribute the lack of modelling in many of his subject's faces, their affinity, in other words, to relief sculpture.

There has been considerable controversy over the identity of the sitter portrayed by Pisanello on this small panel. Of the many suggestions made, two may be mentioned here. The fragile, childlike face, with its high, shaved forehead and hair tightly combed back and held in place by an unevenly bound, transparent calotte-style bonnet, is most frequently thought to belong to Margarita de Gonzaga. She was Lionello d'Este's wife (see ill. p. 53), and was married to him in 1433 – the year in which the portrait is generally thought to have been painted. A second hypothesis identifies the sitter as Ginevra d'Este, who was married to Sigismondo Pandolfo Malatesta of Rimini, with whom she later fell into disgrace. He is thought to have poisoned her in 1440, when she was twenty-two years old.

Whoever she was, there can be little doubt that her likeness belongs to the genre of courtly portraits. The young woman, possibly a princess, may have sat during the course of marriage negotiations, or on the occasion of her approaching, or perhaps even recently performed, wedding ceremony. This hypothesis is supported by the the sitter's decorative, tapestry-style background. The radiant blossoms – columbines and carnations- upon which butterflies have settled, and which have sprung from the dark green leaves of a bush, were Mariological attributes usually representing chastity. However, it is equally possible that this was a posthumously executed portrait of the kind Piero della Francesca may have painted of Battista Sforza (ill. 48), since butterflies often symbolised resurrection in portraits of sitters who had died young. The ornamental symbol of the juniper sprig (Juniperus vulgaris),[57] embroidered on the sitter's ribbed, short-waisted overgarment, seems to reinforce this. Folklore attributed obscure magical powers to the shrub. It was said to protect people against demons, and, in a more practical sense, to help against contagious diseases. Juniper was also recommended as a means of guarding against early death.

PAGE 53 AND DETAILS RIGHT:
Pisanello
Young Lady of the Este Family, c. 1433
Tempera on panel, 43 x 30 cm
Paris, Musée du Louvre

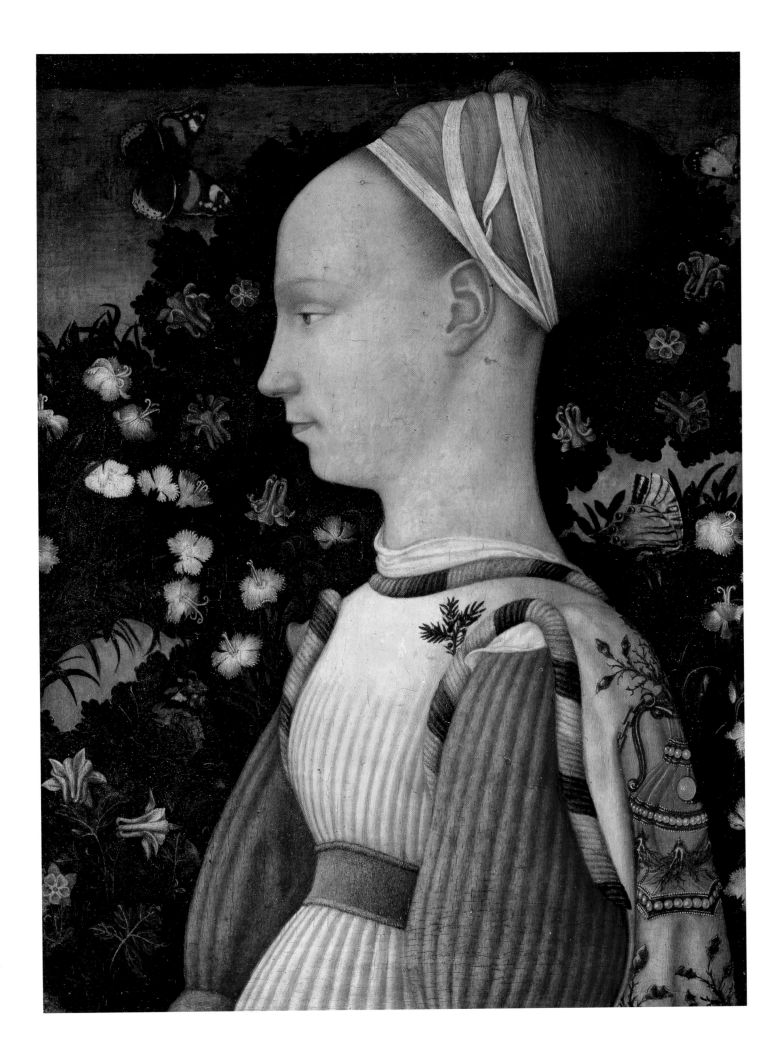

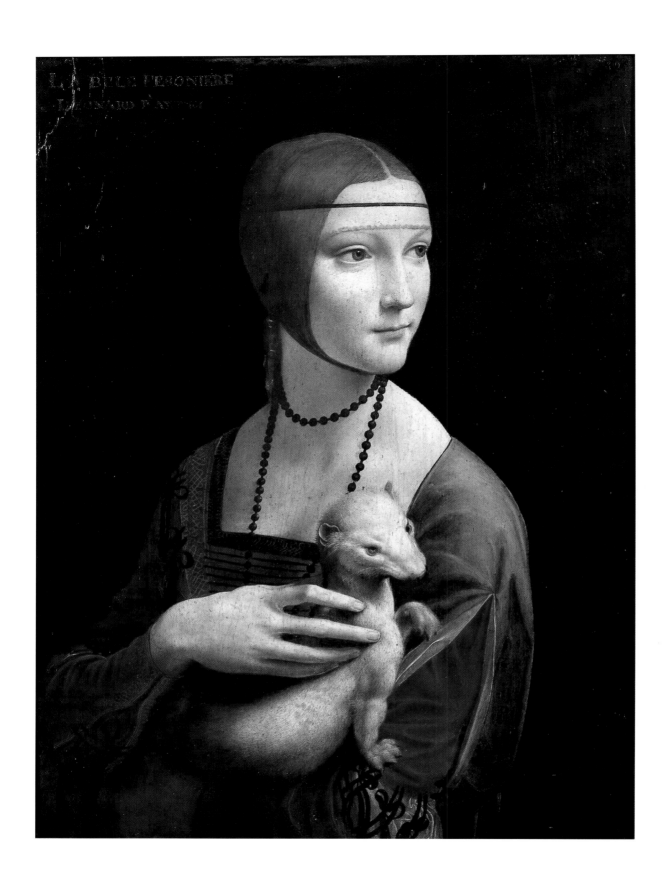

TOP AND DETAIL PAGE 55:
Leonardo da Vinci
Cecilia Gallerani, c. 1484
Oil on panel, 54 x 40 cm
Kraków, Muzeum Narodowe

Leonardo da Vinci: The Lady with the Ermine (Cecilia Gallerani)

Most Leonardo-experts consider the young woman to be Cecilia Gallerani, the mistress of Lodovico Sforza, Duke of Milan.[58] Her eyes are turned towards her left shoulder, a pose which seems remarkably unstrained for the angle at which her head is turned. The ease of her posture is also suggested by the mellow gentleness of her childlike face, and by the manner in which her tightly-combed hair is wound around her chin like the flaps of a bonnet, its spherical rhythm echoed and varied by the double curves of the necklace looped twice around her neck. Her plainly arranged hair and averted gaze lend the sitter an air of chaste respectability. Elucidation of the iconographical significance of the ermine, the sitter's attribute, confirms this impression; the effect was evidently intended by both artist and patron. As early as the third century after Christ, in the moral bestiary of the "Physiologus", the ermine's white fur made it a symbol of chastity and purity. As the Greek word for it is (gale), a knowledge of Classics would enable the spectator to see the name of the animal as a pseudo-etymological pun on the first two syllables of the sitter's name (Gallerani). Witty conversational rhetoric of this kind was popular at the courts of Italian princes, and would often include puns on the names of important people. Furthermore, the ermine was one of the emblems on Lodovico's coat of arms; its purpose here was therefore to call attention to his qualities and powers.

The artist's subtle modulation of the ermine's sinewy muscles and emphasis of its extended claws draw attention to the animal's predatory nature, which, though diametrically opposed to its moral and religious significance, is consistent – even without recourse to psychoanalysis – with its obvious sexual symbolism, a metaphor reinforced by the vaginal symbolism of the slit sleeve. It is not unusual to find the theme of sexual potency in Italian Renaissance art (see Bronzino's *Andrea Doria as Neptune*, ill. p.92); what is interesting here is a ludic inclination in pointing to the equivocal nature of conventional morality: a woman was required to be not only chaste, but a devoted mistress.

The background, with the inscription "LA BELLE FERONIERE",[59] was added later, and was not painted by Leonardo. The patination of the oil surface, however, intensifies the sharp outline and vivid presence of the fragile figure with her long,

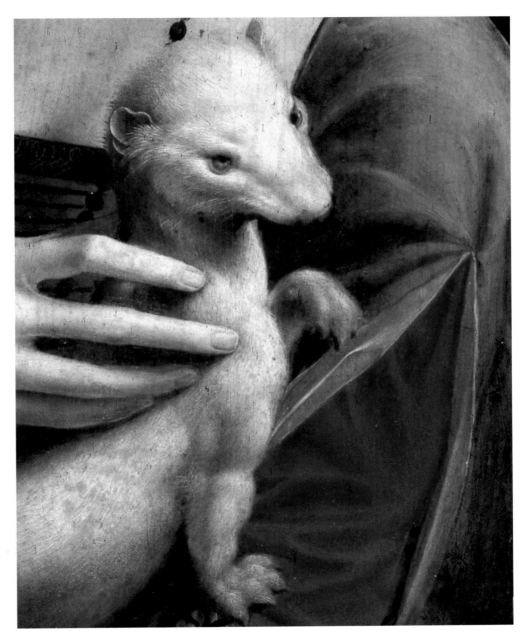

slender hand.

The painting is mentioned in a letter from Cecilia Gallerani to Isabella d'Este, dated 29 April 1498. Isabella had asked Cecilia to send her the painting. Cecilia replied that she was unable to comply, since "it was painted at a time when she was still very young; in the meantime, however, her appearance had completely altered."[60] It is probably correct to assume that Leonardo painted the portrait when Cecilia became Lodovico's mistress, in other words, shortly after 1481.

The ermine was a symbol of chastity and purity. According to legend, it died if its white coat was soiled.

Leonardo da Vinci: Mona Lisa (La Gioconda)

TOP AND PAGE 57:
Leonardo da Vinci
Mona Lisa, details

Motifs like the veil and "path of virtue" in the landscape background (see detail bottom) suggest that Mona Lisa was a married woman rather than a mistress.

This is probably the most famous Renaissance portrait[61]. So many clichés and trivialising stereotypes have come between it and the spectator since it was painted, however, that it hardly seems possible to view it afresh.

The title of the painting can be traced back to Giorgio Vasari,[62] who testified that Leonardo's sitter was Monna (= Madonna) Lisa (= Elisabeta). Born in 1479 in Florence, she married the Marchese Francesco di Bartolomeo di Zanobi del Giocondo in 1495, whose name provided the title usually given to the painting in Italy and France: *La Gioconda*.

The painting's association with France began early. On 10 October 1517, it was seen at Cloux, near Amboise, by the Cardinal d'Aragon and his secretary Antonio de Beatis. Vasari's testimony has been called into question by Antonio de Beatis' own statement that Leonardo showed him the painting and told him he had painted it at the request of Giuliano de' Medici. This has caused some scholars to conclude that the woman in the portrait is Giuliano de' Medici's mistress.

This is hardly the place to discuss problems arising from these contradictory reports, although it must said that the testimony of Antonio de Beatis enjoys the advantage of greater authenticity. Nonetheless, it seems highly unlikely that the sitter was the mistress of a nobleman, since the veil she is wearing – a symbol of "castitias", chastity – was a standard attribute in portraits of married women; it may be seen, for instance, in Bartolommeo da Veneto's *Young Woman* (ill. p.59). Leonardo's sombrely dressed young woman sits in an open loggia (the bases of column supports to her right and left are all that is left of the colonnade). Her upper body is turned slightly inwards, presenting to the spectator an almost full-face view. Leonardo had demanded that the portrait show the "movement of the spirit", a demand he himself fulfilled with this painting. According to Leonardo, the portrait should not restrict itself to the imitation of external reality, but should contrive to translate mental activity into visual effect. At the same time, his subject's famously restrained, practically invisible smile, barely suggested by the shadow hovering at the corner of her mouth – a smile which has inspired almost

every possible interpretation, from lust to chastity, from irony to tenderness – represents the dialectical reversal of an already widespread tendency to portray more agitated emotional conditions (see Antonello da Messina's *Smiling Man*, ill. p.19). From a theoretical point of view, it is therefore closer to the technique of "dissimulatio" advocated by Baldassare Castiglione, whereby true feelings were obscured and the resultant ambiguity of the facial expression precluded its interpretation. Emotional and bodily restraint are demonstrated in the pose of Mona Lisa's hands, too. Her left arm leans on the arm of her chair, while her right hand cautiously rests on top of it. This gives the impression of a compact unity, a state at once relaxed and concentrated.

In his treatise on painting, Leonardo stated that portraits greatly profited from having their subjects sit in dim light.[63] According to this view, the lighting here is particularly advantageous: the greenish-brown mountainous landscape with its rocky crags in the backgound is shrouded in dusky shadow. The contours blur to the horizon – an example of Leonardo's famous "sfumato". Metaphors from the natural world had been used to characterise psychological states since the high Middle Ages, especially since Petrarch; here, too, the landscape characterises the woman's emotional state. The symbolic content, a composite ideal landscape, is conventional. Thus the winding path (or river?) on the left must be seen as an allusion to the story of Hercules' choice (told by Xenophon, Memorabilia 2, 1–22ff., and constantly referred to in Renaissance art), in which a narrow path winding through a barren, rocky landscape is described as the path of virtue. An allegory of virtue would hardly seem to support the idea that the lady was a mistress. Together with the veil-motif, the path symbolism appears rather to bear out the contention that the woman is a "donna", a married woman.

Martin Kemp[64] has shown that Leonardo intended the landscape background to illustrate events in natural history: the origin of certain geological formations. It is well-known that Leonardo undertook various studies of Tuscan geographical features in connection with plans to construct a system of canals along the Arno. In

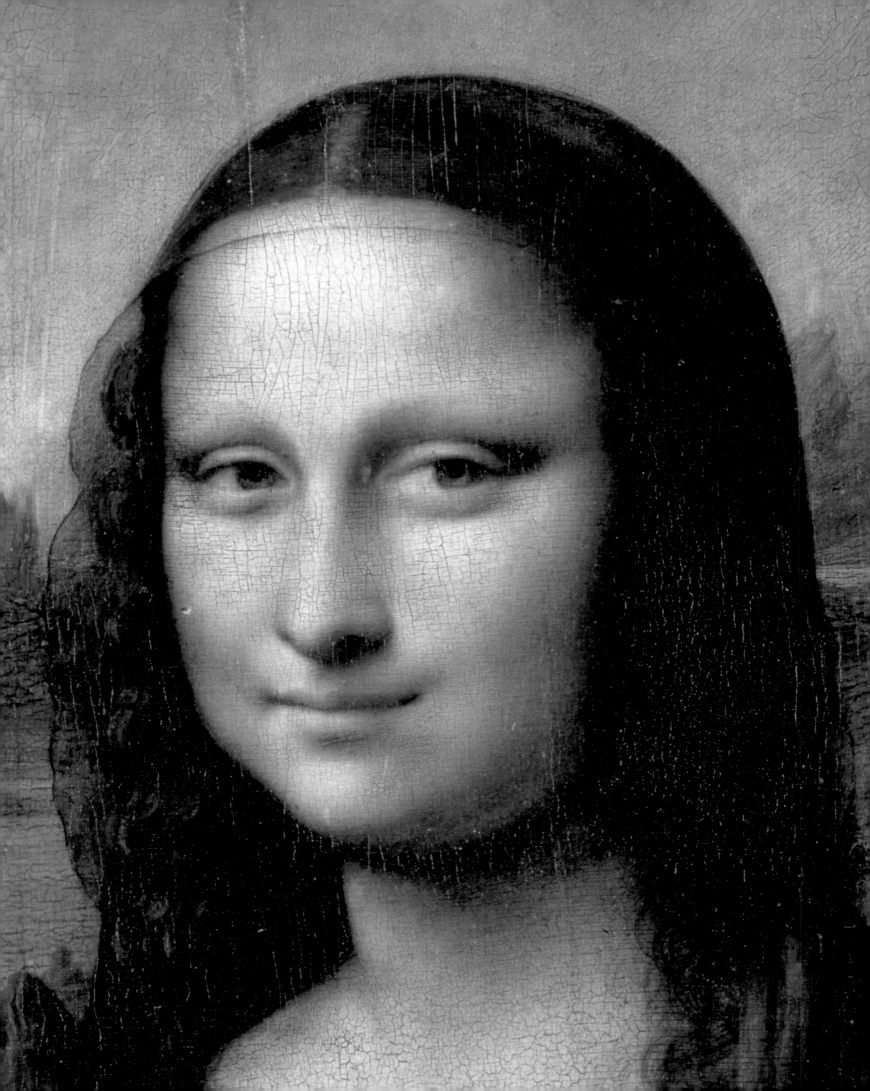

Her famous smile has inspired almost every possible interpretation, and yet it may not express a particular emotion at all. Perhaps it denotes an attempt to disguise feelings that would otherwise seem too obvious by presenting a balance between different emotional extremes. If so, it is a sign of emotional and physical restraint, like her hands, whose pose suggests a state at once relaxed and concentrated.

Leonardo da Vinci
Hand Study, before 1490
Windsor Castle, Royal Library,
© Her Majesty Queen Elizabeth II

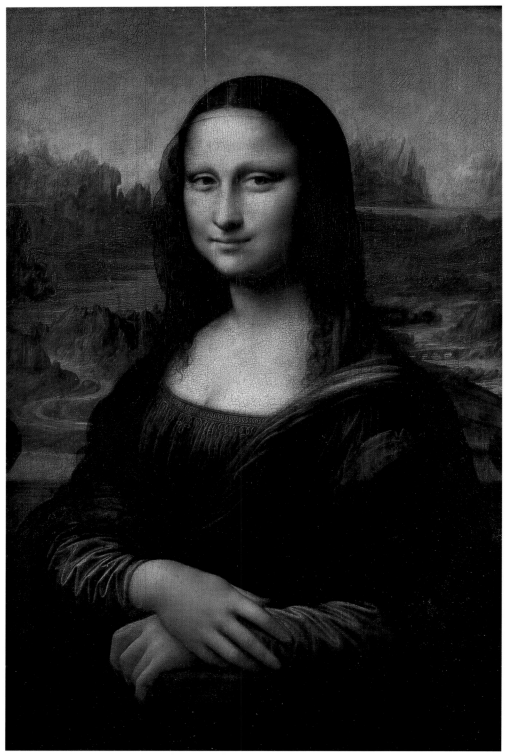

so doing, he arrived at a similar conclusion to Giovanni Villani (c. 1276–1348), who, in his "Florentine Chronicles" (Croniche fiorentine), asserted that the Arno had once been dammed up by an enormous "barrier of rock", behind which had been two lakes. According to Kemp, these two lakes appear in the landscape behind the "Mona Lisa" as "primeval progenitors of the Arno valley". What is more, the natural events alluded to in the background are echoed in details of the woman's face and clothes. Kemp goes on to provide evidence that an analogy of this kind was actually intended by Leonardo, quoting various remarks made by the artist, for example his comparison of the fall of hair with running water. Whatever may be said in defence of Kemp's theses, and there is much to recommend them, it must nonetheless be pointed out that this landscape can hardly be described as "untouched", pure Nature, pre-

Bartolommeo da Veneto
Young Woman (Lucrezia Borgia?),
early 16th c.
Oil on panel, 43.5 x 34.3 cm
Frankfurt/M., Städelsches Kunstinstitut

dating Man's intervention. The stone bridge with its many arches at the right of the painting betrays the presence of a civilizing agent. Perhaps Leonardo was pointing here to the particular importance of the work of architects and engineers, of which he himself was one. Leonardo would certainly have been familiar with the paramount significance attached to bridge-building in ancient Rome (described by Varro and Plutarch); this was carried out under the supervision of one of the highest authorities in the Republic, namely the Pontifex Maximus.

Giorgione: Portrait of a Young Lady ("Laura")

Antonio del Pollaiuolo
Apollo and Daphne, undated
Oil on panel, 28 x 19 cm
London, The National Gallery

Giorgione's paintings, especially his *Poesie,* appear enigmatic to today's spectator. They express a private mythology, eluding conventional interpretation.[65] In fact, the artist transformed traditional iconographical subjects at the behest of his patrons, who wished their paintings full of riddles. He thus invented a new pictorial language which was open to quite different interpretations, and whose sense soon became untranslatable after Giorgione's death. Nonetheless, it is worth bearing in mind that a relationship – however difficult to define – must exist between Giorgione's most innovative work on the one hand, and more traditional themes and subjects on the other, since it was from the latter that his "free" associations departed.

Like his *Poesie,* Giorgione's painting of a young woman before a dark background,[66] now at Vienna, is enigmatic. The almost symbiotic relationship between the figure and the laurel is initially reminiscent of mythological themes – the Daphne myth in Ovid's "Metamorphoses" 1 (452 ff.), for example.[67] However, it is probably quite correct to describe the painting as a portrait, and to see in the laurel an allusion to the sitter's name. The implication here is that her name must be "Laura", an assumption already prevalent by the seventeenth century, when it was thought the painting depicted the woman loved by Petrarch.

In a painting by David Teniers showing the Archduke Leopold Wilhelm's galleries at Brussels, Giorgione's painting is recognisable as a knee-length portrait. The lower part must therefore have been cut off at a later date. In the original, the woman's left hand is shown resting on her belly, whose rounded contours, emphasised by her bulging, red, fur-lined gown, suggest that she is expecting a child. However, as in van Eyck's Arnolfini-portrait (ill. p.32), where Jeanne Cenami is shown gathering up her dress in front of her belly, it is perhaps wiser to assume that the symbolic gesture of a hand laid on the belly does not indicate that the sitter is pregnant, but rather predicts, or promises, a fertile marriage blessed with a large number of children. Attempts to identify the sitter with various courtesans or poetesses of noble birth – Vittoria Colonna, Domenica Gri-

mani and Veronica Gambara have been mentioned in this context – carry little conviction. It is only from the prudish perspective of the nineteenth or early twentieth century that the baring of a breast would be viewed as debauched or meretricious.[68] In the sixteenth century, nudity did not provoke disapproval, but was shown publicly and uninhibitedly. This painting, too, was publicly shown, probably by a proud noble who wished to celebrate his bride's attractiveness – her somewhat pycnic build was fully in keeping with contemporary Venetian ideals of beauty – as well as her virtue and chastity. The laurel was considered a symbol of virtue, as seen in Lorenzo de' Medici's "impresa", where it was accompanied by the motto: "Ita ut virtus".[69] The veil wound about her shoulders and upper body is a bridal veil, and her bared right breast alludes to the proverbial chastity of the Amazons, who, according to antique legend, tolerated men only as a means of sexual reproduction, not, however, as a means of sexual gratification.[70] Since contemporary morality permitted sexual reproduction only within the institution of marriage, the allusion to the Amazons implied a wife's commitment to conjugal fidelity.

Giorgione
Laura, 1506
Canvas transferred to panel, 41 x 33.6 cm
Vienna, Kunsthistorisches Museum

Piero di Cosimo: Simonetta Vespucci

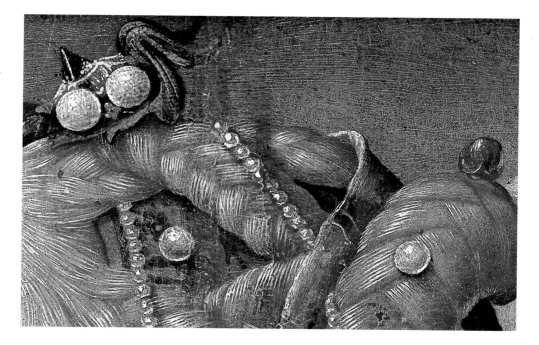

The withered tree often symbolised death in Italian Renaissance landscapes.

Here, Piero di Cosimo has chosen a portrait type which was already outmoded by the time he came to paint it (c. 1520).[71] The profile view may have been borrowed from a medal portrait used by Piero as a model, since Simonetta Vespucci, whose latinized name appears on the strip along the bottom of the painting, had died of consumption in 1476. Simonetta was the mistress of Giuliano de' Medici (1453–1478). Angelo Poliziano (1454–1494), a Florentine poet close to the Medici family, extols her grace and beauty in a renowned love poem: "La bella Simonetta". In the poem he compares her to a nymph frolicking with her playmates on a meadow:

"…Thus Amor sent his brightly burning spirits forth from eyes so sweet to fire the hearts of men.
A miracle it was
that I did not at once reduce to ash."[72]

Poliziano eulogizes her "animated face", framed by loosely hanging golden hair – a symbol of Simonetta's virginal purity. In Piero di Cosimo's painting, in contrast, the young woman wears the elegantly plaited hair-style of a "Donna": a complex arrangement of braids decorated with pearls and intertwined with strings of beads. Her high, shaved forehead corresponds to a fashion in Italian, as well as Netherlandish, aristocratic circles in the last quarter of the fifteenth century. Unlike Antonio del Pollaiuolo's profile of a young woman[73], painted c. 1465, almost a cameo-portrait against an even blue sky, Piero di Cosimo seeks to characterise Simonetta's mood by posing her against an atmospheric landscape. There is something gloomy in the repetitive, almost laminated outlines of the evening clouds, possibly evoking the mood of her early death. This corresponds to the withered tree on the left, a symbol which usually stands for death in Italian Renaissance landscape backgrounds. The motif is echoed by the snake wound around her necklace. Giorgio Vasari, who evidently was not acquainted with symbolism of this kind, saw in this an allusion to Cleopatra, who, according to Plutarch, had died from the bite of an asp. This explanation is unconvincing, however. It is more likely that the snake is a reference to the "hieroglyphic"

TOP AND BOTTOM:
Details from illustration page 63
Simonetta was a member of the rich Florentine Vespucci family. She was related to the famous merchant and discoverer Amerigo Vespucci (1454–1512), who gave his first name to the American continent.

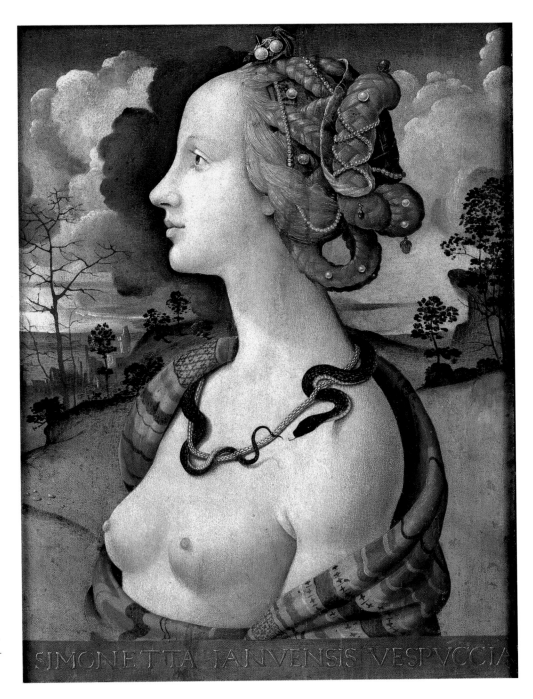

Piero di Cosimo
Simonetta Vespucci, before 1520
Tempera on panel, 57 x 42 cm
Chantilly, Institut de France, Musée Condé

As in Giorgione's *Laura* (see ill. p.61), Simonetta's naked breasts are an allusion to the Amazons, to whom antique legend attributed exceptional chastity.

symbolism of Egyptian "impresa". In the mythography of late Classical antiquity, the snake, especially when shown biting its own tail, was a symbol for eternity, or for time's rejuvenating cycle. It was therefore attributed to Janus, the god of the new year, and to Saturn (Kronos, whose name was often confused with time, Chronos), or "Father Time". In the inscription Simonetta is described as "Ianuensis" (belonging to Janus). The snake was also the symbol of Prudentia.[74] Thus Simonetta is praised for her wisdom. Her contemporaries would not have been offended by her naked breasts. As in Titian's *Venus at her Mirror*, this motif may be seen as an allusion to the "Venus pudica", or "chaste" Venus. In Paris Bordone's allegories on the subject of lovers, executed c. 1550, it was a bridal symbol. Thus Simonetta is honoured not as Giuliano de' Medici's mistress, but as his betrothed, or perhaps even as his wife.

Agnolo Bronzino: Laura Battiferri

TOP, DETAIL BOTTOM AND DETAIL PAGE 65:
Agnolo Bronzino
Laura Battiferri, c. 1555/60
Oil on canvas, 83 x 60 cm
Florence, Palazzo Vecchio, Loeser Collection

Agnolo Bronzino's *Laura Battiferri* is one of the most fascinating Italian Renaissance portraits of women.[75] Reverting in deliberately archaistic manner to a prototype found in the early quattrocento, the artist has portrayed the sitter in profile view, a pose reminiscent of the medal portrait. The upper part of her body with the small head is disproportionately elongated, emphasising the projection of her strikingly large, slightly hooked nose. Laura Battiferri is wearing a transparent veil, which hangs down from the shell-shaped, calotte-style bonnet covering her tightly combed-back hair onto her goffered shawl and puffed sleeves. While pride – or is it modesty? – makes her avoid eye-contact with the spectator, a gesture which lends her something of the majesty of a high-priestess, the painting is certainly not devoid of gestures "ad spectatorem". The mannered spread of the slender fingers of her left hand marks a place in an open book of Petrarch's sonnets to Laura, with whom the lady in the portrait evidently identifies. According to Petrarch, Laura is an "unapproachable, unattainable beauty... as chaste as the adored mistress of a troubadour, as modest and devout as a 'Stilnovismo Beatrice'". "Laura's personality is even more elusive than her external appearance. She remains the incarnation of chaste and noble beauty."[76]

Laura Battiferri (1523–158?) was born at Urbino, the natural daughter of Giovanni Antonio Battiferri, who later legitimated her. Widowed at an early age, Laura married her second husband, the Florentine sculptor Bartolommeo Ammanati, in 1550, at the age of twenty-seven. The marriage remained childless, Laura referring to herself as a "barren tree". Her poetry found many contemporary admirers. The Spanish court had her literary works translated into Spanish. Important writers and artists, notably Torquato Tasso and Benevenuto Cellini, sought her company.[77]

Laura Battiferri, a supporter of the Jesuitical Counter-Reformation, was reputed to have been a devout Catholic. Her great popularity at the Spanish court confirms this. The demure severity of her pose and dress may reflect the increased rigidity of Catholic ethical norms since the Council of Trent (1545–1563).

Laura Battiferri's fingers mark a place in an open book of Petrarch's sonnets to Laura.

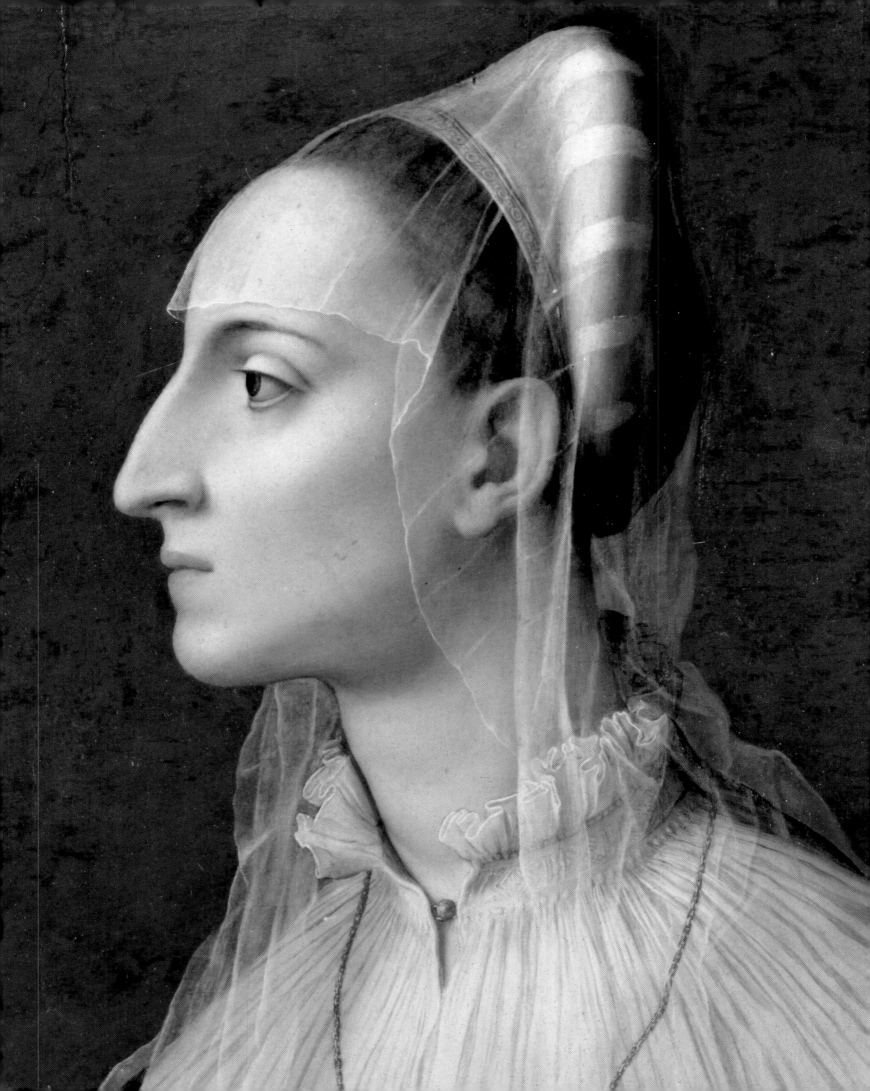

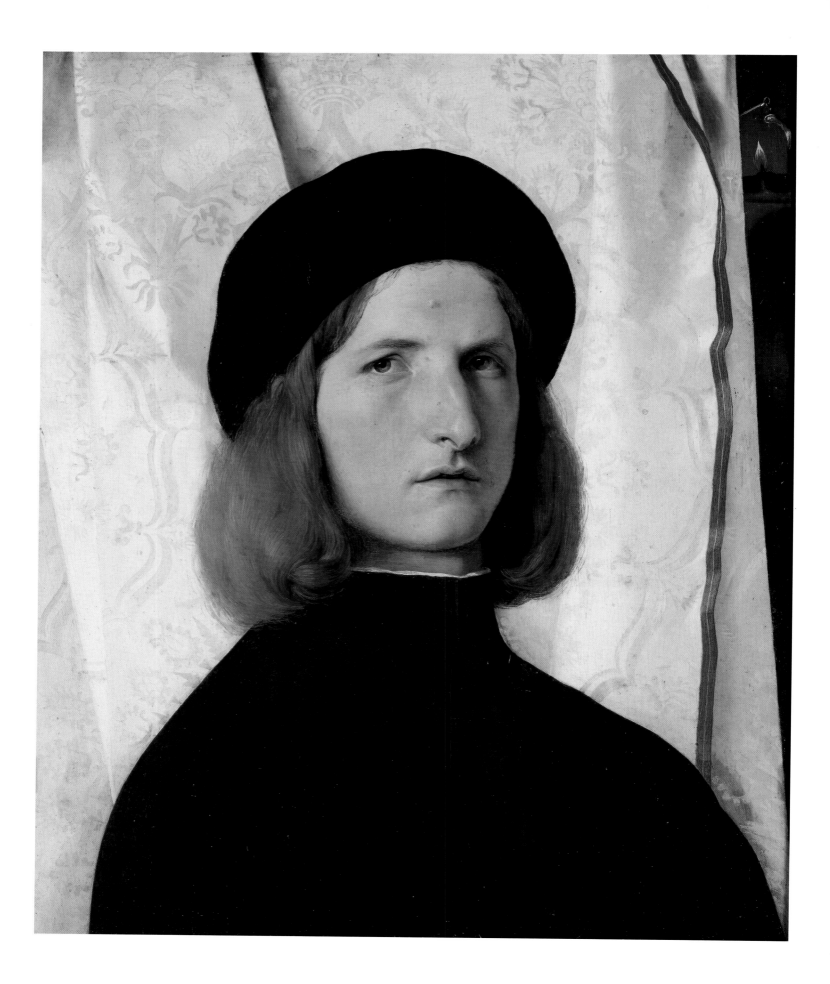

Lorenzo Lotto: Young Man before a White Curtain

More so even than Giorgione and Titian, it is Lorenzo Lotto who should be considered the true inventor of the Renaissance psychological portrait.[78] Lorenzo Lotto was born in Venice. Though he spent many years in Bergamo, and probably entered Alvise Vivarini's studio there, for much of his life he was restless, continually moving from town to town. In their haste to identify the artist's subjects with his way of life, many early historians of art found in his work traces of the instability and restlessness ascribed to Lotto in sixteenth-century accounts of his life. This has meant that Lotto, to whom the authorship of only a small number of paintings can be attributed beyond doubt, has come to be seen as the painter of a considerable number of idiosyncratic works whose authorship cannot finally be determined. The heterogeneous style and subject-matter of Lotto's œuvre thus seems to confirm the conflicting nature of his personality.

Reference to the "psychological" portrait here should not be understood in the modern sense of the epithet. The visual medium chosen by Lotto to portray mental states was less one of analytical disclosure than its opposite: enigma. His tendency to present the spectator with riddles was intensified by his mysterious symbolism, and by his frequent emblematical or hieroglyphic allusiveness. Although Lotto's allusions, in their literal sense, could be fathomed perhaps only by the "cognoscente" of his day, they are nevertheless capable of inspiring a wealth of vivid associative detail. This can be a source of fascination, as well as of frustration, to the the spectator who has little access to their original meaning.

Lotto's early portrait of a young man wearing a round black beret and buttoned, black coat still owes much to the traditional aesthetic of imitation. Scholars have rightly pointed to the influence of Giovanni Bellini here. The physiognomy of "his powerful nose and searching grey-brown eyes, which, under the slightly knitted brow, seem to brood on the spectator, to view him almost with suspicion" (as

Friderike Klauner writes[79]) is so faithful a rendering of empirical detail that we are reminded of another painter, one whose brushwork was learned from the Netherlandish masters: Antonello da Messina. What is new here is the element of disquiet that has entered the composition along with the waves and folds of the white damask curtain. A breeze appears to have blown the curtain aside, and in the darkness, through a tiny wedge-shaped crack along the right edge of the painting, we see the barely noticeable flame of an oil-lamp.

Curtains are an important iconographical feature in Lotto's work. The motif is adopted from devotional painting, where it often provided a majestically symbolic backdrop for saints or other biblical figures. Since early Christian times, the curtain had been seen as a "velum", whose function was either to veil whatever was behind it, or, by an act of "re-velatio", or pulling aside of the curtain, to reveal it.[80] To judge from the curtain which fills most of Lotto's canvas, we may safely conclude that he intends to reveal very little indeed of the "true nature" of his sitter. What he finally does reveal is done with such reserve and discretion as to be barely insinuated. For the burning lamp is undoubtedly an emblem of some kind. It may, in fact, be an allusion to the passage in St. John: "lux in tenebris" ('And the light shineth in darkness', Joh. 1, 5). It is interesting to note that Isabella d'Este chose to cite this light/darkness metaphor in her own "impresa" in 1525, altering the original to refer to her isolation at the Mantuan court: "sufficit unum (lumen) in tenebris" (a single light suffices in the darkness).[81] Perhaps Lotto intended to convey a similar message through his portrait of this young man.

The light of an oil-lamp burning in the dark room behind the curtain is probably a biblical allusion: "And the light shineth in darkness" (Joh. 1, 5).

PAGE 66 AND DETAIL TOP:
Lorenzo Lotto
Young Man before a White Curtain, c. 1506/08
Oil on canvas, 53.3 x 42.3 cm
Vienna, Kunsthistorisches Museum

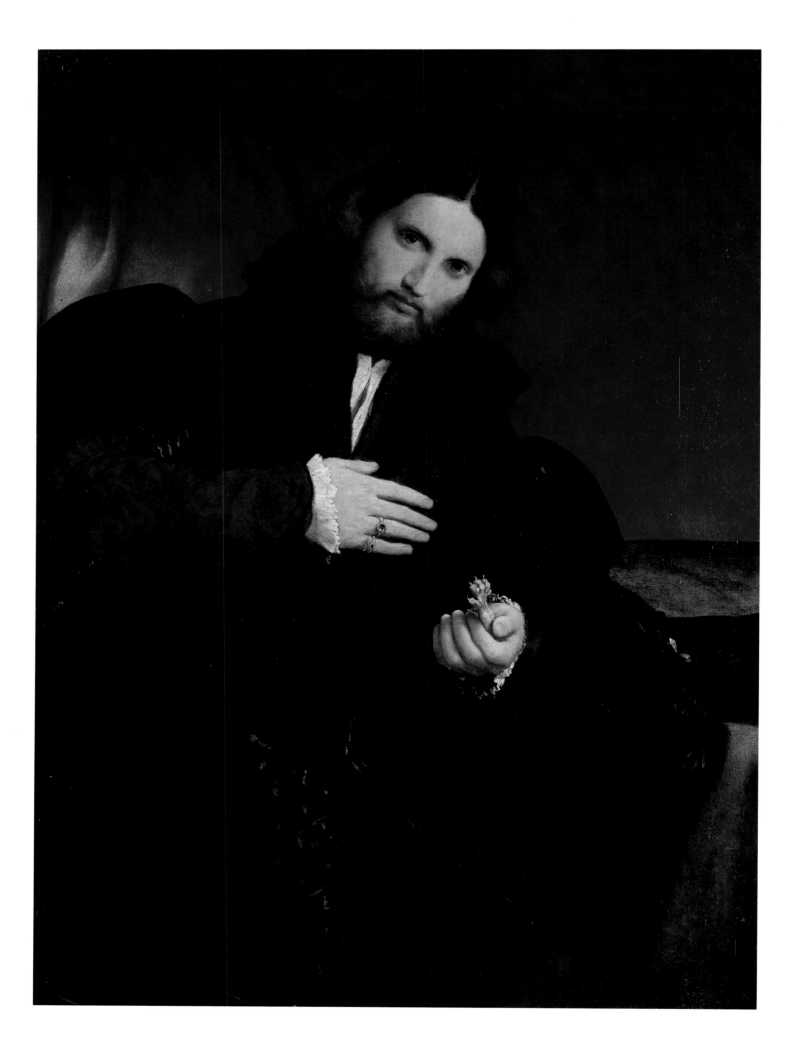

Lorenzo Lotto: Man with a Golden Paw

Like Lorenzo Lotto's *Young Man before a White Curtain* (ill. p.66), this pale, elegantly dressed, bearded man[82] is shown before a curtain, only this time the curtain is a deep, dark red. It fills almost half of the painting, its fall broken by a green table, upon which the man leaning across into the picture space rests his elbow. It is the man's pose which lends such unease to the composition. Unlike the enduring quality imparted by the statuesque tranquility of Lotto's *Young Man*, the almost diagonal pose of this sitter suggests transience, a fleeting revelation, an impression intensified by the questing eyes of the sitter and his stangely mute gestures. Whereas the hand on his chest may be interpreted as a sign of "sincerità" – reverence, or protestation (as when one crosses one's heart, or in the expression "mano sul cuore") – the stretched out left hand holding the golden paw presents us with a problem. It is difficult not to notice a latent aggression in the spread claw, which appears to be leaping from the man's grasp. Placed as it is, a little right of centre, this detail attracts more attention than its small size would initially seem to warrant, an effect underlined by the gleaming brightness of the wrought gold against the black sheen of the man's coat. There can be little doubt that the claw is central to the meaning of the painting. But how should it be understood? Is it intended as an attribute referring to the sitter's profession or social role? If so, then the sitter may be a sculptor or goldsmith, and the paw possibly an allusion to his name. The lion's paw might then stand for Leone Leoni (c. 1509–1590); a medallist himself, Leoni was naturally interested in "impresa", emblems and all kinds of allusions to names, and, for obvious enough reasons, chose the lion's paw as his own heraldic device. Leoni stayed at Venice in 1527 while Lotto was living there. However, these speculations amount to no more than a vague hypothesis, and unless more light is thrown on the origin of the painting, there seems little prospect of ever identifying the man. Attribution and dating can be traced back to Giovanni Morelli, whose method – attribution on the basis of details otherwise considered secondary (e.g. the depiction of the sitter's ears or fingers), but thought to remain constant throughout an artist's "œuvre" - cannot be allowed to pass unquestioned.

It is not unthinkable that the paw, or claw, may be an obscure reference to some Latin phrase which, in this context, would have the force of a motto. The motto might be "ex ungue leonem" (to recognize "the lion by its paw"), a synechoche[83] employed by Classical writers, for example Plutarch and Lucian, to refer – by metonymy – to a painter's brushwork or signature, or "hand" in sculpture, which immediately identifies the work of a particular master. This interpretation of the paw would, of course, be in keeping with the suggestion that it represents a professional attribute.

A conclusive interpretation of this painting is not possible. The historical and aesthetic conditions of the painting's conception and execution evidently precluded access to its meanings by more than a limited circle of Lotto's contemporaries, a problem that makes the painting virtually impossible to decipher today. The precept of "dissimulatio", the demand – frequently voiced in the increasingly popular moralizing literature of the day – that the sitter's inward world remain concealed, or veiled, seems to have influenced its conception. The painting shows a new page turning in the history of the mind, a new stage of awareness of subjectivity and individuality. Here was a dialectical response to a feeling that the self had become all too transparent, all too vulnerable, an example of the new tactics required by the self-assertive individual in contemporary social hierarchies.

Lorenzo Lotto
Gentiluomo, c. 1530
Oil on canvas, 118 x 105 cm
Rome, Galleria Borghese

PAGE 68 AND DETAIL TOP:
Lorenzo Lotto
Man with a Golden Paw, c. 1527
Oil on canvas, 96 x 70 cm
Vienna, Kunsthistorisches Museum

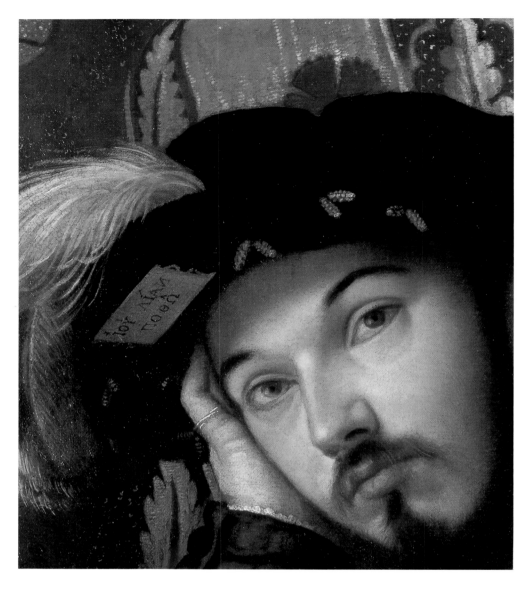

During the 15th century it was seen as a sign of melancholy, or "black bile", to rest one's head, slightly inclined, in one's hand. Melancholy had been viewed unfavourably during the Middle Ages, but later became increasingly fashionable. Humanists and artists, "Saturn's children", appropriated it as *their* state of mind. Among them was Dürer, who made melancholy the subject of this famous engraving.

Albrecht Dürer
Melancholia I, 1514
Copperplate engraving, 23.9 x 16.8 cm
Berlin, Staatliche Museen zu Berlin –
Preußischer Kulturbesitz, Kupferstichkabinett

Moretto da Brescia: Portrait of a Young Man

Ridolfi records that Moretto da Brescia, whose real name was Alessandro Bonvicino, was a pupil of Titian, but this has never been proved. Certainly, there can be little doubt that the Venetian painter influenced the work of this artist, who lived and worked all his life at Brescia. Moretto was primarily a painter of altarpieces and other religious works, and executed only a small number of portraits, but these, owing especially to their powers of psychological observation, are considered, along with works by Lorenzo Lotto, among the most fascinating examples of their genre to be painted during the first half of the sixteenth century, as this portrait from the National Gallery will testify.[84]

The young, flamboyantly dressed man gazing at the spectator is a wealthy, Italian

noble. He is sitting before a brocade curtain, which is ornamented with pomegranate and carnation designs. Or rather – not sitting, but standing, his left hand propping him up on the armrest of a chair. Inclining his body slightly to the left, he rests his head on his right hand, his bent right elbow leaning on two cushions, placed on the table especially for the purpose. This is the typical pose and gesture of the melancholic. Melancholy, a fashionable illness in the sixteenth century, had an important role even in Shakespeare's plays. Here, it is expressed in a mysterious inscription on the badge sewn on the brim of the sitter's feather beret. On it, in Greek lettering, we read [ΙΟΥ ΛΙΑΝ ΠΟΘΩ] (iou lian potho). It is probably right to translate this emblematic motto as: "Alas, I desire too much."

However, an alternative reading joins the first two words to form the name "Julia" (in Italian "Giulia"), the implication being that this short sentence expresses the young man's desire for a woman who has rejected his advances. Speculation of this kind, a taste for the romantic quest, or a readiness to think in terms of persons rather than ideas, often informed the late nineteenth-century view of paintings (indeed, W. Frederick Dickes even announced his discovery, in 1893, of a Giulia Pozzo).[85] It seems more likely, however, that the badge was simply an emblem, or a personal motto, an example, in other words, of a custom that was widespread in aristocratic circles at the time. Johann Huizinga has untertaken extensive research on the practice among fifteenth-century Burgundian

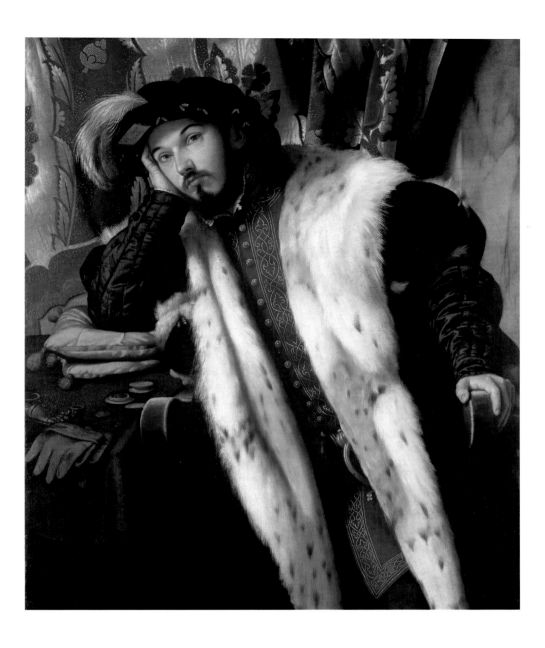

RIGHT AND DETAIL PAGE 70 LEFT:
Moretto da Brescia
Young Man, c. 1530/40
Oil on panel, 113 x 93 cm
London, The National Gallery

nobles of condensing a personal pledge into an epigrammatical phrase.

The motif of melancholy suggested by the pose and motto of the noble gentleman in the portrait[86] is an indication of new standards of personal achievement. Initially established by the ascendant bourgeoisie, such standards had been brought to the notice of the nobility by humanist scholars active at the courts. It is demonstrable that the "too much" in the motto refers not (or rather, less) to worldly possessions, of which the sitter evidently had no shortage, but to spiritual riches. X-ray photographs have revealed that an earlier version of the portrait showed books lying open on the table in front of the sitter. In "The Anatomy of Melancholy", a book which, although it did not appear until many years later, was nevertheless concerned with the mental climate of the sixteenth century, Robert Burton wrote that "too much" exposure to books, and to the confusing contradictory opinions and theories expressed in them, could itself bring on moods of sadness, dejection and desperation.[87]

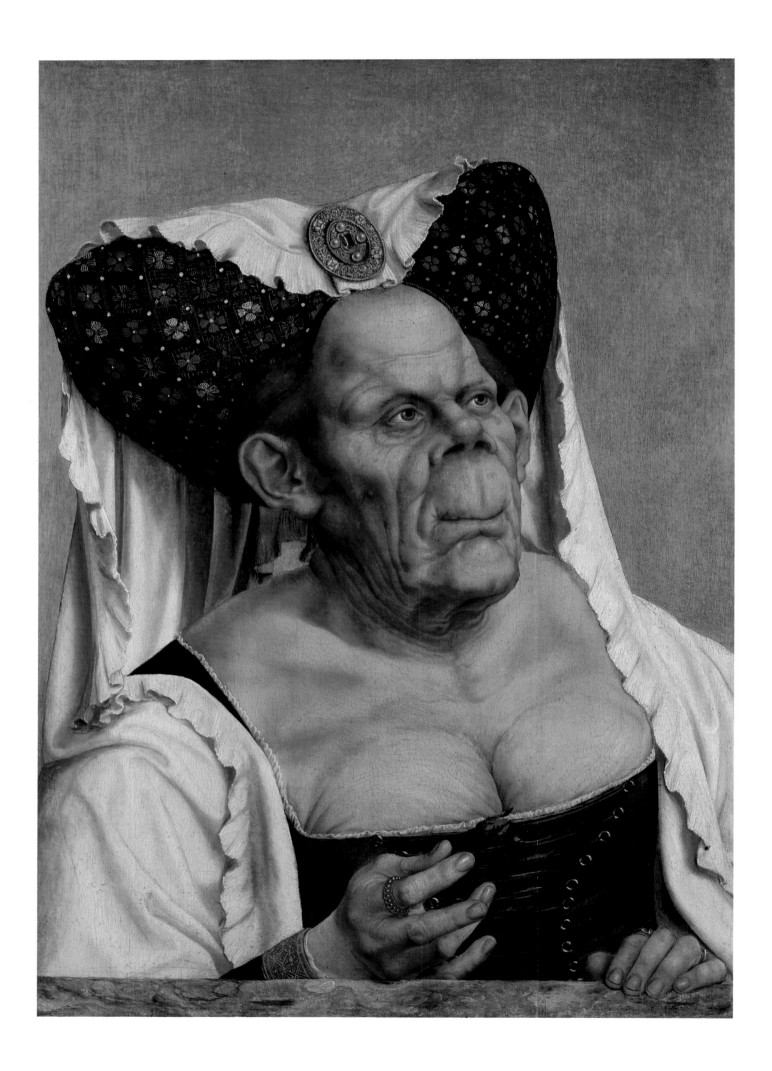

Quentin Massys: Old Woman (The Queen of Tunis)

Although there was rationalism in the impulse to produce empirically correct representations of external reality, the portrait was still imbued with talismanic properties in the minds of most spectators. The likeness had a magical ability to "act" vicariously, as a kind of proxy for the absent person.

A new art form, the caricature, which first appeared in the early sixteenth century – long before the brothers Agostino and Annibale Carracci, the artists who are said to have invented it[88] – clearly shows that the visual distortion of the human likeness, especially the face, was used as a means of vicariously satisfying the need to express hatred or aggression towards certain persons. Thus the objects of hatred were scorned and ridiculed by disfiguring their "effigies".[89] In 1956, Werner Hofmann[90] showed that new norms of beauty and bodily proportion must already have evolved for distortions of this kind – the distension or shrinking of ears, nose, mouth or forehead, for example – to be considered at all funny. Particular ideals of beauty became socially acceptable, making it possible to discriminate against deviants on the grounds that their conduct was unconventional, or unnatural. This development had evidently reached most of Europe by the last third of the fifteenth cen-

tury. Its parallel in literature was Grobianism,[91] or the Rabelaisian style, which amounted to a satirical attack on behaviour which did not conform to social decencies and rules of courtly etiquette which had filtered down from the aristocracy to the bourgeoisie.

This painting – generally attributed to Quentin Massys or one of his circle[92] – of an old woman whose face appears to have been deliberately distorted in the interests of grotesque humour, makes full use of compositional techniques developed by fifteenth-century Netherlandish and Italian portraitists. Wearing an immense horned bonnet, and with a corset pressing together her flabby breasts, the old woman sits with her left hand on a parapet in front of her, while her right engages in some form of gesticulation. But is this really a portrait, a painting purporting to represent the likeness of a particular person? The painting is based on a model which is now lost and which Leonardo may have used in an early drawing (Windsor Castle, N° 12492).[93] Giorgio Vasari[94] reports that Leonardo was moved by an insatiable desire to observe unusual and deformed faces. His interest in these phenomena sprang from his work on a canon of ideal bodily proportions. The new standards of beauty no longer allowed for natural irregularities

Wenzel Hollar
The King and Queen of Tunis (after Leonardo da Vinci), undated
Copperplate engraving, 6.8 x 12.5 cm
Munich, Staatliche Graphische Sammlung

Quentin Massys
Old Woman (The Queen of Tunis), c. 1513
Oil on panel, 64 x 45.5 cm
London, The National Gallery

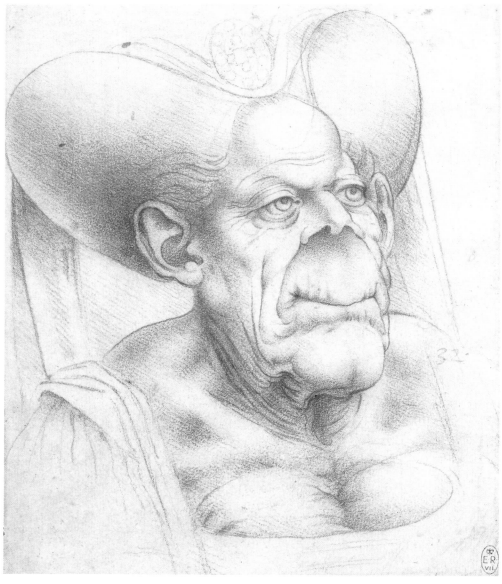

Leonardo da Vinci
Grotesque Head, undated
Red chalk, 17.2 x 14.3 cm
Windsor Castle, Royal Library,
© Her Majesty Queen Elizabeth II

in a person's appearance, but disqualified these as infringements against the social ideal. Despite their emphatic "semantics of individuality" (Niklas Luhmann),[95] Renaissance humanists criticised the individual as ultimately defying classification, and therefore social integration. Whenever beauty is linked to intelligence or ethical integrity, anything that does not correspond to the aesthetic ideal is viewed not only as ugly, but as an expression of abject stupidity, or immorality.

Van Eyck's ruthless registration of the "unbeautiful" details of his sitter's appearance, which was evidently quite acceptable to his patrons, shows that the idea of ugliness as an aesthetic category had not entered contemporary thinking on art or everyday life by the early fifteenth century. Massys, on the other hand, painted his *Old*

Woman by engaging in systematic deviation from the norm. The method that he evolved had much in common with the experiments in deformation to be found in Dürer's sketchbooks on proportion. Moreover, the old woman's costume would also have amused Massys's contemporaries, since they would have found it quite old-fashioned. Her bonnet, a "hennin" as it was called, was worn in, or shortly before, 1450, as can be seen from Jan van Eyck's portrait of his wife Margaret in 1439 (Bruges).[96] The artist's satirical attention to the woman's age would also have ridiculed her in the eyes of his contemporaries, who had begun to think of age as something ugly, and youth as a positive quality, as revealed by paintings which show different human ages, or the portraits of "unequal lovers".[97]

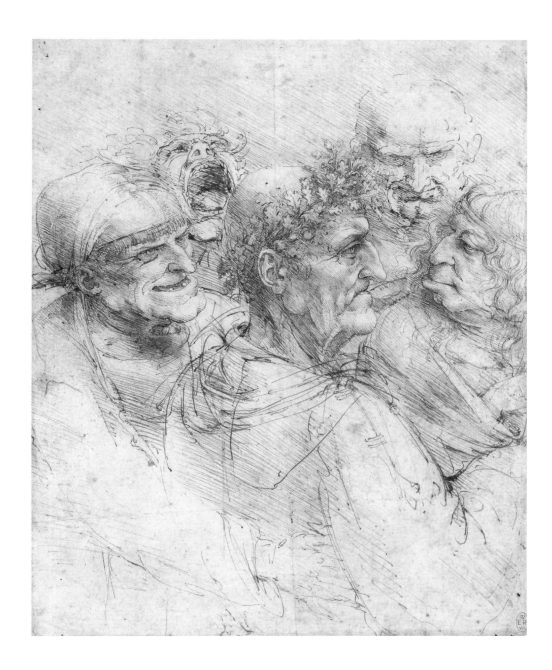

Leonardo's and Massys's grotesque studies of human disproportions created a precedent which could – without a second thought for the problems of mimesis or verisimilitude – be used, or abused, in all kinds of satire. Graphic reproductions of these works have reappeared under various guises ever since: in Wenzel Hollar's *King and Queen of Tunis* (ill. p. 73), for example, or as the likeness of "Countess Margaret of Tirol" (died 1369). Massys's painting was even passed off in the seventeenth century as a portrait of Pope Pius VI's sister, Princess Porcia, who was supposed to have attempted to rescue religion with an army of Jesuits (Paris, Bibliothèque Nationale, Cabinet des Estampes).[98]

Leonardo da Vinci
Grotesque Heads, c. 1494
Pencil and ink on white paper, 26 x 20.5 cm
Windsor Castle, Royal Library,
© Her Majesty Queen Elizabeth II

Leonardo's caricatures were a side product of studies he undertook to establish ideal human proportions. They also illustrate the precept of diversity ("varietà"), which he had outlined in his treatise on painting. Here, Leonardo was referring to the great variety of natural forms, to which the creative artist was capable of adding by inventing new ones.

Luca Signorelli (c. 1441–1523): Portrait of a Middle-Aged Man

The architectural background, together with the mysterious, possibly mythological, scenes in the middle ground, seem to refer to the history of ancient Rome, which may be the subject of the man's reflections.

Owing to his dress – a collarless, vermilion robe and matching, fez-like felt hat, and the black stole, draped over his shoulder and chest – the man portrayed in this portrait[99] has often been seen as a lawyer. However, there is no compelling reason to accept this attribution, since hats of this type were worn by other professional groups in the fifteenth century, too, including artists.

The psychology and personal attributes of Luca Signorelli's sitter remain an enigma. The painting's mysterious content seems directly counterposed to the formal clarity of its incisive, "sgraffito"-like, or "engraved" outlines. The slightly lowered gaze of the man shown in three-quarters view lends the painting a psychological dimension, transcending the mere representation of outward reality. He seems to be looking inwards. Perhaps this denotes melancholy, or simply a thoughtful mood. The content of his thoughts is possibly shown in two background scenes, diametrically opposed to one another at either side of his head: on the left, two girls stand before a round temple; on the right are two nude youths in front of a ruined temple, which is overgrown with weeds and bushes. To judge from her gesture, the woman on the left is banishing the other. The image on the right is reminiscent of Cain's fratricide.

However, the "jaw-bone of an ass", the instrument of murder, is missing. An iconographical alternative: Hercules slaying Cacus, who had laid waste to the Aventine (cf. Virgil, Aeneid 8, 185 ff.; Livy 1, 7, 3 ff.; Ovid, Fasti 1, 543 ff.). But even if this were correct, there would be little apparent correspondence between the figures and their architectural background: the lateral face of the building behind them bears a relief, again showing two youths, this time probably the Dioscuri, Castor and Pollux (Polydeuces).

In the immediate vicinity of the temple of Castor and Pollux, according to antique legend, stood the Aedes Vestae,[100], the temple of Vesta with its round cella surrounded by Corinthian columns and crowned by a brass cupola. Its architecture corresponded to the building on the left in the background, modelled by Signorelli on the Pantheon, the most famous Classical round temple, then as now. Could the two women be Vestal Virgins?

The painting permits so many different interpretations that it is impossible to reconstruct a single, integrated picture. It seems quite likely, however, that the painting is a reflection on the origins of Rome, and that the sitter, whatever his profession, may be pondering Rome's past greatness.

The antique Roman architecture suggests that Luca Signorelli, who was originally from Cortona and spent most of his life in various cities of central Italy, notably Orvieto, Arezzo and Florence, executed the painting during his stay in Rome in 1482/83, when he completed two of the frescos in the Sistine Chapel.

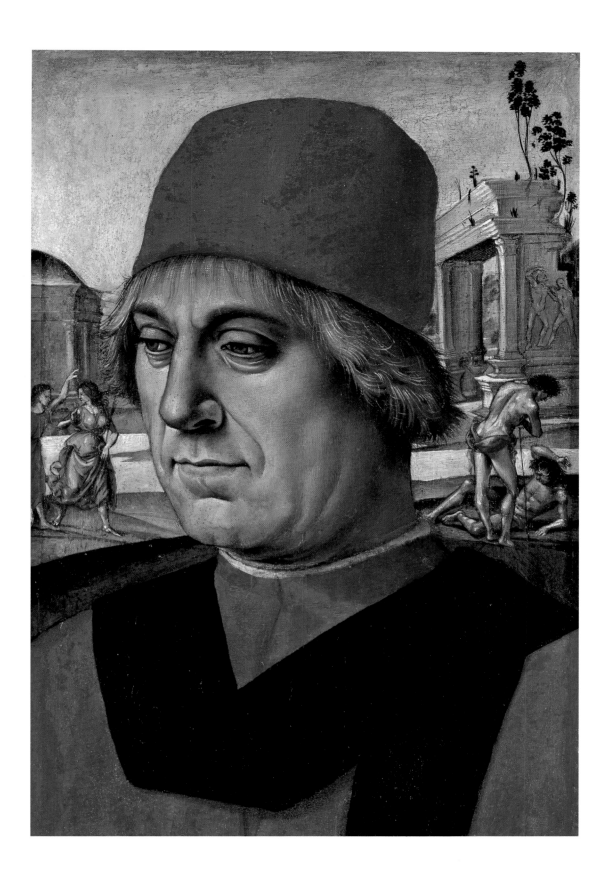

Agnolo Bronzino: Portrait of Ugolino Martelli

Agnolo Bronzino is considered the master of Florentine Mannerism. Held in high esteem by his aristocratic patrons, his portraits bestowed on the sitter an air of confident reserve and dignified elegance. Although his portrait of *Ugolino Martelli* (1519–1592),[101] now in Berlin, is cool and polished in style, Bronzino transcends mere outward appearances to reveal an introverted, intellectual quality in the features of this young humanist scholar. The sitter must have been about twenty years old at the time; evidently, he wished to present himself as somewhat older and deserving of respect: a "puer senex", as it were. Martelli is sitting and gazing contemplatively to one side, his black, silken gown buttoned to the neck, and a black beret on his small oval head. He is apparently thinking about a passage in the book lying open on the table. It is the ninth book of the "Iliad", Homer's epic on the Trojan War. The sequel, as it were, in Latin literature was Virgil's "Aeneid". This is apparently one of Martelli's favourite books, as the inscription MARO (= Virgil) on the book on the left shows. His left hand is supported by a book by Pietro Bembo (1470–1547), whom Martelli's contemporaries would have considered the most erudite of humanist scholars. Baldassare Castiglione gave a prominent place to this Petrarch scholar, poet and philosopher in his treatise "Il libro del Cortegiano" (Book IV), describing Bembo as the very paragon of courtly scholarship. Bembo was made a cardinal in 1539. Perhaps his appointment provided Martelli, who later became Bishop of Grandèves in the south of France, with an opportunity to seek Bembo's patronage as a follower of his Neoplatonic doctrine; the attribute of the book undoubtedly represents an act of homage. Thus the year of Bembo's elevation to the rank of cardinal may help us date the portrait, since the artist himself has left only his signature.

In some of Bronzino's portraits, and those of other Mannerist painters, it is quite common to find the sitter posed before an abruptly receding architectural background. Martelli, too, is posed before the inner court of a palace built by Domenico d'Agnolo, with walls reminiscent of the Biblioteca Laurenziana. Standing against the back wall is a statue of David. Once attributed to Donatello, but probably the work of Bernadino Rosselino, it is now in the National Gallery of Art in Washington.

Just as the "Iliad" and the "Aeneid" were both still considered by Renaissance humanists as literary links to ancient Rome (and thereby to Italy's early history), so the prominent position given to the statue of David in Martelli's "intellectual setting" underscores its function as a symbol of the young humanist's patriotic loyalty towards his native town of Florence. The portrait thus documents the waxing sense of Italian nationhood of the period, described, too, by Francesco Guicciardini and Niccolo Machiavelli in their books on the history of Florence. Pietro Bembo's work "Prose della volgar lingua" (1525) gave support to this movement,[102] encouraging Italian authors to use their own language rather than Latin.

The statue of David was a symbol of patriotic loyalty to Florence. Its presence in the portrait documents the period's waxing sense of Italian nationhood.

PAGE 79 AND DETAIL LEFT:
Agnolo Bronzino
Ugolino Martelli, c. 1537/39
Oil on panel, 102 x 85 cm
Berlin, Staatliche Museen zu Berlin –
Preußischer Kulturbesitz, Gemäldegalerie

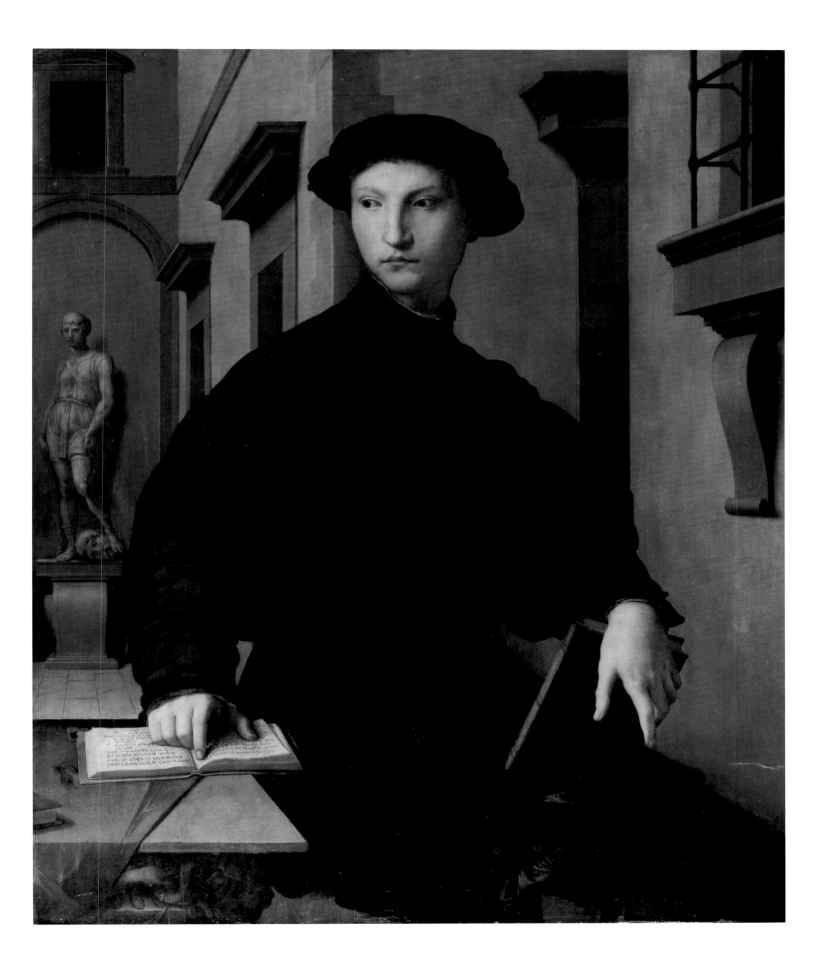

Raphael: Baldassare Castiglione

TOP AND DETAIL PAGE 81:
Raphael
Baldassare Castiglione
Oil on canvas, 82 x 67 cm
Paris, Musée du Louvre

Raphael and Castiglione had probably been friends since 1506, when both served under Guidobaldo, Duke of Urbino. The Urbino court was the most important Italian cultural centre of its day. Castiglione's book "Il libro del Cortegiano" (The Book of the Courtier), written in dialogue form and begun in 1508, although not published until 1528, a year before Castiglione's death, is a literary memorial to the Urbino court.[103] The book demonstrates the art of elegant and scholarly conversation by means of a series of eloquent discussions on a range of different topics. It also contains a code of behaviour for the courtly gentleman, and for the nobleman with duties to perform at court, recommending they maintain a distinguished aloofness and emotional self-control, expressing themselves in a refined and dignified manner and avoiding all exaggeration. The courtier is expected to show knowledge and ability in fine art, music and literature, and to excel in riding, weaponry and dancing. Cultivated manners demanded a fine sense of dress: demonstrated, according to Castiglione, by the dark clothes worn at the Burgundian court, or by the avoidance of strong, or garish, colours.

Raphael's portrait of *Baldassare Castiglione*[104] is executed in subdued, almost monochromatic colouring. His limited palette evidently reflects the behavioural ethics of the sitter, who would have rejected anything loud, affected or showy. Castiglione's dress is precisely what his treatise on manners recommends. With his body turned a little to the right, and his face framed by his beard, black slit cap and high collar, Castiglione's soft eyes hold the spectator in a serious, yet amiable gaze. Visible below the black cuffs of grey velvet, puffed sleeves, his hands are shown pressed together, expressing aristocratic reserve and emotional restraint.

Frontispiece from *Baldassare Castiglione*:
Il libro del Cortegiano. Venice: Aldus, 1528

In this portrait Castiglione incorporates precisely those virtues which, in his main literary work "The Book of the Courtier", he prescribed as the pillars of correct courtly behaviour: distinguished aloofness and emotional self-control.

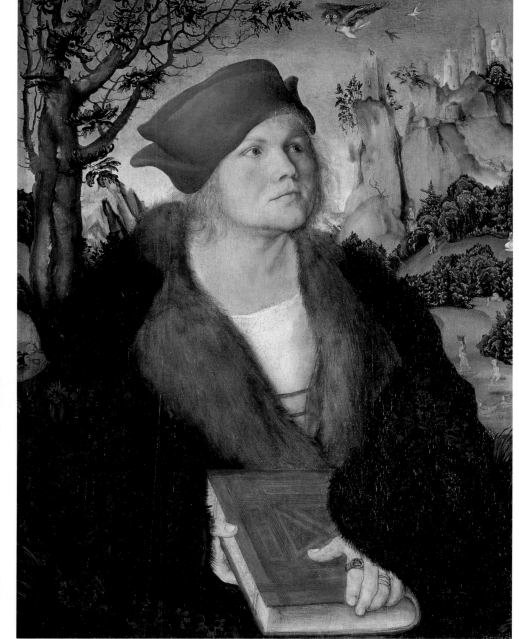

Lucas Cranach the Elder
Dr. Johannes Cuspinian, 1502/03
Oil on panel, 59 x 45 cm
Winterthur, Oskar Reinhart Collection

Lucas Cranach the Elder: Dr. Cuspinian and his Wife

Cranach painted this double portrait[105] on the occasion of the marriage of the Viennese humanist Johannes Cuspinian and his wife Anna, daughter of an official of the Emperor. Cuspinian's (1472–1529) real name was Spießheimer, and he was originally from Schweinfurt. He studied at Leipzig where he earned his laurels as a poet, advancing, at the age of twenty-seven, to the position of rector at the University of Vienna. He went on to hold various other positions – Imperial Superintendent of the University from 1501, and Dean of the Medical Faculty from 1501/02 – eventually becoming personal adviser and official historian at the court of Emperor Maximilian I. In 1508, he edited Rufus' "Descriptio orbis"; he was editor of Otto von Freising's "World Chronicle" (1515 ff.), and author of the "History of Roman Consuls up to Justinian" the so-called "Consules" (almost completed by 1512), and of a re-

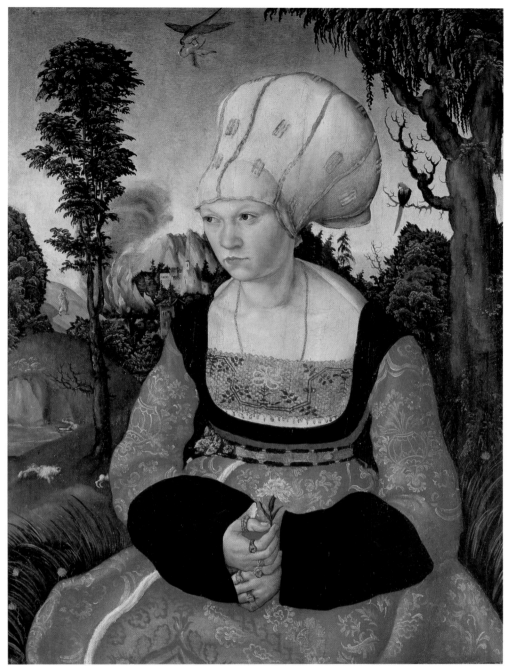

nowned book on Roman emperors ("De Caesaribus atque Imperatoribus Romanis", Strasburg 1540). Like Conrad Peutinger, Conrad Celtis and others, Cuspinian was undoubtedly one of the most versatile humanists of his age. Initially, Cuspinian showed great sympathy for the theological and political aims of the Reformation. Like many other humanists, however, he distanced himself from the revolutionary movement after the Peasants' War and reaffirmed his allegiance to the Catholic Church.[106]

Lucas Cranach, Cuspinian's equal in years, had entered his father's workshop and travelled through south Germany be-

fore meeting with success in Vienna, where his work was particularly well received in humanist circles. The humanists provided him with access to the court, thus paving his way to the position of court painter (in 1504 he went to Wittenberg to take up this office under Frederick the Wise, Elector of Saxony).

Cranach composed these portraits as a pair. This is apparent in the continuity of the landscape behind the elegantly dressed couple. The trees at the edges of the painting, on the left and right of the figures, are placed so that their branches form an arch, imparting an air of grandeur to the sitters. The background was evidently composed

Lucas Cranach the Elder
Anna Putsch, First Wife of Dr. Johannes
Cuspinian, 1502/03
Oil on panel, 59 x 45 cm
Winterthur, Oskar Reinhart Collection

Detail from illustration page 82
As a humanist emblem, the owl sometimes stood for the goddess Athena's wisdom, sometimes for its recalcitrant opposite: blind stupidity.

with a distinct purpose in mind: nothing here is arbitrary. The landscape is full of erudite symbolism, probably devised by Cuspinian himself. In a well-informed study on this double portrait, Dieter Koepplin has suggested that Cuspinian's frame of reference was Pico della Mirandola's "Poetica Theologica", and Marsilio Ficino's doctrine of divine mysteries. He concludes that the various images disguise hieroglyphic allusions to the cabbala. An example of this is the artist's secretive minimalisation of symbols, turning them into "occult" figures. At the left of the picture, for example, behind the tree, there is a minuscule figure with long, flowing hair, whom Koepplin has convincingly identified as Phoebus, or Apollo,[107] since the figure is given a lyre and bow, the attributes of this antique god. However, Apollo does not appear here as the god of light, but rather as the opposite: as a "chtonian-mantic" god (Koepplin), almost a demon. The writhing snake on the ground is a reference to Asclepius, the god of medicine, who was a son of Apollo (cf. Ovid, Metamorphoses 2, 602–620). The detail al-

ludes to Cuspinian's medical profession, as does the red beret on his head: "Medicus rubras fert corpore vestes" (A doctor wears red clothing).

Another figure, one so tiny as to be almost invisible, stands on a pinnacle of rock on the castle-topped mountain behind Cuspinian. Shown in an antique gesture of adoration, the figure prays to a star which Cranach has painted in real gold. The star is evidently supposed to represent the Epiphany in the teachings of the early Christian hymnic poet Clemens Prudentius, whose work demonstrably had a profound effect on Cuspinian. Koepplin interprets the figure as Orpheus, relating his position on the mountain to the Platonic notion of "furor poeticus", and to the mountain-cult which often accompanied the veneration of stars.

The nine women washing, bathing and carrying water in the middle distance between Cuspinian and his wife, may be connected to Apollo, too. They appear to be the nine Muses, who were answerable, according to Greek myth, to their leader ("Musagetes") Apollo. Their element is

Detail from illustration page 82
The nine women appear to be the nine Muses, who were answerable, according to Greek myth, to their leader Apollo, who has been identified as the figure behind the tree at the left of the picture (see detail on p. 82). Their element is water. A balance is intended here to the fire behind Anna Cuspinian (see detail on p. 87). Perhaps this polarity symbolises the distinction between the genders: according to Plutarch, fire was the male element, water the female.

water, and a balance is evidently intended here to the fire behind Anna Cuspinian. Perhaps this polarity symbolises the distinction between the genders: according to Plutarch, fire was male and water female, a notion adopted by Ficino. This theme seems appropriate enough for a wedding painting. It is possible, however, that the fire alludes to the burning bush (Exodus 3, 2), which was used as a symbol for the Immaculate Conception during the late Middle Ages because it "burned with fire" but "was not consumed", just as Mary had remained a virgin during motherhood. The chastity of the Virgin remained an ethical precept for married women for many centuries. The motif of the parrot on the tree, given to Anna Cuspinian as an attribute, is consistent with this precept. The call of the bird was thought to be "Ave", the Angelic Salutation; since the Middle Ages it had therefore been considered as a Marian symbol, a sign of the innocence and purity associated with Mary.

What then is the significance of the other birds shown against the darkening sky? Behind Cuspinian there is an owl with prey in its talons being mobbed by a flock of birds; behind his wife on the right, an eagle and a swan (on its back) are locked in combat. As a humanist emblem, the owl was highly ambivalent, sometimes referring to the goddess Athena's (or Minerva's) wisdom, sometimes to its recalcitrant opposite: blind stupidity.

The motif of the struggle between swan and eagle can be elucidated more clearly. It appears that Cuspinian and Cranach consulted Pliny (X, 203) here. Pliny had been impressed by the swan's courage, since it did not fear to do battle with an attacking eagle, and often emerged victorious from the fight.[108] It is not unlikely that Cuspinian was using the motif of the flying bird – a signifcant cipher in the "divinatory", or mantic, arts, in which the humanists liked to dabble after the example of the Classics – to denote the principles which he wished to govern his conduct: courage and wisdom, for example.

It would be quite unsatisfactory merely to decipher the landscape background

TOP:
Detail from illustration page 83
The parrot, whose call was thought to be "Ave", the Angelic Salutation, was considered a Marian symbol: a sign of innocence and purity.

BOTTOM:
Detail from illustration page 82
The posture of Cuspinian's head may be intended to show the humanist still pondering over a book he is holding in his hands. However, its slightly raised position may indicate that he is listening.

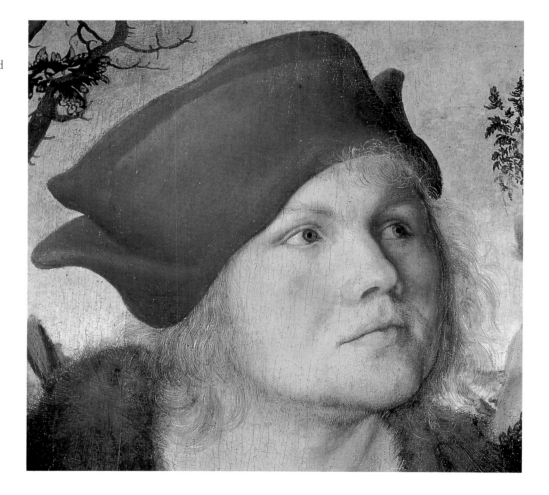

symbol by symbol without seeing its significance as a whole. Beyond a system of occult signs, the landscape allows a generous framework for the couple's understanding of themselves, providing a medium for the new cult of sensitivity and awareness of nature which some humanists, notably Conrad Celtis, Joachim Camerarius and others, were propagating in literary form through the Classical topos of the pleasance, or pleasure-park.

Landscape acts as an echo-chamber for mental states, and, as such, represents a macrocosm in which the individual, or microcosm, finds his or her emotional world reflected. Perhaps this explains the

posture of Cuspinian's head. Of course, his pose may be intended to show the humanist still pondering over a book, which he now holds closed in front of him, his left hand – exposing two ringed fingers – resting on its cover. However, his slightly raised head may indicate that he is listening. The listening motif may refer to a piece of Neoplatonic writing by Marsilio Ficino which was especially popular in humanist circles: "It is through our ears that melodious harmonies and rhythms enter our souls, admonishing and inspiring us to lift our spirits forthwith, and, in the very depths of our being, to ponder on such divine music."[109]

Detail from illustration page 83

Hans Holbein the Younger: Erasmus of Rotterdam

Hans Holbein the Younger
Hand Study of Erasmus of Rotterdam, undated
Pencil and red chalk, 20.6 x 15.5 cm
Paris, Musée du Louvre

Bought by Louis XIV from the Cologne banker Eberhard Jabach, the painting initially entered the royal collection, from whence it found its way to the Louvre.[110]

Hans Holbein the Younger executed several portraits of Erasmus of Rotterdam.[111] His famous portrait of 1523, now at Longford Castle (cf. ill. p.91), shows a three-quarters view of the humanist in the narrow corner of a room, staring out in front of him with tired eyes. To his left there is a richly ornamented pilaster, crowned by a capital with the relief of a fabulous, mermaid-like creature. Behind him, divided off by a curtain, is a recess with a shelf and some books. Erasmus is standing at a table, his hands resting on a book whose facing edge bears an inscription referring to Heracles in slightly incorrect Greek. This is probably meant as a humorous reference to the painstakingly detailed commentaries and annotations that Erasmus supplied with his Latin translation of the New Testament, or to his philological work in general.

Holbein's portrait (now at the Louvre) is similar to a portrait executed by Quentin Massys in 1517 (cf. ill. p. 88) bottom, in that both show Erasmus writing. Holbein's portrait is undoubtedly one of the greatest sixteenth-century portraits of a humanist. The portrait consciously reverts to an old-fashioned profile view. Whereas quattrocento profile-view portraits often ap-

peared conventional and stiff, Holbein introduces an intensely dynamic psychological dimension by showing the sitter actively engaged as a historical subject. The silhouette of the great thinker is shown against a panelled interior with a repeat-pattern tapestry. His large, dark coat with its brown, turned-up cuffs and the black beret on his head provide a contrast against which his face and hands stand out as the centres of his intellectual activity. Erasmus is shown writing, his lowered, seemingly introverted gaze on the written page, obscuring the pupils of his eyes. The scholar is entirely engrossed and appears not to notice the (imagined) spectator.

This was evidently the way in which Erasmus wanted to be seen: at work, recording the movement of thought in writing. He probably sent the likeness to his friend Thomas More, to whom, in 1511, during his third visit to England, he had dedicated his satirical work "In Praise of Folly" (Encomium Moriae), a pun on More's name.

Like his portrait of the French ambassadors (cf. ill. p.118), Holbein's portrait of Erasmus contains a number of hidden allusions. One of the ornamental animals on the tapestry can be identified as a griffin, a fabulous beast described in ancient myths as having the talons of an eagle and the body of a lion. Medieval and Renaissance Christian hermeneutics saw these characteristics as metaphors for vigilance (eagle)

LEFT:
Quentin Massys
Erasmus of Rotterdam, 1517
Oil on panel, 58 x 45 cm
Rome, Galleria Nazionale d'Arte Antica

PAGE 89:
Hans Holbein the Younger
Erasmus of Rotterdam, c. 1523
Oil on panel, 42 x 32 cm
Paris, Musée du Louvre

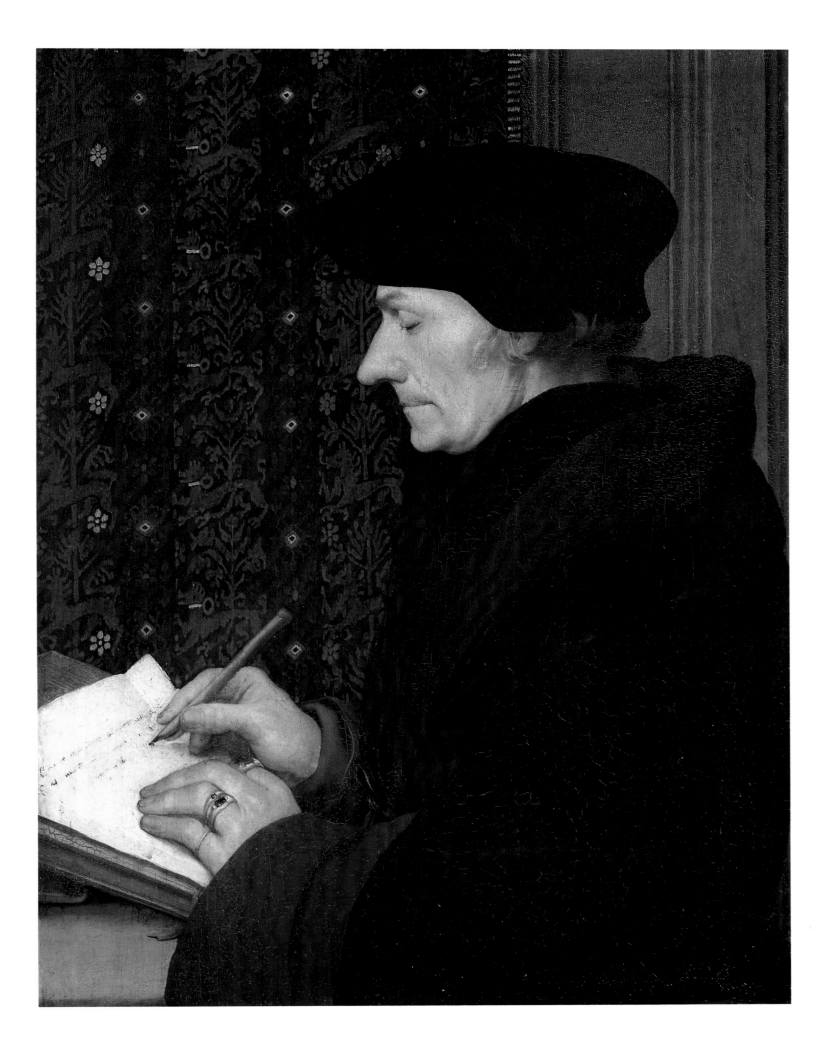

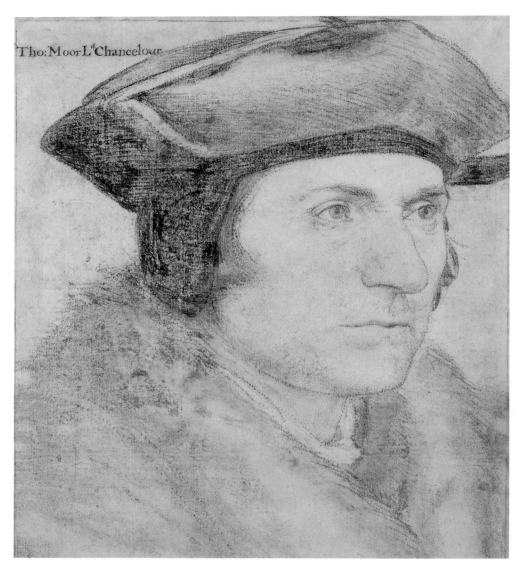

Hans Holbein the Younger
Sir Thomas More
Black and white chalks, 39.7 x 29.9cm
Windsor Castle, Royal Library
© 1992 Her Majesty Queen Elizabeth II

Holbein painted several portraits of Sir Thomas More, who was a close friend of Erasmus. This was the preliminary drawing, executed in 1527, for a painting of More's family (for which there are further drawings of the heads of individual sitters). After his return to Basle, Holbein delivered the drawing to Erasmus, who was most enthusiastic.

Hans Holbein the Younger
Sketch for the Portrait of Sir Thomas More and his Family, 1527
Pen, brush and ink over chalk on paper, 38.9 x 52.4cm
Basle, Öffentliche Kunstsammlung, Kupferstichkabinett

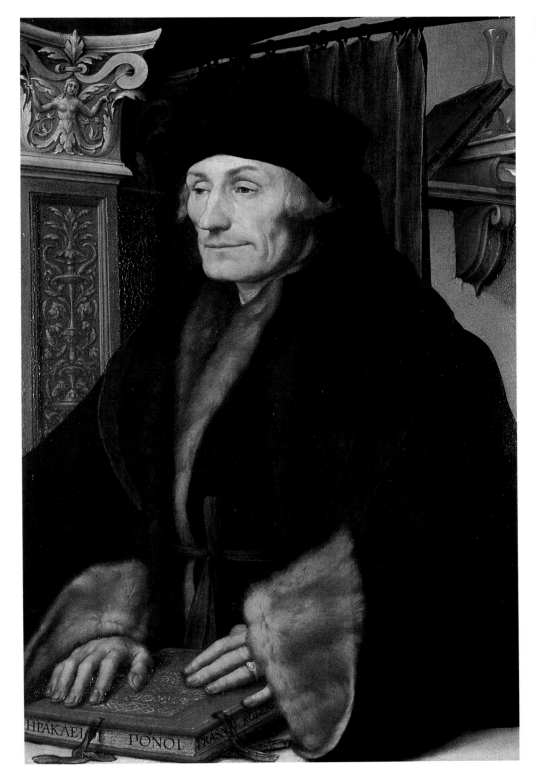

and courage (lion). At the same time, the beast symbolised the ambivalent nature of Christ: the bird represented divinity, the lion's body the human being. In Dante Alighieri's "Purgatory" (29, 106 ff.) there is a description of a griffin pulling the triumphal chariot of the church.[112] On the eve of the Peasants' War, with various religious groups either attacking or championing him for their own cause, Erasmus used the hidden allusion to Dante's "Divine Comedy" to demonstrate his allegiance to the church. He remained loyal to the church all his life, despite his sympathies for the Reformation and criticism of the Roman Catholic clergy.

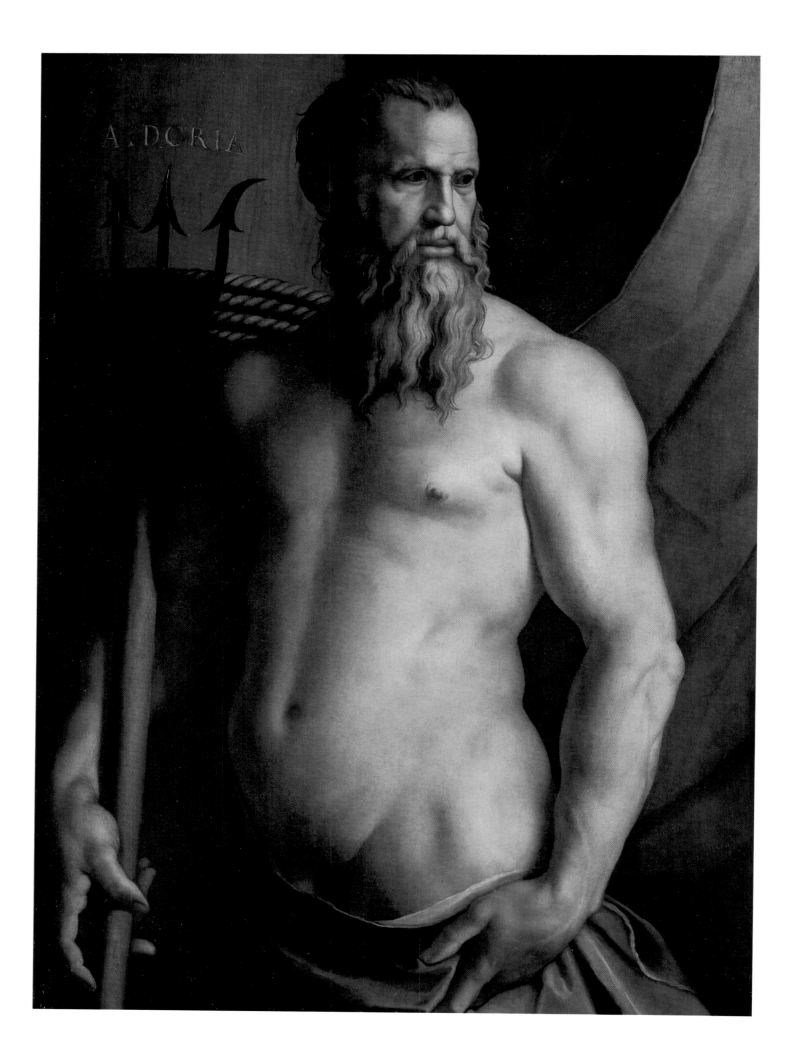

Agnolo Bronzino: Andrea Doria as Neptune

This portrait heroises and idealises[113] the Genuese admiral and statesman Andrea Doria (1466/68–1560), showing him as Neptune. Standing before a ship's mast on which his name is carved in gold letters, Doria carries a trident in his sinewy right hand, while in his left he holds part of a sail that hangs down from the top right of the picture – gathering it into a kind of loin-cloth which barely covers his genitals.

John Pope-Hennessy has suggested the portrait may have been painted to com-memorate Andrea Doria's occupation of Tunis in 1535. A medal by Leone Leoni, also showing Doria as Neptune, places him in a more narrative context, whereas Agnolo Bronzino's allegorical figure is reminiscent of the statuesque plasticity of a Michelangelo. The portrait has an official character. It represents the appropriate form of idealisation for a condottiere who, a member of Pope Innocence VIII's per-sonal body-guard, worked his way to the top of the social ladder in the service of various Italian princes: in other words, a state portrait. During the internecine dis-putes between Charles V and Francis I, Andrea Doria initially served the French king; swapping his allegiance to the Ger-man Emperor, he finally, following the liberation of Genoa, became a dictator of this republican city-state.

Doria's wish to give himself mythologi-cal stature is not perhaps the most surpris-ing aspect of this portrait; even more cons-picuous is his self-conscious exhibition of nudity, his apparent obsession with virility. Vitality and aggressive, warlike behaviour, springing from instinctual, libidinous drives, are shown here as the only route to power. Nudity was not unusual for a mythological subject, but the fact that Doria wished to portray his body in this way shows that he was not interested in displaying the external trappings of a power based on dynastic tradition, but in demonstrating a power which derived its natural legitimacy from a new ethics of achievement, and its supremacy from reserves of determination and physical strength which were the exclusive domain of the powerful individual.[114]

TOP:
Leone Leoni
The Triumph of Andrea Doria, 1541
Bronze medal
Washington (DC), National Gallery of Art,
Samuel H. Kress Collection

PAGE 92 AND DETAIL RIGHT:
Agnolo Bronzino
Andrea Doria as Neptune, c. 1540/50
Oil on canvas, 115 x 53 cm
Milan, Pinacoteca di Brera

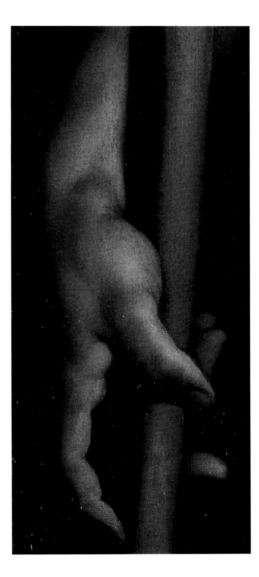

Nicoletto da Modena (?): Francis I of France as an Antique God

Despite its small format, this portrait of Francis I (1494–1547) is a state portrait, a genre whose function was similar to that of the princely codes:[115] to demonstrate the virtues and abilities of the despot. Once attributed to Niccolò dell' Abbate, the portrait is now thought to have been executed by Nicoletto da Modena, although it is possibly the work of a French artist of the School of Fontainebleau.[116] Like Agnolo Bronzino's *Andrea Doria as Neptune,* Francis I is portrayed in mythological costume. His facial features, recognisable from Jean Clouet's dispassionate portraits of the monarch,[117] are evidently true to life. The full-length portrait is vaguely reminiscent of the type of portrait painted by Jakob Seisenegger and Titian of Charles V. The contrapposto is not quite correct, since his prancing left foot should, in fact, bear his weight. The king poses on a pedestal which fills the entire breadth of the canvas and is ornamented with strapwork reliefs. On the front of the pedestal is a panegyric inscription in French, according to which the king's qualities "surpass" those of Nature herself.[118] These qualities are allegorised in the form of the attributes of five antique gods who are said to be united in his person. Minerva (Athena) is the dominant deity, represented by his robes, although these are partly covered by the chiton of Diana, the goddess of the chase. The tall, plumed helmet is a Minervan attribute, too, the goddess of war and peace, as is the Gorgon's head on Francis' breastplate. According to antique legend, the effect of the terrible sight of the Gorgon's head was to make attackers turn tail and run. The allusions to Minerva accentuate the king's outstanding wisdom and presence of mind (the proverbial attributes in Classical antiquity). Here, Minerva is the goddess of peace, while the monarch's martial qualities are expressed through the attributes of Mars: the raised sword, for example. Francis I had fought many wars; the last, a few years before he died, against the superior allied forces of the German Emperor and Henry VIII.

The naked left arm is associated with Diana, the goddess of the chase, as is the horn and quiver of arrows; the latter, at the same time, is a reference to Amor, the god of love. Since the beginning of the six-teenth-century, with the formation of absolutist states, the hunt had been the privilege of the courts and ruling aristorcracy. Prowess in amorous pursuits, too, was ascribed to princes, an ancient superstition still prevalent in the Renaissance. This, associated with absolute power, was partly responsible for the impressive charisma of the ruler. Finally, Francis I is given the attributes of Mercury (Hermes), the god of commerce: the magic wand, caduceus, which he holds like a sceptre, and the winged sandals worn by the messenger of the gods.

In one person, these different characteristics add up to an androgynous being, but it would be quite wrong to understand their synthesis as a sign of transsexuality or transvestitism. Their allegorical significance is obvious enough. Certainly, philosophical ideas, derived perhaps from the Aristophanic fable of the "androgynous being", or from "Androgyne de Platon" (the title of a book by Héroet in 1536), influenced portraits of this type, which, demonstrably, were not considered irreverent.[119]

Hermaphroditic motifs are frequently found in Manneristic painting, indicating that reflection on gender roles had entered a new phase. This was partly due to the fact that distinctly defined sexual identities were now emerging as a prerequisite for the success of patriarchal society. In this respect, the court's privileged position set it apart from the new – and essentially bourgeois – social constraints. It was here, in the refined air of the courts, that an ancient, threatened, social order could attain its final apogee: if only in the realm of the imagination.

Carravaggio
Head of the Medusa, after 1590
Canvas on panel tondo, 60 cm
Florence, Galleria degli Uffizi

PAGE 95:
Nicoletto da Modena (?)
Francis I of France as an Antique God, c. 1545
Oil on panel
Paris, Bibliothèque Nationale

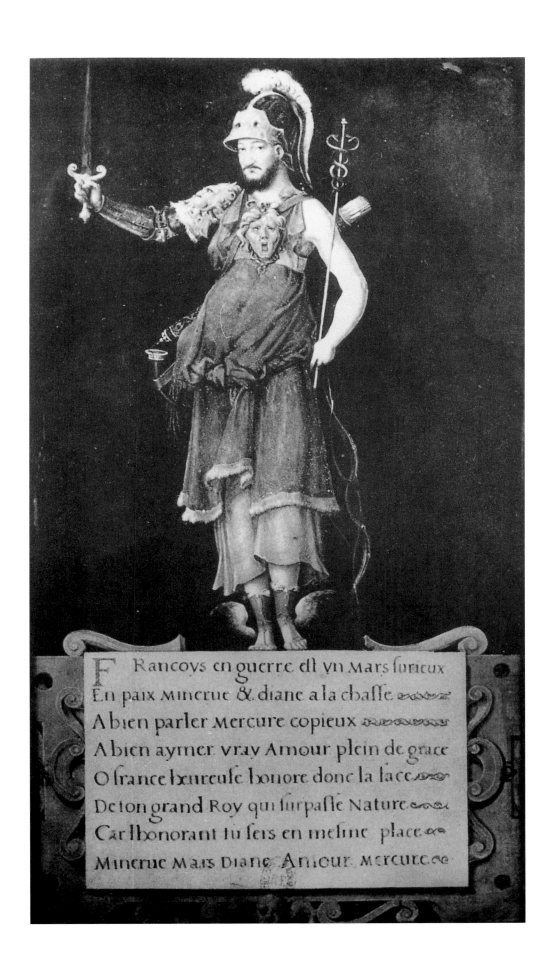

François en guerre est un Mars furieux
En paix Minerve & diane a la chasse
A bien parler Mercure copieux
A bien aymer vray Amour plein de grace
O france heureuse honore donc la face
De ton grand Roy qui surpasse Nature
Car lhonorant tu sers en mesme place
Minerve Mars Diane Amour Mercure.

Raphael: Pope Leo X with Cardinals Giuliano de' Medici and Luigi de Rossi

With this group portrait,[120] executed on the occasion of Lorenzo de' Medici's marriage in Florence (September 1518), Raphael established an enduring model for portraits of popes. Melozzo da Forli had already painted Pope Sixtus IV on the throne (cf. ill. p. 22), but the concentration of a small number of mute, motionless and apparently unrelated figures in interior space was seen in Raphael's work for the first time.

One of these figures, Luigi de Rossi, is shown gazing out of the painting at the spectator. He stands behind the pope with both hands resting on the backrest of the papal throne. The pose pays tribute to him as one of the pope's most trusted confidants. Raphael has accentuated the role of Rossi here because the portrait was completed a short time after Rossi was elevated to the college of cardinals on 26 June 1517. The reason for co-opting Rossi had been a plot, hatched by leading members of the Curia, to assassinate the pope.[121] Following the purging of his opponents, Leo X had enlarged the college of cardinals. By appointing a number of loyal supporters, three of his own nephews among them, he had managed to turn the situation to his own advantage.

Leo X sits at a table which extends diagonally into the picture against a deeply shadowed background. The central axis of the painting passes through his imposing head, which is flanked symmetrically on either side by the faces of the two cardinals. Attired in purple pontificals, the Medici pope is shown with an illuminated manuscript, the so-called Hamilton Bible (now in the Staatliche Museen zu Berlin), open before him. In his left hand is a magnifying glass with which he has been studying the artistic merit of the miniatures. His eyes now raised from the book, he meditates on what he has seen.

The reflection in the golden knob on the backrest of the throne of part of a room with a double window which can only be behind or to the side of the spectator is a device probably learned from Jan van Eyck, Petrus Christus or other early Netherlandish artists, who would sometimes paint compressed reflections of the otherwise invisible parts of an interior – on armour, for example, or in a convex mirror.

The official function of Raphael's portrait of Leo X is to show the pope in full command of his powers even when apparently engaged in private pursuits. The presence of two assisting cardinals does not relativise, but rather adds to the effect of this display of the pope's might.

PAGE 97 AND DETAIL LEFT:
Raphael
Pope Leo X with Cardinals Giuliano de' Medici and Luigi de Rossi, 1518/19
Oil on panel, 154 x 119 cm
Florence, Galleria degli Uffizi

Titian: Pope Paul III, Cardinal Alessandro Farnese and Duke Ottavio Farnese

Titian, in this portrait of a pope,[122] adapts to his own ends the group-of-three portrait invented by Raphael with his portrait of Leo X. Unlike Raphael, however, Titian does not portray his subject, described by Francesco Guicciardini as an "uomo ornato di lettere" (a man whose erudition is ornamental), as a bibliophile, or lover of the arts. Pope Paul III is not shown with a priceless manuscript, but with an hourglass. This symbol of transience perhaps refers to the advanced age of the seventy-eight-year-old pontiff, who was born in 1468 and died in 1549. Whereas the figures in Raphael's painting hardly interact at all, Titian's portrait is given a narrative structure by the approach of Ottavio Farnese,[123] the pope's grandson, from the right. Ottavio is shown bending down to speak to the pope, who is evidently hard of hearing. His gesture is reverential, his right arm held in front of his body, his left hand holding the sheath of his sword. Paul III is shown granting Ottavio an audience; stooping with age, he turns his head with the long white beard round to face his grandson. Cardinal Alessandro Farnese (1520–1589) is shown (like Raphael's Luigi de Rossi) holding the backrest of the papal throne. The ceremonial gesture evidently reveals his proximity to the Pope, even within the hierarchy of the Curia. The pose demonstrated the person's rank as personal adviser and confidant. The cardinal, Ottavio's brother, was only twenty-six at the time; he appears to stand outside the dramatic interchange captured by the painting. Posing behind the pope, he holds the spectator in his placid gaze.

Following a tendency in the work of Jacob Burckhardt and Ludwig von Pastor to demonise Italian Renaissance power-politics, this painting has been interpreted as a dramatisation of every possible form of malice. Commentators have read slyness, cunning and trickery into the pope's features, while attributing to Ottavio the obsequious hypocrisy of a scheming conspirator. Moralising opinions of this kind, based as they are on outmoded methods of evaluating historical data, should be treated with the utmost scepticism. Puritanical historians in the nineteenth and

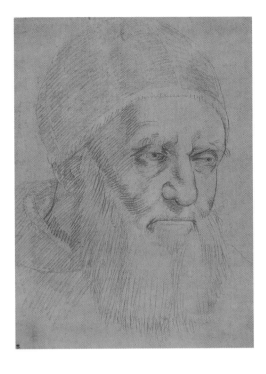

early twentieth century considered Paul III morally despicable because he had fathered two bastards as a young man. This was not unusual, however, since the institution of celibacy had taken some time to find acceptance. It was an expression of the pope's patriarchal support for his dynasty when Paul III made his son Pierluigi Duke of Piacenza and Parma, or invested his grandson Ottavio with the fee of Camerino.

Traditional views of the painting have failed to look closely enough at its representative, courtly function, its ceremonial role as a means of defining relationships within the closed community of the papal state. Its gestural vocabulary expressed the ritual subjugation of nobility – even of the pope's own family – to the Holy See, which had developed an absolutist system of government by monopolising state power.

Lorenzo Lotto: Andrea Odoni

The humanist and antique dealer Andrea Odoni is presented amidst his collection of antiques.[124] He sits at a green-covered table, wearing a voluminous and richly lined, fur-collared coat. His large head, inclined a little to one side, is framed by his beard, and by his dark hair, which is parted in the middle. Gazing at the spectator, Odoni has placed one hand on his chest in a gesture of "sincerità" (here: reverence, or deference), while his other holds out a small, possibly Egyptian statue to the spectator. By contrast with the room in Titian's portrait of Jacopo de Strada (ill. p.102), Odoni's antique cabinet is simply furnished. Against the whitewashed wall, the statues seem to have developed a fantastic life of their own, especially on the right where the shadows are deeper. Antaeus is shown wrestling with Hercules on the left, while a statue on the right, from the Vatican Belvedere court, shows Hercules with the skin of the Nemean lion. On the far right there is yet another Hercules, a "Hercules mingens" (the Classical hero as "Manneken Pis"), before a well, or trough, over which a female figure, perhaps Venus, is leaning. Classical antiquity seems revived in the form of a huge head emerging from under the table-cloth. In fact, this is the head of Emperor Hadrian, the "Adrian de stucco" mentioned by Marcantonio Michiel in 1555 in his Odoni-collection inventory. The much smaller torso of Venus appears to nestle up to the head, to – probably calculated – comic effect.[125] Although monochromatic, and indeed partly ruined, the sculptures seem mysteriously animated. Lotto invokes the magical properties of the image; he gently parodies the theme of the "re-birth" of Classical art by taking it literally. The small statue in the collector's hand, reminiscent of Diana of Ephesus, indicates the artist's and sitter's

Detail from illustration page 101
Although partially ruined, the antique sculptures in the background seem mysteriously animated. The renaissance of Classical art is taken quite literally here.

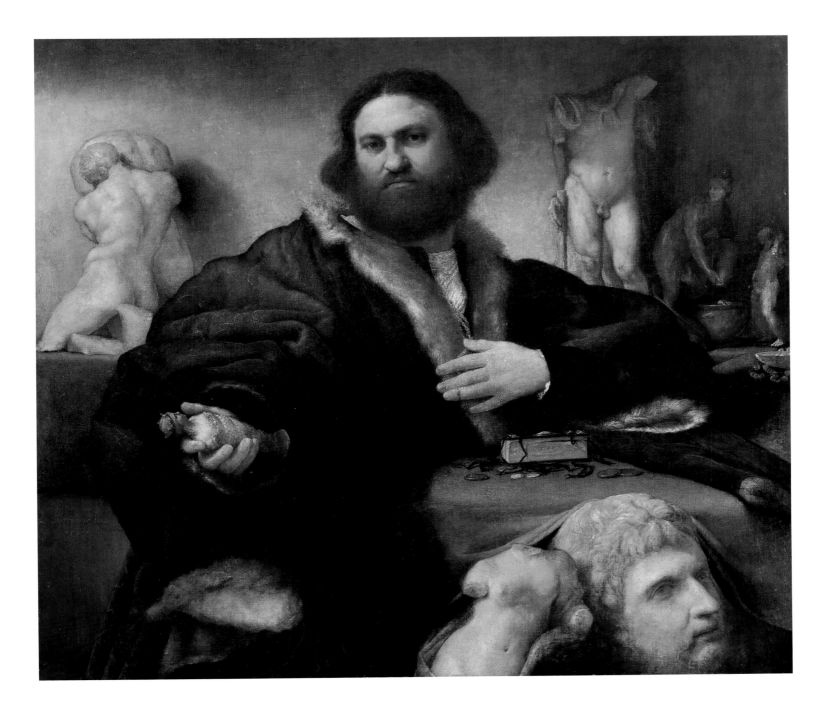

demonstrable interest in Egyptian religion.[126] At Venice, Lorenzo Lotto's place of birth, where he often stayed – the painting was executed after 1526, while Lotto was staying at Venice – there was widespread interest among the humanists in Egyptian hieroglyphics as a source of arcane knowlege and divine wisdom. This "science" could be traced back to Horapollo, the author of a treatise on hieroglyphics, which had survived in Greek translation.[127]

In her dissertation on the work of Lorenzo Lotto, published in 1977, Diana Wronski Galis posited that the artist's rendering of antique sculptures was intended as a warning – along the lines of Petrarch's "De remediis utriusque fortunae" (On the use of medicines for good and evil) – against the evils of collecting worldly treasures. However, this theory is neither borne out by the painting itself, nor can it be reconciled with the self-image of the patron; indeed, the very fact of his having commissioned the painting in the first place would then make no sense at all. Her thesis therefore has little in common with the reality of the painting. The passionate collector Odoni would hardly – as patron – permit such censure of his person, let alone commission it.

Lorenzo Lotto
Andrea Odoni, 1527
Oil on canvas, 101.5 x 114 cm
London, The Royal Collection, St. James Palace, © Her Majesty Queen Elizabeth II

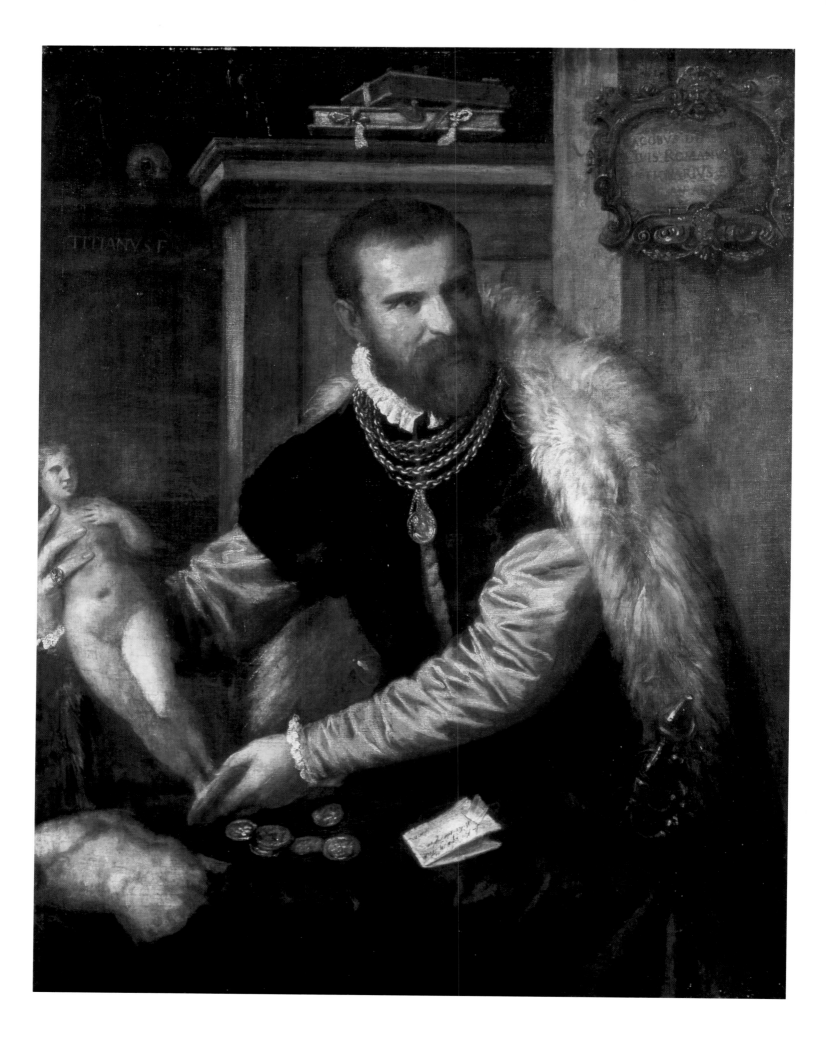

Titian: Jacopo de Strada

Unlike Giovanni Battista Moroni's *Sculptor*, who is shown from the side with his head turned toward the spectator and strong hands firmly holding a small antique torso of Hercules, Titian's *Jacopo de Strada*[128] is portrayed in action. Strada seems to be communicating with an imaginary person to the right of the spectator, for whom, as if in response to a request of some kind, he has picked up a Roman copy of the Aphrodite Pseliumene (Aphrodite with the necklace).[129] The movement has caused the fur around his collar to slip, so that only his left shoulder prevents it from falling.

Here Strada has the aged artist, his close friend, paint him not only surrounded by the trappings of his profession, but with all the badges of his office. His clothing – the fur, red silk sleeves and satin sheen of his waistcoat – shows the great wealth of this painter, goldsmith, archaeologist, art collector and art expert from Mantua. The gold chain wound four times around his neck, carrying a pendant with a helmeted head in profile, is a sign of his noble birth, as is his sword, whose hilt is casually visible to the right of the table. Ostensibly, the sitter is indulging in a vastly exaggerated display of self-importance. His vanity is equally expressed in the cartouche ornamenting a pillar which, like part of a stage set, has no structural purpose beyond providing a surface for the following inscription: JACOBVS DE STRADA CIVIS ROMANVS CAESS. ANTIQVARIVS ET COM. BELIC. AN: AETAT: LI: et C.M.D.L. XVI (Jacopo de Strada, Roman citizen, Imperial Collector of Antiques and War Minister, aged 51, in the year 1566). Strada was evidently proud of his activities as a collector and merchant of antique objects.[130] Under Duke Albrecht V of Bavaria he founded the Munich "Antiquarium", later going on to fulfil similar duties at the imperial courts of Vienna and Prague under Emperors Ferdinand I, Maximilian II and Rudolf II, to whom he succeeded – incapable as he was of passing off an opportunity – in marrying off his own daughter. His position as War Minister is another exaggeration. The term (possibly added later) "comes bellicus" should be understood as as description of his actual work, which involved drawing up plans for war machines. Strada's interest in numismatics – he began his career collecting coins and wrote a book in the late 1550s entitled "De consulibus numismatibus" – is illustrated by the Roman coins lying on the table next to the torso. His erudition is indicated by a pile of books on the ledge behind him, probably his own writings. That the portrait is as much an act of friendship and homage as a commissioned piece of work can be seen in the words of a letter lying on the table: "Al Mag^{co} Sig^{or} Tizian Vecellio… Venezia".

"A younger artist than Titian… could not have painted such a beautiful, dignified likeness of a person so lacking in charm. For a younger artist would not have had the benefit of the boldness of style that was so characteristic of Titian's later years, his generosity and expressive brushstroke, the wonderful glowing warmth of his colours… It was the rank of the sitter which decided the character of his portrait; a person's individuality was shown through the media of various attributes, books and the like, but not by means of the psychological analysis or labelling of a sitter. That Titian nonetheless managed simultaneously to express the general and the particular, the ideal and the reality, the sitter's gentility and his villainy, is due to a restlessness that is not usually found in this artist's work."[131]

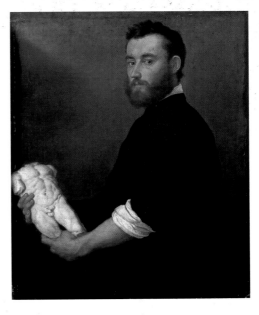

Giovanni Battista Moroni
The Sculptor Alessandro Vittoria, c. 1560/65
Oil on canvas, 87.5 x 70 cm
Vienna, Kunsthistorisches Museum

Titian
Jacopo de Strada
Oil on canvas, 125 x 95 cm
Vienna, Kunsthistorisches Museum

Albrecht Dürer: Self-Portrait with a Fur Coat

While confirming Albrecht Dürer's[132] reputation as a keen observer of the natural irregularities of the human form and a scrupulous recorder of minute empirical detail, this self-portrait nonetheless appears idealised. This impression probably derives from the intense symmetry of the full-face, bust portrait. F. Winziger has traced the underlying structural principles of its composition to medieval systems of proportion and triangulation.[133] Dürer adopted the technique of hieratic frontality from medieval paintings of Christ, and from representations of Veronica's kerchief with the imprint of Christ's face. This has led a number of art historians to make the portrait the object of their own, quasi-religious aestheticism. Ernst Buchner (1953), for example, found its "elevation to a realm transcending quotidian individuality, a realm of human greatness bordering on the sacred" so "compelling" that he felt "removed by the artist's serious gaze to a higher plane of human existence".[134]

Whether it is permissible to see this painting as an "Imitatio Christi", or whether, inspired by the Italian theorists of art Marsilio Ficino and Pico della Mirandola,[135] Dürer saw himself as a creator-god, or demiurge, remains open to debate. In fact, a sentimental passage from one of Dürer's later writings (1512) enthuses over the esteem in which artists once were held, when "great masters were placed on a level with God".[136] It is difficult to ascertain whether this reflected Dürer's opinion in 1500. It has been even suggested that the inscription may not be genuine. In John Pope-Hennessy's opinion, for example, Dürer cannot have executed the painting before his second visit to Italy in 1505/07.[137]

If iconographical and typological considerations make some of these suggestions seem quite feasible, their wholesale acceptance as a model for the interpretation of Dürer's self-portrait would be more than rash. The qualities demanded by the "Imitation of Christ" – according to the late medieval writer Thomas à Kempis in a widely-known work entitled "De imitatione Christi"[138] – were modesty, austerity and humility. Dürer's vain awareness of his own, fashionable good looks in this self-portrait, especially evident in his hairsyle and fur-lined coat, hardly seems in keeping with these moral precepts. His finely curled hair falls in a cascade of ringlets onto his shoulders, and a flurry of curls stands up on his forehead. Dürer had already projected a dandified image of himself in a self-portrait he painted in 1498, now in Madrid (ill. p. 107). An even earlier self-portrait, executed in 1493 and now in Paris (ill. p. 106), had shown the artist as a highly fashion-conscious young man. While Erasmus criticised long hair in his "Golden Book of Manners for Little Boys", demanding hair be prevented from "hanging onto the forehead or falling loosely onto the shoulders"[139], Dürer continued to advocate an artistic "counter-culture".

It is difficult to explain the position of the artist's right hand. With index and middle fingers spread, and fingertips practically closed – an unlikely, and physically awkward feat – his hand seems to function as a clasp, fastening the two flaps of his fur-collar. Or is it meant as a "reflexive" gesture? Perhaps it is an expression of deferential respect, a recurrent feature in the Italian portrait of the day.

TOP:
Albrecht Dürer
Self-Portrait at the Age of 13, 1484
Silverpoint on paper, 27.5 x 19,6 cm
Vienna, Graphische Sammlung Albertina

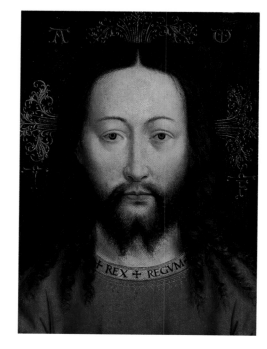

RIGHT:
Jan van Eyck
Christ (copy)
Oil on panel, 44 x 32 cm
Berlin, Staatliche Museen zu Berlin –
Preußischer Kulturbesitz, Gemäldegalerie

PAGE 105:
Albrecht Dürer
Self-Portrait with a Fur Coat, 1500
Oil on linden panel, 67 x 49 cm
Munich, Alte Pinakothek

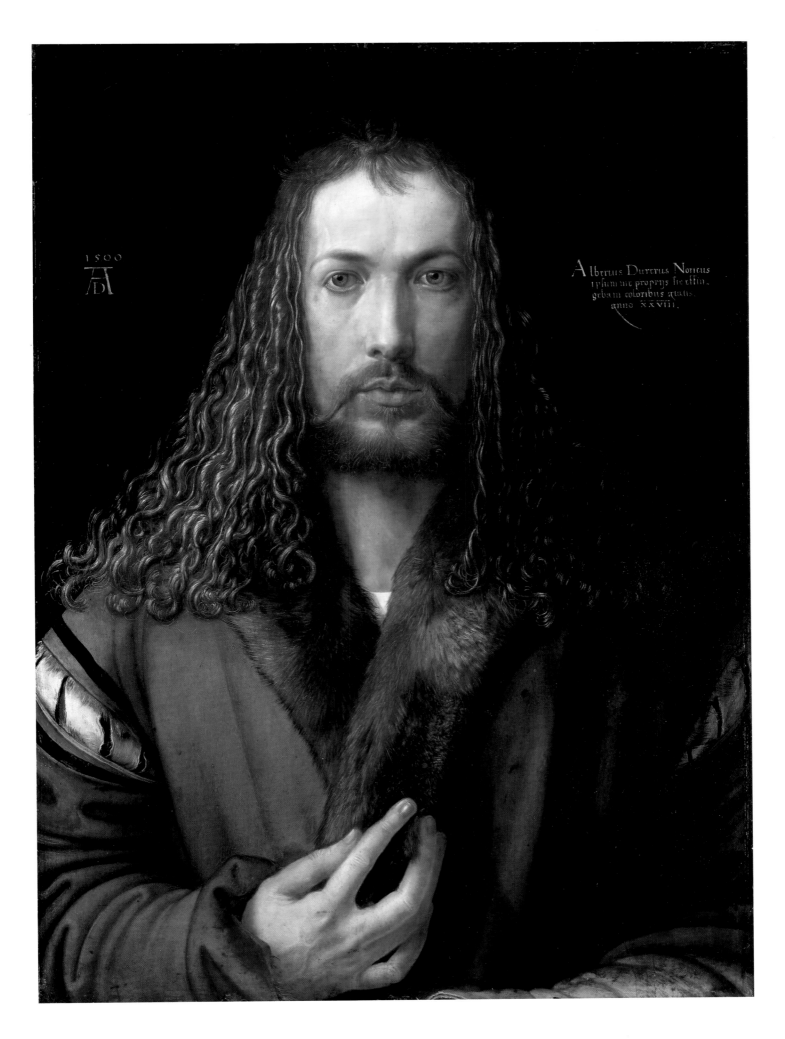

Albertus Durerus Noricus
ipsum me proprijs sic effin
gebam coloribus aetatis
anno XXVIII.

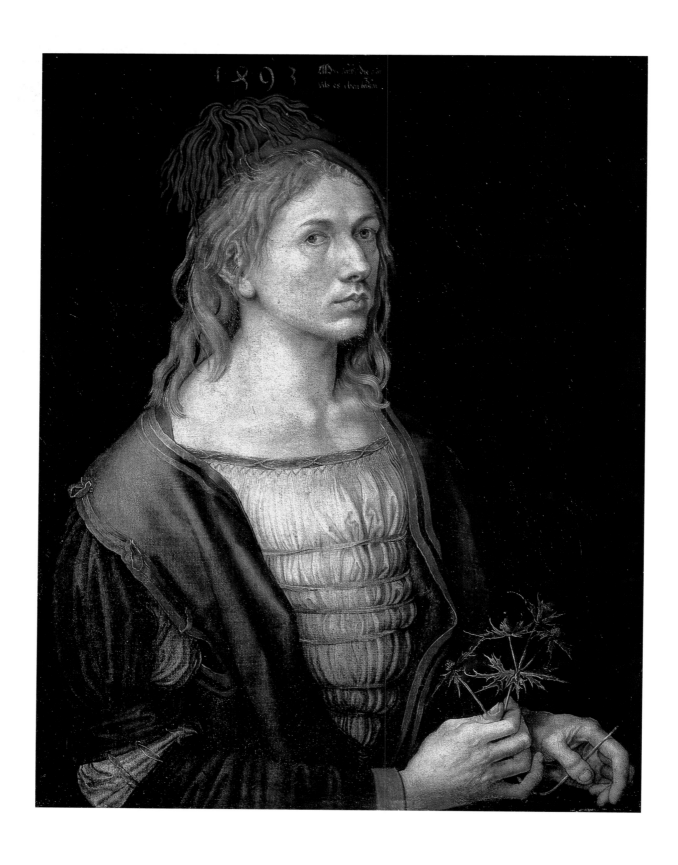

Albrecht Dürer
Self-Portrait, 1493
Parchment on panel, 56.5 x 44.5 cm
Paris, Musée du Louvre

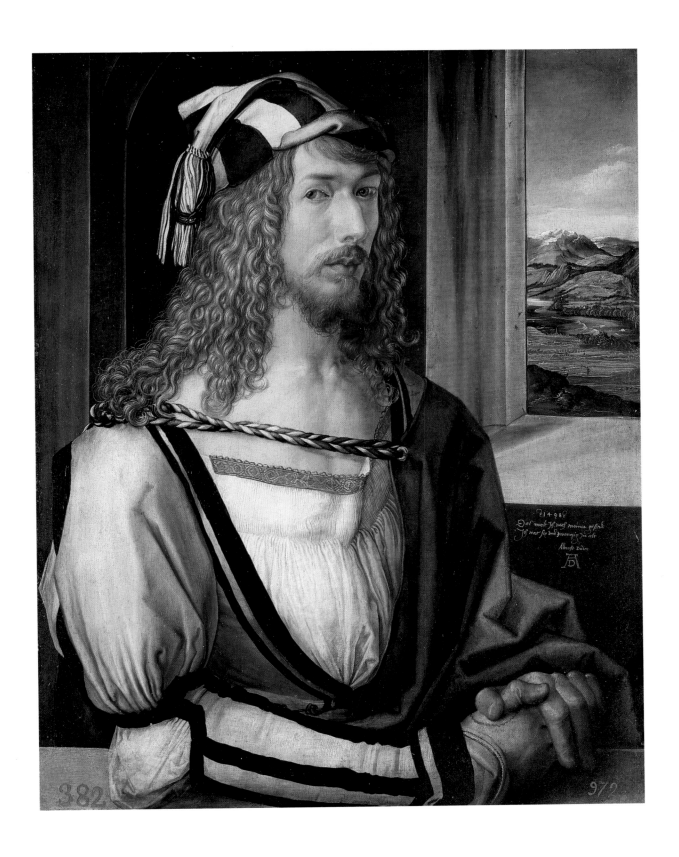

Albrecht Dürer
Self-Portrait, 1498
Oil on panel, 52 x 41 cm
Madrid, Museo Nacional del Prado

Within the painting, the following text appears:

EFFIGIES: NICOLA POVSINI ANDEL
YENSIS PICTORIS. ANNO ÆTATIS 56
ROMÆ ANNO IVBILEI
1650.

Nicolas Poussin: Self-Portrait

Nicolas Poussin's *Self-Portrait*, executed in 1650,[140] is a painted theory of art: a cryptogram containing the aesthetic principles of an artist, who, since 1628, had spent most of his working life in Rome. Poussin had done an earlier version of the painting in 1649 (now in the Gemälde-galerie, Staatliche Museen zu Berlin – Pre-ußischer Kulturbesitz), painted to replace a disappointing portrait of himself which his Parisian patrons had commissioned from a Roman artist.

The most conspicuous motif of the earlier self-portrait is the "memento mori". The artist presents himself before a sepulchral monument – anticipating his own – flanked by putti;[141] the expression on his face is almost cheerful. Viewed from a distance he appears to be smiling, while his head, inclined slightly to one side, suggests a melancholic mood (compare the portraits by Lorenzo Lotto and Moretto da Brescia, ill. p.68 and 71). Cheerfulness in the face of death demonstrated the composure of the Stoics, a philosophy for which Poussin had some sympathy. The early self-portrait, too, contains an allusion to Poussin's theory of art: the title of the book "De lumine et colore" (On light and colour). Poussin's reference to colour here is less surprising than Anthony Blunt, who defined Poussin as a "partisan" of "disegno" (drawing, design), would have us believe. In his correspondence with Paul Fréart de Chantelou, Poussin repeatedly defined the analysis of light as the basis of all painting.[142] In Poussin's view, echoing earlier theories of art, colour was the modification of light. Poussin was therefore not as radical an advocate of the "designo – colore" antithesis as doctrinaire Classicist historians of art theory have suggested. His practice as an artist speaks against the view of him as one-sided; instead it betrays the influence of the Venetian colourists, in whose work the world was suffused in a golden light.

In the self-portrait at the Louvre the artist, wearing a dark green gown and with a stole thrown over his shoulders, is shown in a slightly different pose: posture is erect, his head turned to present an almost full-face view. His facial expression is more solemn, but also less decided. Instead of funereal symbolism, the setting is the artist's studio, lent a strangely abstract quality by a staggered arrangement of three framed canvases, one behind the other, whose quadratic structure is echoed by the dark doorframe behind them. It is apparent that the canvas nearest to us is empty, except for a painted inscription.

The empty canvas is a cipher for the "disegno interno" (internal idea),[143] or "concetto" (plan), a conceptual version of the painting which, according to a theory formulated in 1590 by Giovanni Paolo Lomazzo ("Idea dell' tempio della pittura"), precedes its practical realisation. Poussin's emphasis of the painters ability to work with his intellect concurs with the ideas of the philospher and poet. At the left of the second canvas there is a woman in front of a landscape, wearing a diadem with an eye; a man's hands are reaching out to hold her

At the left of the canvas there is a woman wearing a diadem with an eye. This has been interpreted as an allegory: painting crowned as the greatest of the arts.

PAGE 108 AND DETAIL RIGHT:
Nicolas Poussin
Self-Portrait, 1650
Oil on canvas, 98 x 74 cm
Paris, Musée du Louvre

Detail from illustration page 111

shoulders. This has – probably rightly – been interpreted as an allegory: painting crowned as the greatest of the arts. At the same time, the embrace is a symbol for the bond of friendship between Poussin and his patron Chantelou.

A tiny, but highly significant detail is the ring Poussin is wearing on the little finger of his right hand, which rests on a fastened portfolio.[144] Studied closely, the stone reveals itself to be a diamond, cut in the shape of a four-sided pyramid. As an emblematic motif, this symbolised the Stoic notion of Constantia, or stability and strength of character. Poussin was referring here both to his friendship with Chantelou, and to his intention to remain firmly loyal to the strict discipline of heroic Classicism. Popularised by contemporary moralizing literature, the notion of personal identity had begun to make itself felt in this era for the first time, and constancy in a person's attitudes, thoughts and conduct was its most important quality.

Poussin struggled to maintain his independence of mind and loyalty to his own ideals against the demands of the French court, and, in so doing, articulated the growing sense of autonomy of the ascendant bourgoisie.

Detail from illustration page 108
The ring holds a diamond, cut in the shape of a four-sided pyramid. As an emblematic motif, this was the Stoic symbol of stability and strength of character.

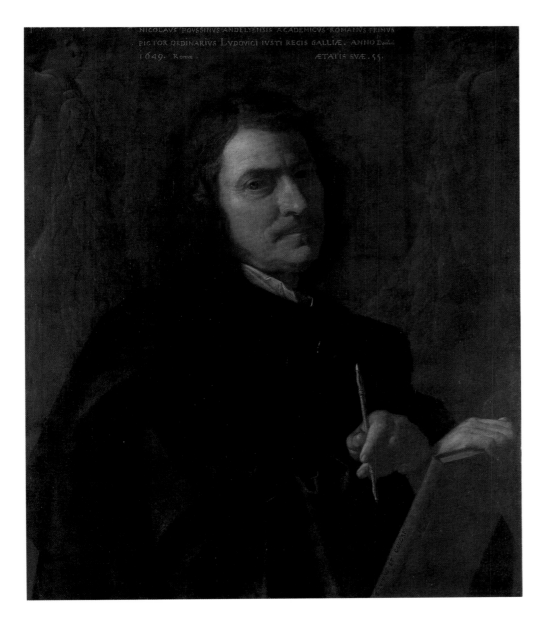

TOP:
Nicolas Poussin
Self-Portrait, 1649
Oil on canvas, 78 x 65 cm
Berlin, Staatliche Museen zu Berlin –
Preußischer Kulturbesitz, Gemäldegalerie

MIDDLE:
Detail from illustration page 108
Portrait of the painter Nicolas Poussin of Les
Andelys (painted) at Rome during the Jubilee
Year of 1650, aged 56 years.

BOTTOM:
Detail from illustration page 111 top
Nicolas Poussin of Les Andelys, Member of
the Academy of Rome, Principal Painter in
Ordinary to Louis, the rightful King of
France. Painted at Rome in the year of our
Lord 1649, aged 55 years.

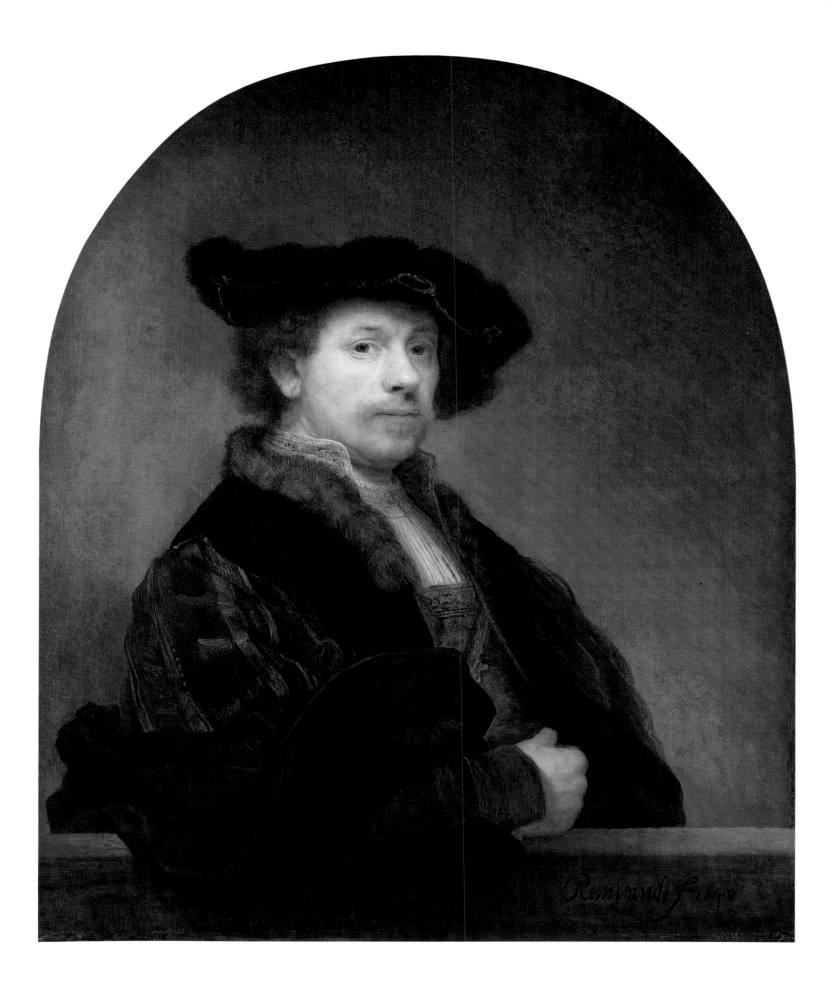

Rembrandt: Self-Portraits

Very few artists of the modern period have left as many self-portraits as Rembrandt. His lifelong study of his own physiognomy, his desire to keep a pictorial record of his constantly changing physical and psychological features, can be taken as a sign of his interest in autobiography and as proof of the belief he nurtured, in spite of the many crises and setbacks he suffered, in the uniqueness of the individual.

Different kinds of autobiographical narrative – memoirs, for instance, or episodes from lived experience interspersed in fictional texts (as with Grimmelshausen), or regular diary entries – were becoming increasingly important in seventeenth-century literature. "Affective individualism" (Lawrence Stone),[145] which had begun to penetrate every aspect of bourgeois experience, had entered poetry, too. Petrarch had anticipated this centuries before with the interest he provoked in his biography: "You will wish to know what kind of person I was."[146]

In the seventeenth century, this humanist motto was generally seen in a confessional or religious light. Rembrandt is known to have maintained frequent contact with members of many different confessions, religious groupings and sects (Jews, Mennonites, Socinians etc.), and it is probably not far wrong to assume that qualities which all these groups had in common – their ethical awareness, their intensely emotional character, and even their potentially oppositional nature – had a profound influence on Rembrandt's character.

On the other hand, it would be quite wrong to see Rembrandt's self-portraiture entirely in the light of his religious introspection. Indeed, his method reveals somewhat more affinity to doctrines of emotional expression[147] which influenced contemporary academic art theory. In his early self-portraits (ill. pp. 113 and 114), and in a number of smaller etchings which, significantly enough, are almost entirely devoid of ornament, allowing the artist to concentrate exclusively on the face, Rembrandt experiments with constantly changing facial expressions, working his way through the full gamut of human feelings and their physiognomic equivalents until, at one end

of the scale, all that remains is a grimace. The face, the focal point of the personality, is given symbolic status: it represents human feeling.

Rembrandt thus acts out and gives visual form to different emotional states: alarm, worry, care, the torment of fear; or he portrays himself as someone staring with desperate, distracted eyes, with his hair standing on end (Wright 31, 1630),[148] or as a person laughing and showing his teeth. While Charles Le Brun (1619–1690), the Director of the Académie Royale founded in 1648, reduced the various forms of emotional expression to a schematic code in his posthumously (1698) published tract "Méthode pour apprendre à dessiner des passions, proposée dans une conférence sur l'expression générale et particulière" (Method of learning how to draw the passions, proposed during a lecture on expression in general and particular), Rembrandt plumbed the depths of human emotion and discovered, by practical experiment, the means of its visual representation.[149]

Rembrandt was not, therefore, giving vent to his own feelings. He was not interested in revealing his "innermost being", but rather in exploiting his own mimic abilities to produce an encyclopaedia of the human feelings. He fashioned an instrument of empirical psychology out of his theatrical, indeed comic, ability to slip into and simultaneously observe a wide range of emotional states: an example of the valuable contribution made by the fine arts to the development of a modern science whose subject was the study of different forms of human individuality.[150]

While the examples of his work mentioned above, especially those of the early period, presented a range of physical reflexes or expressive reactions to emotional states, his portraits of the middle period go beyond spontaneous physical expressiveness to experiment with a number of conventional poses and gestures. The pose in his self-portrait of 1640 (ill. p. 112), for example (Wright 65), imitates Titian's so-called "Ariosto" portrait (ill. p. 18), with the sitter's sidelong glance and his bent arm resting on a parapet. Another self-portrait, executed in 1659, now in the Mellon Col-

Rembrandt
Self-Portrait, Open-Mouthed, 1630
Etching, first state, 8.3 x 7.2 cm
Amsterdam, Rijksmuseum,
Rijksprentenkabinet

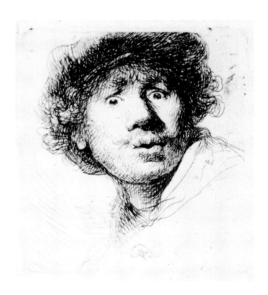

Rembrandt
Self-Portrait, Staring, 1630
Etching, only state, 5.1 x 4.6 cm
Amsterdam, Rijksmuseum,
Rijksprentenkabinet

Rembrandt
Self-Portrait, 1640
Oil on canvas, 90 x 75 cm
London, The National Gallery

In his early etchings Rembrandt experimented with facial expressions to find a way of painting different emotional states.

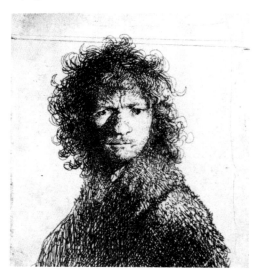

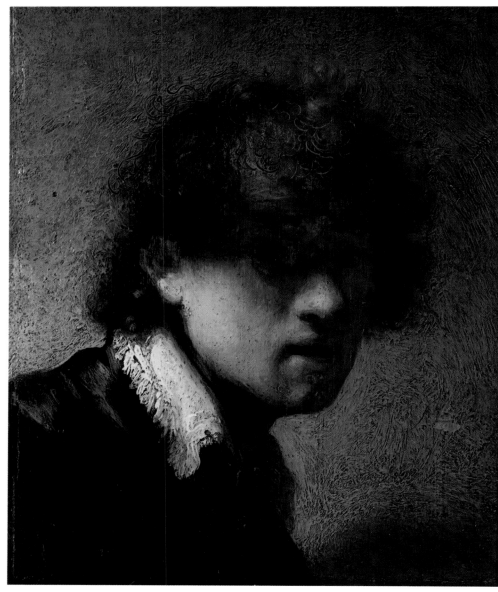

lection at the National Gallery, Washington (Wright 88; ill. p. 115), imitates the type of pose established by Raphael's portrait of Castiglione. Rembrandt purports here to paint himself as a "gentiluomo" (nobleman, gentleman), or "cortegiano" (courtier).

A third form of self-expression explored by Rembrandt is the use of ornamental devices, attributes and costumes to define status and present a calculated, or desirable, image of the self. Thus Rembrandt leaps from one role to another, constantly altering his social position. Sometimes, he appears as a beggar with outstretched hand, sitting on a rock (Wright 27, 1630); there is perhaps good reason, too, for a number of his self-portraits to turn up surrounded by sketched scenes of beggars. At other times, we find him posing as a sophisticated gentleman with reinforced collar, chain of honour, precious stones or other attributes of rank; on one occasion, he paints himself as a prince with a scimitar (Wright 48, 1634, etching. In the same year, interestingly enough, he portrays himself as a burgher wearing a beret). Yet another guise is that of the oriental sultan in a turban, executed in full-length; in this painting, the histrionic artificiality of the scene is underlined by the presence of an alternative costume in the shape of Roman helmets lying on a table behind him (Wright 37, 1631, and 38, c. 1631).[151]

It would, of course, be possible to interpret the enormous variety of roles and poses in Rembrandt's self-portraiture psychologically, seeing them as examples of megalomaniacal wishful thinking, or as the sign of a frustrated social climber, or as a form of imaginative compensation for the suffering he experienced during various critical periods of his life. Some of this may well be true. Beyond mere wish-fulfilment, however, the majority of the approximately ninety self-portraits show Rembrandt mentally reflecting on social structures whose new permeability, flexibility and dynamism were the result of the bourgeois revolution in the Netherlands.[152] Economic aspects played an important role here, too, although not in the superficial sense of a trademark representing the artist's business interest in marketing his own subjectivity, as Svetlana Alpers has suggested.[153] Rembrandt's work elucidated the nature of macro-economic structures

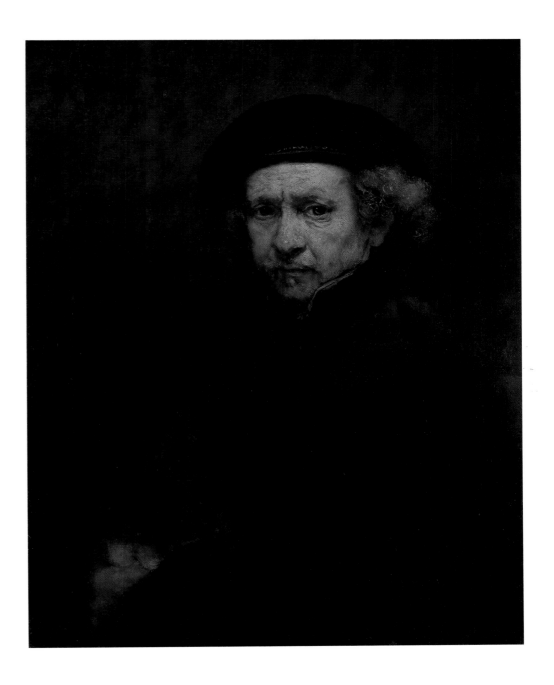

Rembrandt
Self-Portrait, 1659
Oil on canvas, 84 x 66 cm
Washington (DC), National Gallery of Art,
Andrew W. Mellon Collection

to the individual who sought an imaginative grasp of the new social reality.

In his final self-portrait, executed in 1669 (Cologne; ill. p. 116 left),[154] Rembrandt appears stricken by age, stooping, in a state of melancholic mirth. This reverts to the subject of his early physiognomic studies; and yet here, for the first time, Rembrandt's imagined role appears consistent with his real mood. Appearances are deceptive here too, however; it would hardly be permissible to assume the painting represented a proclamation of Rembrandt's true state of mind. For once again, Rembrandt presents us with a visual puzzle, disclosing no more than he conceals. Albert Blankert[155] has found evidence to suggest that Rembrandt portrayed himself here as the Greek painter Zeuxis, after an anecdote related by Karel van Mander: "It is said that Zeuxis put an end to his own life by suffocating on his own excessive laughter one day while painting the likeness of a funny old wrinkled woman... It was this which the poet meant when he wrote: 'Are you laughing too much again? Or are you trying to emulate the painter who laughed himself to death?'"[156]

On the left of the self-portrait there is the blurred shape of a face, probably the likeness of an old woman. The patches of light on the shaft and pommel of the mahlstick denote a studio setting.

Considering the large number of portraits he executed of himself in different roles, very few show Rembrandt at work, or even suggest the nature of his pro-

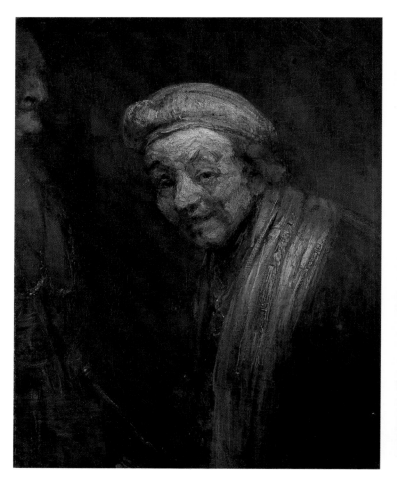

fession. Apart from two self-portraits executed in 1636 and 1648, one of which shows him from the side, drawing (with Saskia in the background), while the other shows a frontal view of him alone, engaged in the same activity, but standing near a window in a dark room, only two paintings from his later period refer to his work as an artist (Wright 89, 1660 and 91, 1667/68). But here, too, the artist concentrates on rendering the face, while his painting utensils are only vaguely suggested. In one of the paintings, in which Rembrandt shows himself actually working at the canvas, his utensils are just visible in the darkness of the setting; in the other, where he seems poised between two bouts of work, his brush and palette have been rendered immaterial to the point of transparency by repeatedly scraping them with the brush and rubbing in left-over paint, while the face, marked by age, is trenchantly modelled in pastose layers of strong colour. The self-portrait in the Frick Collection, showing him sitting majestically on his throne, was probably conceived as a "portrait historié" (portrait showing the sitter in significant historic costume). Here, too, Rembrandt appears to have adopted a role: the ruler casually

holding up a sceptre in his left hand, which is resting on the armrest of his throne. However, since the sceptre can hardly be distinguished from a mahlstick, the impression that we are looking at a self-portrait showing Rembrandt as a painter is probably justified.

Unlike Aert de Gelder, who treated the Zeuxis subject (1685) as a full historical canvas,[157] Rembrandt's self-portrait (at Cologne), by keeping direct allusion to the story itself to a minimum, places emphasis on the representation of the face. The unreflected and disrespectful satirical treatment of deformity has vanished under Rembrandt's treatment; what remains is a vulnerable depiction of the ugliness age has brought to his own features. Rembrandt's laughter does not poke fun at anybody, not even at himself. Too exhausted even to defy his own frailty, it is an expression of the stoic equanimity with which he resigned himself to approaching death.

Hans Holbein the Younger: The French Ambassadors to the English Court

Hans Holbein's double portrait[158] is an early example of the friendship portrait. It depicts the two French ambassadors to the English court, Jean de Dinteville (1504–1555) and Georges de Selve (1508/09–1541). Dinteville, who spent many years in London, probably commissioned the painting to record his friend's visit at Easter 1533. His own figure displays great worldly pomp, wearing an opulent, fur-lined coat and decorated with the Order of St. Michael, while de Selve's clothes, at least in colour, are more restrained. His full-length robe is the appropriate dress for a Bishop of Lavour, an office he had entered upon in 1526, when he was not much older than eighteen.

culated to portray persons and objects as ideal types.

As is often the case in Holbein's portraits (compare his portrait of *Georg Gisze*, ill. p. 8), the objects on the shelves refer to the intellectual interests and professional and practical activities of the sitters. The instruments and books displayed reflect the design of the cupboard itself in that those on the upper shelf would be used for the study of the heavens and heavenly bodies (celestial globe, compasses, sundial, cylindrical calendar, level and quadrant), while the objects on the lower shelf have more to do with everyday worldly matters. Thus, on the left – next to the worldly-minded Dinteville – is an open copy of

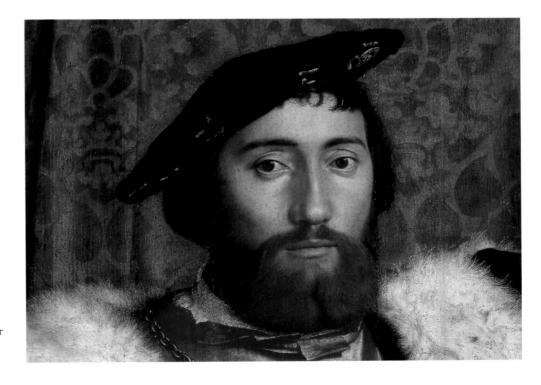

The stange shape rising diagonally into the picture space in Holbein's portrait of the ambassadors is a distorted ("anamorphic") skull. When viewed from the lower left-hand corner of the painting, the image resumes its normal proportions (see ill. p. 120, top).

PAGE 118 AND DETAIL RIGHT:
Hans Holbein the Younger
The French Ambassadors to the English
Court, 1532
Oil on panel, 203 x 209 cm
London, The National Gallery

The two, almost life-sized figures of the ambassadors are shown leaning against a two-storey cupboard, the upper of whose two shelves is spread with a rug, before a green damask curtain. The floor design imitates a mosaic in the sanctuary at Westminster Cathedral, laid by Italian craftsmen at the beginning of the fourteenth century. This shows that Holbein's painting, though appearing to imitate reality with almost photographic attention to detail, is not merely a "reproduction" of reality, but an "invented" composition, cal-

Peter Apian's book of calculations for merchants (published in Ingolstadt, 1527), and on the right – near the bishop – a copy of Johann Walther's "Geystliches Gesangbüchlein" (*Hymnal*) (Wittenberg 1524), containing Luther's hymns. The globe itself, an exact copy of Johann Schöner's globe of 1523, documents their interest in geography, which, due to discoveries made at the turn of the century, had become an increasingly central aspect of humanist scholarship. The cumulative effect of the objects is to demonstrate the ambassadors'

This explains the reason for the anamorphic skull Holbein has painted rising diagonally from the bottom left of the canvas.[159] Its real presence in the ambassadors' world is underlined by the heavy shadow it casts on the floor.[160] Earlier portraitists, Barthel Bruyn for example, had showed the skull, a symbol of the vanity of all worldly things, on the reverse of their paintings, anticipating of the future state of the sitter portrayed on the obverse. Here, however, the skull is less an occult symbol, than lived presence: the cause, no doubt, of the melancholic moods of which Dinteville is reputed to have so often complained. His friend's visit was particularly important to him during such a period of depression. At a time when the state had begun to determine the legal contours of social institutions such as marriage, the relative independence of friendship and the opportunity it afforded for the unsanctioned exchange of feelings and views became more and more important. The terms in which Michel de Montaigne later praised friendship in his "Essais" are therefore hardly surprising: "Each friend entrusts himself so completely to the other, that he has nought left to give to a third."[161]

close association to the scientific and educational community of the Renaissance, a movement considered highly "progressive" at the time. Although religious motifs are present here, they are given secondary status. This testifies to the placatory, tolerant attitude of the Catholic bishop, who, during a period of bitter religious strife, sought to reconcile the confessions. His attitude is documented by two of Luther's hymns in Walther's hymnal. His desire for harmony is echoed in the symbolic presence of the lute. Enlightened humanism had come to see religion as an ethical guide in matters of conduct: it was essential to develop an empirical awareness of physical reality; equally, it was important to be aware of the brevity of life and, constantly, to reckon with death's intervention.

LEFT AND PAGE 121:
Details from illustration page 118
The objects demonstrate the ambassadors' close association to the revolutionary scientific and educational community of the Renaissance, a movement considered highly "modern" at the time.

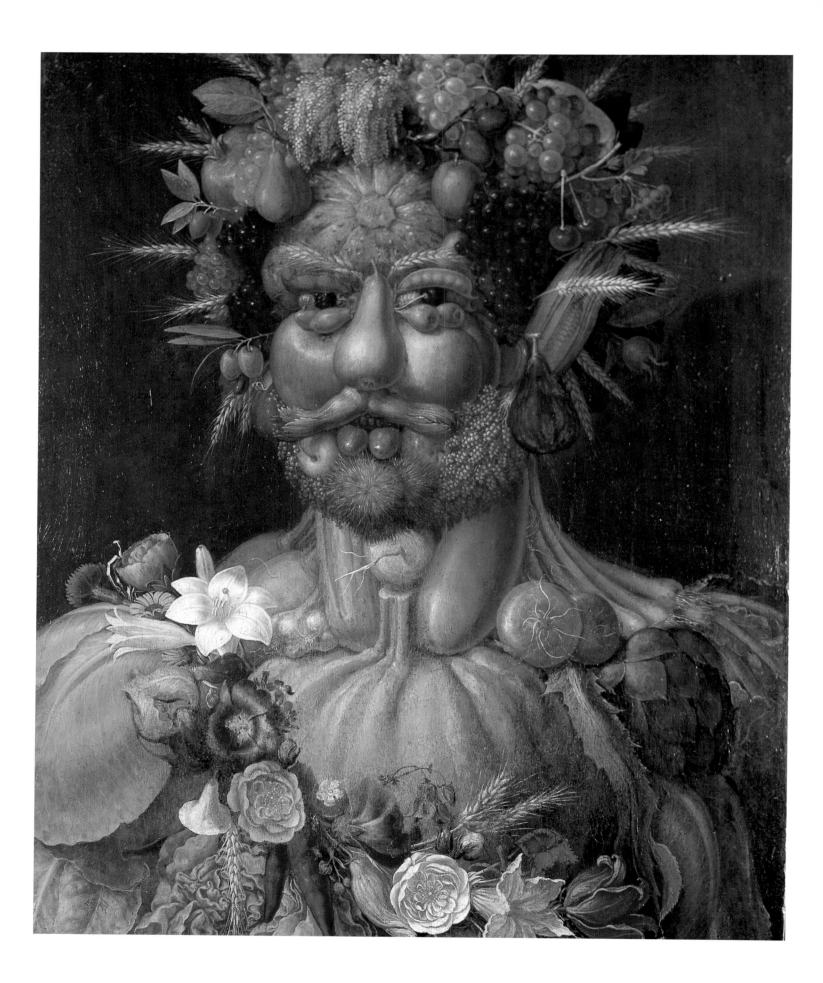

Giuseppe Arcimboldo: Vertumnus

Although they may seem like a parody of portraiture altogether to today's spectator, Giuseppe Arcimboldo's "teste composte" (composite heads), as a contemporary theoretician of art, Giovanni Paolo Lomazzo, called them,[162] were generally given a positive reception when they were first shown. Partly, they were viewed as "grilli", as jokes, capriccios, or "chimaera". Set in relation to Horace's basic precept of "delectare et prodesse" (to be pleasing and useful), they could have a deeper meaning, too, making their apparent banality the object of scholarly discourse. Futhermore, many of these heads, although composed as accurately observed collections of different bits and pieces of reality (thus: personifications of the seasons, of the elements, of various professions), were actually intended as portraits and bore considerable resemblance to their sitters. In so doing, however, they were not thought disrespectful, but often viewed as acts of homage to the emperors Arcimboldo served as "court counterfeiter". (He was responsible, too, for the design of sets for courtly festivals and theatre productions).

The "M" "embroidered" in the staw-coat worn by the allegorical figure of *Winter,* for example – like the *Summer* painting, this was signed in 1563 – is a reference to Emperor Maximilian II, who was crowned King of Bohemia and Hungary in the same year. The personification of *Fire,* executed in 1566, consisting of a match, an oil-lamp, a flint, a candle, burning wood, barrels of cannon and mouths of flintlocks, also contains an allusion to the Emperor. Hung over a coat-of-arms (showing the twin eagles of the Habsburgs) on the end of a bejewelled necklace around the figure's neck, is a Golden Fleece, an order founded by the Burgundian Philip the Good, an ancestor of the Habsburgs. The portrait's intention is even more pronounced in Arcimboldo's *Vertumnus.* The god of vegetation referred to here is Rudolf II who, according to Lomazzo, had asked the artist to make something amusing for him. The protean versatility which mythology ascribed to *Vertumnus* is attributed in this act of homage to the Emperor, with his vast variety of different fields of influence and activity. At the same time, the painting refers us to a principle of aesthetic metamorphosis which Comanini explains in 257 lines of verse in his somewhat verbose "Canzoniere" (1609).[163] Here, Vertumnus calls himself a picture of deformity, bound to make people laugh. But paradox has it that ugliness of this kind is more beautiful than beauty itself. The chaos of the composition, it is said, relates to primaeval chaos, in which everything was mixed up. Arcimboldo, whose art, according to Comanini, outdoes even that of the antique painter Zeuxis, creates the illusion that we are looking at parts of the body when he is really showing us spiked ears of June corn, summer fruits etc. In this sense, the apparent chaos of the composition forms a unity, just as Rudolf II comprises many different things in one person. The ugliness of the figure is compared to that of the "Silen" admired by Plato (Socrates, in other words), who was apparently a "monster" on the outside, but whose inward qualities were quite magnificent.

Giuseppe Arcimboldo
Fire, 1566
Oil on panel, 66.5 x 51 cm
Vienna, Kunsthistorisches Museum

PAGE 122 AND DETAIL BOTTOM:
Giuseppe Arcimboldo
Rudolf II as "Vertumnus", c. 1590
Oil on panel, 70.5 x 57.5 cm
Bålsta, Skoklosters Slott

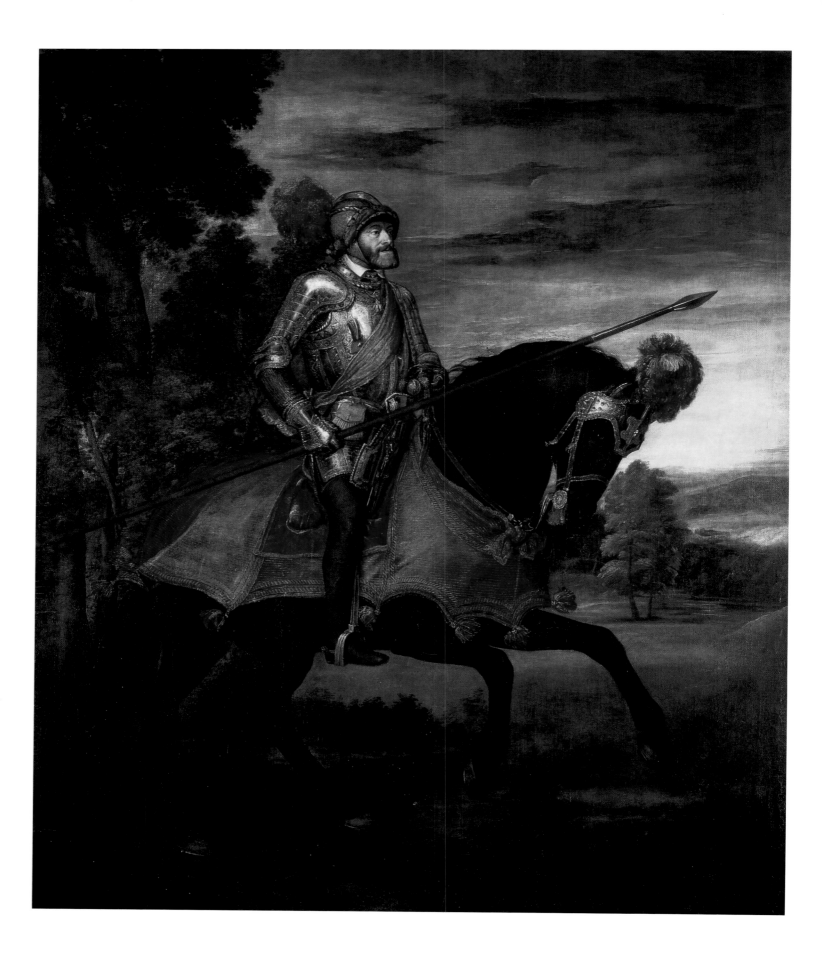

Titian: Emperor Charles V after the Battle of Mühlberg

The equestrian portrait had a pre-eminent role among the portraits of princes and rulers. While the horse had always been considered a privilege and attribute of the nobility, the famous equestrian sculpture by Marc Aurel (ill. p. 26), with its thaumaturgical gesture of blessing or liberation, had become an iconological prototype for the demonstration of imperial power. The statue had served as a model for artists whose task it had been to portray the

situation. Mastery of the art of war was considered one of the foremost duties of every prince. Here, the Emperor has had himself portrayed in full armour on a mighty steed decorated with shabrack and headdress, ready for combat, his lance gripped firmly in his right hand. The painting shows Charles V riding home victorious at dusk, having defeated the Protestant princes of the Schmalkaldic League at the battle of Mühlberg. Charles saw this

"condottieri", the mercerary commanders of the day. Donatello, for example, had executed a posthumous memorial to Gattamelata, while Verrocchio had immortalised Bartolommeo Colleoni in a monument at Venice. The motif of the equestrian ruler had also been prefigured in countless pictures of the journey of the Magi. The figures closest to the picture plane in Benozzo Gozzoli's fresco at the Palazzo Medici-Riccardi are members of the Medici family – the young Lorenzo il Magnifico among them – depicted as kings.

Titian's famous *Emperor Charles V after the Battle of Mühlberg*[164] must be seen against this background. Unlike earlier equestrian portraits of "condottieri", however, Titian's portrait shows its subject in the dramatic historical context of a war

victory as a turning-point, for having suffered the insolence of the opposing princes for long enough, he hoped now to see his power restored and consolidated, and the strain of his office eased.

Titian's equestrian portrait served as a prototype for a number of portraits by Peter Paul Rubens, such as his portrait of the "Cardinal Infante" (c. 1634),[165] or his famous portrait of the Duke of Lerma (1603). In this portrait the Duke is shown on a raised piece of ground before battle. Horse and rider appear in full-face view, which was considered a sensation at the time. Moreover, the effect of the Duke's majestic pose is intensified by the view of him from below, seated high in the saddle against a stormy sky, lit by flashes of lightning. It was a fitting image for the undecided character of a war which had surged

PAGE 124 AND DETAIL RIGHT:
Titian
Emperor Charles V after the Battle of Mühlberg, 1548
Oil on canvas, 332 x 279 cm
Madrid, Museo Nacional del Prado

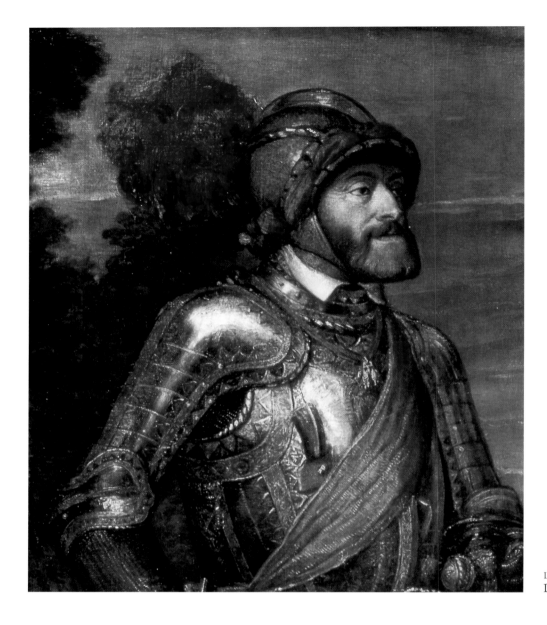

LEFT AND PAGE 127 TOP:
Details from illustration page 124

back and forth between hope and despair, finally ending in victory.

Anthony van Dyck modelled many of his portraits of Charles I on the Lerma-prototype, crowning its sublime pathos by the addition of a triumphal arch, through which the king is shown riding.

Diego Velázquez' manifold equestrian portraits were also influenced by Titian and Rubens. A famous example is the portrait of the Duke of Olivares,[166] which shows Philip IV's chief minister of the interior, foreign affairs and war as a marshal (ill. p.127, bottom right): he is viewed almost from behind on a curvetting horse, looking over his shoulder at the spectator. Since there was a great demand for imposing equestrian portraits at the Spanish court, Velázquez painted a good stock of riderless steeds in advance. Later, on order, he painted in his patrons seated in their saddles.

Franz Krüger's *Outing of Prince William of Prussia on Horseback, Accompanied by the Artist* (ill. p.127, bottom left), executed in 1836 during the Biedermeier period,[167] seems almost a parody on the pathos which portraits of feudal princes had intended. The overcast, sulphur-yellow sky and dust kicked up by the cantering horses are distant reflections of past battle scenes. Instead of armour, however, the prince looking down at his dachshund, like the painter shyly glancing over at him, wears bourgeois clothes; and instead of a lance or a marshal's baton, the prince is wielding a walking-stick.

The horse had been an attribute of imperial power since antiquity (see ill. p.26).

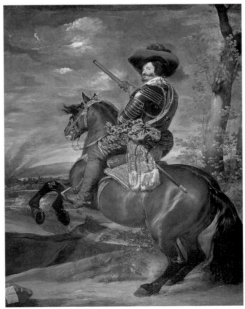

LEFT:
Franz Krüger
Outing of Prince William of Prussia on Horse-back, Accompanied by the Artist, 1836
Oil on canvas, 31 x 24 cm
Berlin, Staatliche Museen zu Berlin –
Preußischer Kulturbesitz, Nationalgalerie

RIGHT:
Diego Velázquez
Duke Olivares on Horseback, 1638
Oil on canvas, 313 x 239 cm
Madrid, Museo Nacional del Prado

Anthony van Dyck: Charles I of England, Hunting

Soon after his graduation as master of St. Luke's painters' guild in Antwerp (1618), Anthony van Dyck, who had worked independently since 1615 when barely more than a youth, started work on a number of important paintings in the workshop of Peter Paul Rubens, who was twenty-two years his senior. Rubens's influence on the style of the younger artist is unmistakable, and this was as good an entry as any to the world of society portraiture, both at home and abroad. Van Dyck specialised in portraiture from very early on. An important early work is the double portrait, actually a pair, of a Genuese senator and his wife (ill. p. 131), probably executed in 1622 during a visit to Italy. It is an early example of the monumental style used by van Dyck to emphasise the power, dignity and rank of his artistocratic patrons, a style which, in spite of the artist's attention to the individual psychology expressed in each face, bestowed upon his sitters a demure sense of reserve, further intensified by painting them against a background of palatial architecture.

In 1632 van Dyck went to London, where he became painter to Charles I.

Here he remained until his death in 1641, except for a two-year visit to Brussels (1634/35). As "principalle Paynter in Ordinary to their Majesties at St. James" from 1633 onwards, and with an annual income of two hundred pounds per annum, he now had the necessary freedom and routine to develop his own style. While remaining within the bounds of conventional decorum, his elegant portraits nonethless allowed the sitter to appear more relaxed.

This is well illustrated by a portrait of Charles I (now in the Louvre)[168] which, during the eighteenth century, entered the collection of Countess Dubarry, who had insisted, rather too boldly as it turned out, that she was an heir to the Stuarts. Unlike many of van Dyck's official portraits of the English king – often modelled on paintings like Titian's *Emperor Charles V after the Battle of Mühlberg* (ill. p. 124), or Rubens's equestrian portraits such as the Duke of Lerma, which show the ruler from below in order to emphasise his sublime grandeur and regal majesty – Charles I is portrayed here almost as a private gentleman, without the insignia or pomp of royalty. A

The glove had an important place in matters of diplomatic protocol, investiture and aristocratic legal culture. Yellow and white gloves were considered especially elegant.

PAGE 129 AND DETAIL LEFT:
Anthony van Dyck
Charles I of England, Hunting
Oil on canvas, 226 x 207 cm
Paris, Musée du Louvre

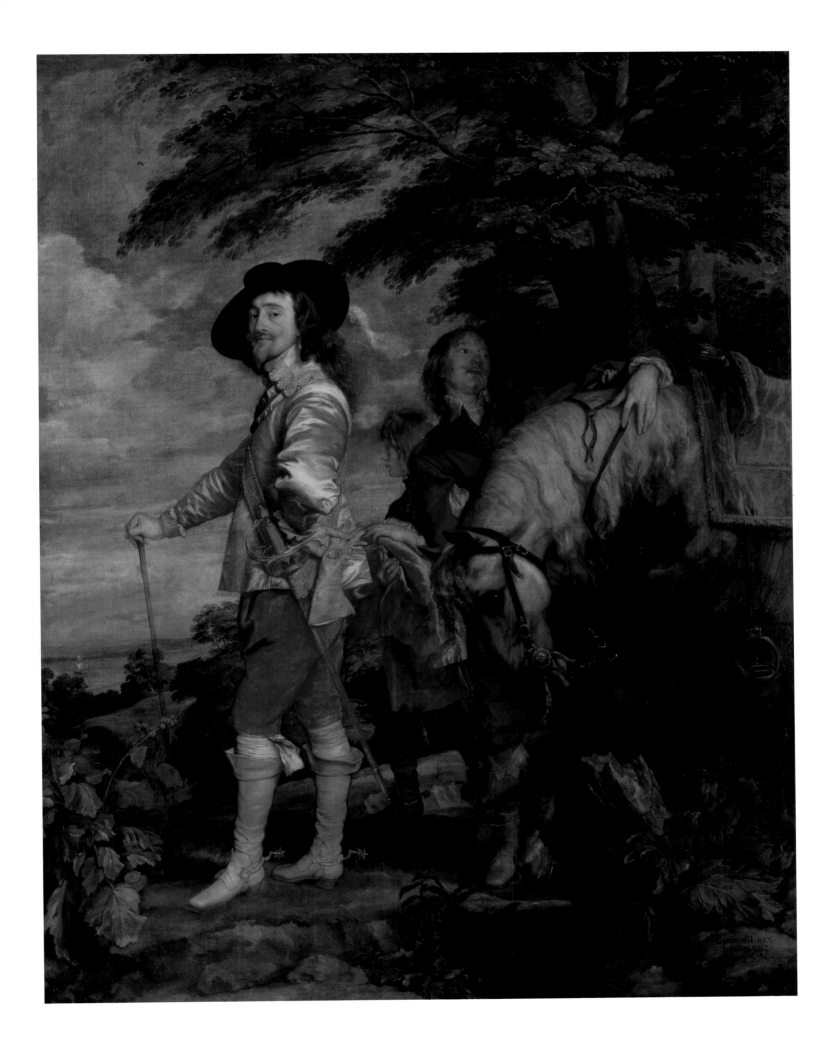

closer look, however, reveals that the purpose of this painting, too, is to demonstrate the power of the throne. Even the theme itself – a hunting trip – refers to an aristocratic privilege. Accompanied by two pages, or stable boys, one of whom is saddling the horse, while the other brings blankets, Charles I stands casually in a forest clearing, posing against a distant maritime landscape. He is wearing a fashionably tilted, broad-brimmed hat, a shining silver doublet and turndown boots. His left hand rests on his hip, nonchalantly holding a kid glove. However negligent the pose may initially seem, its gestural vocabulary was, in fact, quite rigorously defined. The hand-on-the-hip was a setpiece gesture adopted by rulers to impress their subjects, a gesture whose exclusivity became even more visible when non-aristocratic sitters, for example Frans Hals's *Willem van Heythuyzen*,[169] attempted to

imitate it. The glove, too, was a symbol invested with special chivalric significance.

Christopher Brown has rightly pointed out that the impression of casual elegance imparted by this painting must be viewed in relation to the reception of Baldassare Castiglione's *Cortegiano* (for Raphael's portrait of the count, see ill. p.81). The "courtier's code" described in this book had been influential in England since Elizabethan times. Charles I was concerned to appear before his subjects as the ideal, universally educated nobleman, well-versed in all the arts, including that of hunting. Here, his pose is leisurely, unconstrained; at the same time, his regal dignity is intact, commanding a respectful distance between the spectator and himself.

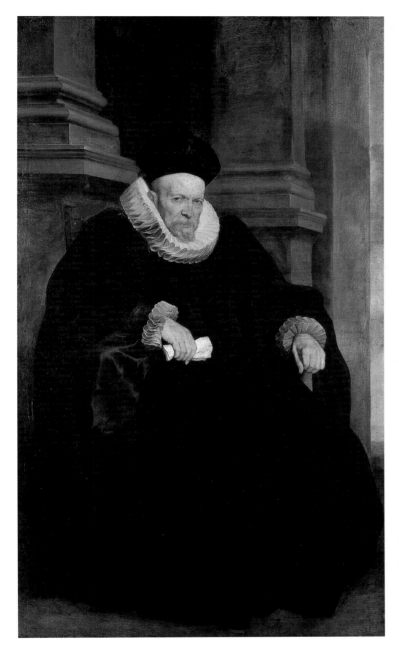

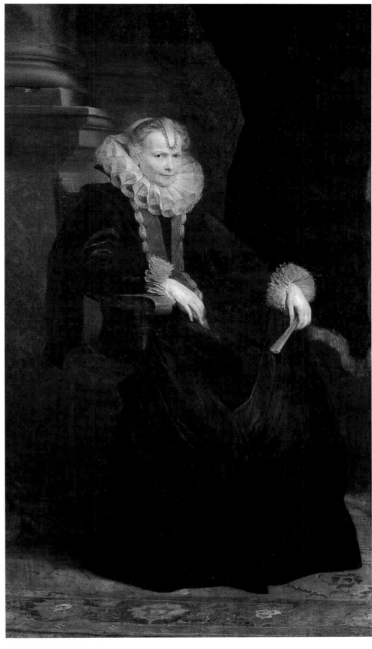

LEFT:
Anthony van Dyck
Genuese Nobleman, c. 1622/26
Oil on canvas, 200 x 116 cm
Berlin, Staatliche Museen zu Berlin –
Preußischer Kulturbesitz, Gemäldegalerie

RIGHT:
Anthony van Dyck
Genuese Noblewoman, c. 1622/26
Oil on canvas, 200 x 116 cm
Berlin, Staatliche Museen zu Berlin –
Preußischer Kulturbesitz, Gemäldegalerie

Anthony van Dyck (1599–1641) ran his own studio from the age of 17. His fame soon spread beyond the Flemish borders. His work was much in demand abroad. He became painter to the English court in 1620/21. In October 1621 he travelled to Italy with letters of introduction from Rubens, whose workshop he had entered in 1617. Van Dyck's portraits of Genuese nobility were modelled on standards set by Rubens's own portraits of noblemen. Rubens had emphasised the dignity and rank of his patrician patrons, commanding the spectator's respect by viewing the sitter from slightly below.

Hyacinthe Rigaud: Louis XIV of France

This portrait, partly owing to the frequent use of reproductions of it in history textbooks, is often viewed as the classic symbol of the absolutist state. Hyacinthe Rigaud painted it when the sixty-three year-old king was at the height of his power. It was the period in which Louis XIV radically implemented his Catholicization policy, persecuted the Huguenots for the second time and wiped out Jansenism at Port-Royal. This "terreur", which Jules Michelet thought even worse than the revolutionary terror of 1793,[170] enabled Louis XIV to stabilise his power, which, according to Jacques Bénigne Bossuet, who coined the phrase, was based on the princicple: "un roi, une loi, une foi".

Hyacinthe Rigaud (1659–1743), whose real name was Jacinto Rigau y Ros,[171] had entered the Académie Royale in 1681, where he soon took second prize in historical painting, established his reputation as a portraitist and entered the services of the French court. His portrait of Louis XIV had been intended for the Spanish court. However, the king's admiration for the portrait was so great that he had it copied, keeping the original at Versailles. It is almost impossible to imagine anything which could outdo this exhibition of courtly pomp and circumstance. The king wears a long, flowing robe with a gold, Bourbon, fleur-de-lys pattern repeated on a blue ground, folded back to reveal to the spectator a full, ermine lining. He is presented in a full-bottomed wig, posing in an attitude similar to, but considerably less casual than, that adopted by van Dyck's *Charles I of England, Hunting* (ill. p.129). Louis XIV rests one hand on a staff – a martial sceptre bearing the fleur-de-lys[172] – while his other is propped on his hip behind the bejewelled hilt of his sword. The king has risen from the throne, which is placed on a podium beneath the vaulted, tasselled canopy behind him. His chief badge of office, the crown, lies on a cushion-topped table, spread, once again, with a fleur-de-lys-patterned cover. Rising behind it is the pedestal of an enormous column, a symbol of power and grandeur, the mark of lasting majesty and stability. Since the days of early Renaissance portraiture – in the work of Giovanni Battista Moroni, for example – the column had featured as an attribute of the aristocracy.

The exposure to view of the ruler's legs is not dandified, as we might assume today, but exemplifies a ritual followed by ruling princes since antiquity. In 1783, Antoine-François Callet portrayed Louis XVI with his knee exposed to view (see ill. p.6), and Ingres continued the tradition in his portrait of the newly enthroned French Emperor Napoleon in 1804.

PAGE 133 AND DETAILS LEFT AND RIGHT:
Hyacinthe Rigaud
Louis XIV, 1701/02
Oil on canvas, 279 x 190cm
Paris, Musée du Louvre

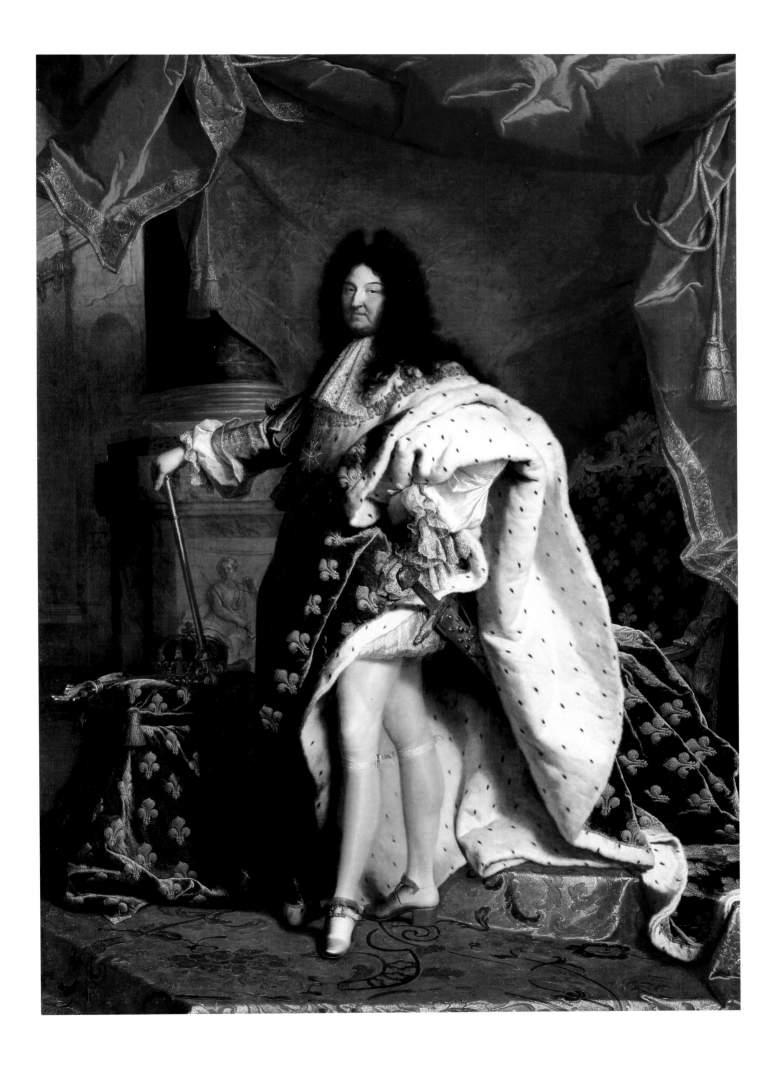

Philippe de Champaigne: Triple Portrait of Cardinal Richelieu

Besides portraits of the actual ruler, it became customary during the period of absolutism to have state portraits painted of prime ministers, the figures in charge of state affairs. The best examples of such portraits are Philippe de Champaigne's likenesses of Armand-Jean du Plessis de Richelieu, who rose to great power under Louis XIII. Richelieu's family had risen to the lower nobility by office; his mother was the daughter of a lawyer, while his father had served as Seigneur de Richelieu, Provost General of the Royal Household under Henry IV. At the age of twenty-one, Richelieu was nominated by Henry IV as candidate for the office of Bishop of Luçon, a position for which his family in Poitou traditionally possessed the right of proposal, and which he finally succeeded in obtaining by skilfully tricking Pope Paul V about his age.[173] The way was now open for this legally adroit clergyman to enter a career in politics. Patronized by Maria de' Medici and Concino Concini, he was eventually appointed Secretary of State in 1616.

Among the other protegés of Maria de' Medici was Philippe de Champaigne from Brussels, who was appointed painter to the court by her in 1628, and put in charge of decorating the Palais du Luxembourg.

Many of Champaigne's portraits reveal the influence of the Jansenists, a Catholic sect supported largely by bourgeois circles whose quasi-Calvinistic severity was directed against Jesuit laxity in matters of faith. One such portrait is the famous "ex voto" portrait of two nuns, of whom one was his own daughter. Considering his religious views, it might perhaps seem odd that Champaigne was commissioned to paint the portrait of a cardinal and prime minister who was responsible for the persecution of the Huguenots. However, Richelieu's background and policy had made him an exponent of bourgeois political thought and a statesman who made determined use of his office to dismantle the privileges of the aristocracy and centralize state power (cf. his edict of 1626). Despite his eminent position within the church, Richelieu, a typically "modern" rationalist, was driven by an ascetic work ethos. His puritanical attitude to state office is accentuated in the famous full-length portrait, of which there are a number of variants.[174] Although the fullness of his cardinal's robe is made quite apparent here, its triangular shape draws the eye upwards to his small, pale face, which, marked by years of tiring office, and partly as a result of the total masking of his body

Philippe de Champaigne
Triple Portrait of Cardinal Richelieu, 1642
Oil on canvas, 58 x 72 cm
London, The National Gallery

Hyacinthe Rigaud
Two Views of the Artist's Mother, 1695
Oil on canvas, 83 x 103 cm
Paris, Musée du Louvre

and rhetorical agility of his hands, seems the focal point of a puritanical force of will directed against the body.

Cardinal Richelieu's face is emphasised even more strongly in a triple portrait (ill. p.134) which unites three views of him, two profile and one frontal, so that the initial impression is of three separate persons communicating with each other. However, this was no caprice intended to attract undue attention, but was primarily painted to act as a model for a bust commissioned from the sculptor Francesco Mocchi (1580–1654). Anthony van Dyck had painted a triple portrait of Charles I of England to the same end for Giovanni Lorenzo Bernini.[175] Whether or not Hyacinthe Rigaud's portrait of two views of his mother (ill. p.136) was intended as a model for a sculpture has never been fully explained. It is difficult not to see a parallel between the creation of an apparent group portrait out of two or three different views of one sitter, and the split of the ego of the solitary, narcissistic individual engaged in exploratory, internal dialogue. This trait was of particular interest to the moralists of the day (e.g. Michel de Montaigne). A recurrent form of schizoid depersonalisation found in the seventeenth century was expressed in the theme of the "Doppelgänger", a motif especially popular in Spanish literature.

The painting of three different views of the sitter's face may have been inspired by knowledge of the "Prudentia" theme[176], a subject of central importance in Italian painting of the Renaissance. A fifteenth-century Florentine relief (London, Victoria and Albert Museum) shows an – admittedly syncretistic – allegory of prudence in the form of three faces. This can be traced back to Cicero's discussion of "prudentia" as a human quality consisting of three parts – "memoria" (memory), "intelligentia" (understanding) and "providentia" (foresight) – each of which, in turn, corresponded to a temporal dimension: past, present or future (Cicero, De inventione II, 13). Inscribed on an allegory of prudence attributed to Titian are the words: EX PRAETERITO/PRAESENS PRUDENTER AGIT/NI FUTURA ACTIONE DETURPET (from the past come the wise actions in the present of a person who wishes to make no mistakes in future). This could almost be Richelieu's motto, a man who took every known factor into account before coming to a rational decision.

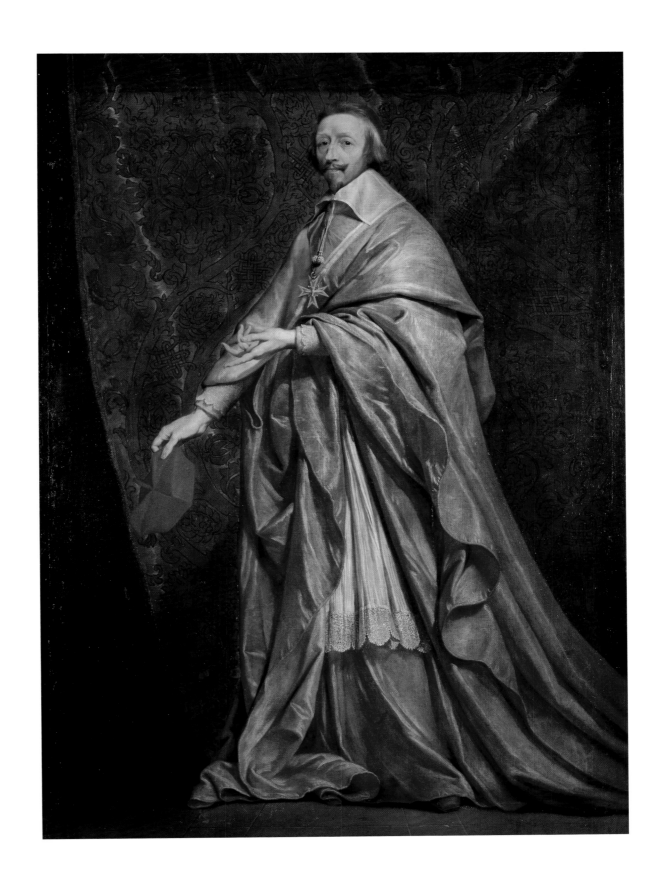

Philippe de Champaigne
Richelieu
Oil on canvas, 222 x 165 cm
Paris, Musée du Louvre

Peter Paul Rubens: Rubens and Isabella Brant under the Honeysuckle

Peter Paul Rubens
Isabella Brant, the Artist's First Wife, c. 1622
Black, red and white chalks, pen and ink on
light brown paper, 38.1 x 29.2 cm
London, British Museum

Following his return from Italy, Peter Paul Rubens married Isabella Brant, the daughter of a respected patrician and secretary of state. To mark the occasion, he painted this double portrait. He had spent the previous eight years working for the Duke of Mantua, in whose service he had been sent on diplomatic missions to Spain, Venice, Rome and Genoa. Rubens, the son of an Antwerp lawyer, had graduated as master of St. Luke's painters guild in Antwerp in 1598. Since then he had come into frequent contact with courtly society, developing manners that would have been becoming in a person of aristocratic birth, while maintaining his bourgeois sense of freedom and independence of mind. Intellectually, he had reason to be grateful to Justus Lipsius, the teacher who had schooled him in Stoic philosophy.[177]

In his portrait Rubens transforms the joining of hands – the "dextrarum junctio", still considered a legally binding, ritual gesture of betrothal in Jan van Eyck's Arnolfini-portrait (ill. p. 34, top left) – to a sign of loving tenderness, playing down the more official aspect of the ceremony without losing respect for the gesture's legal and symbolic significance. Love and affection are shown as the basis of the union, and the free decision of each of the spouses to enter marriage is underlined, irrespective of legal relations governing their property. It is nonetheless apparent that affluence, luxury, rank and reputation ulti-

mately form the material basis of their union. This is especially evident in the couple's clothes. Rubens himself, his left leg crossed casually over his right, is wearing an elegantly fashionable costume with a pressed lace collar, while Isabella Brant wears a long, voluminous, red silk skirt, with a lace ruff encircling her lace bonnet and high yellow hat. Her bejewelled bracelet displays her family wealth. The sword hilt nonchalantly held in Rubens's hand – his hand partly hides it, partly attracts the spectator's attention to it – is a casual reference to the quasi-aristocratic status of the artist. The relationship between the sexes initially seems egalitarian; a hierarchy is suggested, however, by the fact that he is sitting, while she kneels on the grass.

The couple is posed in an arbour under some honeysuckle. Traditionally, in Italian betrothal and marriage portraits of the Renaissance – in Giorgione's *Laura* (ill. p. 61), for example – bushes and other such settings or backdrops were included as symbolic attributes or emblematic decorations, while here the honeysuckle appears natural, a bush blossoming in a real garden or landscape. The symbolism seems quite coincidental: "longer-the-better" was a popular name for the shrub. Whereas the couple in van Eyck's Arnolfini-portrait is seen in a parlour, Rubens's double portrait suggests that "his" couple has left the interior for a "love garden", or pleasance, a

PAGE 139 AND DETAIL RIGHT:
Peter Paul Rubens
Rubens and Isabella Brant under the Honeysuckle, c. 1609
Oil on canvas on oak panel, 178 x 136.5 cm
Munich, Alte Pinakothek

Rubens married Isabella Brant (1591–1626), the daughter of the Antwerp patrician and humanist Jan Brant (1559–1639), on 3rd December 1609. The double portrait which he painted to mark the occasion is set against a natural background, a pastoral idyll emphasising the happiness and loving tenderness of the moment rather than the offical ceremony.

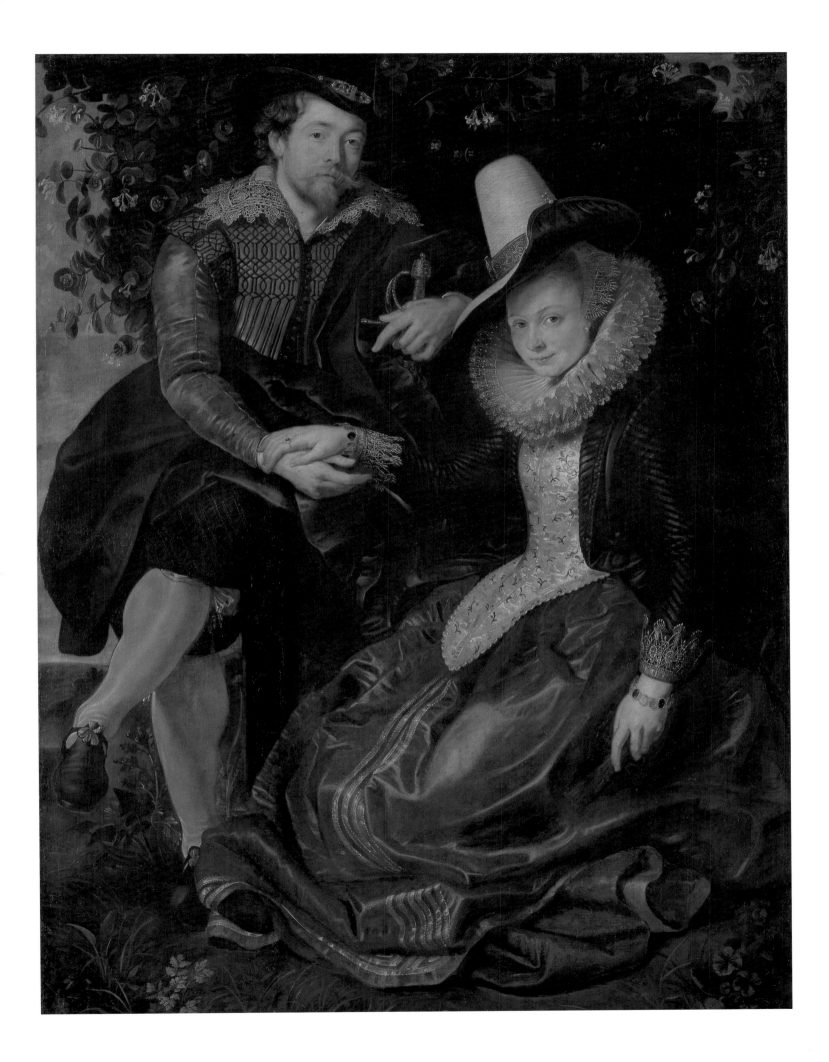

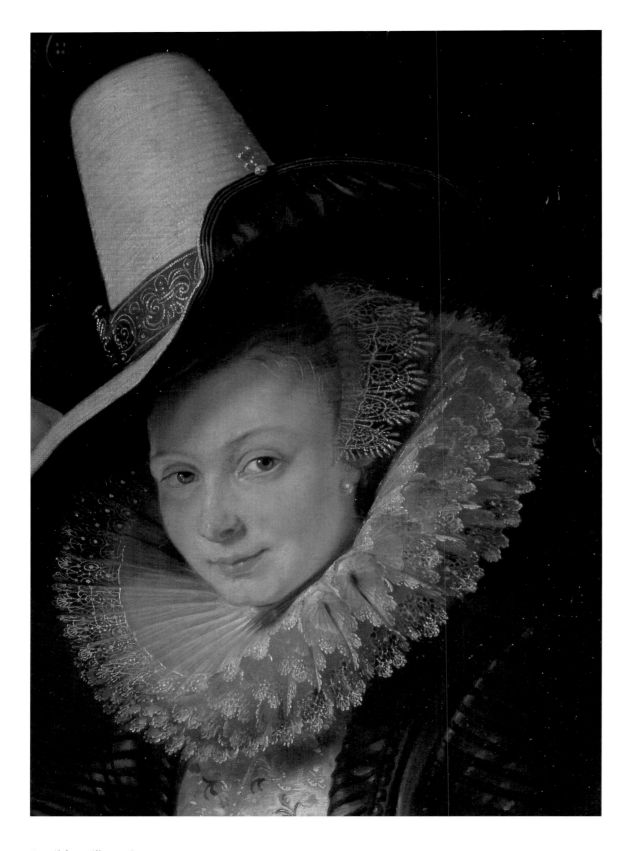

Detail from illustration page 139

sphere of human happiness in the natural world. The tradition of the pastoral idyll, with its utopian allusions to a Golden Age and the Garden of Eden, had been revived in the literature of the period.[178]

In 1622, almost two decades later, Frans Hals returned to Rubens's subject of the seemingly unconstrained and unconventional couple under the honeysuckle, exploring the theme in a portrait which probably shows Isaak Massa and his wife (ill. p. 141).[179] The pose of the recently married couple, leaning against the trunk of a tree, emphasises the casual air of the portrait. The ivy twining itself around the tree and curling round at the woman's feet, who, in turn, has her hand negligently resting on the man's shoulder, symbolises the permanence of marriage. The thistle growing next to the man in the bare patch of ground at the bottom left of the picture may be an allusion to God's words to Adam after the Fall: "Cursed is the ground for thy sake; in sorrow shalt thou eat of it all the days of thy life; thorns also and thistles shall it bring forth to thee." (Genesis 3, 17 f.) Thus, the thistle may symbolise labour, itself a consequence of the Fall.[180] In puritanical Calvinist ethics, which had already gained considerable currency in the Netherlands, work was considered a cardinal virtue, and achievement a central aspect of personal conduct.

While Peter Paul Rubens found it neither desirable nor necessary – at least in his *Honeysuckle* painting – to add ennobling background scenes, Frans Hals's work for his Dutch bourgeois couple included an Italian landscape background on the right – a sunlit villa, marble statue and spring – whose purpose was to create the impression of elevated rank and dignified elegance. However, the background features are fanciful, bearing no relation whatsoever to the real world of the couple. Rather than the couple's country residence, scrutiny of iconographical details shows the villa to be the temple of Juno, the goddess of marriage, whose attribute was the peacock.

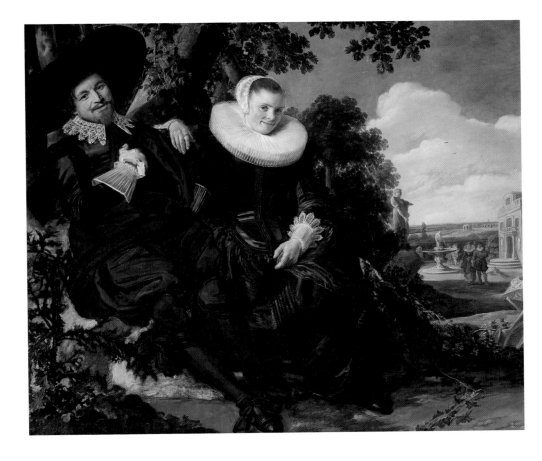

BOTTOM AND DETAIL TOP:
Frans Hals
Isaak Abrahamsz Massa and Beatrix van der Lean, 1622
Oil on canvas, 140 x 166.5 cm
Amsterdam, Rijksmuseum

Marriage and Family Portraits 141

Jacob Jordaens: The Artist and his Family

In this almost quadratic picture, which entered the Prado from the collection of Philip IV in 1829, the Flemish painter Jacob Jordaens proudly presents himself and his family.[181] The view from below – eye level is practically ground level – lends the subject dignity. The use of this optical device allows Jordaens to portray himself in an almost aristocratic light. In 1621 he was made Dean of the Guild of St. Luke in Antwerp and later carried out a large number of royal commissions, both independently and under Rubens's guidance.

The composition defines family gender roles. Jordaens himself stands on the right, one foot casually supported on the cross-

she is shown here holding a basket of grapes. This role is usually ascribed to children in seventeenth-century Netherlandish family portraits. The grape-motif is a symbol for the strength of familiy ties, based on the old meaning of the Eucharist.[182] The girl is probably between thirteen and fifteen years old. If she were really the daughter of the artist, who married the daughter of his teacher Adam van Noort in 1616, then the portrait could not have been painted in 1620/22, as is generally supposed, but must have been executed eight to ten years later.

Jordaens, like Rubens, saw himself as a scholar. Indeed, notwithstanding his mem-

bar of a raised chair. His right hand leans on the chair's backrest, while his left holds the neck of a lute. His wife, wearing elegant clothes and a large ruff, sits on the left on a lower chair, her arms casually holding her little girl. In her hands, the girl has a basket of flowers and an apple. In the middle ground, between husband and wife, is another girl, who, although also shown frontally, is the only figure not to gaze directly at the spectator. The older girl is generally held to be a servant. However,

bership in what amounted to a guild for craftsmen, he saw himself as a highly sophisticated court painter. This portrait, for example, is full of hidden allusions to his status and to his – albeit hardly unconventional at the time – ideas on marriage and the family. A putto at the top left of the painting suggests marriage is a union based on love, not merely on property. The putto is riding a dolphin, which, since early Christian times, had been viewed as an archetypical symbol – often in relation to the

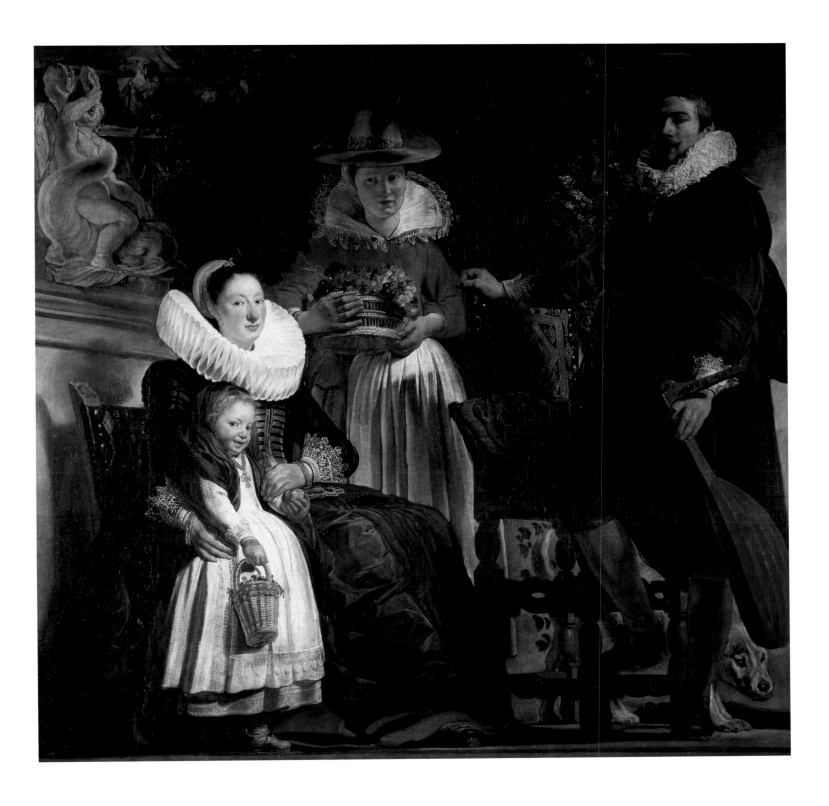

story of Jonas – for Christ's death and resurrection.[183] Marriage is thus portrayed as a union founded on faith. The parrot in the top left, a Marian attribute, is, by allusion to the purity of the Virgin, a cipher for the chastity expected of married women. The dog behind the artist is a symbol of devotion (compare van Eyck's *Arnolfini* portrait, ill. p.34, top right) implying – as a kind of "quid pro quo" for his wife's promise of chastity – the conjugal fidelity sworn by the husband.

As in Frans Floris's family portrait (1561; Lier), the musical instrument stands for "concordia", family harmony. At the same time, in recalling Leonardo's description of an elegantly dressed painter listening to music and standing at his easel, it points to the artist's privileged status in society. In this sense, it is interesting that Jordaens has chosen to portray himself in the privacy of his family, rather than in a professional setting.

Jacob Jordaens
The Artist and his Family, c. 1620/22
Oil on canvas, 181 x 187 cm
Madrid, Museo Nacional del Prado

Giovanni Francesco Caroto: Boy with a Drawing

It is no longer possible to ascertain whether this small-format work by the Veronese painter Giovanni Francesco Caroto was originally intended as a portrait.[184] It shows the smiling face of a boy with long, flowing red hair. The boy has turned his head out of profile to look at the spectator and is holding up a child's scribbled drawing. Probably, however, it is quite correct to see it as a portrait, since its subject bears no relation to any of the other genres becoming increasingly established in sixteenth-century painting. It is remarkable for the way it shows, probably for the first time in painting, a specifically childlike represention of reality, giving the spectator an amusing opportunity to compare the child's view with that of the artist himself. The idea of allowing the spectator to form an expert opinion of the artist's talents by showing reality and its representation within one painting is prefigured in paintings of St. Luke and the Virgin by Derick Baegert (ill. p.144) and Jan Gossaert. The scribbled figure, which the boy proudly holds up to view, seems to be a "self-portrait".

The period was one in which artists – in Italy Leon Battista Alberti, Francesco di Giorgio, Leonardo da Vinci and Fra Luca Pacioli, and in Germany Albrecht Dürer – were studying human proportions in order to establish a formula for the Classical ideal, in other words the rational basis for a canon of perfect beauty. At the same time, however, these artists also began to understand much more about the deviations from the norms they were establishing. It was this which led artists like Leonardo and Dürer to the caricature. The interest in children's drawings to which Caroto's painting testifies probably arose in this context, too. It may have gone hand in hand with a new interest in specifically childlike patterns of perception as such, including their manner of portraying reality in drawings, since the child was no longer merely viewed as a small adult.

Long before Corrado Ricci "discovered" children's drawings for modern child and developmental psychology, Caroto's example of "children's realism"[185] showed that aesthetic perception and the representation of reality were linked to certain mental standards or developmental stages. As an essay in art theory, the painting therefore also relativises dogmatic approaches to artistic method.

Derick Baegert
St. Luke the Evangelist painting the Virgin, c. 1490
Tempera on oak panel, 113 x 82 cm
Münster, Westfälisches Landesmuseum für Kunst und Kulturgeschichte

PAGE 145:
Giovanni Francesco Caroto
Boy with a Drawing
Oil on panel, 37 x 29 cm
Verona, Museo di Castelvecchio

As in earlier paintings of St. Luke, Caroto allows the spectator to compare reality with its representation (assuming the drawing is the boy's "self-portrait").

Jan van Scorel: The Schoolboy

Unlike portraits of aristocratic or courtly children, such as those painted by Agnolo Bronzino or Diego Velázquez (ill. p. 149), showing princes and princesses whose prescribed role is evidently too demanding, whose features are either doll-like or too old, and who, despite all their privileges, seem robbed of their freedom of movement, this young burgher with his red beret has such a fresh, vivacious expression on his face, such a lively desire to learn in his manner, that he seems already a fully developed, confident individual.[186] Indeed, the difference between this likeness and portraits of adults, especially those of sixteenth-century humanists, is only one of degree. The age of the boy, whose alert gaze is fixed directly on the spectator, is given by an inscription in Latin as twelve years (AETATIS XII). In his desire to work he has picked up a quill and looks as if he is about to write something down. Indeed, in his left hand is a note which is already inscribed. The writing, like a code, is laterally inverted: "Omnia dat dominus non habet ergo minus" (The Lord provides everything and yet has nothing less). This sentence, admittedly rather precocious for a twelve-year-old, is thematically linked to the words written in Roman capitals on the painted lower section of the frame: QUIS DIVES? QUI NIL CUPIT – QUIS PAUPER? AVAR(US) (Who is rich? He who desires nothing – Who is poor? The miser). Stoic or Cynic wisdom is expressed here in Christian biblical diction; the postulate of selflessness is probably directed against the boundless avarice of usury, a practice which the church had initially condemned, but later tended to condone. The ideas encapsulated in these quotations are similar to those of humanists like the Spanish writer Juan Luis Vives (1492–1540). It was no coincidence that Vives published his main pedagogical work "De disciplinis" (1531) in the same year as Jan van Scorel painted his *Schoolboy*.[187]

According to Vives, children were born with a spiritual ability to withstand the base materialism of instinctual avarice; this spiritual predisposition was the "germ of all art and science". Jan van Scorel's *Schoolboy* was an early treatment of the theme of childhood, but one in which children were neither infantilised, nor reduced to their "natural state" – a pedagogical ideology later propagated during the age of Jean-Jacques Rousseau.

Hans Holbein the Younger
Schoolmaster's Signboard, c. 1516
Tempera on two panels, each 55.5 x 65.5 cm
Basle, Öffentliche Kunstsammlung,
Kunstmuseum

Jan van Scorel
The Schoolboy, 1531
Oil on panel, 46.6 x 35 cm
Rotterdam, Museum Boymans-van Beuningen

Diego Velázquez: The Infante Philip Prosper

During the last decade of his life, Velázquez executed a series of portraits whose intuitive insight into the "childlike nature behind the façade of regal dignity"[188] makes them possibly the most impressive of their genre.

In 1649, Philip IV of Spain had remarried. His new wife was Maria Anna, the daughter of Ferdinand III of Austria, who gave birth to the Infanta Margarita Teresa and Prince Philip Prosper. Velázquez painted several portraits of Margarita. However, the only existing portrait of the heir to the throne (born 28 Nov. 1657; died at the age of four) is the painting reproduced here (now in Vienna). The portraits of the royal children were intended for the imperial court at Vienna. Those of Margarita were sent as presents in the course of marriage negotiations, for she was betrothed to her mother's brother, Emperor Leopold I, whom she married in 1666.

Velázquez was required by the court to emphasise the pre-eminent social position of the children he portrayed. The portraits must therefore be viewed as official state portraits; they depict the regal dignity and nobility of attitude which the royal sitters had inherited by virtue of birth. Following courtly convention, Philip Prosper is therefore portrayed standing with his right arm outstretched, a pose designed to recall the thaumaturgical gesture of a king. It is nevertheless apparent that the pale, sickly-looking child, who was two years old at the time, is unable to play – much less understand – the historical role ascribed to him. His right hand hangs limply and weakly over the backrest of a red, velvet-covered child's chair, on which his little playmate, a lap-dog, is lying with its nose and one paw slightly extended.

Over his full-length dress, Philip Prosper wears a white apron hung with various amulets whose purpose was to protect the frail little heir to the throne against illness, a practice based on the ideas of sympathetic magic. The portrait may have been executed on St. Prosper's day, marking the prince's second birthday.

Margarita is the main figure in a group portrait which is probably Velázquez's

LEFT:
Detail from illustration page 151

PAGE 149:
Diego Velázquez
The Infante Philip Prosper, 1659
Oil on canvas, 128.5 x 99.5 cm
Vienna, Kunsthistorisches Museum

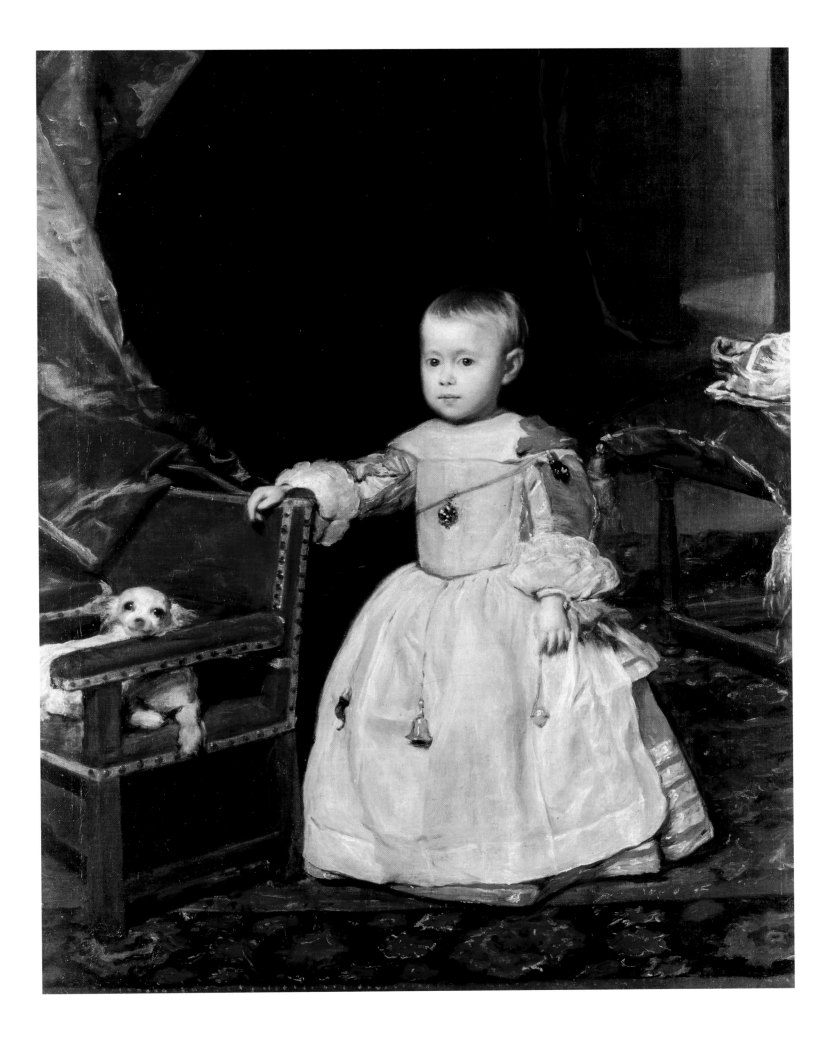

Detail from illustration page 151
On his chest Velázquez wears the Cross of the Order of Santiago, which he was awarded in 1659. It was added to the painting later.

Detail from illustration page 149
It is as if their roles had somehow become reversed: the lap-dog, the Infante's playmate, lies sprawled on the prince's throne.

most famous work of all: *Las Meninas* (The Maids of Honour), executed in 1656 (ill. p. 151). The Infanta stands at the centre of the composition; her head, with its silky, shoulder-length hair, is turned slightly sideways, looking out towards the spectator. Kneeling down, with her head at the same level as that of the Infanta, a maid of honour, Doña Maria Agustina de Sarmiento, offers the Infanta a little pot of drinking chocolate. The other maid of honour, Doña Isabel de Velasco, standing a little behind and to the right of the Infanta, is shown making a curtsey to persons beyond the picture-plane who seem to be approaching the group and whose position is more or less identical to that of the spectator. Maribárbola, the coarse-looking dwarf standing in the lower right corner, seems to be glancing up at approaching persons, too (while Nicolasito Pertusato, the other dwarf, caught in the act of kicking the dog lying on the floor, has not noticed them). The spontaneity of the scene is accentuated by the figure of Velázquez himself, shown stepping back from his work, his palette and brush in his hands. Only the reverse of the large-format canvas propped up against his easel in the lower left of the painting is visible. Also looking out of the picture are two shadowy figures in the middle distance, and, standing at the back of the painting on some steps in an open doorway, the court treasurer Don José Velázquez, presumably one of the painter's relatives.

It is quite possible that the figures grouped in this palace interior have suddenly become aware of the approach of the King and Queen, whose blurred image appears in a gleaming mirror on the wall at the back of the room (beside paintings by Mazo after works by Rubens and Jordaens). As in Jan van Eyck's wedding portrait for Giovanni Arnolfini (ill. p. 32), which was in the Spanish court collection at the time, and may therefore have been known to Velázquez, fictional borders are broken down with the help of a mirror which reflects persons outside the picture space.

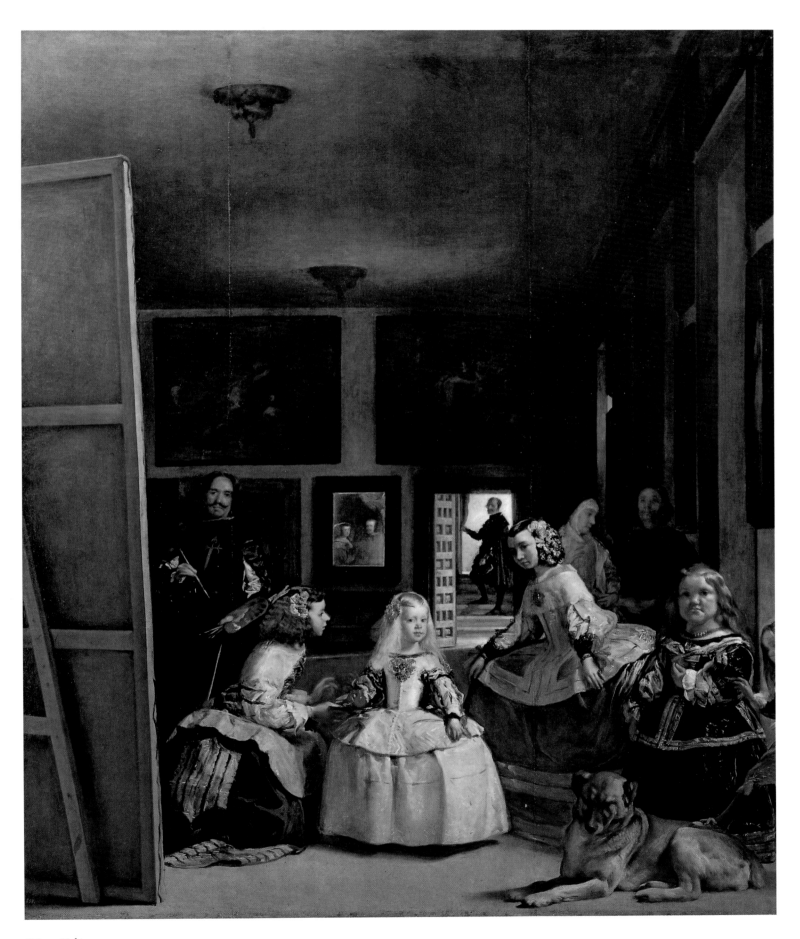

Diego Velázquez
"Las Meninas", 1656
Oil on canvas, 318 x 276cm
Madrid, Museo Nacional del Prado

Portraits of Children 151

Rembrandt: "The Night Watch"

Detail from illustration page 153

Bob Haak has quite rightly pointed out that Rembrandt's so-called *Night Watch* "has a greater historical burden to carry than any other seventeenth-century Dutch painting".[189] Since the nineteenth century especially, when Rembrandt was made the object of a cult of genius, the painting has been obscured by so many different layers of meaning that it has become inordinately difficult to throw light on the conditions under which it was executed. According to popular legend, Rembrandt's use in this painting of an entirely new method of composition so appalled his public that his fall into penury was sealed from that moment onwards. The story draws on the myth of the unrecognised genius whom an insensitive public condemns to tragic isolation. This stock device in the rhetoric of modern art bemoans the fate of the typical secessionist whose rebellion against the dominant aesthetic is fought out at the cost of his secure existence.

However, contemporary sources suggest that the painting's rejection was not as great as was later supposed. Indeed, the evidence tends to point to the contrary. Despite one or two, hardly unusual, critical remarks concerning various practicalities of the painting's execution, Samuel van Hoogstraten described the composition in his "Schilderkonst" (1678) as "dashing". It was "so powerful", he said, "that, according to some, the pictures beside which it was hung were made to seem like playing cards".[190] Filippo Baldinucci reported that the painting was received to considerable acclaim. Rembrandt had "made such a great name for himself that he is better known than almost any other artist in these climes".[191] Although it is demonstrable that Rembrandt now turned away from the group portrait, it would be difficult to establish a causal nexus between this change of direction and the financial crisis which overshadowed his life from then on.

Rembrandt's *Night Watch* – erroneously named, since it depicts an event taking place in the shadows, with patches of sunlight breaking through[192] – belongs to the genre of the "doelenstuk", or militia company piece. The painting shows members of the Amsterdam "Kloveniersdoelen" (civic militia company of harquebusiers). The subject is introduced by a vis-ual pun: the muskets ("kloven" is Dutch for the butt of a gun) which the men are holding, or loading and firing. Moreover, Rembrandt has included a hidden, emblematic reference to the militia company in the middle ground. At the same time, the detail is accentuated by painting it in a bright light: a white fowl, shown dangling from the belt of a dwarflike girl, who may be a sutler – the "claws" (Dutch: "klauw") of the bird are a visual pun on "Kloveniers".[193]

The painting shows only the more wealthy, upper and middle class members of the militia company from Amsterdam's District II, the "Nieuwe Zijde". In fact, the company had several hundred members, while about four thousand civic guards were organised in the Amsterdam companies altogether.[194] To become a high-ranking officer of the civic guards was a means of demonstrating one's rise to political influence. This certainly applies to the two main protagonists here: Captain Frans Banning Cocq, with his red sash and sword, and Lieutenant Willem van Ruijtenburch, with his sunlit yellow uniform, upon which the Captain's hand, giving marching orders to the assembled company, casts its shadow. Frans Banning Cocq was the child of an immigrant from Bremen, who, according to the records, was initially forced to beg in order to survive, but was later able to improve his circumstances by working for a chemist. His son studied, became a Doctor of Law, and was soon a respected member of Amsterdam society. His marriage to the daughter of the mayor, whose considerable wealth he inherited at the age of twenty-five, gave him financial independence and paved his way to high political office in Amsterdam.[195]

Rembrandt's *Night Watch* breaks with an older genre of militia company paintings, of which there were two main types: the banquet group portrait, particularly associated with Frans Hals (ill. p.157), and the full-length civic guard portrait, in which the sitters would usually be shown parading, with guns and unfurled company banner, in brightly coloured officer's uniforms. A characteristic of earlier examples of the genre was their arrangement of figures according to the principle of isocephaly – showing them all the same height

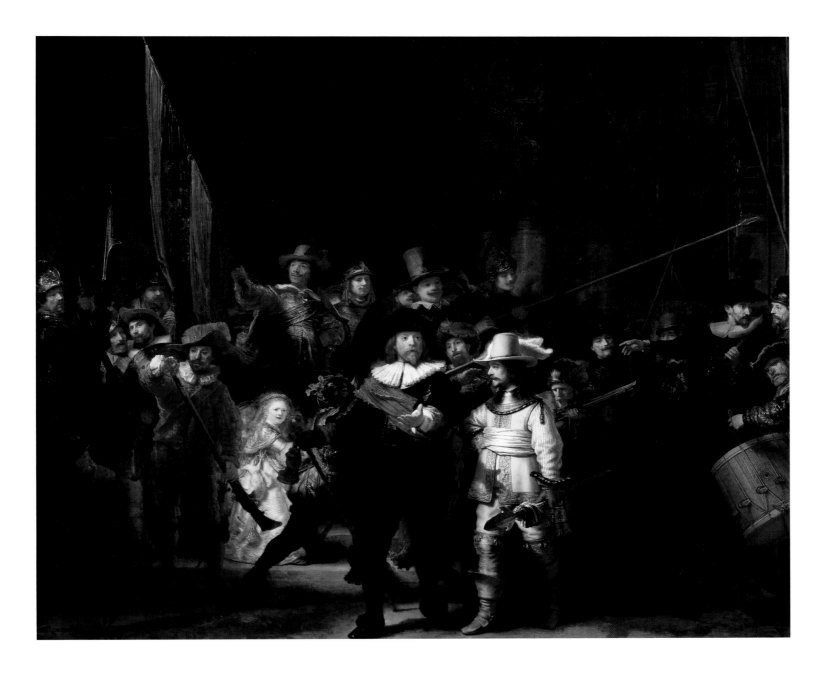

– as seen in works by Dirck Jacobsz and Cornelis Anthonisz (ill. p. 156 bottom).

It was not until the early seventeenth century that this schematic arrangement of figures became less rigid and began to accommodate the idea of narrative. Compositions which had hitherto stressed fraternal equality within the militia company now began to emphasise its hierarchy, gradually transforming the genre of the "doelenstuk" into the history painting. This is anticipated by the prominence given to the officers in Thomas de Keyser's *Militia Company of Captain Allaert Cloeck* (ill. p. 156 top). Rembrandt adapts these formal developments to his own ends, animating the configural arrangement as a whole. Furthermore, he imparts to the setting a dignity and grandeur otherwise considered the exclusive preserve of

the ruling class. He does this partly, it seems, by inventing the architecture in the background himself, since the arch cannot be identified as one of Amsterdam's city gates.

It has never been disputed that Rembrandt attempted to break down boundaries between the portrait and the history painting (considered the highest in the hierarchy of genre paintings at the time), in other words, that the so-called *Night Watch* refers to a particular event in history. The event to which the painting alludes has never been established, however. According to one tentative hypothesis, the painting shows the guards assembling to escort Queen Henrietta Maria of England on 20th May 1642. In this case, the subject of the painting would be an event which took place in the same year as the painting

Rembrandt
The Militia Company of Frans Banning Cocq ("The Night Watch"), 1642
Oil on canvas, 363 x 437 cm
Amsterdam, Rijksmuseum

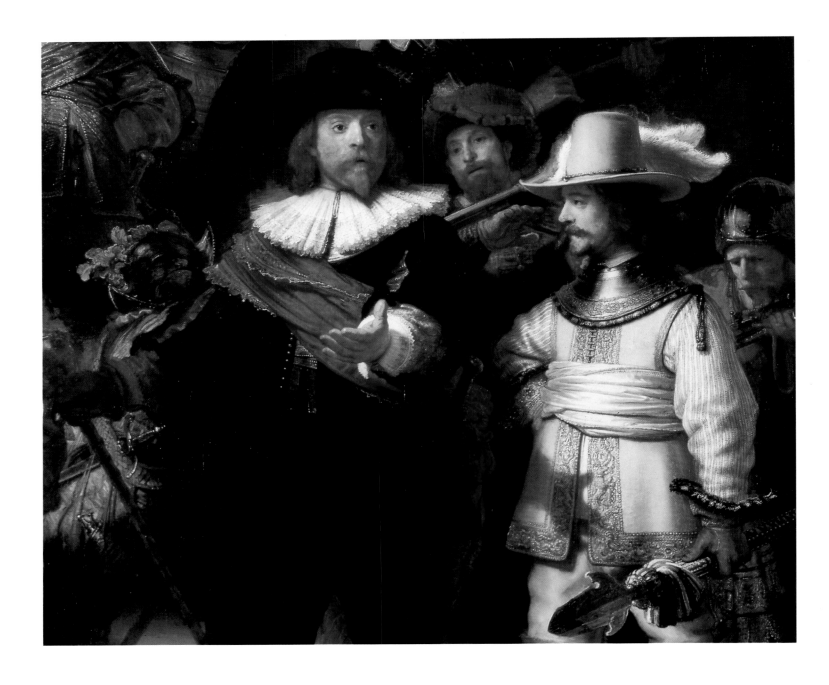

Detail from illustration page 153

was executed. Another theory suggests the painting may refer to the state visit to Amsterdam of Maria de' Medici in September 1638.[196] Whatever the correct answer, it is apparent that Rembrandt's purpose here is to impart nobility to his bourgeois clientele by showing them as historical agents, a role hitherto considered above their station. In so doing, he is not far from illustrating Shakespeare's dictum: "There is a history in all men's lives" (Henry IV, Act III, 1, 80–81).[197] Ennobling his subject, however, does not mean depriving his figures of their spontaneity, a quality indicating bourgeois lack of restraint: a musket going off behind the Lieutenant, for example, or a man loading a gun, another beating a drum or boisterous children dressed in a burlesque martial style.

Turbulence was an essential component of Baroque history painting. Leon Battista Alberti had defined the guiding principle of the genre as "varietá": diversity of movement, gesture and pose. In co-ordinating elements aesthetically that were not co-ordinated historically, Rembrandt gave shape in painting to a principle which had been postulated for drama in contemporary French Classical poetics, namely the unities of time, place and action (later summarised by Pierre Corneille in his "Discours des trois unités", 1660).

The spontaneity of the figures in the painting initially suggests their autonomy, their democratic freedom from constaint. Closer scrutiny reveals the opposite, however. Unlike earlier examples of the "doelenstuk", Rembrandt's composition

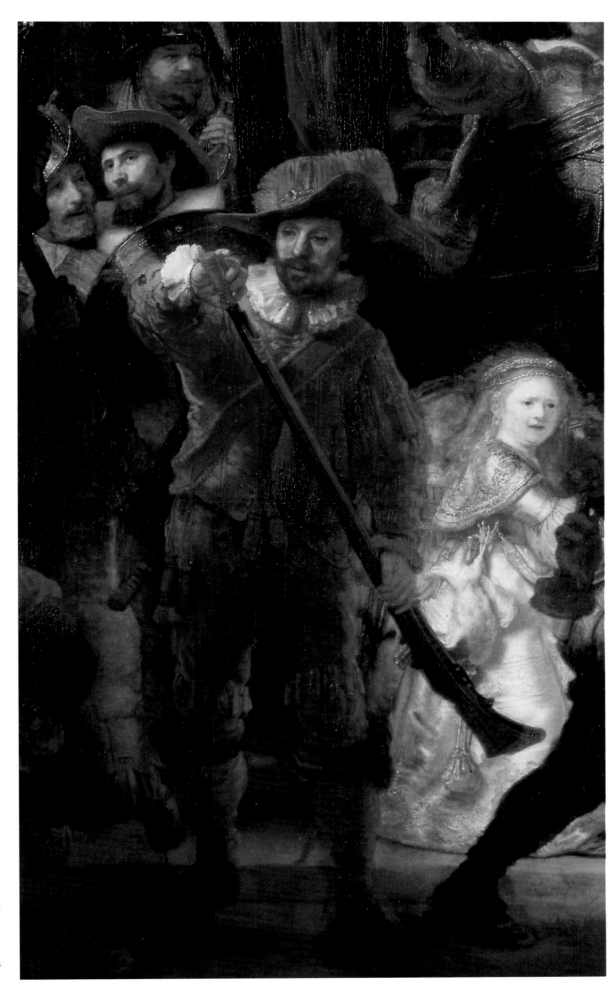

Detail from illustration page 153
The claw (Dutch: "klauw") of
the white fowl hanging from the
girl's belt is a visual pun on the
name of the "Kloveniers" militia
company.

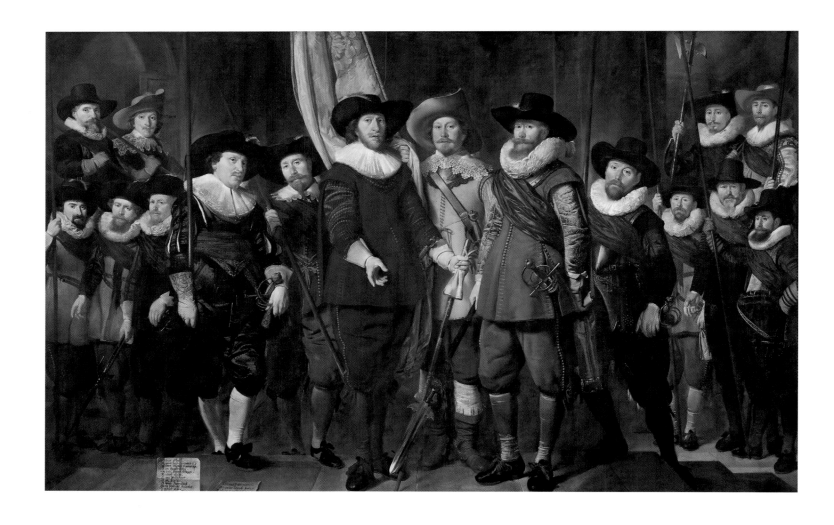

TOP:
Thomas de Keyser
The Militia Company of Captain Allaert
Cloeck, 1632
Oil on canvas, 220 x 351 cm
Amsterdam, Rijksmuseum

BOTTOM:
Cornelis Anthonisz
Banquet of the Amsterdam Civic Guard, 1533
Oil on panel, 130 x 206.5 cm
Amsterdam, Historisches Museum

stresses the dominant positions of the Captain and the Lieutenant. In an original, uncut version of the painting, which has survived in the form of a copy by Gerrit Lundens (London, National Gallery), the emphasis was even more obvious. Here, the action – the assembly and departure of the guard – tapers to a formal conclusion in the figures of the company's two leaders (disregarding the artist's use of lighting, the device is convincingly revealed in Schmidt-Degener's reconstruction of the basic plan of the composition).[198]

Paradoxically, the society depicted here appears to allow the unrestrained expression of individuality, and yet, at the same time, its structure remains rigidly hierarchical. With the old feudal system shaken off, hierarchical structures continued to exist, only now they were based on a consensus achieved by the new principles of bourgeois democracy. The problem was how to reconcile the new power structures with individual freedom of development.

Frans Hals
The Banquet of the St. George Militia Company of Haarlem, 1627
Oil on canvas, 179 x 257 cm
Haarlem, Frans Halsmuseum

A static configuration would have made hierarchical structures more conspicuous. Here they are obscured by synchronizing temporally unrelated incidents, creating the impression of a great variety of un-coordinated movements and impulsive actions.

Frans Hals: The Governors of the Old Men's Almshouse at Haarlem

The governors of hospitals and almshouses were among the most important patrons of the Netherlandish group portrait. Unlike the sitters for paintings of militia companies or archers' guilds, however, these regents and regentesses,[199] as they were called, were not members of traditional professional associations, but the honorary governing bodies of charitable institutions; men and women, usually of aristocratic background, who were appointed by the city's ruling élite.

Since the late Middle Ages, the care of the aged in towns had become a matter of public concern. The growth in commodity relations and the partly violent expropriation of peasant farmers had led to the latters' ruin and consequent migration to towns, where they were exposed to a ruthless system of capitalist exploitation and extortion.[200] Poverty and begging now increased to such an extent that traditional forms of charity, which had existed since the Middle Ages, such as those based on the ideas of Francis of Assisi or Elizabeth of Marburg, no longer sufficed. Following Luther's example, reformers began to put pressure on municipal councils to seek a long-term solution to the problem by setting aside appropriate funds to cover the cost of looking after old people. Wittenberg itself, with its edict of 1521 proclaiming the founding of a "common purse",

was exemplary in this respect, and Nuremberg, with its "Rules for the Dispensation of Alms", perhaps even more so. Nuremberg even appointed public servants to care for the needy. In the Netherlands, the Spanish humanist Juan Luis Vives demanded the endowment of charitable institutions in his book "De subventione pauperum" (On Supporting the Poor).[201]

The mass phenomenon of begging was a source of constant irritation to the burghers and ruling strata of the towns, who found beggars difficult to distinguish from the "traditional" poor. This presented a moral dilemma, since the poor had never been held responsible for their plight. In the Middle Ages, after all, poverty had been accepted as God's will. Soon, however, the ruling strata began to view persons who were suffering hardship, or who were socially marginalised, as lazy or unwilling to work. The upper classes, whose economic interests, based on the principle of wealth accumulation, had led to the widening of the gulf between rich and poor in the first place, thus tended to see the resultant misery as deriving from a congenital ignobility of character in members of the lower classes.

While early sixteenth-century charitable practice had adhered to Martin Luther's dictum "Love serves without regard to reward" (WA 2, 757),[202] increasing penetra-

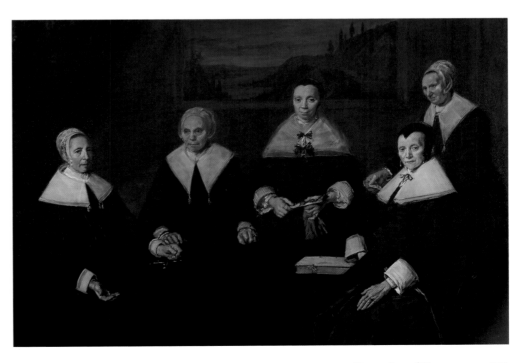

RIGHT AND DETAIL PAGE 158:
Frans Hals
The Lady-Governors of the Old Men's Almshouse at Haarlem, 1664
Oil on canvas, 170.5 x 249.5 cm
Haarlem, Frans Halsmuseum

tion of every sphere of human life by the capitalist principles of wages and profit soon undermined ideals of charity and encouraged demands for the poor to be detained in institutions which would serve their correction. The poorhouses were little more than prisons – sometimes even called so – and were organised according to the principle of centralised manufacture. Their inmates were forced into gruellingly hard labour in return for a mere pittance.[203] Some of the worst working conditions were found in the rasp-houses, where dyeing powder was extracted by rasping logwood. The exploitation of this cheap labour force led to grand profits. Orphanages, or foundling hospitals, and sometimes mental asylums, each with their own regents, or governing bodies, were often found attached to the workhouses. However, there were also charitable institutions offering asylum to those who had fallen on hard times. These included homes of refuge for the ill and aged.

In the sixteenth century, it had been customary for works of art to show the poor in the company of their benefactors – in *The Seven Works of Charity*, for example, or in the scenes accompanying *The Last Judgement*. In seventeenth-century Netherlandish portraits of the governors of charitable institutions, however, human

misery itself, with few exceptions, was evidently subject to taboo, or at least was banished from sight; an invisible barrier thus existed between "selflessly" or "generously" acting dignitaries on the one hand, and the inmates of institutions on the other. The governors remained aloof, avoiding prejudice to their social status which might derive from being seen in company with those whom the age had already branded as virtually criminal: the company, in other words, of persons entrusted into their care. The most they could bear was the presence of a servant, or a wardress; and even then, the servant's lower status was clearly indicated by their being shown bareheaded. The governors would usually sit for their portraits at one of their regular meetings, and they would have themselves shown keeping the minutes, or counting money.

Frans Hals's pair of large-format group portraits of *The Governors and Lady-Governors of the Old Men's Almshouse at Haarlem*, painted in 1664 (ill. pp. 159 and 161), were among the last works commissioned from him. Indeed, he had now become a pensioner himself, receiving, during the last four years of his life, an annual stipend of 200 guilders, awarded by the municipal authorities.[204] Hals executed the portraits in the manner outlined above,

Detail from illustration page 161

at the same time modifying the dominant portrait type: the "regents and regentesses" were no longer placed in a narrative context, depicted carrying out certain typical forms of activity. This had been a compositional achievement of the first half of the century, to whose attainment Hals himself had greatly contributed. Here, however, he showed the sitters in full-face view: plain, rather formal figures, without the faintest hint of swagger. In deference to the sitters' wishes, each of whom paid the artist individually, Hals retained the principle of showing their faces separately. On the other hand, a new quality now entered his work via an unconventional, pre-Impressionist mode of painting: the direct, spontaneous application of paint to the ground ("alla prima"), with its tendency to favour more open forms.

Scholars have frequently suggested that these structural innovations – appearing as they do to anticipate the (aesthetic) rebelliousness of a later avant-garde – must be seen in conjunction with Hals's allegedly critical attitude towards the governors and lady-governors of the almshouse. It has

been said, for example, that the governor whose hat sits askew was given to drunkenness, or to the abuse of drugs, and that Hals wanted to poke fun at him. However, it is demonstrable that the man was actually suffering from facial palsy.[205] It is therefore misleading to indulge this late nineteenth-century cliché by attributing to Hals the motive of revenge for ill-treatment he is reputed to have endured at the hands of his patrons.

As usual in genre portraits of "regents and regentesses", the figures in both paintings are shown against a dark background. On the wall behind the lady-governors is a landscape painting. This probably represents a "paysage moralisé", a morally significant landscape, whose purpose is to provide a "clavis interpretandi", a key to understanding the work:[206] the narrow path winding upwards into the mountains may be an allusion to the "path of virtue", a symbol often encountered in Renaissance art and "emblem books". If so, it may indicate what kind of behaviour was expected of the inmates by the lady-governors.

Frans Hals
The Governors of the Old Men's Almshouse at Haarlem, 1664
Oil on canvas, 172.5 x 256 cm
Haarlem, Frans Halsmuseum

Rembrandt: The Anatomy Lesson of Dr. Nicolaes Tulp

In his "Introduction to Anatomy" Leonardo da Vinci wrote that he had "dissected more than ten human bodies, dismembering every other part and removing every tiny piece of flesh surrounding the arteries without spilling more than a few drops of blood from one or two capillary veins... And even if you are interested in such matters, you may well be deterred by a feeling of disgust; and should this not repulse you, you still might be disturbed by fear of spending your nights in the company of horribly flayed and mutilated corpses; and if this prospect does not put you off, you may yet have failed to acquire the proficiency in drawing which is necessary for such studies..."[207]

Leonardo was by no means the first artist to study pathological anatomy in order to perfect his ability to depict the human body. His teacher Andrea Verrocchio, and Andrea Mantegna, painter to the Mantuan court, had both experimented in this field.[208] Century-old church prohibitions against the dissection of human corpses had gradually relaxed during the last dec-

ades of the quattrocento. Various tentative postmortem examinations had been carried out in the Middle Ages, too – by Mondino de Luzzi (c. 1275–1326) at Bologna (1306), for example. A textbook based on his examinations had somehow managed to escape prohibition for over two centuries.

However, Pope Boniface VIII had forbidden, under penalty of excommunication, all further experiments involving the dismembering or boiling down of human corpses. Leonardo's words, cited above, reveal the sense of novelty, disgust and horror which accompanied the first breaches of this prohibition to be undertaken in the spirit of "curiositas", or scientific curiosity. For even teachers of medicine at the universities had avoided all contact with human corpses. In the late fifteenth century Italian woodcuts had depicted professors of medicine removed from their listeners behind raised lecterns, as they delivered abstract lectures based on anatomical knowledge derived solely from Classical sources like Hippocrates, Galen

TOP:
Anatomical Section
Woodcut from: Johannes de Ketham:
Fasciculo di Medicina. Venice 1493–94

BOTTOM:
Detail from illustration page 163

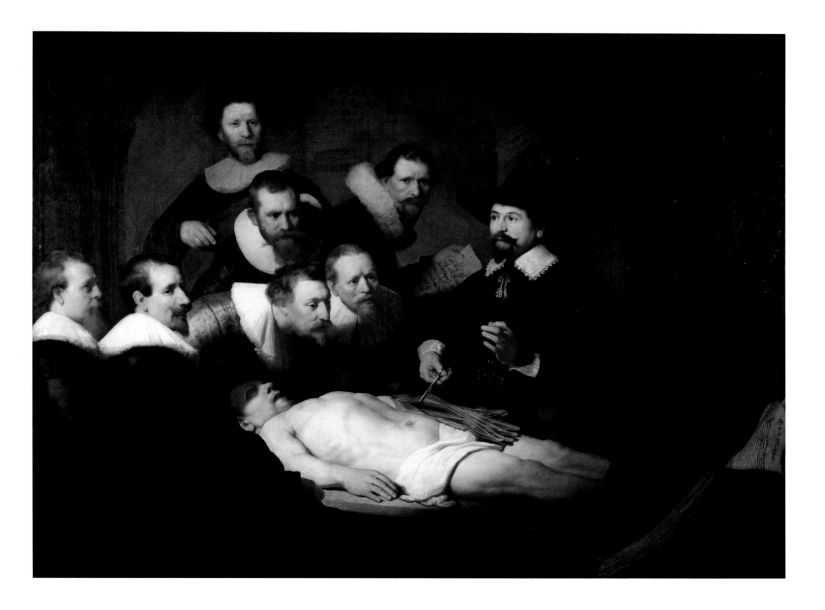

or Dioscurides,[209] while beneath them, surgical assistants dissected real corpses.

This did not change until the sixteenth century. One of the most important testimonies to new developments in anthropotomy, or human anatomy, is the work, based almost entirely on his own observations, of the Netherlandish anatomist Andreas Vesalius ("De corporis humani fabrica", 1543). This work also expressed its author's theological views, for Vesalius saw the human body as a "product of divine handiwork".[210] One interesting aspect of the woodcuts (possibly by Jan Stephan van Calcar) which accompanied the book is the way in which the corpses, depicted to illustrate various systems of arteries, tendons, muscles and bones etc., seem paradoxically vital, moving and behaving as if they were living beings, indeed even reflecting – in a manner possibly also illustating the artist's macabre sense of humour – on the transience of all earthly life.

Rembrandt's famous painting *The Anatomy Lesson of Dr. Nicolaes Tulp* (1632),[211] an example of a type of group portrait cultivated particularly by Netherlandish artists, shows the changing relationship of medical science to the human corpse in the early days of empiricism. A more secular view of death is apparent here in the matter-of-fact attitude towards the corpse demonstrated by the professor and his students. The professor, the only figure shown wearing a hat, has exposed to view the tendons and muscles of the left arm. The corpse – dissections were usually performed on the bodies of executed criminals – lies almost diagonally across the picture space. The listeners, some portrayed in profile, others "en face", are grouped around the dead man's head. They are bending over to compare the empirical data with an open textbook, placed rather inconspicuously in the shadows at the foot of the bed.

Rembrandt
The Anatomy Lesson of Dr. Nicolaes Tulp, 1632
Oil on canvas, 169.5 x 216.5 cm
The Hague, Mauritshuis

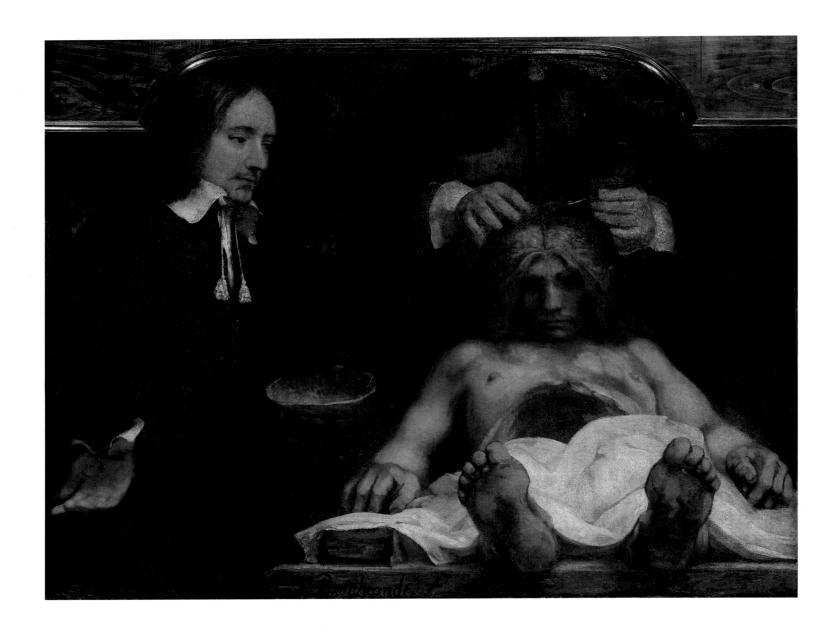

"Rembrandt met his sitters' demands to portray each one of them individually. He also enabled his main subject, an anatomy lesson, to be seen for the first time in its own right."[212] The truth of this statement can only be fully appreciated by comparing Rembrandt's painting with the earliest known painting of an anatomy lesson, executed by Aert Pietersz in 1603,[213] in which the 28 members of the Amsterdam Surgeons' Guild, together with their lecturer, are shown standing in three paratactic rows. The arrangement reveals their desire to be portrayed as separately from one another as possible. The effect is partly to conceal the corpse, making the assembled company look as if it has been engaged in some form of clandestine pursuit.

Attention has too rarely been called to the fact that Rembrandt's composition builds on an earlier type of painting, developed by Gerard David to depict the course of justice when the corrupt judge Sisamnes was flayed alive at the behest of King Cambyses (ill. p.165).[214] The humorous parallel suggested here by Rembrandt – between an executioner's assistant flaying someone alive and a professor of anatomy dissecting a corpse – may have introduced a latent element of criticism in the painting.[215]

The appropriate sense of sobriety brought by Rembrandt to this painting does not seem to have precluded his imbuing it with an equally apparent emotional depth. This is confirmed in a second – albeit fragmentary – "anatomy lesson", presided over by a Dr. Joan Deyman (ill. p.164) and executed in 1656.[216] A preliminary study in bistre and ink (now in the Rijksprentenkabinett, Amsterdam) shows that the painting, which was largely destroyed by fire in 1723, was composed sym-

Andrea Mantegna
The Dead Christ, c. 1480
Tempera on canvas, 66 x 81.3 cm
Milan, Pinacoteca di Brera

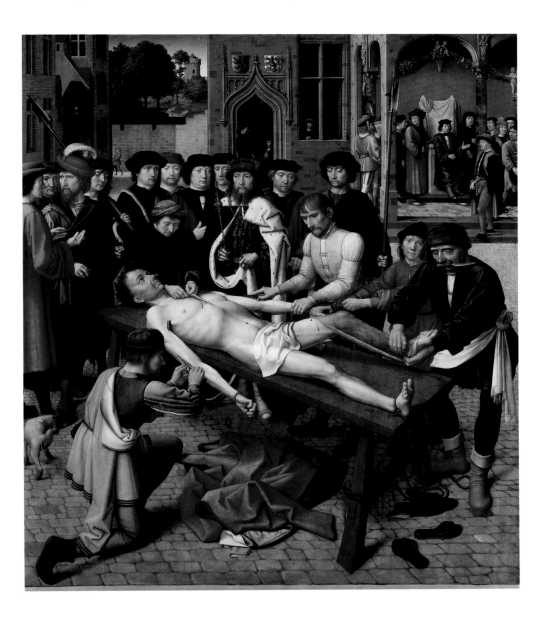

Gerard David
The Flaying of the Corrupt Judge Sisamnes,
1498/99
Oil on panel, 182 x 159 cm
Bruges, Groenigemuseum

PAGE 164 TOP:
Rembrandt
The Anatomy Class of Dr. Joan Deyman,
c. 1656
Oil on canvas, 100 x 134 cm
Amsterdam, Rijksmuseum

Whereas Mantegna wishes to show the grief of the women surrounding the dead body of Christ, the lecturer's assistant holding the skullcap in Rembrandt's painting seems only to be professionally interested in the corpse.

metrically. Small groups of figures are shown standing to the left and right. Behind the corpse – which belonged to a certain Joris Fontein, condemned to death for robbery on 27 January 1656 – is the lecturer, whose hands, holding a scalpel, are all that now remain of him. The top of the skull has been lifted off to reveal the cerebral hemispheres. When viewed from a distance, the scalp, peeled off and hanging down at either side of the head, resembles long, flowing hair, so that the frontal view of the dead man's face recalls certain renderings of Christ. Indeed the compositional arrangement of the dead body, with its feet stretched out towards the spectator, closely follows that of Mantegna's *Christo*

in scurto (c. 1480)[217], one of the most impressive devotional paintings of the early Renaissance. The formal parallel here implies that the dead man in Rembrandt's painting, who has been outlawed by society, and whose mortal remains have been denied all sanctuary and due respect, is redeemed in Christ's words: "Inasmuch as ye have done it unto one of the least of these my brethren, ye have done it unto me" (Matth. 25, 40). Spirituality, and, by extension in Rembrandt's painting, social pathos, had played an increasingly important role in the artist's work during the 1650s. The subject of the painting may even have been a deliberate reference to the biblical passage cited above.

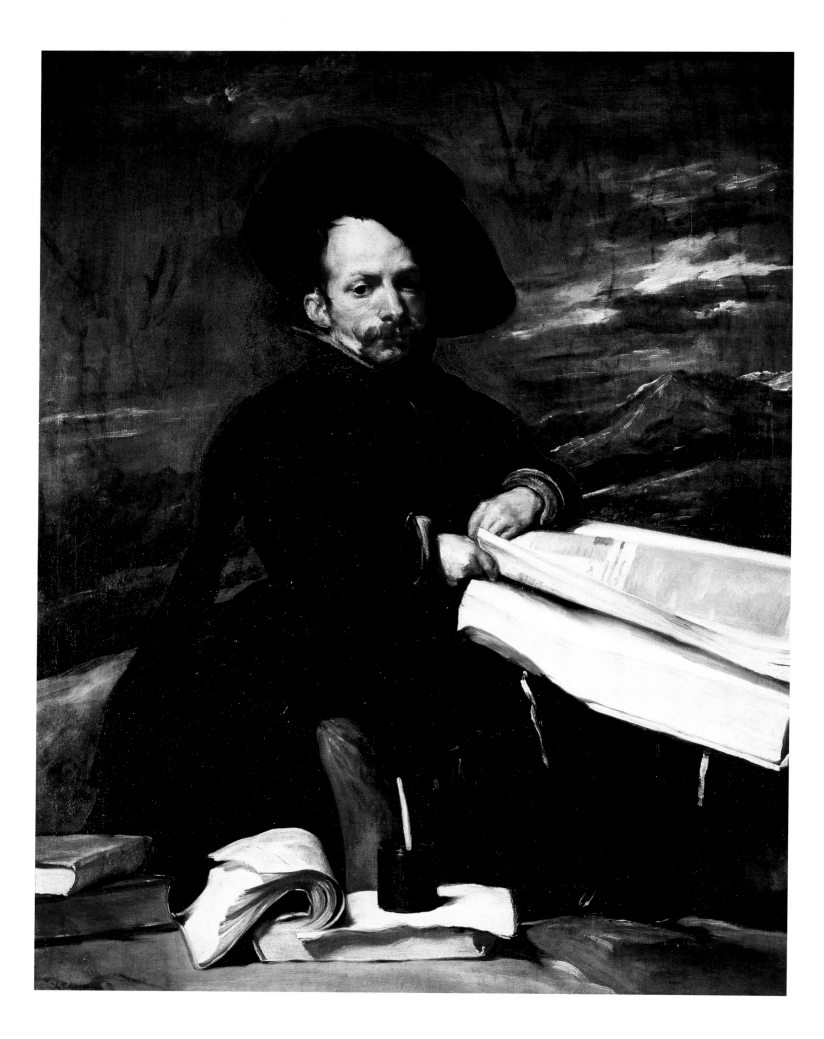

Diego Velázquez: The Dwarf "El Primo"

It was customary at the courts of Europe during the seventeenth century – indeed, right up to the French Revolution – for monarchs to keep dwarfs. Together with other "prodigia" (monsters), these "errors of Nature", as one contemporary referred to them, provided a source of amusement. "Considered rare attractions at the royal courts, dwarfs were bought and sold throughout Europe. They were decked with finery, adorned with jewellery and gold, and shown off at ceremonies of state, or on festive occasions. Often, they were presented as gifts, or as a surprise spectacle, a fashion to which not even church dignitaries were immune."[218]

This "fashion", which had spread to Europe from the Ottoman court, was linked to yet another, similar custom. For their entertainment aristocratic households would keep a number of fools who were privileged to make witty or pointed remarks and to engage in provocative parodies, thus challenging legal and conventional taboos and providing an anarchic counter-balance to the vacuum of critical opinion at court. Undoubtedly, this showed the survival – albeit in isolated pockets, and in much reduced form – of the medieval tradition of "fooles", whose carnivalesque origins probably lay in the Roman Saturnalia, and whose burlesque goings-on set up a kind of popular political and ecclesiastical opposition for a short period of every year (between the end of December and Epiphany on 6 January), exposing many feudal institutions, especially those of the church, to ridicule and criticism. The tradition of oppositional jest had then entered the early absolutist courts via the travelling conjurers, the "ioculatores".

Since the late fifteenth century there had been an increasing demand for the normative ideals of logic in reason and regularity in appearance – the attempt, for example, to establish a canon of proportions for the expression of ideal beauty has been referred to above (see ill. p.73f.). Deviations from such norms must increasingly have come to appear comical, or grotesque, or as crimes against a nature whose very essence was thought to be ordered uniformity. Indeed, without the existence of norms, the mere sight of deformed, crippled or mad people,[219] or the lack, or imaginary lack, of "iudicum" (powers of discernment), could not have provided occasion for scorn and ridicule. At the same time, the image of the fool tended to oscillate between one that saw him as unnatural, the representive of everything that was evil and sinful, and its opposite, in which the fool's wisdom lay precisely in his innate access to a language mentally distorted enough to adequately describe the absurdity of reality. The latter notion played a role in Erasmianism,[220] a humanist school of thought, widespread among the Spanish, educated élite of the sixteenth and early seventeenth centuries, based on works such as Erasmus's (cf. ill. p.89) "In Praise of Folly" (Moriae encomion). Enlightened parodies of conventional thinking now began to attribute a positive meaning to terms such as "stultitia" (stupidity) and "insania" (madness).

It is not known whether Diego Velázquez sympathised with Erasmianism. Nonetheless, his sympathy for the fools and dwarfs of the Spanish court is obvious: in the pathos and humane understanding demonstrated by the single portraits with which he (and he alone) paid tribute to them. It has been pointed out that courtly etiquette – for seating arrangements at audiences, for example, or for seat-numbering at bull-fights – placed Velázquez in the same category as dwarfs and fools. As "Pintor del Rey" (Painter to the King) he was relegated to the fourth row among the barbers and footmen.[221]

A particularly impressive portrait is Velázquez's painting of the dwarf Don Diego de Acedo, alias *El Primo* (The Cousin), probably commissioned by the court and executed at Fraga in about 1644.[222] Like the midget Sebastian de Morra[223], who served in the retinue of the Infante Don Fernando and Prince Baltasar Carlos, El Primo is shown sitting, and is viewed slightly from below. The effect of presenting them from this dignified aspect is to raise their status in the eyes of the spectator. El Primo is portrayed leafing through the pages of an enormous tome. His small size makes the

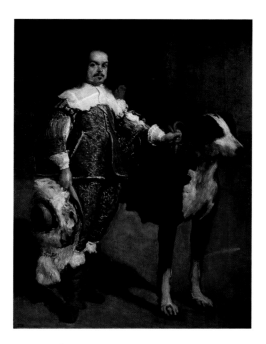

Diego Velázquez
The Court Dwarf Don Antonio el Inglés
Oil on canvas, 142 x 107 cm
Madrid, Museo Nacional del Prado

Diego Velázquez
The Dwarf "El Primo", 1644
Oil on canvas, 107 x 82 cm
Madrid, Museo Nacional del Prado

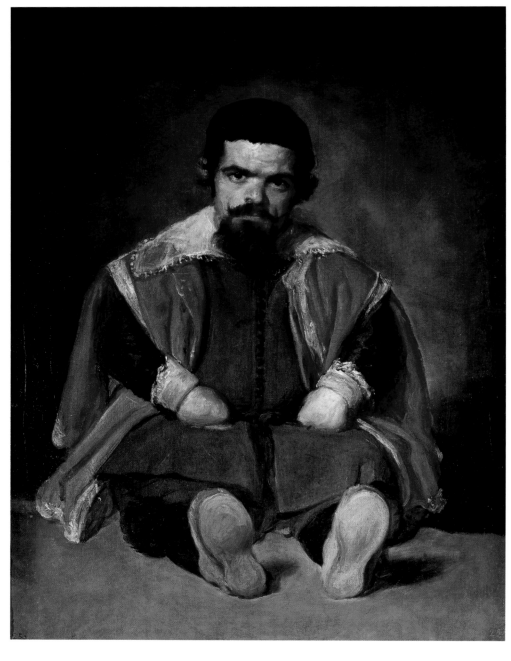

books surrounding him appear even more gigantic than they are. His occupation here is undoubtedly a reference to his administrative duties at the court.[224] At the same time, it is probably an example of humanist satirical jest, which would often decry the senseless writing and reading of books as a contemptible vice. Contemporary spectators would never have accepted that a dwarf knew how to use the attributes of a scholar; the artist thus seems to be using an apparently grotesque discrepency to poke fun at the pseudo-scholars of his day. The satirical tradition had spread throughout Europe via the humanists,[225] and Veláz-

quez's knowledge of it is evident in his use of ideal types in portraits of the Cynic philosopher Menippus (MOENIPPVS, c. 1636–40) and the Greek composer of fables Aesop (AESOPVS, c. 1636–40), possibly painted for the hunting lodge Torre de la Parada, near the Buen Retiro Palace. It was here, too, that many of his portraits of court fools and dwarfs were hung, possibly including that of El Primo.

Aesop's face with its flattened nose was probably not – as is commonly thought – painted after a man of the people (even if the painting did attempt to show a simple man whose features were marked by toil,

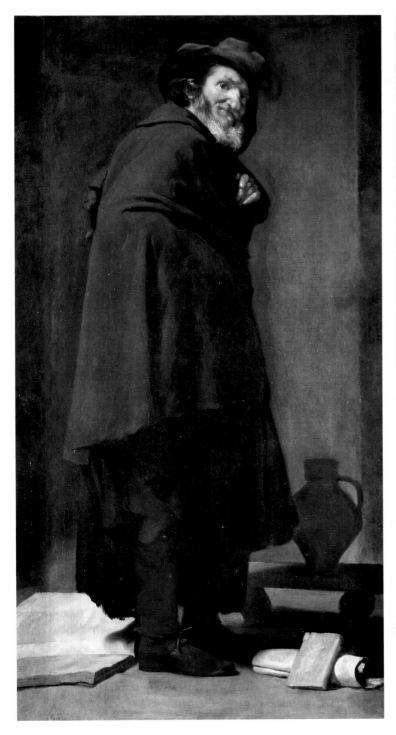

and who therefore represented the Cynic ideal of the modesty and wisdom of the people). The portrait seems rather more reminiscent of Giovanni Battista della Porta's physiognomic parallels between various types of human faces and the heads of animals associated with certain temperaments. Aesop had, during Classical antiquity, been seen in conjunction with the Seven Sages; Menippus was known as a castigator of hack philosophers, whom he satirised in different literary genres.[226] It is to the vice of sham scholarship, too, that Velázquez's portrait of the dwarf El Primo seems to allude.

Diego Velázquez
Menippus, c. 1636–40
Oil on canvas, 179 x 94 cm
Madrid, Museo Nacional del Prado

Diego Velázquez
Aesop, c. 1636–40
Oil on canvas, 179 x 94 cm
Madrid, Museo Nacional del Prado

According to Plutarch, Aesop was a counsellor to the Lydian King Croesus (6th century). Velázquez was suggesting a parallel with the situation at the Spanish court. The two portraits of philosophers, together with the portraits of fools and dwarfs, were intended to warn the king not to lose touch with the common people and their wisdom.

Notes

1 Cf. Max J. Friedländer: Über die Malerei. Mit einem Vorwort von Hugo Perls. Munich [2]1963, pp.226 ff. – For the group portrait cf.: Alois Riegl: Das holländische Gruppenporträt. Vienna [2]1931, 2 vols. – Works on the history of the portrait cited in the appendix below.

2 Giovanni Pico della Mirandola: De dignitate hominis, in: Opera. Bologna 1496 (Über die Würde des Menschen. Translated by H. W. Rüssel. Amsterdam 1940, pp.48 ff.) – Compare also edition: De dignitate hominis. Latin and German. Introduction by Eugenio Garin. Bad Homburg v. d. H. 1968, p.29. – Cf. also August Buck: Die humanistische Literatur in der Romania, in: ibid.: Renaissance und Barock. Part I, Frankfurt/M. 1972, pp.61 ff., here p.63 f. – On individualism, cf. Leo Kofler: Zur Geschichte der bürgerlichen Gesellschaft. Versuch einer verstehenden Deutung der Neuzeit. Neuwied/Berlin [3]1974, pp.175 ff. – Alfred von Martin: Soziologie der Renaissance. Munich [3]1974, pp.25 ff. passim.

3 Jacob Burckhardt: Die Anfänge der neueren Porträtmalerei, in: ibid.: Kulturgeschichtliche Vorträge, edited by Rudolf Marx. Leipzig (year not given), pp.209-227. – For reference to the "crisis" of portraiture about 1800 cf. Gottfried Boehm: Bildnis und Individuum. Über den Ursprung der Porträtmalerei in der italienischen Renaissance. Munich 1985, p.9.

4 Stephan Berg: Form an Sich. Don Judd in der Kunsthalle Baden-Baden, in: Frankfurter Allgemeine Zeitung, No.211, 12. 9. 1989, p.35.

5 Cf. Paul Ortwin Rave: Bildnis, in : Reallexikon zur deutschen Kunstgeschichte, edited by O. Schmitt. Stuttgart 1948, vol. 2, cols. 639-680. – Cf. also Wilhelm Waetzoldt: Die Kunst des Porträts. Leipzig 1908, pp.2–16 (quotations from Bosse and Félibien are taken from this edition). – Abraham Bosse: Le Peintre converti aux… règles de son art. Paris 1667. – André Félibien: Des Principes de l'architecture etc. Paris 1676. – Ibid.: L'idée du peintre parfait. London 1707 (reprinted Geneva 1970). – Ibid.: Entretiens sur les ouvrages des plus excellents Peintres. Paris 1666–1688.

6 Cf. Hans H. Hahnloser: Villard de Honnecourt. Kritische Gesamtausgabe des Bauhüttenbuches ms. fr. 19093 of the Biblio-thèque National, Paris. Vienna 1935, p.144.

7 Abraham Bosse, cited by Rave (see note 5).

8 André Félibien, cited by (see note 5).

9 Cf. W. Schild: Alte Gerichtsbarkeit. Munich [2]1985, pp.65 ff.

10 Arthur Schopenhauer: Die Welt als Wille und Vorstellung (1819/1860), in: Werke, edited by J. Frauenstädt. Leipzig [2]1891, vol. 2, p.260.

11 Cf. Philip Grierson: Münzen des Mittelalters. Munich 1976, pp.45 ff. – A. Luschin von Ebengreuth: Allgemeine Münzkunde und Geldgeschichte des Mittelalters und der neueren Zeit. Munich 1973 (= Munich/Berlin 1926, 3rd ed.).

12 Cf. n. 32.

13 Cf. Erik H. Erikson: Identität und Lebenszyklus. Frankfurt/M. 1973.

14 Nikolaus von Kues: Compendium. Latin – German. Hamburg 1970, p.42 f.

15 Cf. Natalie Zemon Davies: Die wahrhaftige Geschichte von der Wiederkehr des Martin Guerre. Preface by Carlo Ginzburg. Munich/Zurich 1984.

16 Georg Wilhelm Friedrich Hegel: Vorlesungen über die Ästhetik, in: Sämtliche Werke, edited by Hermann Glockner. Stuttgart 1927/28, vol. 12, p.73.

17 Giovanni Paolo Lomazzo: Trattato dell'arte della pittura. Milan 1584, I, 1, p.24. – Erwin Panofsky: Idea. Ein Beitrag zur älteren Kunsttheorie (Studien der Bibliothek Warburg, V). Hamburg 1924 (reprinted Berlin 1960), p.45, p.105.

18 Cf. André Chastel: Der Mythos der Renaissance 1420–1520. Geneva 1969, pp.145 ff.

19 Cf. Arnold Hauser: Sozialgeschichte der Kunst und Literatur. Munich [2]1979, p.309 passim – On ethics cf. Norbert Elias: Die höfische Gesellschaft. Neuwied/Berlin 1969, p.169 passim – Gerhart Schröder: Gracián und die spanische Moralistik, in: August Buck (ed.): Renaissance und Barock, part II. Frankfurt/M. 1972, pp.257–279.

20 Cf. Chastel (see note 18), p.145.

21 Giovanni Battista della Porta: De humana physiognomia libri quattuor, 1570 (also in: ibid.: Magia naturalis libri viginti. Hanovia 1644, 10 vols.). – Cf. Boehm (see note 3), pp.92 ff. – Cf. also Otto Baur: Bestiarium Humanum. Munich/Gräfelfing 1974, pp.41 ff.

22 Cf. Georg Christoph Lichtenberg: Über Physiognomik wider die Physiognomen zur Beförderung der Menschenliebe und Menschenkenntnis. Göttingen 1778 (directed against Johann Caspar Lavater: Physiognomische Fragmente. Leipzig/Winterthur 1775–78).

23 Cf. F. Petri: Landschaft (I), in: Joachim Ritter/Karlfried Gründer (ed.): Historisches Wörterbuch der Philosophie. Basle/Darmstadt 1980, vol. 5, cols. 11–13.

24 For the "impresa" cf. Franco Cardini in: Sergio Bertelli/Franco Cardini/Elvira Garbero Zorzi: Italian Renaissance Courts. London 1985, pp.122–125. – August Buck: Die Emblematik, in: ibid. (see note 19), pp.328–345. – Ernst Robert Curtius: Europäische Literatur und lateinisches Mittelalter. Berne/Munich [7]1969, p.351. – Karl Giehlow: Die Hieroglyphenkunde des Humanismus in der Allegorie der Renaissance, in: Jahrbuch der Kunstsammlungen des Allerhöchsten Kaiserhauses, 32, Vienna 1915, pp.1–232. – Important source material: Paolo Giovio: Dialogo delle imprese militare e amorose. Rome 1555. – For the significance of the "impresa" in everyday courtly life: "Disputes would sometimes arise concerning various subjects, or we would tease each other with witty remarks; we would often invent mottos, or impresas, as we now call them. We would greatly enjoy ourselves with such entertainment, since the house was full of the most noble spirits." (Baldassare Castiglione: Das Buch vom Hofmann (Engl. title: The Book of the Courtier). German translator Fritz Baumgart. Munich 1986, p.20 f.)

25 For Horapollo cf. Ernst H. Gombrich: Icones Symbolicae. Die Philosophie der Symbolik und ihr Einfluß auf die Kunst, in: ibid.: Das symbolische Bild. Zur Kunst der Renaissance, II. Stuttgart 1986, pp.150–232, especially p.191.

26 Cf. also Norbert Schneider: The Art of the Still Life. Still Life Painting in the Early Modern Period. Cologne 1990, pp.156 ff., 186 ff.

27 Cf. Zedler: Grosses vollständiges Univer-

sal-Lexicon Aller Wissenschaften und Künste. Halle/Leipzig 1733, vol. 3, col. 1827. – On magic cf. Leander Petzoldt (ed.): Magie und Religion. Beiträge zu einer Theorie der Magie (Wege der Forschung, volume CCCXXXVII). Darmstadt 1978.

28 Zedler, op. cit., col. 1825. – Cf. also Adolf Reinle: Das stellvertretende Bildnis. Plastiken und Gemälde von der Antike bis ins 19. Jahrhundert. Zurich/Munich 1984.

29 Horst W. Janson: DuMonts Kunstgeschichte unserer Welt. Cologne 1962, p.141. – Cf. also "Imagines maiorum", in: Der kleine Pauly, Lexikon der Antike, Munich 1979, vol. 2, cols. 1371–73.

30 Cf. Fernand Braudel: Histoire et sciences sociales. La longue durée, in: Annales 13, 1958, pp.725–753.

31 Cf. Erwin Panofsky: Early Netherlandish Painting. Its Origins and Character. Cambridge (MA) 1953, vol. I, pp.196 ff.

32 Van Eyck frequently uses expressions taken from the language of notorial records and certificates. Thus the phrase "Actu anno domini…" in the painting was often found in employment contracts. The well-known Graecized inscription "as I can" (ΑΛΣ ΙΧΗ ΧΑΝ) in van Eyck's *Man in a Red Turban* (National Gallery, London; 1433; thought to be the artist's self-portrait) is a recurrent motto in van Eyck's work, e.g. in the Dresden triptych and the *Virgin at the Well* (Brussels). Contrary to the opinion of C. Schnaase (Geschichte der bildenden Künste im 15. Jahrhundert. Stuttgart 1879, p.153), the phrase was not a sign of modesty, but a loan translation for the Latin "ut potui" which was used by notaries and chancery clerks. Cf. R.W. Scheller: 'Als ich can', in: Oud Holland 83, Amsterdam 1968, pp.135–139. "Leal Souvenir" is also a phrase used in legal records. Etymologically, "leal" derives from the Latin "legalis".

33 Cf. Wendy Wood: A New Identification of the Sitter in Jan van Eyck's Tymotheus Portrait, in: The Art Bulletin 60, New York 1978, pp.650–654. According to Wood, the name is a metonymic reference to the Tymotheus mentioned by Pliny (Hist. Nat. 36, IV, 30–31) who was involved in the sculptural decoration of the mausoleum at Halikarnassos, considered during antiquity to be one of the seven wonders of the world. Wood sees the stone parapet in the portrait as a reference to the sitter's profession.

34 Cf. Panofsky (see note 17), p.201 f. – Cf. also: Jan Baptist Bedaux: The reality of symbols. The question of disguised symbolism. Jan van Eyck's Arnolfini portrait, in: Simiolus 16, Amsterdam 1986, pp.5–26. – Dieter Jansen: Similitudo, Untersuchungen zu den Bildnissen Jan van Eycks, (Dissertationen zur Kunstgeschichte, vol. 28, Cologne/Vienna 1988, pp.144–157.

35 This term is used by H. Th. Musper: Altniederländische Malerei. Cologne 1968, p.66.

36 Once again van Eyck is using a term used in legal certificates and records (see note 32).

37 For the history of marital law in the late

Middle Ages see Paul Mikat: Ehe, in: Handwörterbuch zur deutschen Rechtsgeschichte. Berlin 1971, vol. I, cols. 809 ff. – Cf. also Lucy Freeman Sandler: The handclasp in the Arnolfini wedding, in: The Art Bulletin 66, New York 1984, pp.488–491. Sandler interprets the outstretched left hand as signifying a clandestine "left-handed" marriage, but this hypothesis is rejected by Bedaux (see note 34) p.11, note 12, with reference to certain iconographical features peculiar to wedding portraits since the Middle Ages.

38 On the "rod of life" cf. Siegfried Kube: Der Schlag mit der Lebensrute. (Thesis) Leipzig 1942 (typescript) (although here the term is seen only in conjunction with the "geofolkloric region of Middle Germany"). R./K. Beitl: Wörterbuch der deutschen Volkskunde. Stuttgart 1974, p.502 f.

39 On Rolin cf. Claude Schaeffner (ed.): Reformation – Renaissance – Die italienischen Kriege (Weltgeschichte in Bildern). Lausanne 1969, p.185. – Musper (see note 35), p.68. – Raffaello Brignatti/Giorgio T. Faggin: L'opera completa di Van Eyck. Milan 1968, p.94 (No.16).

40 For the *Paele-Virgin* cf. Musper (see note 35), p.70.

41 On nominalism cf. Kurt Flasch: Das philosophische Denken im Mittelalter. Stuttgart 1986, pp.216 ff. passim – Friedrich Überweg: Die patristische und scholastische Philosophie, in: Geschichte der Philosophie, edited by Bernhard Geyer. Darmstadt 1967, vol. 2, pp.587 ff., §§ 48–50.

42 For the "hortus conclusus" cf. Friedrich Ohly: Hohelied-Studien. Wiesbaden 1958.

43 Cf. Emil Kieser: Zur Deutung und Datierung der Rolin-Madonna des Jan van Eyck, in: Städel-Jahrbuch, I, Munich 1967, pp.73 ff.

44 Some scholars attribute the painting to Enguerrand Charonton (Quarton). Cf. Michel Laclotte: L'Ecole d'Avignon. La peinture en Provence aux XIVe et XVe siècles. Paris 1960, pp.86 ff.

45 Cf. catalogue: Gemäldegalerie, Staatliche Museen zu Berlin – Preußischer Kulturbesitz. Katalog der ausgestellten Werke des 13.-18. Jahrhunderts. Berlin-Dahlem 1975, p.155 f. "The diptych was placed above Etienne Chevalier's tomb at the Collegiate Church of Our Lady at Melun, Chevalier's birthplace. It was removed in 1775 and sold during the years of the Revolution" (ibid.). – Cf. also Rainald Grosshans in: Gemäldegalerie Berlin. Geschichte der Sammlung und ausgewählte Meisterwerke. Berlin 1985, p.130 f. The panel with the donor's inscription temporarily entered the estate of the poet Clemens Brentano.

46 Cf. Charles Sterling/Claude Schaefer: Jean Fouquet. Les Heures d'Etienne Chevalier. Paris 1971. – Jacques Lassaigne/Carlo Giulo Argan: Das Fünfzehnte Jahrhundert. Von van Eyck zu Botticelli. Geneva/Paris/New York 1955, p.78 f.

47 Cf. Maria Corti/Giorgio T. Faggin: L'opera completa di Memling. Milan 1969, plate

LXII, No.96 (p.110) – The coin bears the inscription: NERO CLAUD(IUS) CAESAR AUG(USTUS) GERM(ANICUS) TR(IBUCINIA) P(OTESTATE) IMPER(ATOR).

48 For the white horse (Rev. 6,2) cf. Jörg Träger: Pferd, in: Lexikon der christlichen Ikonographie. 4 vols. Freiburg 1968 ff., vol. 3, cols. 411–415 (under symbols of virtue). – For the swan cf. E. A. Armstrong: The symbolism of the swan and the goose. London 1945. – Lexikon der christlichen Ikonographie, loc. cit., vol. 4, cols. 133 f.

49 Cf. Ronald Lightbrown: Sandro Botticelli. Complete Catalogue. London 1978. Vol. II, pp.33 ff. (Cat. No.B 22), and bibliography.

50 Germain Bazin: La peinture au Louvre. Paris 1979, p.133 – Leonardo Sciascia/Gabriele Mandel: L'opera completa di Antonello da Messina. Milan 1967, No.66 (p.100). – Jan Lauts: Antonello da Messina. Vienna 1940.

51 For Nikolaus von Kues's "De visione Dei" cf. Edgar Wind: Heidnische Mysterien in der Renaissance. Frankfurt/M. 1981, p.225. – Cf. also Nikolaus von Kues: Compendium. Translated and edited by Bruno Decker/Karl Bormann. (Philosophische Bibliothek, vol. 267), Hamburg 1970.

52 Cf. R. Delbrück: Die Konsulardiptychen und verwandte Denkmäler. (Studien zur spätantiken Kunstgeschichte, vol. 2), Berlin 1929.

53 Kenneth Clark: Piero della Francesca. Cologne 1970, pp.55 ff. (pls. 98-103). – E. Battisti: Piero della Francesca. Milan 1971. – Mario Salmi: La pittura di Piero della Francesca. Novara 1979, pp.118-121.

54 For Petrarch's "Trionfi" cf. C. F. Goffis: Originalità dei "Trionfi". Florence 1951. – E. H. Wilkins: The First Two Triumphs of Petrarch, in: Ithalica 40, 1963, pp.7–17.

55 For princely codes see note 116.

56 Cf. Gian Alberto Dell'Acqua/Renzo Chiarelli: L'opera completa di Pisanello. Milan 1972, No.78, p.95 f. (plate XLV).

57 For the juniper as a symbol, cf. Handwörterbuch des deutschen Aberglaubens. Berlin 1938/1941, vol. IX, col. 1 ff. – The juniper shrub was said to afford protection against demons. As an evergreen it was associated with freshness and youth. It was symbolically related to the "rod of life", which itself was usually made of juniper sprigs. These qualities gave the juniper a particularly important place in the art of medicinal magic.

58 Cf. Kenneth Clark: Leonardo da Vinci in Selbstzeugnissen und Bilddokumenten. Reinbek 1969, p.54 f. – Cf. also Jack Wasserman: Leonardo da Vinci. New York 1975, p.136.

59 Literally: "The beautiful ironmonger". The portrait of a woman painted by Leonardo between 1485–1488 still hangs in the Louvre under this title, the nickname given by Henry II to one of his mistresses. Cf. also Clark (see note 58) p.57.

60 Clark (see note 58), p.54.

61 Clark (see note 58), pp. 108 ff. – John Pope-Hennessy: The Portrait in the Renaissance. London/New York 1966, pp. 106 ff.

62 Pope-Hennessy, op. cit., p. 109.

63 "Light and shadow play in a most charming manner on the faces of those who sit at the doors of dark dwellings. For the eye of the beholder sees the dark side of the face made darker still by the gloom of the domestic interior, and sees the bright sky lend greater light to the bright side of the face." Leonardo da Vinci: Das Buch von der Malerei. German edition. After the Codex Vaticanus 1270. Translated by Heinrich Ludwig. Osnabrück 1970 (reprint of the 1882 edition), p. 83 (No. 123). – Cf. also Leonardo (ibid.): "… or when you take someone's portrait, try drawing him towards evening when the weather is bad".

64 Cf. Martin Kemp: Leonardo da Vinci, The Marvellous Works of Nature and Man. London/Melbourne/Toronto 1981, pp. 263 ff. – On the path of virtue motif, cf. Erwin Panofsky: Hercules am Scheidewege und andere Bildstoffe in der neueren Kunst. (Studien der Bibliothek Warburg, XVIII). Leipzig 1930.

65 Cf. Edgar Wind: Giorgione's Tempestà. With comments on Giorgione's Allegories. Oxford 1969. – Herbert von Einem: Giorgione als Dichter. Wiesbaden nd (Akademie der Wissenschaften und Literatur, Abhandlungen der geistes- und sozialwissenschaftlichen Klasse, 1972, No. 2).

66 Cf. Günther Tschmelitsch: Zorzo, genannt Giorgione. Der Genius und sein Bannkreis. Vienna 1975, p. 323. – Virgilio Lilli/Pietro Zampetti: L'opera completa di Giorgione. Milan 1968, No. 12 (p. 89). – Egon Verheyen: Der Sinngehalt von Giorgiones Laura, in: Pantheon 26, Munich 1968, No. 3, pp. 220–227. – Christian Hornig: Giorgiones Spätwerk. Munich 1987, p. 70 (Cat. No. 21). – Berthold Hinz: Studien zur Geschichte des Ehepaarbildnisses, in: Marburger Jahrbuch für Kunstwissenschaft 19, Marburg 1974, p. 139.

67 Cf. Antonio del Pollaiuolo's painting Apollo and Daphne (not dated), London, National Gallery. Cf. also Frederick Hartt: History of Italian Renaissance Art. Englewood Cliffs (NJ)/New York nd, ill. 329, p. 274.

68 Thus also in Tschmelitsch (see note 66), p. 324.

69 James Hall: Dictionary of Subjects and Symbols in Art. New York/San Francisco/London 1974, p. 190.

70 The Amazons lived in a state "from which men were either excluded entirely, or were tolerated merely as a means of preserving the race." Graef: article on "Amazones", in: Pauly-Wissowa: Realencyclopädie der classischen Altherthumswissenschaften. Stuttgart 1894, vol. I/2, cols. 1754–1789.

71 Cf. Mina Bacci: L'opera completa di Piero di Cosimo. Milan 1976, No. 6 (p. 86), plate I. – Ibid.: Piero di Cosimo. Milan 1966, p. 67 f. (Cat. No. 4).

72 Poliziano cited by Will Durant: Das hohe Mittelalter und die Frührenaissance (Kulturgeschichte der Menschheit, vol. 7) Frankfurt/M. et al. 1981, p. 384. – Cf. also Isolde Kurz: Die Stadt des Lebens. Schilderungen aus der Florentiner Renaissance. Stuttgart/Berlin 1919, p. 138 f.

73 Cf. catalogue of the Gemäldegalerie, Staatliche Museen zu Berlin – Preußischer Kulturbesitz (see note 45), p. 324.

74 Cf. Hall (see note 69), p. 119 f. – Erwin Panofsky: Father Time, in: ibid.: Studies in Iconology. New York 1962, pp. 69–93. – On the snake as a symbol of time, cf. Horapollo: Hieroglyphica I, 2; – Martianus Capella: De nuptiis Mercurii et Philologiae I, 70, (first printed edition of this work dating from the late 4th or early 5th century A.D.) Vicenza 1499. – Cf. also F. Cumont: Textes et monuments figurées relatifs aux mystères des Mithra. Brussels 1896. – Cf. also Erwin Panofsky: Sinn und Deutung in der bildenden Kunst (Meaning in the Visual Arts). Cologne 1975, p. 187. – For Giorgio Vasari's identification of the young woman as Cleopatra, cf. the edition: Le vite de' più eccellenti Pittori, Scultori e Architettori. Florence 1568, IV, p. 144. – Cf. also Ernst H. Gombrich: Botticelli's Mythologies. A Study in the Neoplatonic symbolism of his circle, in: Journal of the Warburg and Courtauld Institutes 7, London 1945, pp. 7 ff. – On Janus-facedness ("Januensis") cf. Pico della Mirandola's "Commento" in which humans are said to have originally been Janian beings. According to Wind (see note 51), p. 244.

75 Cf. Edi Baccheschi: L'opera completa di Bronzino. Milan 1973, No. 107 (p. 102), plates LXI–LXIII.

76 W. Theodor Elwert: Die Lyrik der Renaissance und des Barocks in den romanischen Ländern, in: Buck (see note 2), pp. 82 ff., especially p. 83.

77 Cf. Charles McCorquodale: Bronzino. London 1981, pp. 50, 61, 131, 139 f. (colour plate XV). The author points out that Laura Battiferri was portrayed together with her husband, who is "disguised" as St. Bartholomeo, in Alessandro Allori's painting Christ and the Canaanites.

78 Cf. Flavio Caroli: Lorenzo Lotto e la nascita della psicologia moderna. Milan 1980.

79 Friderike Klauner: Die Gemäldegalerie des Kunsthistorischen Museums in Wien. Vier Jahrhunderte europäischer Malerei. Salzburg/Vienna 1978, ²1981, pp. 118 ff. – Rodolfo Pallucchini/Giordana Mariani Canova: L'opera completa di Lotto. Milan 1975, No. 21 (p. 90), plate XIII.

80 For a curtain veiling the "Sanctum", cf. the portrait of Gregor the Great in the Registrum Gregorii (Trier, about 983), Trier, City Library (= ill. 108 in Hans Holländer: Kunst des frühen Mittelalters. Stuttgart 1969, p. 134). As a symbol of dignity, the curtain also surrounded the back props of the baldachin over a throne. Used in the manner of Petrarch's "secretum", this backdrop both dramatised but also isolated the human figure. It was often used to represent the individualisation process in early modern society.

81 For Isabella d'Este's "impresa" cf. Hall (see note 69), p. 57 (see under "candle"). – For the history of the metaphysics of light cf. Hans Blumenberg, in: Studium Generale 10, 1957, pp. 432–447. – On the metaphysics of light in the work of Marsilio Ficino ("Theologia Platonica". Florence 1474) cf. Paul Oskar Kristeller: The Philosophy of Marsilio Ficino. New York 1943.

82 Pallucchini/Canova (see note 79), No. 177 (p. 110), plate XLVI. – Klauner (see note 79), pp. 120 ff.

83 On the synecdoche cf. Heinrich Lausberg: Elemente der literarischen Rhetorik. Munich ⁴1971, pp. 69 ff. (§§192–201).

84 Cf. Alessandro Bonvicino il Moretto. Scritti di Gian Alberto Dell'Acqua, Mina Gregori et al. (np and nd) (Brescia 1988), Cat. No. 72, p. 148 f., colour plate p. 147. – Cecil Gould: The Sixteenth-Century Italian Schools (National Gallery Catalogues). London 1975, p. 156 ff.

85 W. Frederick Dickes, in: The Athenaeum, 3rd of June, 1893. Cf. also Gould (see note 84) p. 157, note 4 and 5.

86 Cf. Erwin Panofsky/Fritz Saxl: Dürers "Melancholia I". Eine quellen- und typengeschichtliche Untersuchung (Studien der Bibliothek Warburg, II). Leipzig/Berlin 1923. – Rudolf Wittkower: Born under Saturn. The Character and Conduct of Artists. New York 1963, p. 104.

87 Robert Burton: The Anatomy of Melancholy. Oxford 1621.

88 Cf. Harald Osborne (ed.): The Oxford Companion to Art. Oxford 1970, pp. 203-205.

89 Cf. Michel Melot: Die Karikatur. Das Komische in der Kunst. Stuttgart et al. 1975, pp. 19 ff.

90 Cf. Werner Hofmann: Die Karikatur von Leonardo bis Picasso. Vienna nd (1956), especially p. 11.

91 On Grobianism cf. Adolf Hauffen/Carl Diesch: Grobianische Dichtung, in: Reallexikon der deutschen Literaturgeschichte, edited by W. Kohlschmidt/P. Merker. Berlin ²1958, vol. 1, p. 605.

92 Cf. Martin Davies: Early Netherlandish School (National Gallery Catalogues). London 1968, pp. 92-95 (and extensive bibliography).

93 Cf. Kenneth Clark: Catalogue of the Drawings of Leonardo da Vinci at Windsor Castle. London 1935, vol. I, No. 12 492 (ill. in vol. II). – Cf. also Ernst H. Gombrich: The Grotesque Heads, in: Gombrich: The Heritage of Apelles. Studies in the Art of the Renaissance. Ithaca 1976, pp. 57-75.

94 Cf. Clark (see note 58), p. 69 f.

95 Niklas Luhmann: Gesellschaftsstruktur und Semantik. Studien zur Wissenssoziologie der modernen Gesellschaft, vol. 3. Frankfurt/M. 1989, pp. 149 ff.

96 Cf. Davies (see note 92), p. 92.

97 Cf. Alison G. Stewart: Unequal Lovers. A Study of Unequal Couples in Northern Art. New York nd (1977).

98 Cf. Melot (see note 89), p.20, ill.10.

99 Cf. Leopold Dussler: Signorelli. Stuttgart 1927, p.82. – H. Mackowsky, in: Zeitschrift für Bildende Kunst (New Series 11), Leipzig 1900, p.117.

100 For vestal virgins see the work of St. Ambrose, whose description of the phenomenon remained the standard Christian interpretation until well into the Renaissance: Epistolae I, 18 (ad Valentinianum Imperatorem 11 f.), in: Migne, Patrologia Latina, vol. 16, col. 1016 f., and in St. Augustine: De civitate Dei X, 16, 2 (Migne, Patrologia Latina, vol. 41, col. 294 f.). – Oskar Holl, in: Lexikon der christlichen Ikonographie (see note 48), vol. 4, col. 457.

101 Cf. A. Emiliani: Il Bronzino. Busto Arizio 1960, p.63 (plate 19). – Pope-Hennessy (see note 61), p.235. – McCorquodale (see note 77), p.51 f. and illustration 32. – Martelli, together with the Venetian humanist Daniele Barbaro, was one of the founders of the Accademia degli Infiammati. In 1544 he was elected Consul of the Academy at Florence. As the Bishop of Grandèves he later gave his support to the Counter-Reformation and was forced to flee from the Hugenots under the leadership of Henry of Navarra. Amongst other works he wrote a Life of Emperor Maximilian.

102 On Pietro Bembo's "Prose nelle quali si ragiona della volgar lingua" (1525) cf. Paul Oskar Kristeller: Humanismus und Renaissance II. Philosophie, Bildung und Kunst. Munich (year not given), pp.135-148, especially p.143. – Francesco Guicciardini. Geschichte Italiens. Translated by Eduard Sander. Darmstadt 1843/44, 3 vols. – English translation of Niccolo Machiavelli's "Istorie Fiorentine 1215–1494" (Florence 1532): History of Florence and of the Affairs of Italy. New York 1960.

103 Cf. Castiglione (see note 24). – Erich Loos: Castigliones "Libro del Cortegiano". Studien zur Tugendauffassung des Cinquecento. Frankfurt/M. 1955.

104 Cf. Leopold D./Helen S. Ettlinger: Raphael. Oxford 1987, p.138.

105 Werner Schade: Die Malerfamilie Cranach. Dresden 1974, p.17 ff. – Cf. also Dieter Koepplin: Cranachs Ehebildnis des Johannes Cuspinian von 1502, seine christlich-humanistische Bedeutung. (Thesis) Basle 1973.

106 For further details of the humanist's biography cf. Hans Rupprich: Die deutsche Literatur vom späten Mittelalter bis zum Barock. Part I. Munich 1972, p.671 f. – Cf. also Pope-Hennessy (see note 101), pp.223 ff.

107 Koepplin (see note 105), p.121.

108 Cf. Schneider (see note 26), p.52.

109 Marsilio Ficino: Epistolarium lib. I, in: Opera omnia, Basle 1567, vol. I, pp.612 ff. (1st ed.: Epistolae. Venice 1495).

110 Cf. Bazin (see note 50), p.143. – W.S. Heckscher: Reflections on Seeing Holbein's Portrait of Erasmus at Longford Castle, in: Essays in the History of Art Presented to Rudolf Wittkower. London 1967, pp.128–148.

111 Cf. Wilhelm Waetzoldt: Hans Holbein der Jüngere. Berlin 1938, pp.41 ff.

112 Dante Alighieri: The Divine Comedy. Translated by Charles S. Singleton, Princeton 1973, p.321f.

113 Cf. Pope-Hennessy (see note 61), p.244 f.

114 On the problem of power cf. Niccolo Machiavelli: Libro della arte della guerra. Florence 1521.

115 Cf. Wind (see note 51), p.245 and note 69. – André Chastel/Robert Klein: Die Welt des Humanismus. Europa 1480–1530. Munich 1963, ill.235. – Catalogue: Androgyn. Sehnsucht nach Vollkommenheit. Berlin 1986, p.35.

116 Cf. Wilhelm Berges: Die Fürstenspiegel des hohen und späten Mittelalters. Leipzig 1938. – Josef Röder: Das Fürstenbild in den mittelalterlichen Fürstenspiegeln. (Thesis) Münster 1933. – Ernst Robert Curtius: Europäische Literatur und lateinisches Mittelalter. Berne/Munich 1969, pp.184–186.

117 Cf. A. E. A. Moreau-Nélaton: Les Clouet et leurs émules. 3 vols. Paris 1924. – Anthony Blunt: Art and Architecture in France 1500–1700. London 1953, pp.37 ff., 69 f.

118 "O France heureuse, honore danc la face
De ton grand roi qui surpasse Nature:
Car l'honorant tu sers en même place
Minerve, Mars, Diane, Amour, Mercure."
The lines were not written by Pierre de Ronsard, as was originally thought. The author is unknown.

119 Cf. Wind (see note 51), p.245, n. 68. – For the use of Minerva as an allegory of wisdom and virtue personifying the glory of rulers, cf. Ruprecht Pfeiff: Minerva in der Sphäre des Herrscherbildes. Von der Antike bis zur Französischen Revolution (Bonner Studien zur Kunstgeschichte). Münster 1990.

120 Cf. Ettlinger (see note 104), p.195, plate 179.

121 A particularly prominent figure here was Raffaele Riario, one of Pope Julius II's cousins, portrayed in Raphael's *Bolsena Mass*.

122 Cf. Harold E. Wethey: The Paintings of Titian. Complete Edition Vol. II. The Portraits. London 1971. Wethey extols the portrait as "perhaps the greatest psychological portrait of all time" (p.125). Cf. also at Wethey, Cat. No.76.

123 Ottavio, born 1524, was the second son of Pierluigi Farnese and his wife Girolama Orsini. At the age of fifteen he married Margaret of Austria, the illigitimate daughter of Charles V.

124 Cf. Pallucchini/Canova (see note 79), No.175 (p.109), plate IL.

125 Cf. Diana Wronski Galis: Lorenzo Lotto. A study of his career and character, with particular emphasis on his emblematic and hieroglyphic works. (Thesis) Bryn Mawr College 1977 (Ann Arbor 1977), Cat. No.73, pp.375 ff. – On Odoni cf. also ibid. pp.225 ff. – Cf. also Caroli (see note 78), p.178 f.

126 Cf. Galis, op cit.

127 Cf. Giehlow (see note 24). – Cf. especially Celio Calcagnini: De rebus Aegyptiacis, in: Calcagnini: Opera aliquot ab Antonio Musa Brasavolo edita. Basle 1544. – Cf. also Wind (see note 51), p.119, note 8.

128 Cf. Wethey (see note 122), Cat. No.100, pp.141 f., 48 f.

129 Cf. Giulio Emanuele Rizzo: Prassitele. Milan/Rome 1932, p.60, plate 89.

130 Cf. Jacopo de Strada: Epitome thesauri antiquitatum hoc est imperatorum orientalium et occidentalium ex Museo Jacobi de Strada Mantuano, Lyon 1553.

131 Klauner (see note 79), p.190.

132 Cf. Fedja Anzelewsky: Albrecht Dürer. Das malerische Werk. Berlin 1971, pp.35, 78 f., 85, 164 ff. passim. Cf. also Fedja Anzelewsky: Dürer-Studien. Berlin 1983, pp.90–100. Dürer's self-portrait bears "testimony to the creative powers invested in him, which make him comparable to the Creator of all things (…)." ibid. p.100.

133 Cf. F. Winzinger: Albrecht Dürers Münchner Selbstbildnis, in: Zeitschrift des Deutschen Vereins für Kunstwissenschaft, (New Series) 8, Berlin 1954, pp.43 ff.

134 Ernst Buchner: Das deutsche Bildnis der Spätgotik und der frühen Dürerzeit. Berlin 1953, p.160.

135 Cf. Della Mirandola (see note 2), p.48 f.

136 Cited by Hugh Honour/John Fleming: Weltgeschichte der Kunst. Munich 1983, p.361. – Cf. Albrecht Dürer: Schriftlicher Nachlaß, edited by Hans Rupprich. Berlin 1956–69, vol. II, p.109, No.5, 1. – "For they (i.e. the ancient princes. Author's note) gave the best artists riches and honour, knowing the scriptures (Genesis. Author's note) placed the great masters on a level with God. For a good painter has form and meaning within him. And if you ask me whether an artist lives for ever, my answer is that he has within him such ideas as Plato describes, through which his work will always bring forth something new…" Cited by Anzelewsky in op. cit. 1983 (see note 132), p.95. – Cf. also Marsilio Ficino: De vita triplici, in: Opera omnia. Turin 1959, p.498.

137 Cf. Pope-Hennessy (see note 61), p.129.

138 Thomas von Kempen: Das Buch von der Nachfolge Christi. Stuttgart 1976, especially pp.10 ff., 17 ff.

139 Erika Thiel: Geschichte des Kostüms. Die europäische Mode von den Anfängen bis zur Gegenwart. Berlin 1980, p.170.

140 Cf. the exh. cat.: Poussin. Paris 1960, p.119 f. – Anthony Blunt: The Paintings of Nicolas Poussin. London 1966, p.265. – Doris Wild: Nicolas Poussin. Leben, Werk, Exkurse. Vol. I, Zurich 1980, pp.144-147.

141 For the revival of antique funereal symbolism during the Renaissance and Baroque, cf. F. Cumont: Recherches sur le symbolisme funéraire des Romains. Paris 1942, p.249 passim.

142 Also in Nicolas Poussin's letter of 1. 3. 1665 to Fréart de Chambray, in: Lettres de Poussin, edited by Pierre Du Colombier. Paris 1929, p.310.

143 Cf. also F. Zuccaro: L'idea de' pittori, scultori ed architetti, 1718, vol. I, 2, reprinted in: Wladislaw Tatarkiewicz: History of Aesthetics. Volume III. Modern Aesthetics. Edited by D. Petsch. The Hague/Paris/Warsaw 1974, p.219 f. – Cf. also Wolfgang Kemp: Disegno – Beiträge zur Geschichte des Begriffs zwischen 1547 und 1607, in: Marburger Jahrbuch für Kunstwissenschaft 19, Marburg 1974, pp.219–240.

144 Cf. Georg Kauffmann: Poussin-Studien. Berlin 1960, pp.88 ff. – On the personification of painting in Poussin's self-portrait see Donald Posner: The Picture of Painting in Poussin's Self-Portrait, in: D.Frazer/H. Hibbard/M. J. Lewine (ed.): Essays in the History of Art Presented to Rudolf Wittkower. Vol. 2. London 1967, pp.200–203. – Also Matthias Winner: Poussins Selbstbildnis im Louvre als kunsttheoretische Allegorie, in: Römisches Jahrbuch für Kunstgeschichte 20, Tübingen 1983, pp.417–449. With regard to the motif of the empty canvas, Winner refers to an engraving by Marc Antonio Raimondi, showing Raphael sitting on a bench with his back to an empty panel (Winner, op. cit., illustration 6). – According to Doris Wild, Nicolas Poussin did not paint his Paris self-portrait at a mirror, but from a wax bust with a wig. Cf. Wild (see note 140), p.146.

145 Cf. Lawrence Stone: The Family, Sex and Marriage in England 1500–1800. London 1977, p.296.

146 Cf. Roy Pascal: Autobiographie, in: Wolf-Hartmut Friedrich/Walther Killy (ed.): Literatur II/1 (Fischer Lexikon 35/1). Frankfurt/M. 1970, pp.78–84. (The quotation from Petrarch is mentioned on p.80). – Roy Pascal: Die Autobiographie. Gehalt und Gestalt. Stuttgart 1965. – H. Wenzel (ed.): Die Autobiographie des späten Mittelalters und der frühen Neuzeit. Munich 1980, 2 vols. – B. Neumann: Identität und Rollenzwang. Zur Theorie der Autobiographie. Frankfurt/M. 1970.

147 Cf. Wilhelm Dilthey: Die Funktion der Anthropologie in der Kultur des 16. und 17. Jahrhunderts, in: Gesammelte Schriften, vol. II. Stuttgart/Göttingen 1969, pp.416 ff.

148 Cf. Christopher Wright: Rembrandt: Self-Portraits. London 1982.

149 Elizabeth Gilmore Holt (ed.): A Documentary History of Art, vol. II. New York 1958, figure 7.

150 Historical studies usually refer exclusively to explicit theories of psychology, and rarely, if ever, mention the contribution of art to the subject. For the development of different forms of individuality in bourgeois society see Siegfried Jaeger/Irmingard Staeuble: Die gesellschaftliche Genese der Psychologie. Frankfurt/New York 1978, pp.53 ff.

151 Cf. Wright (see note 148).

152 Cf. J. L. Price: Culture and Society in the Dutch Republic in the 17th Century. London 1974

153 Svetlana Alpers: Rembrandt als Unternehmer. Sein Atelier und der Markt. Cologne 1989, p.259. "Rembrandt painted his self-portraits first and foremost for his workshop, then for himself and for the market. The last two options were really one, as far as Rembrandt was concerned."

154 Wright (see note 148) 98; around 1669. – Cf. also Gary Schwartz: Rembrandt. Sämtliche Gemälde in Farbe. Stuttgart/Zurich 1987, pp.354 ff., ill.424.

155 Albert Blankert: Rembrandt, Zeuxis and ideal beauty, in: Album amicorum J. G. van Gelder. The Hague 1973, pp.32–39.

156 Cited by Schwartz (see note 154), p.354.

157 Cf. Schwartz (see note 154), ill.423. (The painting is now at the Städelsches Kunstinstitut, Frankfurt/M.)

158 Cf. Wilhelm Waetzoldt (see note 5), pp.213–220. – Carl Georg Heise: Hans Holbein d.J., Die Gesandten. (Werkmonographien zur bildenden Kunst, No.43) Stuttgart 1959. – Konrad Hoffmann: Hans Holbein d.J., Die "Gesandten", in: Festschrift für Georg Scheja zum 70. Geburtstag. Sigmaringen 1975, pp.133–150.

159 Cf. Jurgis Baltrusaitis: Anamorphoses ou perspectives curieuses. Paris 1955. – Cf. Hoffmann, op. cit., p.133.

160 Konrad Hoffmann considers the anamorphic skull may be intended as a fictional reflection on a glass pane, or peep-hole (as in Dürer's glass-panel device, or Leonardo's definition of perspective: "Perspective is nothing but the view of a certain space through a transparent glass pane upon whose surface the outlines of objects which are behind the pane are traced"). For an understanding of the painting cf. also I Corinthians, 13, 12 f.: "For now we see through a glass, darkly."

161 Michel de Montaigne: Essais de messire Michel de Montaigne,… livre premier et second. Bordeaux 1580, vol. I, 27.

162 Giovanni Paolo Lomazzo: L'idea del Tempio della Pittura. Milan 1590, p.154.

163 Cited by Benno Geiger: Die skurrilen Gemälde des Giuseppe Arcimboldi (1527–1594). Wiesbaden 1960, pp.83–89. – Cf. also Schneider (see note 26), p.130 f.

164 Cf. Wethey (see note 122), vol. II, No.21, pp.87 ff. (plates 141–144). – Mentioned by Pietro Aretino: Lettere sull' arte, edited by Ettore Camesasca/Fidenzio Pertile. Milan 1957 ff., vol. II, p.212.

165 For Rubens's Cardinal Infante of 1634 see Hans Vlieghe: Rubens, Portraits of identified sitters in Antwerp (Corpus Rubenianum Ludwig Burchard, part 19, V, 2). New York 1987, No.93, and p.82. – On van Dyck's Charles I see Christopher Brown: Van Dyck. Freren 1983, p.168 passim – Erik Larsen: L'opera completa di Van Dyck 1626–1641. Milan 1980, No.773 (p.110), plate XXIX.

166 For Velázquez's Olivarez on Horseback see Kurt Gerstenberg: Diego Velázquez. Munich/Berlin 1957, pp.100 ff.

167 Cf. catalogue Galerie der Romantik. Nationalgalerie, Staatliche Museen zu Berlin – Preußischer Kulturbesitz, Berlin 1986, p.143 f. (and bibliography).

168 Cf. Brown (see note 165), p.169. – Cf. also catalogue by Oliver Millar: Van Dyck in England. National Portrait Gallery, London, 1982, p.21.

169 On Frans Hals's Willem van Heythuyzen see Erich Steingräber: Willem van Heythuyzen von Frans Hals, in: Pantheon 28, Munich 1970, pp.300 ff. – Seymour Slive: Frans Hals. London 1970, vol. I, pp.52 ff. – Claus Grimm: Frans Hals. Berlin 1972, pp.57 ff., No.21. – M. Boot: Über Willem van Heythuyzen, seinen Nachlaß und die symbolische Bedeutung des Porträts von Frans Hals in München, in: Pantheon 31, Munich 1973, pp.420 ff.

170 Jules Michelet: Histoire de France. Paris nd, vol. IV, p.509.

171 On Rigaud cf. U. Thieme/F. Becker: Allgemeines Lexikon der bildenden Künstler. Leipzig 1934, Vol. XXVIII, pp.349 ff. – Jacques Thuillier/Albert Châtelet: Von Le Nain bis zu Fragonard. Geneva 1964, pp.131 ff.

172 Cf. Percy Ernst Schramm: Der König von Frankreich. Das Wesen der Monarchie vom 9. bis zum 16. Jahrhundert. Weimar 1960, vol. 1, pp.210 ff.

173 On Richelieu cf. Will/Ariel Durant: Europa im Dreißigjährigen Krieg (Kulturgeschichte der Menschheit Vol. 11). Frankfurt/M. et al. 1982, pp.169–188.

174 Bernard Dorival: Philippe de Champaigne 1602–1674. La vie, l'œuvre et le catalogue raisonné de l'œuvre. Vol. II. Paris 1976, No.213 (p.120 f.).

175 For van Dyck's triple portrait cf. Larsen (see note 165), No.821 (p.114). – Cf. Millar (see note 169), p.65 f. (No.22, and plate). For Lotto's triple portrait of a sculptor cf. Pallucchini/Canova (see note 79), No.195 (p.112).

176 On ethics cf. Michel de Montaigne: Essais, edited by H. Lüthy. Zurich 1953, p.537. – Also Uwe Schultz: Michel de Montaigne mit Selbstzeugnissen und Bilddokumenten. Reinbek 1989, p.15. – On the motif of the "Doppelgänger" in literature cf. Elizabeth Frenzel: Motive der Weltliteratur. Stuttgart 1976, pp.94–114. On "Prudentia"-iconography cf. Erwin Panofsky: Tizians 'Allegorie der Klugheit'. Ein Nachwort, in: Panofsky (see note 74) 1975, pp.167–191.

177 Cf. Christopher White: Peter Paul Rubens. Man and Artist. New Haven/London 1987, pp.59 ff. – Wolfang Schöne: Peter

Paul Rubens, Die Geißblattlaube. Stuttgart 1956.

178 Cf. Otto von Simson: Peter Paul Rubens' "Liebesfest", in the catalogue: Bilder vom irdischen Glück. Berlin 1983, pp. 14–19.

179 Cf. H. P. Baard: Frans Hals. London 1981, p. 86 (plate 12). – Seymour Slive: Frans Hals. London 1974, vol. III. Cat. No. 17, p. 11 f.

180 Baard (see note 179) sees it as an aphrodisiac, however.

181 Cf. R. A. d'Hulst: Jacob Jordaens. Stuttgart 1982, ill. 234.

182 Cf. Eddy de Jongh: Grape symbolism in paintings of the 16th and 17th centuries, in: Simiolus 7, Amsterdam 1974, No. 4, pp. 166–191.

183 It may just as easily be a pagan symbol, however. In Renaissance combinations of emblems the dolphin often stood for "velocitas" (speed, hurry) of the kind which needs slowing down (so that the emblem may suggest a motto such as "festina lente": "more haste, less speed"). Cf. Wind (see note 51), p. 118 f.

184 Cf. Maria Teresa Franco Fiorio: Giovanni Francesco Caroto. Verona 1971, p. 100, Cat. No. 48, ill. 27; p. 47 f. (a study solely in style).

185 Jean Piaget/Bärbel Inhelder: Die Psychologie des Kindes. Frankfurt/M. 1977, pp. 52 ff. – G. Luquet: Le dessin enfantin. Alcan 1927. – Jean Piaget: L'image mentale chez l'enfant. Paris 1947. – Günther Mühle: Entwicklungspsychologie des zeichnerischen Gestaltens. Grundlagen, Formen und Wege in der Kinderzeichnung. Berlin/Heidelberg/New York ⁴1955. – Corrado Ricci: L'arte dei bambini. Bologna 1887

186 Cf. R. van Luttervelt: Holländische Museen. Munich/Berlin 1961, p. 110 f.

187 Cf. Lodovico Vives: De disciplinis libri XX. Antwerp 1531. – Cf. Jean-Claude Margolin: L'éducation à l'époque des grands humanistes, in: Histoire mondiale de l'éducation publiée sous la direction de Gaston Mialaret et Jean Vial. Vol. 2, Paris 1981, pp. 167 ff.

188 Enriqueta Harris: Velázquez. Stuttgart 1982, p. 162.

189 Bob Haak: Das Goldene Zeitalter der holländischen Malerei. Cologne 1984, p. 107 f. – Cf. also J. A. Emmens: Rembrandt en de regels van de kunst. Amsterdam (1968) 1979.

190 Cited by Kurt Bauch: Rembrandt van Rijn, Die Nachtwache 1642. Stuttgart ³1957, p. 27. – Samuel van Hoogstraten: Inleyding tot de Hooge Schoole der Schilderkonst. Rotterdam, 1678, V, 1, p. 176.

191 Cited by Bauch, p. 27 f. – Filippo Baldinucci: Cominciamento e progesso dell' arte dell' intagliare in rame etc. Florence 1686, pp. 78 ff.

192 Cf. Otto Benesch: Rembrandt. Geneva 1957, p. 64 f. – Jakob Rosenberg: Rembrandt. Life and Work. With 282 Ill. London/New York 1968, pp. 138, 350.

193 Cf. Rose-Marie/Rainer Hagen: Meisterwerke europäischer Kunst. Cologne 1984, pp. 173–188, especially 182.

194 Cf. Schwartz (see note 154), p. 209.

195 Cf. Hagen (see note 193), pp. 179 ff.

196 Cf. Schwartz (see note 154), p. 210.

197 Cited by Robert Weimann: Strukturen des Renaissancerealismus. Grundzüge seiner Theorie, in: Realismus in der Renaissance. Aneignung der Welt in der erzählenden Prosa. Berlin/Weimar 1977, p. 85.

198 Cf. illustration in Bauch (see note 190), p. 13.

199 Cf. Bob Haak: Regenten en regentessen overlieden en chirurgijns. Amsterdamse groepsportretten van 1600 tot 1835. Amsterdam, Historisch Museum 1972. – Catalogue: Groepsportretten in het Amsterdams Historisch Museum. Deel 2. Regenten, regentessen en overlieden. Amsterdam 1986. – Bob Haak (see note 189), pp. 52 ff., 378 passim.

200 Cf. catalogue: Arm in de Gouden Eeuw. Amsterdam Historisch Museum, 1965/66 (with an introduction by Marijke Kok, pp. 2–8). – For the development of capitalism in Western Europe cf. S. D. Skaskin et al.: Geschichte des Mittelalters, Berlin 1958, vol. II, pp. 3–32.

201 Cf. Robert Stupperich: Armenfürsorge III/IV, in: Theologische Realenzyklopädie. Vol. IV. Berlin/New York 1979, especially pp. 24 ff. (and bibliography). – WA = Luther, Werke (Weimar edition 1883 ff.).

202 Cf. Stupperich, op. cit., p. 29.

203 Cf. Josef Kulischer: Allgemeine Wirtschaftsgeschichte des Mittelalters und der Neuzeit. Darmstadt ⁴1971, pp. 146 ff.

204 Cf. Slive (see note 170) pp. 212 ff. – Cf. also Slive (see note 181), Nos. 221, 222 (p. 112 f.). – On Hals's portrait cf. also Slive (ed.): Frans Hals. Munich 1989, pp. 362-368 (Nos. 85, 86).

205 On facial palsy cf. P. J. Vincken/Eddy de Jongh: De boosardigheid van Hals' regenten en regentessen, in: Oud Holland 78, Amsterdam 1963, pp. 1–26.

206 Cf. Josua Bruyn: Toward a Scriptural Reading of Seventeenth-Century Dutch Landscape Paintings, in: Peter C. Sutton et. al.: Cat. Masters of 17th-Century Dutch Landscape Painting. Amsterdam, Rijksmuseum/Boston, Museum of Fine Arts/Philadelphia, Museum of Art 1987/88, pp. 84–103.

207 Leonardo da Vinci: Philosophische Tagebücher. Italian and German. Edited by Giuseppe Zamboni. Hamburg 1958, p. 81.

208 Cf. Alistair C. Crombie: Von Augustinus bis Galilei. Die Emanzipation der Naturwissenschaft. Munich 1977, p. 499.

209 The large number of Classical and medieval medical textbooks in print reveals to what extent they were still regarded as authoritative sources. Cf. Galen: Opera. Venice 1490 (Latin translation Diomedes Bonardi). Hippocrates: Opera. Rome 1525. – Dioscurides: De materia medica. Cologne 1478. Regimen sanitatis Salernitanum. Cologne 1480 (?).

210 Crombie (see note 208), p. 504.

211 Cf. Schwartz (see note 154), pp. 143–146. – Haak (see note 189), pp. 111 ff.

212 Haak (see note 189), p. 113.

213 Cf. Haak (see note 189), p. 112, ill. 203.

214 Cf. Peter and Linda Murray: Die Kunst der Renaissance. Munich/Zurich 1965, p. 158, ill. 130.

215 The comparison, for purposes of satire, of doctors and surgeons (rather than anatomists) with executioners, as in this quatrain by the Netherlandish writer Maxaemilianus Vrientius, is not unusual in humanist literature:
Chirurgus medico quo differt? Scilicet illo:
Enecat hic succis, enecat ille manu.
Carnifice hoc ambo tantum differre videntur,
tardius hi faciunt, quod facid ille cito.
(What is the difference between a surgeon and a doctor?
Only this: one kills with potions, the other with his knife.
Which makes them both quite different from a hangman:
For they take their time to do what he gets done in a jiffy)
Cited by Harry C. Schnur/Rainer Kößling (ed.): Galle und Honig. Humanistenepigramme. Leipzig 1982, p. 122.

216 Cf. Schwartz (see note 154), p. 281.

217 Cf. Murray (see note 214), p. 141, ill. 112.

218 Gotthard Jedlicka: Spanische Malerei. Frankfurt/Vienna/Zurich 1962, p. 53.

219 Cf. Michel Foucault: Wahnsinn und Gesellschaft. Eine Geschichte des Wahns im Zeitalter der Vernunft. Frankfurt/M. 1973.

220 Cf. Marcel Bataillon: Erasmo y el Erasmismo. Nota previa di Francisco Rico. Traducción castellana de Carlos Pujol. Barcelona 1977, especially pp. 162 ff.; for the reception of "Moriae encomion" cf. pp. 327–346. – Joseph Pérez: L'Espagne du XVIe siècle. Paris 1973, p. 120 passim – John Lynch: Spain under the Habsburgs. Vol. I. Oxford 1981, pp. 70–73, 75 f. passim – Jean-Pierre Amalric et al.: Lexique historique de l'Espagne. XVe–XXe siècle. Paris 1976, p. 89 f. (see under "Erasmisme").

221 Cf. Jedlicka (see note 218) p. 53 f.

222 Cf. Enriqueta Harris (see note 188), pp. 108 ff.

223 Cf. Harris, op. cit., ill. 104.

224 Cf. Harris, op. cit., ibid., p. 109.

225 Cf. Amalric et al. (see note 220), p. 123 (see under "Illuminisme").

226 Cf. Paul Kroh: Lexikon der antiken Autoren. Stuttgart 1972, p. 412. – J. P. Sullivan: Die antike Satire, in: Prophyläen Geschichte der Literatur. Vol. I: Die Welt der Antike 1200 v. Chr. – 600 n. Chr. Berlin 1988, pp. 389–408, especially p. 394.

Biographies

Antonello da Messina
Born c. 1430. Died 1479, Messina.
Antonello was educated at Naples, where he was initially painter to the court of Alfonso of Aragon, King of Naples. He travelled widely between 1465 and 1473. Scholars have attributed his knowledge of oil painting to a probable journey to the Netherlands, where van Eyck had already developed the technique, but this is not supported. Many of Antonello's works were painted during his stay at Venice (1475/76). His work had a powerful influence on Venetian painting of the late fifteenth and early sixteenth centuries.
Bibl.: Jan Lauts: Antonello da Messina. Vienna ³1940. – Stefano Bottari: Antonello. Milan/Messina 1953. – Leonardo Scascia/Gabriele Mandel: L'opera completa di Antonello da Messina. Milan 1967. – Natale Scalia: Antonello da Messina e la Pittura in Sicilia. Palermo 1981. – Exhibition catalogue: Antonello da Messina. Messina, Museo Regionale 1981/82. – Eugenio Battisti: Antonello. Il teatro sacro, gli spazi, la donna. Palermo 1985. – Fiorella Stricchia Santoro: Antonello e l'Europa. Milan 1986.

Giuseppe Arcimboldo
Born c. 1527/30, Milan. Died 1593, Milan.
Famous for his allegorical "teste composte" (Lomazzo 1584) – compositions of flowers, animals, books, weapons or other implements arranged in the form of the human head – Arcimboldo was apprenticed in his father's workshop (stained glass windows for Milan Cathedral). From 1592 he was painter to the court of emperor Ferdinand I at Prague. He continued as court painter in the service of Maximilian II and Rudolf II, who elevated him to the rank of Count Palatine.
Bibl.: Roland Barthes: Arcimboldi. Parma 1978. – Francesco Porzio: L'universo illusorio di Arcimboldi. Milan 1979. – Werner Kriegeskorte: Arcimboldo. Cologne 1988. – Exhibition catalogue: The Arcimboldo Effect (Venice, Palazzo Grassi). Milan 1987.

Sandro Botticelli
(properly Alessandro di Mariano Filipepi)
Born 1445, Florence. Died 1510, Florence.
He initially entered his brother's workshop as a goldsmith. In 1465 he learned painting under Filippo Lippi, possibly also under Verrocchio. There are signs of Antonio del Pollaiuolo's influence on his early style. His mythological paintings (*Primavera,* for example, or *The Birth of Venus*), many of which were commissioned by the Medici family, were influenced by the ideas of the Florentine humanists. The mystical, even ecastatic tendency of his later religious works and manneristic human types betray the influence of the Dominican monk Girolamo Savonarola (1452–98).
Bibl.: Leopold D. and Helen Ettlinger: Botticelli. London 1976. – Ronald Lightbrown: Sandro Botticelli. Life and Work. 2 vols. London 1978. – Stanley Meltzoff: Botticelli, Signorelli and Savonarola. Theologica Poetica and Painting from Boccaccio to Poliziano. Florence 1987. – Umberto Baldini: Botticelli. Florence 1988.

Agnolo Bronzino
Born 1503 at Monticelli, near Florence. Died 1572, Florence.
Bronzino trained under Jacopo da Pontormo (1494–1557). A designer of several villas and palaces, he became known as the leading proponent of Florentine Mannerism. In 1540 he entered the service of Cosimo I of Tuscany and Eleonora of Toledo, who appointed him painter to the court.
Bibl.: Andrea Emiliani: Il Bronzino. Busto Arsizio 1960. – Edi Baccheschi: L'opera completa del Bronzino. Milan 1973. – Charles McCorquodale: Bronzino. London 1981.

Giovanni Francesco Caroto
Born 1480 (?), Verona. Died 1546, Verona.
His first signed works date from 1514. In 1540 he did a number of illustrations for Torello Saraina's "De origine et amplitudine civitatis Veronae". Influenced by Raphael and Correggio, his work was commissioned largely for churches (many altar retables of the Virgin and saints).
Bibl.: C. del Bravo: Per Giovanni Francesco Caroto, in: Paragone 123, 1964, pp. 3–16. – Maria Teresa Franco Fiorio: G. F. Caroto. Verona 1971 (with catalogue of works and artist's biography, p. 77). – Gunter Schweikhart: Le antichità di Verona di Giovanni Caroto. Verona 1977.

Philippe de Champaigne
Born 1602, Brussels. Died 1674, Paris.
Learned under the landscape painter Jacques Fouquières. Together with Nicolas Poussin he designed the Palais du Luxembourg, after which Maria de' Medici appointed him court painter. In this capacity he had considerable sway over the development of a specifically French Classical idiom. He painted a large number of portraits and religious paintings. He was influenced by Jansenist religious doctrine.
Bibl.: Bernard Dorival: Philippe de Champaigne 1602–1674. La vie, l'œuvre, et le catalogue raisonné de l'œuvre. Paris 1976, 2 vols.

Lucas Cranach the Elder
Born 1472 Kronach/Upper Franconia. Died 1553, Weimar.
Following a brief stay in Vienna (1503/04) he went to Wittenberg as court painter to Frederick the Wise, Elector of Saxony. His early paintings are typical of the so-called "Danube School". A follower of Martin Luther, Cranach developed a specifically reformational iconography in his work. He ran a large studio, and his many paintings and woodcut-illustrations brought him into contact with almost every pictorial theme of his age.
Bibl.: Werner Schade: Die Malerfamilie Cranach. Dresden 1974. – Dieter Koepplin/Tilman Falk: Exhibition Catalogue: Lucas Cranach. Basle 1974, 2 vols. – Max J. Friedländer/Jakob Rosenberg: Die Gemälde von Lucas Cranach. 2nd edition, edited by Gary Schwartz. Basle/Boston/Stuttgart 1979.

Albrecht Dürer
Born 1471 Nuremberg. Died 1528, Nuremberg.
Apprenticeship under Michael Wolgemut. In 1490 he set out on his bachelor's journey (Upper Rhine, Basle, Strasbourg), returning to Nuremberg in 1494. During the same year, he went on his first visit to Italy. He visited Italy a second time in 1505/07. Between 1512 and 1518 he received numerous commissions from emperor Maximilian I. He travelled to the Netherlands in 1520/21.
Bibl.: Erwin Panofsky: The Life and Art of Albrecht Dürer. Princeton 1948 – Exhibition catalogue: Albrecht Dürer. Nuremberg 1971. – Fedja Anzelewsky: Albrecht Dürer. Das malerische Werk. Berlin 1971.

Anthony van Dyck
Born 1599, Antwerp. Died 1641, Blackfriars/London.
Flemish Baroque painter. He began his apprenticeship with Hendrik van Balen, later entering Rubens's studio where he was both Rubens's pupil and accomplished fellow-painter. Following his visit to Italy in the 1620s, he became court painter to Archduchess Isabella of Brussels. From 1632, the date of his second visit to England, van Dyck, already one of the most sought after portraitists of his time, became court painter to Charles I of England, of whom he made numerous portraits. His work had considerable influence on English portraiture (Sir Peter Lely et al.).
Bibl.: Erik Larsen: L'opera completa di Van Dyck. Milan 1980, 2 vols. – Christopher Brown: Van Dyck. Freren 1983.

Jan van Eyck
Born c. 1390 at Maaseyck, near Maastricht. Died 1441, Bruges.
The founder of the Early Netherlandish School. An inscription, not discovered until 1823, on

his masterpiece the Ghent Altarpiece, names one Hubert (van Eyck?), evidently Jan's brother, who was – according to the inscription – a far greater artist, but scholars often consider this figure a "personnage de légende". In 1422 Jan van Eyck entered the service of John III of Bavaria. From 1425 until 1429, as court painter and "Va(r)let de chambre" (equerry) to Philip the Good, Duke of Burgundy, he travelled on diplomatic missions (to Spain and Portugal, where he executed a portrait of Isabella of Portugal for the Duke, who planned to marry her).

Bibl.: Erwin Panofsky: Early Netherlandish painting. Its Origins and Character. Cambridge (MA) 1953, vol. I, pp. 178 ff. – L. von Baldass: Jan van Eyck. Cologne 1952. – Norbert Schneider: Jan van Eyck, Der Genter Altar. Vorschläge für eine Reform der Kirche. Frankfurt/M. ²1989. – Dieter Jansen: Similitudo. Untersuchungen zu den Bildnissen Jan van Eycks. Cologne/Vienna 1988.

Jean Fouquet
Born c. 1420, Tours. Died 1480, Tours.
Probably educated at Paris. Influenced by Franco-Flemish miniature painting (Boucicaut and Bedford Masters). From 1443–1447 he visited Italy, where he was influenced by Fra Angelico and other Florentine artists. Following his return to France he founded a workshop in his native Tours. He was active at the French court (for Charles VII and Louis XI), eventually serving as "Peintre du roy".

Bibl.: Claude Schaefer: Recherches sur l'iconologie et la stylistique de l'art de Jean Fouquet. Thèse présentée devant l'Université de Paris IV 1971. Lille 1972, 3 vols. – Nicole Reynaud: Jean Fouquet (Les dossiers du département des peintures). Paris 1981. – Sandro Lombardi: Jean Fouquet. Florence 1983.

Giorgione (Giorgio de Castelfranco)
Born 1477/78, Castelfranco (Veneto). Died 1510, Venice.
Little is known of Giorgione's life. There is evidence of his collaboration on frescos for the exterior of the Fondaco dei Tedeschi (the German warehouse) at Venice. His early work was much influenced by Giovanni Bellini. Among the works admired by his contemporaries were especially his "Poesië" ("Poetry"; e.g. "The Three Philosophers", Vienna; "The Tempest", Venice). Giorgione's iconography betrays the Neo-Platonic influence of Florentine humanist thinkers.

Bibl.: Virgilio Lilli/Pietro Zampetti: L'opera completa di Giorgione. Milan 1978. – Günther Tschmelitsch: Zorzo, genannt Giogione. Vienna 1975. – Rodolfo Pallucchini (ed.): Giorgione e l'umanesimo veneziano. Florence 1981. – Christian Hornig: Giorgiones Spätwerk. Munich 1987.

Frans Hals
Born 1581/85, Antwerp. Died 1666, Haarlem.
Hals's early work largely consists of genre scenes, but also included some portraiture, a subject in which he soon specialised and which he continued to practice for the rest of his life. His first large commission was *The Banquet of the Officers of the St. George Militia Company*, painted during 1616. Hals is widely considered the chief master of the group portrait, a particularly characteristic Dutch genre. When he began

work, his financial situation was relatively good, but it worsened as he got older. From 1662 until his death, he received a small annual pension. Hals was buried in the chancel of St. Bavo's Church at Haarlem, a sign of the high esteem in which he was held even during old age.

Bibl.: Seymour Slive: Frans Hals. London 1970, 3 vols. – Seymour Slive (ed.): Frans Hals. Munich 1989.

Hans Holbein the Younger
Born 1497/98, Augsburg. Died 1543, London.
The son of Hans Holbein the Elder (c. 1465–1524). From 1515-1526 he lived at Basle, and from 1526–1528 in London. He lived in Basle again between 1528–1532, but returned to London in 1532, where he lived until his death. From 1536 he was painter to the court of Henry VIII. Holbein's portraits attempt an unerringly faithful analysis of his sitters' outward appearance, often characterising his subject via precisely rendered material attributes.

Bibl.: Wilhelm Waetzold: Hans Holbein d. J. Berlin 1938. P. Ganz: Hans Holbein d. J.: Die Gemälde. Basle 1950. – R. Salvini/H. W. Grohn: Holbein il Giovane. Milan 1971. – Jane Roberts: Holbein and the court of Henry VIII. Exhibition catalogue, The Queen's Gallery, Buckingham Palace. London 1978/79.

Jacob Jordaens
Born 1595, Antwerp. Died 1678, Antwerp.
Became a member of the Guild of St. Luke at Antwerp in 1615. In 1637–1638 he executed paintings after oil sketches by Rubens for the hunting lodge Torre de la Parada, near Madrid. Besides Rubens and van Dyck, Jordaens was the most significant seventeenth-century Flemish artist. He did particularly large-format genre paintings and popular mythological and allegorical scenes.

Bibl.: Exhibition catalogue: Jordaens. Ottawa 1968/69. – R. A. d'Hulst: Jacob Jordaens. Stuttgart 1982.

Leonardo da Vinci
Born 1452, Anchiano, near Vinci. Died 1519, Cloux Palace, near Amboise.
Leonardo was the pupil of Andrea del Verrocchio (1436–1488). In 1472 he was enrolled as a member of the Florentine painters' guild. Between 1482 and 1498 he worked at the court of Duke Ludovico Sforza of Milan. He was in Florence again from 1500 to 1506, when he returned to Milan. In 1513 he went to Rome. In 1516 he followed an invitation of Francis I to move to France, where he remained until his death.

Bibl.: Kenneth Clark: Leonardo da Vinci. Basle/London/New York 1954, 2 vols. – Jack Wasserman: Leonardo da Vinci. New York 1975. – Cecil Gould: Leonardo. The Artist and the Non-Artist. London 1975. – Hans Ost: Leonardo-Studien. Berlin/New York 1975. – Martin Kemp: Leonardo da Vinci. London et al. 1981.

Lorenzo Lotto
Born 1480, Venice. Died 1556, Loreto.
His early work shows the influence of Antonello da Messina, Giovanni Bellini and Giorgione, as well as Titian and Dürer. He led an almost vagrant life, wandering from town to

town in the Marches. Between 1506 and 1508 he painted the altarpiece at Recanati/Marches. In 1526 he returned to Venice, where his work does not appear to have met with much success. Impoverished, he became a lay-brother at the monastery at Loreto, near Ancona, a place of pilgrimage where he had settled in 1549.

Bibl.: Rodolfo Pallucchini/Giordana Mariani Canova: L'opera completa di Lotto. Milan 1975.

Andrea Mantegna
Born 1431, Isola de Carturo. Died 1509, Mantua.
Mantegna was the pupil of F. Squarcione, of whom little is known but that he collected antiques. Mantegna himself was intensely interested in antique literature and art, seeking to imitate a dignified Classical mode in his own work (cf. the frescos, executed 1448–1457 and partly destroyed in 1944, in the Eremitani Chapel at Padua; also his *Triumph of Caesar*, nine paintings executed in 1486–1492). From 1459 Mantegna was court painter to the Gonzaga family at Mantua. It was for Ludovico Gonzaga that Mantegna painted the illusionistic fresco decoration of the Camera degli sposi in the Ducal Palace.

Bibl.: P. Kristeller: Mantegna. Leipzig 1902. – E. Tietze-Conrat: Mantegna. Gemälde, Zeichnungen, Kupferstiche. Cologne 1956. – R. Lightbrown. Mantegna. Oxford 1986.

Quentin (Quinten) Massys (Metsys)
Born 1465/66, Leuven. Died 1530, Antwerp.
In 1491 he became Master of St. Luke's Guild in Antwerp. He was acquainted with a number of humanists, including Erasmus, and painted mainly religious works, portraits and genre scenes. He had a strong influence on sixteenth-century Flemish painting.

Bibl.: Max J. Friedländer: Early Netherlandish Painting. Leyden/Brussels 1967 ff., vol. VII.

Hans Memling
Born c. 1430/40 at Seligenstadt, near Aschaffenburg. Died 1494, Bruges.
According to tradition, he was taught by Rogier van der Weyden. He is known to have been active in Bruges from 1466. He painted numerous large altarpieces (e.g. *Last Judgement*, about 1472, St. Mary's, Danzig; Altar of St. John, 1479, at St. John's Hospital, Bruges).

Bibl.: Max J. Friedländer: Early Netherlandish Painting. Leyden/Brussels 1967 ff., vol. VI.

Nicoletto da Modena
Almost nothing is known of Nicoletto's life. During the 1530s he was involved in work on the Palace of Fontainebleau. He should not be confused with Niccolò dell'Abbate, also from Modena.

Bibl.: Lotte Pulvermacher, in: U. Thieme/F. Becker: Allgemeines Lexikon der Bildenden Künstler. Leipzig 1931, vol. XXV, col. 456 f. – André Chastel/Robert Klein: Die Welt des Humanismus. Europa 1480–1530. Munich 1963, p. 335 (No. 235).

Moretto da Brescia
(properly Alessandro Bonvicino)
Born 1498, Brescia. Died 1554, Brescia.
The first major works of the Lombard painter were paintings for the Chapel of the Holy Sac-

rament in S. Giovanni at Brescia (1521–1524). In 1529 Moretto moved to Bergamo. Besides portraits, he painted numerous altarpieces. He was influenced by Lotto and Savoldo.
Bibl.: Alessandro Bonvicino il Moretto. Brescia 1988.

Piero della Francesca
Born c. 1410/20, Borgo San Sepolcro. Died 1492, Borgo San Sepolcro.
His early work shows him already absorbing the innovations of his fifteenth-century Florentine contemporaries, especially Masaccio. He was taught by Domenico Veneziano. From 1445 he worked at the court of Federigo da Montefeltro at Urbino where he met Leon Battista Alberti, the leading art theorist of his time. Piero's major work is the series of frescos of the "Legend of the True Cross" in San Francesco at Arezzo. He is the author of a treatise on art entitled "De prospectiva pingendi", one of the most important works to be written on the mathematics of perspective.
Bibl.: Kenneth Clark: Piero della Francesca. London 1951. – P. Bianconi: Tutta la pittura di Piero della Francesca. Milan 1962. – P. Henry: Piero della Francesca. London 1951. – P. Henry: Piero della Francesco and the Early Renaissance. London 1967. – Creighton Gilbert: Change in Piero della Francesa. Locust Valley (NY) 1968. – Tout l'œuvre peint de Piero della Francesca. Inroduction par Henri Focillon. Documentation par P. de Vecchi. Paris 1990 (Les Classiques de l'Art). – Carlo Bertelli: Piero della Francesca. London 1992. – Ronald Lightbown: Piero della Frnacesca. New York 1992.

Piero di Cosimo
Born 1461/62, Florence. Died 1521, Florence.
Influenced by Filippo Lippi, Domenico Ghirlandajo, Signorelli and Leonardo, Piero was considered an eccentric by many of his contemporaries and by the younger generation (cf. Giorgio Vasari: Le vite de' più eccellenti Pittori etc., 1550). His *Scenes from the Early History of Man* (1480, New York, The Metropolitan Museum of Art, and Oxford, Ashmolean Museum) and *Battle of the Lapiths and the Centaurs* (London, National Gallery) provide a negative counterpart to the popular contemporary notion of the Aetas aurea (Golden Age) as the origin of man.
Bibl.: Erwin Panofsky: Studies in Iconology. Princetown 1939. – R. Langton Douglas: Piero di Cosimo. Chicago (IL) 1946. – Mina Bacci: Piero di Cosimo. Milan 1966. – Mina Bacci: L'opera completa di Piero di Cosimo. Milan 1976.

Jacopo da Pontormo
(properly Jacopo Carrucci)
Born 1494 at Pontormo, near Empoli. Buried 1557 in Florence.
Considered an exponent of Mannerism, Pontormo studied under Andrea del Sarto and Leonardo. His early work was much influenced by his study of (especially the prints) of Dürer, and Lucas van Leyden. In around 1530 his work became increasingly enriched by the study of Michelangelo. His major work is the *Entombment* (altarpiece in Sta. Felicità, Florence, 1526–1528). His Mannerism consists of deliberately over-exposed colouring and almost total neglect of shade.
Bibl.: K. W. Forster: Pontormo. Munich 1966

(with critical catalogue). – L. Berti: L'opera completa del Pontormo. Milan 1972.

Nicolas Poussin
Born 1594, Les Andelys. Died 1665, Rome.
Poussin is regarded as the greatest French painter of the seventeenth century. He made a first visit to Rome in 1624. In 1640 he was appointed "First Painter" to Louis XIII. Following a short visit to Paris during the same year (decoration of the Louvre), he returned to Rome in 1642, where he remained for the rest of his life. His work shows his predilection for themes from ancient history and Greek and Roman mythology. He made it his endeavour to lend each subject a particular mood, analogous to the five keys or "modes" in the musical theory of Classical antiquity. Poussin was the mainspring of a Classicism based on the principle of design (disegno, dessin), which came to be known as Poussinisme (in opposition to Rubenisme, which stressed the importance of colouring).
Bibl.: Georg Kauffmann: Poussin-Studien. Berlin 1960. – Anthony Blunt: The Paintings of Nicolas Poussin. London 1966, 2 vols. – Walter Friedlaender: Nicolas Poussin. London 1966. – Doris Wild: Nicolas Poussin. Zurich 1980, 2 vols.

Raphael
(properly Raffaello Santi)
Born 1483, Urbino. Died 1520, Rome.
He was apprenticed to Perugino (properly Pietro Vanucci, c. 1450–1523). In 1504 he is recorded in Florence. He moved to Rome in 1508 where, following the death of Bramantes, he became architect to St. Peter's and curator of Roman antiques. He painted numerous devotional works, "Virgins" (e.g. *Madonna del Cardellino*, 1506, Florence, Uffizi), and "Holy Families" (e.g. *The Holy Family of the House of Canigiani*, around 1505/06, Munich, Alte Pinakothek); also portraits (e.g. *Agnolo Doni*, around 1505, Florence, Galleria Pitti, *Baldassare Castiglione*). His career was furthered in 1508 by a summons from Pope Julius II to paint frescos for the papal rooms (Stanza) (*The School of Athens, Disputà, The Expulsion of Heliodor, The Fire in the Borgo*). Raphael died at the age of 37. He was buried in the Pantheon.
Bibl.: O. Fischel: Raphael. Berlin 1962. – L. Dussler: Raphael. London/New York 1971. – Leopold D. and Helen S. Ettlinger: Raphael. Oxford 1987.

Rembrandt
(properly Rembrandt Harmensz van Rijn)
Born 1609, Leyden. Died 1669, Amsterdam.
A Dutch painter and pupil of Pieter Lastman, he began work in his native Leyden, but moved to Amsterdam in 1631, where, in 1634, he married Saskia van Uylenburgh. Following her death in 1642, he lived with Hendrickje Stoffels. In 1639 he bought a house on the Breestrat. Initially very successful, Rembrandt ran into financial difficulties in the 1640s. In 1655/56 he was forced to declare his insolvency, part with his collections of art and curiosities, and sell his house.
Bibl.: Christian Tümpel: Rembrandt. Reinbek 1977. – Christian Tümpel: Rembrandt. Mythos und Methode. Königstein i. T. 1986. – Gary Schwartz: Rembrandt. Sämtliche Gemälde in Farbe. Stuttgart/Zurich 1987. – Perry Chap-

man: Rembrandt's Self-Portraits. Princeton (NJ) 1990.

Hyacinthe Rigaud
(properly Jacinto Rigau y Ros)
Born 1659, Perpignan. Died 1743, Paris.
French late Baroque portraitist. Trained with Paul Pezet and Antoine Ranc. In 1681 he settled in Paris, studying at the Académie Royale (where he received second prize in history painting in 1682). Following his studies he concentrated largely on portraiture. He was held in high esteem at the French court, from whence he received numerous important commissions. His most famous portrait is the state portrait of Louis XIV (1701, now at the Louvre).
Bibl.: Charles Colomer: La famille et le milieu social du peintre Hyacinthe Rigaud 1659–1743. Perpignan 1973 (Connaissance du Roussillon, 2).

Peter Paul Rubens
Born 1577, Siegen. Died 1640, Antwerp.
Rubens learned with Tobias Verhaecht, Adam van Noort and Otto van Veen. Between 1600–1608 he undertook various journeys to Italy and Spain, after which he became active at Antwerp. He was court painter to Archduke Albert. Rubens also received numerous commissions from Maria de' Medici in Paris. Between 1628 and 1630 he was entrusted with a number of diplomatic missions to Spain and England for Archduchess Isabella.
Bibl.: H. G. Evers: Rubens und sein Werk. Brussels 1943. – Hans Kauffmann: Peter Paul Rubens. Bildgedanke und künstlerische Form. Berlin 1977. – Martin Warnke: Peter Paul Rubens. Cologne 1977.

Jan van Scorel
Born 1495, Schoorl, near Alkmaar. Died 1562, Utrecht.
Netherlandish painter. Following his education at a Latin grammar school he became a pupil of Cornelis Buys the Elder. He was influenced by Jan Gossaert, alias Mabuse, and Jan Joest van Kalkar. He was widely talented, working as a painter, an architect, an engineer and a humanist scholar. In 1520 he travelled to Italy, initially staying at Venice, but then continuing to Rome, where, in 1522, the pope appointed him curator of the Belvedere (collection of antiques). In 1524 he returned to Utrecht where he painted numerous altarpieces in an Italianate style.
Bibl.: Exhibition catalogue: Jan van Scorel. Utrecht, Centraal Museum, 1955. – M. A. Faries: Jan van Scorel, His style and its historical context. (Thesis). Bryn Mawr College 1972. – J. A. L. de Meyere: Jan van Scorel 1495–1562. Schilder voor prinsen en prelaten. Utrecht, Centraal Museum, 1981. – Catalogue: Een schilderij centraal. De Jeruzalemvaarders van Jan van Scorel. Utrecht 1979.

Luca Signorelli
Born c. 1445/50, Cortona. Died 1523, Cortona.
An Umbrian painter, probably a pupil of Piero della Francesca. Came under the influence of Antonio del Pollaiuolo. In 1482–83 he painted two frescos in the Sistine Chapel in Rome. His major work is the *Last Judgement* in the Brizio Chapel at Orvieto Cathedral.
Bibl.: Luitpold Dussler: Signorelli. Des Meisters Gemälde. Berlin/Leipzig 1927. – Pietro

Scarpellini: Luca Signorelli. Florence 1964. – Gloria Kury: The Early Work of Luca Signorelli: 1465–1490. New York/London 1978 (Outstanding Dissertations in the Fine Arts).

Titian
(properly Tiziano Vecellio)
Born (probably) around 1487/90, Pieve di Cadore, Friuli. Died 1576, Venice.
Venetian painter. He was initially apprenticed to the mosaicist Sebastiano Zuccato at Venice, then entered the studios of Gentile and Giovanni Bellini. In 1508 he collaborated with Giorgione on the Fondaco dei Tedeschi, the German warehouse at Venice. In 1516 he became official painter to the Venetian Republic. In 1529/30 (in Bologna) he first met Charles V, who later made him court painter and elevated him to the rank of Count Palatine. In 1548 and 1550/51 he stayed in Augsburg. Titian had a predilection for religious and mythological subjects, but was also celebrated for his portraits.
Bibl.: Francesco Valcanover: L'opera completa di Tiziano. Milan 1978. – Harold E. Wethey: The Paintings of Titian. Complete Edition. London 1969–1975, 3 vols.

Diego de Silva y Velázquez
Born 1599, Sevilla. Died 1660, Madrid.
The greatest master of the seventeenth-century Spanish School. He was a pupil of F. Pacheco, whose daughter he married in 1618. In 1623 he went to Madrid where he became court painter and the favourite portraitist of the royal family. He visited Italy twice, in 1629–1631 and 1649–1651. His early work, consisting largely of religious paintings and "bodegones" (kitchen pieces), shows an affinity to the chiaroscuro of Caravaggio.
Bibl.: J. Lopez-Rey: Velázquez. London 1963. – Enriqueta Harris: Velázquez. Stuttgart 1982. – Jonathan Brown: Velázquez. Painter and Courtier. London 1986. – Exhibition catalogue: Velázquez. Madrid, Museo del Prado, 1990. – John Berger: Veláquez, Äsop. Erzählungen zur spanischen Malerei. Frankfurt/M. 1991.

Rogier van der Weyden
Born 1399 or 1400, Tournai. Died 1464, Brussels.
A pupil of Robert Campins, whose workshop he entered as "Roglet de la Pasture" on 5. 3. 1426. In 1432 he graduated as Master at Tournai. Rogier probably studied before his apprenticeship, which would explain why he started it so late. After settling in Brussels, Rogier was appointed official painter to the city. This was a respectable position, equivalent in status to court painter. In the "Jubilee" year of 1450, he undertook a pilgrimage to Rome. In Italy, Rogier's work was much loved during his own lifetime. – Some scholars (e.g. E. Renders) think that works usually ascribed to Robert Campin (or to the Master of Flémalle, who is generally agreed to be identical with Campin) should be identified as the early work of Rogier.
Bibl.: E. Renders: La solution du problème van der Weyden – Flémalle – Campin. Bruges 1931, pp. 13 ff. – Hermann Beenken: Rogier van der Weyden. Munich 1951. – Erwin Panofsky: Early Netherlandish Painting. Its Origins and Character. Cambridge (MA) 1953, vol. I, pp. 154 ff. and 247 ff. – Martin Davies: Rogier van der Weyden. London 1972.

Select Bibliography

Alazard, Jean: The Florentine Portrait. New York 1968 (Translation ibid.: Le portrait florentin de Botticelli à Bronzino. Paris 1924).

Bailbe, Josef-Marc (ed.): Le portrait. (Publications de l'Université de Rouen, 128). Rouen 1987.

Bauch, Kurt: Bildnisse des Jan van Eyck, in: Studien zur Kunstgeschichte. Berlin 1967, pp. 79–122.

Bauch, Kurt: Portraiture (The Middle Ages), in: Encyclopedia of World Art. New York et al. 1966, cols. 483–487.

Benkard, Ernst: Das Selbstbildnis vom 15. bis zum Beginn des 18. Jahrhunderts. Berlin 1927.

Bergström, Ingvar: On religious symbols in European portraiture of the 15th and 16th centuries, in: E. Castelli: Umanesimo e esoterismo. Padua 1960, pp. 335–343.

Boehm, Gottfried: Bildnis und Individuum. Über den Ursprung der Porträtmalerei in der italienischen Renaissance. Munich 1985.

Brilliant, Richard: On Portraits, in: Zeitschrift für Ästhetik und allgemeine Kunstwissenschaft 15, 1971, pp. 11–26.

Brückner, Wolfgang: Bildnis und Brauch. Studien zur Bildfunktion der Effigies. Berlin 1966.

Buchner, Ernst: Das deutsche Bildnis der Spätgotik und der frühen Dürerzeit. Berlin 1953.

Burckhardt, Jacob: Das Porträt in der Malerei. Beiträge zur Kunstgeschichte in Italien. Basle 1898.

Burckhardt, Jacob: Die Anfänge der neueren Bildnismalerei, in: Burckhardt, Jacob: Kulturgeschichtliche Vorträge, edited by R. Marx. Leipzig nd, pp. 209–227.

Buschor, Ernst: Das Porträt. Bildniswege und Bildnisstufen in fünf Jahrtausenden. Munich 1960.

Castelnuovo, Enrico: Das künstlerische Porträt in der Gesellschaft. Das Bildnis und seine Geschichte in Italien von 1300 bis heute. Berlin 1988.

Chapeaurouge, Donat de: Theomorphe Porträts der Neuzeit, in: Deutsche Vierteljahresschrift für Literaturwissenschaft und Geistesgeschichte 42, 1968, pp. 262–302.

Deckert, Hermann: Zum Begriff des Porträts, in: Marburger Jahrbuch für Kunstwissenschaft 5, Marburg 1929, pp. 261–282.

Dellbrück, Richard: Spätantike Kaiserporträts. Von Constantinus Magnus bis zum Ende des Weltreiches (reprint of the 1933 edition). Berlin 1978.

Deuchler, Florens et al. (ed.): Von Angesicht zu Angesicht. Porträtstudien. Festschrift zum 70. Geburtstag von Michael Stettler. Berne 1983.

Dülberg, Angelika: Privatporträts. Geschichte und Ikonologie einer Gattung im 15. und 16. Jahrhundert. Berlin 1989.

Foister, Susan et al.: The National Portrait Gallery Collection. London 1988.

Friedländer, Max. J.: Über die Malerei. Mit einem Vorwort von Hugo Perls. Munich 1963 (reprint of the edition: The Hague 1947), pp. 226–249.

Garas, Klara: Italienische Renaissance-Porträts. Budapest ²1965.

Gerstenberg, Kurt: Die deutschen Baumeisterbildnisse des Mittelalters. Berlin 1966.

Götz-Mohr, Brita von: Individuum und soziale Norm. Studien zum italienischen Frauenbildnis des 16. Jahrhunderts. (Europäische Hochschulschriften, 28) Frankfurt/Berne et al. 1987.

Goldscheider, Ludwig: Fünfhundert Selbstporträts. Von der Antike bis zur Gegenwart. Vienna 1936.

Gombrich, Ernst H.: Maske und Gesicht, in: E. H. Gombrich/J. Hochberg/ M. Black: Kunst, Wahrnehmung, Wirklichkeit. Frankfurt/M. 1977, pp. 10–60.

Gould, Cecil: Titian as Portraitist. London, National Gallery, 1976.

Haak, Bob: De vergangelijkheidssymboliek in 16e eeuwse portretten en 17e eeuwse stillevens in Holland, in: Antiek 1, 1967, pp. 23–30.

Haak, Bob: Regenten en regentessen, overlieden en chirurgijns. Amsterdamse groepsportretten van 1600 tot 1835. Amsterdam 1972 (Exhibition catalogue: Historisch Museum Amsterdam 1972).

Hamann, Richard: Theorie der bildenden Künste. Berlin 1980, pp. 71–80.

Heller, Elizabeth: Das altniederländische Stifterbild. (Thesis) Munich 1976.

Hetzer, Theodor: Tizians Bildnisse, in: ibid.: Vorträge und Aufsätze, vol. 1, Leipzig 1957, pp. 43–74.

Hinz, Bertold: Studien zur Geschichte des Ehepaarbildnisses, in: Marburger Jahrbuch für Kunstwissenschaft 19. Marburg 1974, pp. 139–218.

Hofmann, Werner (ed.): Köpfe der Lutherzeit. Exhibition catalogue Hamburger Kunsthalle. Hamburg 1983.

Holsten, Siegmar: Das Bild des Künstlers. Selbstdarstellungen. Exhibition catalogue Hamburger Kunsthalle. Hamburg 1978.

Hutter, Heribert: Porträtmalerei, in: Bildende Kunst, vol. III, edited by W. Hofmann (Fischer Lexikon, 23). Frankfurt/M. 1961, pp. 189–192.

Jansen, Dieter: Similitudo. Untersuchungen zu den Bildnissen Jan van Eycks. Cologne 1988.

Jenkins, Marianna: The State Portrait, Its Origins and Evolution, in: College Art Association in Conjunction with the Art Bulletin, No. 3. New York 1947.

Jongh, Eddy de: Portretten van echt en trouw. Huwelijk en gezin in de Nederlandse kunst van de zeventiende eeuw. Exhibition catalogue: Frans Halsmuseum, Haarlem 1986.

Keisch, Claude: Porträts in mehrfacher Ansicht. Überlieferung und Sinnwandel einer Bildidee, in: Forschungen und Berichte (Staatliche Museen zu Berlin) 17, Berlin 1976, p. 205 ff.

Keller, Harald: Das Nachleben des antiken Bildnisses. Freiburg i. Br./Basle 1970.

Keller, Harald: Die Entstehung des Bildnisses am Ende des Hochmittelalters, in: Römisches Jahrbuch für Kunstgeschichte 3, Leipzig 1939, pp. 229–356.

Kocks, Dirk: Die Stifterdarstellung in der italienischen Malerei des 13. bis 15. Jahrhunderts. (Thesis) Cologne 1971.

Künstler, Gustav: Die Entstehung des Einzelbildnisses in der flämischen Malerei, in: Wiener Jahrbuch für Kunstgeschichte 27, Vienna 1974, pp. 20–64.

Künstler, Gustav: Das Bildnis Rudolfs des Stifters, Herzog von Österreich, und seine Funktion, in: Mitteilungen der Österreichischen Galerie 16, 1972, p. 5 f.

Lipman, J.: The Florentine Profile Portrait in the Quattrocento, in: The Art Bulletin 18, New York 1936, p. 54 ff.

Meller, Peter: Physiognomical Theory in Renaissance Heroic Portraits, in: M. Meiss et al. (ed.): The Renaissance and Mannerism Studies in Western Art. Acts of the Twentieth International Congress of the History of Art. Princeton (NJ) 1963, vol. 2, p. 53 ff.

Moretti, Lino: Portraits, in: The Genius of Venice 1500–1600. London 1983, pp. 32–34.

Piper, David: Catalogue of Seventeenth-Century Portraits in the National Portrait Gallery 1625–1714. London 1963.

Pohl, J.: Die Verwendung des Naturabgusses in der italienischen Porträtplastik der Renaissance. Würzburg 1938.

Pope-Hennessy, John: The Portrait in the Renaissance (The A. W. Mellon Lectures in the Fine Arts 1963). London/New York 1966.

Prinz, Wolfram: Die Sammlung der Selbstbildnisse in den Uffizien. Berlin 1971.

Raupp, Hans-Joachim: Untersuchungen zu Künstlerbildnis und Künstlerdarstellung in den Niederlanden im 17. Jahrhundert. Hildesheim/Zurich/New York 1984.

Rave, Paul Ortwin: Bildnis, in: Reallexikon zur deutschen Kunstgeschichte, edited by Otto Schmitt. Stuttgart/Waldsee 1948, vol. II, cols. 639–680.

Rave, Paul Ortwin: Paolo Giovio und die Bildnisvitenbücher des Humanismus, in: Jahrbücher der Berliner Museen 1959, p. 119 ff.

Reinle, Adolf: Das stellvertretende Bildnis. Plastiken und Gemälde von der Antike bis ins 19. Jahrhundert. Zurich/Munich 1984.

Riegl, Alois: Das holländische Gruppenporträt. Vienna 1931, 2 vols.

Ring, Grete: Beiträge zur Geschichte der niederländischen Bildnismalerei im 15. und 16. Jahrhundert. Leipzig 1913.

Ruckelshausen, Olga: Typologie des oberitalienischen Porträts im Cinquecento, in: Gießener Beiträge zur Kunstgeschichte 3, Gießen 1975, p. 63 ff.

Schaeffer, E.: Über Andrea del Castagnos "uomini famosi", in: Repertorium für Kunstwissenschaft 25, Stuttgart 1902, pp. 170–177.

Scheffler, Karl: Bildnisse aus drei Jahrhunderten. Königstein i. T. nd.

Schlosser, Julius von: Geschichte der Porträtbildnerei in Wachs. Ein Versuch, in: Jahrbuch der Kunsthistorischen Sammlungen des Allerhöchsten Kaiserhauses 29, Vienna 1910/11, pp. 171–258.

Schramm, Percy Ernst: Die deutschen Kaiser und Könige in Bildern ihrer Zeit 751–1190. Edited by Florentine Mütherich et al. Munich 1983.

Schubring, Paul: Uomini famosi, in: Repertorium für Kunstwissenschaft 23, Stuttgart 1900, p. 424 f.

Singer, Hans Wolfgang: Allgemeiner Bildniskatalog. 14 in 7 Bänden. Leipzig 1930–1936 (reprinted Stuttgart 1967).

Smith, D. R.: Masks of Wedlock. Seventeenth-Century Dutch Marriage Portraiture. Ann Arbor 1982.

Waetzoldt, Wilhelm: Die Kunst des Porträts. Leipzig 1908.

Walbe, Brigitte: Studien zur Entwicklung des allegorischen Porträts in Frankreich von seinen Anfängen bis zur Regierungszeit König Heinrichs II. (Thesis) Frankfurt/M. 1974.

Warburg, Aby: Bildniskunst und Florentinisches Bürgertum. Domenico Ghirlandaio in Santa Trinità. Leipzig 1913.

Westendorp, K.: Die Anfänge der französisch-niederländischen Portraittafeln. Cologne 1906.

Wind, Edgar: Studies in Allegorical Portraiture, in: Journal of the Warburg Institute 1, London 1937, p. 138 ff.

Winter, Gundolf: Zwischen Individualität und Idealität. Die Bildnisbüste. Stuttgart 1985.

Wishnevsky, Rose: Studien zum "portrait historié" in den Niederlanden. (Thesis) Munich 1967.

Woermann, Karl: Die italienische Bildnismalerei der Renaissance. In: ibid.: Von Apelles zu Böcklin. Esslingen 1912, vol. I, pp. 48–87.

Zucker, Paul: On Painting. A Comparative Study. New York 1963 ([1]1950), p. 127 ff.

The publisher would like to thank the following museums, archives and photographers for permission to reproduce photographic material and for their generous support towards the realization of this book: Artothek, Peissenberg: ill. pp. 27, 59, 105, 139; Bildarchiv Preußischer Kulturbesitz, Jörg P. Anders, Berlin: ill. pp. 8, 9, 14, 17, 19, 29, 35, 42, 46, 70, 77, 79, 104, 111, 127, 131 (both ill.); Philip A. Charles: ill. p. 93; Colorphoto Hans Hinz: ill. p. 147; Courtauld Institute of Art, London: ill. p. 91; © Claudio Garofalo, Naples: ill. p. 98; H. Maereens, Bruges: ill. p. 165; Stanislaw Michta: ill. p. 54; Musées de la Ville de Paris, Paris: ill. p. 117; © Photo R. M. N.: ill. pp. 13, 24, 37, 43 (both ill.), 47, 53, 58, 88, 89, 106, 108, 129, 132, 136, 137; Rheinisches Bildarchiv, Cologne: ill. p. 116; SCALA Instituto Fotografico Editoriale S.p.A., Antella: ill. pp. 13, 19, 22, 26, 28, 45, 46, 48, 50, 64, 69, 88, 92, 94, 97, 145, 164; G. Schmidt: ill. p. 122; J. Whitaker: ill. p. 23. All photographic material not listed above was supplied and reproduced by courtesy of the institutions named in the captions.